be an artist
IN 10 STEPS

KT-376-932

be an artist
IN 10 STEPS

Ian Sidaway • Patricia Seligman

hamlyn

An Hachette Livre UK Company
www.hachettelivre.co.uk

First published in Great Britain in 2009 by Hamlyn,
a division of Octopus Publishing Group Ltd
2-4 Heron Quays, London E14 4JP
www.octopusbooks.co.uk
www.octopusbooksusa.com

Copyright © Octopus Publishing Group Ltd 2009

Distributed in the United States and Canada by
Hachette Book Group USA,
237 Park Avenue, New York, NY 10017 USA

All rights reserved. No part of this work may be reproduced or utilized in any form or by any
means, electronic or mechanical, including photocopying, recording or by any information
storage and retrieval system, without the prior written permission of the publisher.

ISBN 978-0-60061-856-0

A CIP catalogue record for this book is available from the British Library

Printed and bound in China

10 9 8 7 6 5 4 3 2 1

contents

introduction

This book will set you on the path to becoming an artist, offering as it does a masterclass in five different mediums – drawing, watercolour, oils, acrylics and pastels. Each chapter is structured in such a way that you'll focus on just one aspect of your chosen medium at a time. Discover which materials you need to start then, in just 10 lesson-like steps, you'll progress from making your first marks to completing a still-life work of art.

Drawing is intuitive. It is among the first skills we reveal as very young children, and yet the ability to draw often becomes lost and forgotten as we grow older. It is possible to rediscover drawing, however, and in many cases all that is needed is a little practice. You'll learn to get to grips with the basics covered in the 'mini art classes' – scale, shape and perspective, tone, colour and texture – before completing your still-life drawing.

The chapter on painting with watercolour will guide you through exploring your palette of colours, looking at their characters, ways of mixing them and trying them out in useful techniques. This will give you a chance to get used to the brushes and the individual properties of the paints. You'll start with simple drawings and paintings of fruit, which are paintings in their own right but are also preparatory studies for the still-life painting you will tackle in the final step.

Today, oils have never been easier to use. The range and quality of colours available is vast; and mediums, additives and solvents enable artists to use the

paint in any number of different ways. Furthermore, the flexible nature of oil paint means that mistakes are easily rectified, making this an extremely attractive medium for beginners. Early steps include laying the foundation for a good painting, how to establish the tonal structure of a painting and how to use colour effectively. Once these steps are mastered, you'll learn how to apply the paint using alla prima, glazing and impasto techniques, and how to manipulate the paint by blending, scumbling and using broken colour. Learn about composition then put your acquired knowledge and skills into practice in creating a still life in oils of your own.

The fourth chapter in this book is the perfect introduction to painting with acrylics, an incredibly versatile medium. The steps cover basic paint application, effective use of colour and establishing the tonal structure of a painting. You will then move on to applying the paint using watercolour, impasto and painting-knife techniques, and discover how to employ different paint effects. After a close look at composition you'll be able to produce your acrylics masterpiece.

The final chapter in the book introduces you to applying pastels, a remarkably simple and pure painting material, which draws on techniques from both drawing and painting. The steps take you through how to create a pastel painting from start to finish, helping you avoid any pitfalls and teaching you a wide range of useful tips and techniques. You'll learn which materials to use, how to choose a suitable surface, how to lay the foundations and how to establish tone, colour and texture; you'll also discover how to organize the elements in the picture and how to manipulate pastels to create a wide range of effects.

drawing in 10 steps

before you begin

choosing the right materials

Artists have exploited a wide variety of materials and equipment over the years and manufacturers have responded by producing an incredible range of art materials, most of which are easily and readily available. When buying drawing materials, you will find that they have advantages over those for painting in that they are relatively inexpensive, last a reasonably long time and are very easy to carry. The materials you will need to follow the projects in this book, and to produce compositions of your own, are available at most art stores. Beware when buying, however: art stores are seductive places and you may be tempted to purchase more than you actually need.

Shopping list

Hot-pressed watercolour paper,
 300 gsm/140 lb

White cartridge paper, 120 gsm/60 lb

White cartridge paper, 300 gsm/140 lb

Mid-grey pastel paper, 160 gsm/90 lb

Beige pastel paper, 160 gsm/90 lb

Scrap paper

2B graphite pencil

2B thick graphite stick

3B graphite stick

Reed pen

Dip pen

Fine steel nib

Medium steel nib

Black Indian ink

Bisque waterproof drawing ink

No 2 sable brush

White gouache

Putty eraser

Blending stump

Fixative

Pencil sharpener

Ruler

Stick charcoal

White chalk stick

Charcoal pencils:

Medium-soft

Hard

Artist's pencils:

Terracotta

Black

Lead holder

Drawing leads:

Sepia

Terracotta

Black

Pastel pencils:

White

Light grey

Mid grey

Dark grey

Cadmium red

Crimson

Cadmium orange

Cadmium yellow

Lemon yellow

Naples yellow

Yellow ochre

Light ochre

Olive

Mid green

Light green

Lime green

Light violet

Violet

Indigo

Ultramarine

Light blue

Burnt sienna

Burnt umber

Terracotta

Black

DRAWING SURFACES

The surface upon which a drawing is made is commonly known as the support. When it comes to drawing this is, invariably, a type of paper, although you can draw on many surfaces, including card or wooden boards prepared with gesso (a white, plaster-like base). The type of paper that you choose is very important and will have an impact on the marks and effects that you can make and how your chosen drawing material behaves.

There are, essentially, three types of paper surface: hot pressed, which has a smooth surface; cold pressed, sometimes known as 'not' (not hot pressed), which has a slight texture; and rough. Drawing materials that are relatively hard – graphite, coloured pencils and some artist's pencils – perform very well on smooth, hot-pressed papers, allowing the artist to make precise and textural marks with a full range of tonal density. The same is true when using ink: smooth papers allow the nib to move freely over the paper surface without snagging, which can result in blots and splashes.

When using softer 'friable', or crumbly, drawing materials, such as charcoal and soft chalks the story is slightly different. On hot-pressed papers, the dusty pigment from these materials sits loosely on the paper, unable to attach to the smooth surface. This makes it difficult to make dense, dark marks or to build the work up in layers. Such mediums are much more effective on medium-grain, cold-pressed papers, which have a degree of texture, or surface 'tooth', for the pigment to adhere to. You can also use rough papers, which will result in bold drawings that are heavily influenced by the texture of the paper.

Several manufacturers produce coloured and tinted papers specifically for use with soft drawing materials like charcoal, pastel pencils and chalks. These fall into two groups: woven paper and laid paper. A sheet of woven paper is made by picking up the pulp on a fine wire mesh, which results in the fibres being knitted or woven together in a random way. This is the way most papers are made. A sheet of laid paper is made by picking up the pulp on a wire mesh that has the wires running in a grid pattern, parallel to one another. You can identify laid paper by holding it up to the light: a series of fine lines left by the mesh is visible.

All papers are sold by weight, which describes the thickness of the paper, using either grams per square metre (gsm) or pounds per square inch (lb): the higher the figure the thicker the paper. Cartridge paper (a smooth hot-pressed paper), also known as drawing or Bristol paper, is mostly used for drawing.

There are countless other papers available, many with special surfaces. There are also some exciting innovations from countries like Japan, India and Thailand. They all make excellent drawing surfaces and should provide you with limitless opportunities for experimentation.

GRAPHITE

The graphite pencil is familiar to everyone, although few realize its true potential. Traditional graphite pencils – lead strips encased in wood – are available in a range of grades. In most cases, although it depends on the manufacturer, the hardest pencil in the range is 9H and 9B is the softest. A good all-round pencil, HB, is in the middle of this range. For drawing you will seldom need anything harder than H. For example, a 2B pencil, if used correctly, will render a full range of tones from very light grey to a deep, dense black. Wooden pencils have either round, hexagonal or triangular-shaped barrels. The choice is personal. Hexagonal barrels are easier to hold for long periods and provide a firm grip, while a round barrel is easy to roll between the fingers as you work.

Graphite is also available as solid pencil-like sticks, or 'leads', which, owing to the shape of the point, can make a wider range of marks. You can buy various thicknesses and grades of graphite, as well as coloured leads, to fit holders that have a clutch mechanism to reveal more of the lead as it wears. You will also find square, rectangular and round graphite blocks. Graphite powder is a dust that is rubbed into the paper and 'worked into' using more graphite or erasers.

CHARCOAL

Charcoal is perhaps the simplest of all art materials, consisting of carefully carbonized, or burnt, wood. Today most stick charcoal is made from willow – although beech and vine charcoal also exist – and is available in varying lengths, thicknesses and grades of hardness, as well as in rectangular blocks and irregular chunks. Compressed charcoal is made by binding charcoal dust together to form a solid. It is harder than traditional charcoal and is made into blocks, short sticks and strips that are encased in wood or held in holders. Like stick charcoal, compressed charcoal is available in varying degrees of hardness. Both types are messy to use, but you can keep your fingers clean by wrapping the charcoal in aluminium foil.

CHALKS

Also known as carré sticks, chalks are made using a pigment and a binder and are harder than pastels. They are square in profile, can be sharpened to a point and held in a holder. Traditional colours are black, white, sepia, bistre, terracotta and sanguine. You may also find a range of greys, browns and ochres. The colours produce wonderfully subtle drawings, particularly when several different shades or colours are combined together on a tinted paper.

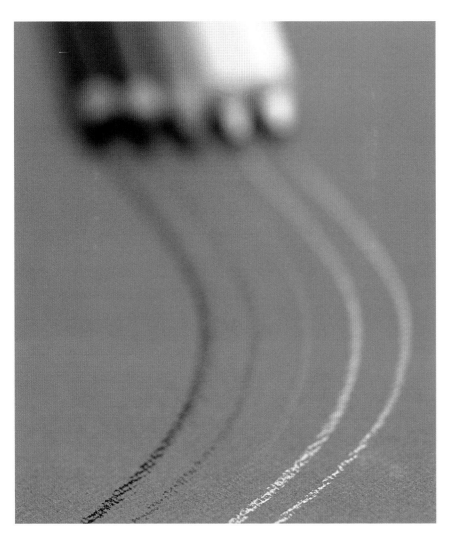

ARTIST'S PENCILS

The traditional colours used for making chalks are also available as artist's pencils. Some of these also contain wax, which means they can be used without fixing, however this also makes them difficult to use with erasing techniques (see page 53). You can sharpen these pencils in the same way that you would sharpen a graphite pencil. You may also find different coloured 'leads' to insert into a holder with a clutch mechanism for lengthening or shortening the point.

PASTEL PENCILS

Coloured pigment, held together with a binder, is used to produce pastel pencils in a reasonably comprehensive range of colours. They can be sharpened to a point and you can smudge and blend them together on the paper using your finger or a blending stump (see page 16). You can also erase them with care. They respond particularly well when used on coloured or tinted backgrounds. You can buy pastel pencils in sets or separately, which means that you can buy just the colours you need.

DIP PEN AND INK

Inks are available in a range of colours, the most traditional ones being sepia, bistre and black. They are either water-soluble when dry, or waterproof. Water-soluble inks are easier to correct, but are not as easy to find as waterproof versions. Both can be diluted with clean water to produce a range of tints and shades.

There are numerous pens and brushes for applying ink. Nib holders will take steel nibs of varying size and shape: some are even double-ended so that two nibs can be held at the same time. Each nib gives a different quality and thickness of line and some work better on rougher papers. Bamboo and reed pens are also used. The former are inflexible and give a dry, course mark with a distinct quality, while the latter are flexible and deliver a line that can alter in width and character. Bamboo pens are very hard wearing, reed pens less so: they wear and the nib often needs to be re-cut using a sharp craft knife. You may also find traditional quills made from goose feathers. These are particularly enjoyable to use and leave a wonderfully expressive line.

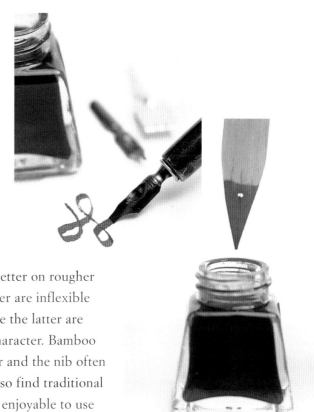

COLOURED PENCILS

Coloured pencils are similar to pastel pencils but contain wax, which makes them more difficult to erase. They also come in a far greater range of colours. The effects of coloured pencils are more subtle than those of other media, and this makes them more suitable to use on white backgrounds. Like pastel pencils, these are available in sets, or individually, allowing you to build up your colours over time.

ERASERS

Erasers are not used simply for making corrections, but are important mark-making tools in their own right. They enable you to create many different effects, some of which would be difficult, if not impossible, to achieve using the drawing medium itself. They are inexpensive and you should equip yourself with several different types. Avoid erasers that are brightly coloured, as they may leave traces of colour on your drawing.

Erasers are made from various materials and have a range of different uses. Putty erasers are soft and can be moulded or cut to shape. They are very good for tidying up dirty areas of clean paper and for lightening tones. However they get dirty very quickly, especially when used with charcoal and chalk. Putty erasers make relatively soft-edged marks. Plastic and India rubber erasers are harder and produce crisper marks. They do not pick up as much pigment as putty erasers, so do not get quite so dirty. They can be cut to size and shape as required.

BLENDING STUMPS

Many types of drawing material are such that, until fixed, you can move, smudge and manipulate the pigment once you have applied it. Although you can do this with your fingers, rolled or pulped paper 'blenders' will make the process cleaner and more precise. Sometimes known as stumps, torchons or tortillons these blenders are available in various sizes. Once dirty they can be cleaned, either by unrolling a clean section of paper or by rubbing them on fine-grit glass paper. Cotton wool buds can also be used for the same purpose.

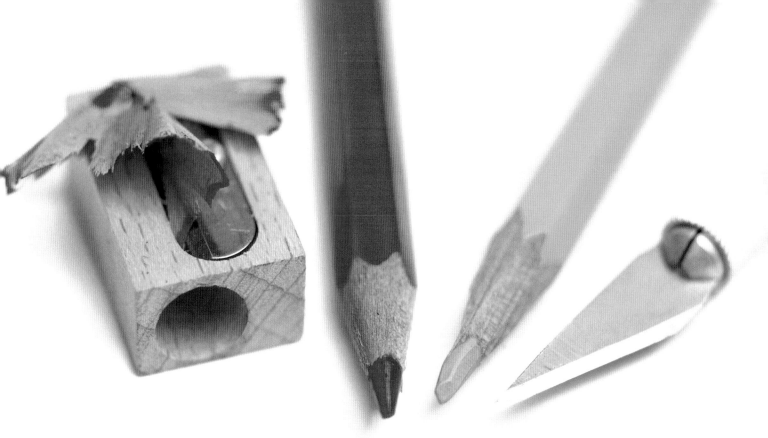

SHARPENERS

It is very important to keep your drawing implements sharp. A blunt drawing tool creates a dull, uniform line and is perhaps only of use when blocking in large areas of single tone or colour. Pencil sharpeners are inexpensive and can take drawing implements of varying diameter. However, they do get blunt relatively quickly, and will cause soft drawing tools like charcoal or pastel pencils to break during sharpening. Although all sharpeners are excellent for sharpening pencil-shaped graphite sticks, desk-mounted sharpeners can be a little too vigorous for soft 'leads'.

By far the best way to sharpen drawing tools that have the 'lead' or pigment strip enclosed in wood or carré sticks and drawing chalks, is to use a sharp craft knife or scalpel – suitable for even very soft materials. You can also tailor or shape the point to suit. Sandpaper blocks are also very useful, especially for maintaining some kind of point on graphite sticks or blocks and chalks.

FIXATIVE

Fixative is important, not only to preserve and protect your finished image, but to secure the loose pigment to the background during the drawing process, enabling you to work over in layers. Available in CFC-free aerosol cans and in bottles with a pump-action spray mechanism, you should always use all fixatives according to the manufacturers' instructions and in well-ventilated spaces.

step 1 proportion and shape

focus: **grapes**

Materials

White cartridge paper, 300 gsm/140 lb

Medium-soft charcoal pencil

Putty eraser

Before spending any time on detail, colour, tone or texture, it is essential that you establish the correct shape and proportion of your subject in relation to its surroundings. This will provide you with a proper foundation on which to build. If this stage of the drawing process is overlooked, the completed work is unlikely to look quite as it should. Furthermore, trying to remedy any faults later on will almost certainly cause unnecessary complications and make the whole drawing process far more difficult to master.

MEASURING

In order to draw something correctly, artists usually estimate its size and shape in relation to other objects in the composition. For example, in the exercise that follows, how long is the stalk in relation to the length of any one grape? Experienced artists often accomplish this simply by eye, but even they might make a few initial measurements to get started.

You can do this by holding out your drawing implement, say a pencil, at arm's length. Look down your arm to the pencil and beyond to your subject. Position the top of the pencil at a point on the subject that marks one end of the required measurement and move your thumb along the shaft of the pencil until it comes to rest at the point on the subject where that measurement ends. You can then transfer this unit of measurement to your paper. A single unit can be used over and over to compare distances or several different measurements taken – as long as your measuring remains consistent the drawing should be correct.

NEGATIVE SHAPES

Negative shapes are those that surround an object as opposed to the 'positive' shape of the thing itself, and are usually instantly recognizable: think of the spaces between the legs of a chair or the space through the handle of a cup. Negative shapes are often simpler or clearer to define than the positive shape of an object and are a useful means of checking how correct your drawing is.

SHAPE RATHER THAN SUBJECT

When analyzing a subject for drawing, try to think of it in terms of abstract shapes and not as an object as a whole. Artists often check for accuracy by looking at a drawing upside down or in a mirror, where faults are often easier to see. All drawings can be rendered using three basic geometric shapes: the square, the circle and the triangle. Turned into three-dimensional forms – a cube, a sphere and a cone – these can be elongated and stretched to become rectangular or ovoid, tall, thin, fat or squat, without altering their basic shape. If you begin a drawing by breaking the subject down into these basic shapes, you will provide yourself with a good foundation on which to build.

Simple shapes: The three basic shapes are the square, the circle and the triangle.

Simple forms: The basic shapes are translated into a cube, a sphere and a cone.

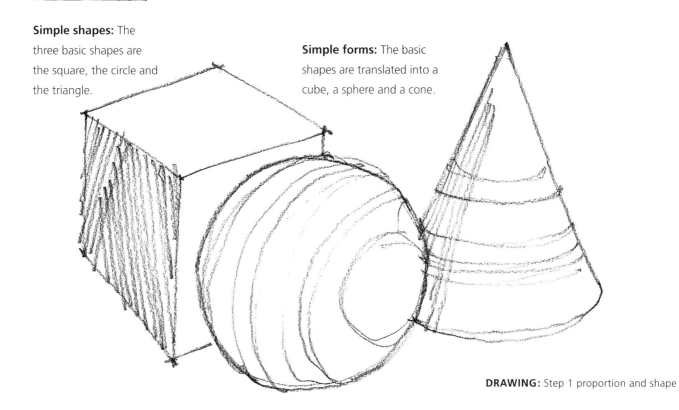

DRAWING THE BUNCH OF GRAPES

A bunch of grapes has been chosen for this exercise. It has a distinct shape as a whole but is made up of many similar small shapes. The idea is to draw the individual parts correctly in order to create the whole.

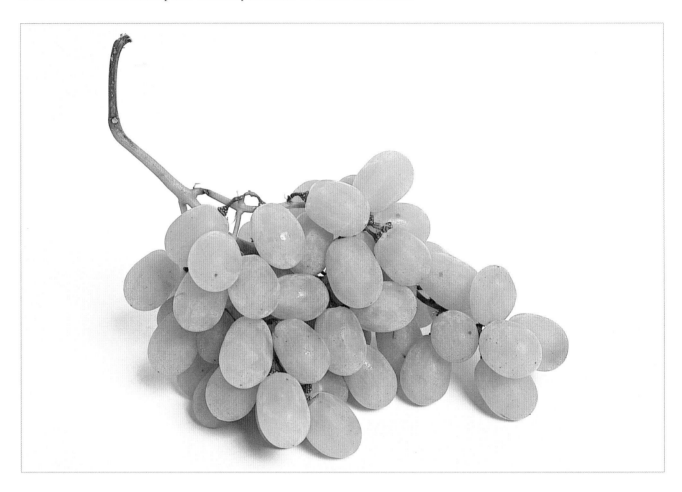

1 Begin by establishing the correct proportion of the bunch of grapes: you can do this easily by taking two measurements. The first is a vertical measurement from the tip of the stalk to a position that is level with the base of the lowest grape. Use the charcoal pencil to transfer these two points to your paper. The second measurement is the distance from the extreme left edge of the grapes to the extreme right. Again, mark the two points on your paper.

2 Consider the basic shapes that make up your subject. From the tip of the stalk to the last grape on the bunch occupies an approximately triangular shape, so lightly draw three straight lines on the paper. The bunch of grapes itself is roughly oval and sits within the triangle outline. Again, draw this lightly on the paper.

3 Once you have established the overall shape and proportion of the bunch, you can draw the approximate shape of the stalk. Draw, roughly, the position and number of grapes, using a light charcoal line.

4 Once happy with this, you can redraw the bunch more carefully using a darker, more deliberate line. Draw the stalk first, paying attention to its curve. Now redraw each grape in turn, positioning it in relation to the grape next to it. Look at the 'negative' shapes around and between the grapes as well as the 'positive' shapes of the grapes themselves.

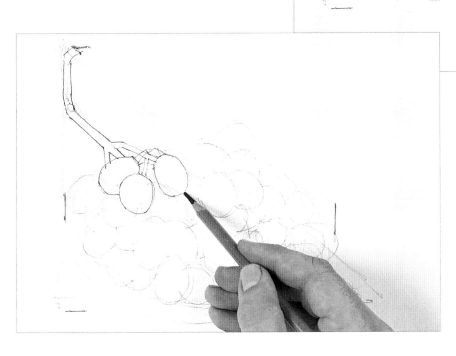

5 Continue to build up the drawing. As you do so, take time to appreciate how the orientation of each oval shape changes slightly from grape to grape.

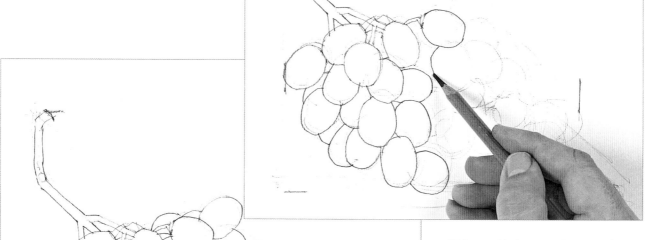

6 Pay particular attention to each grape's position on the bunch: grapes that are in front need to look in front, while those positioned at the back should also appear so. This may seem obvious, but a misplaced line can easily result in a grape that appears to be neither in front nor behind.

7 With the initial drawing complete and the bunch of grapes positioned to your satisfaction, you can remove any construction lines or marks that jar by working over the drawing, carefully, using the putty eraser.

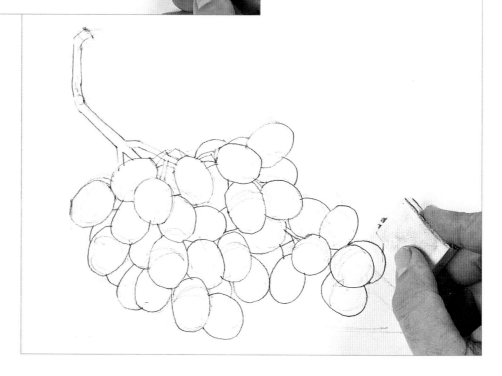

8 Your drawing will resemble a bunch of grapes, but may be lacking in depth because the aim of this exercise is to establish shape rather than form or volume. You can, however, remedy this by adding a series of contour lines that follow the curvature of each individual grape. You can complete the drawing by 'tidying' up any unwanted lines with the putty eraser.

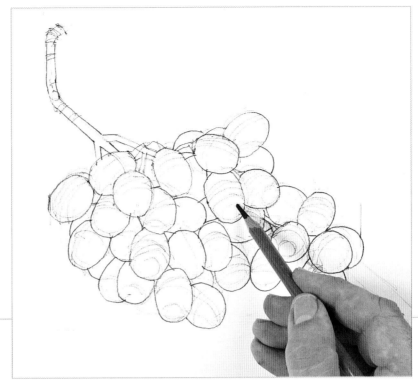

9 Having established the correct shape and proportion of your subject matter, you now have a very solid foundation on which to build.

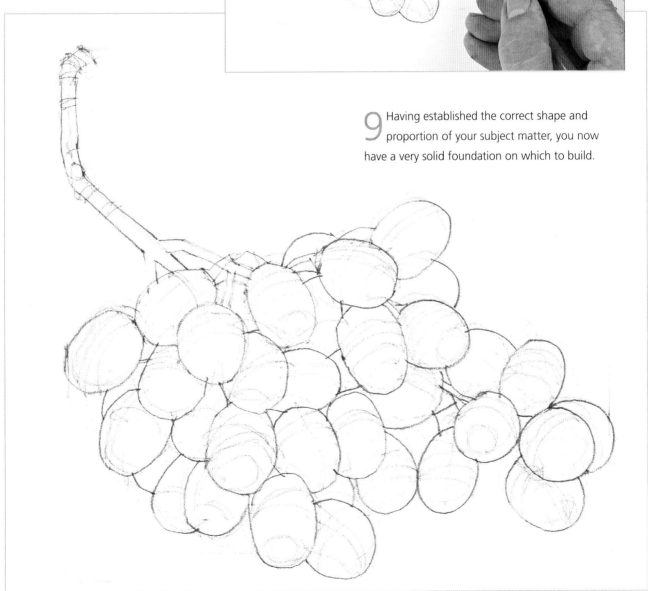

step 2 perspective

focus: **jug and board**

Materials

White cartridge paper, 300 gsm/140 lb

Ruler (optional)

Artist's pencils
- *Black*
- *Terracotta*

Perspective is a device that enables the artist to make a convincing representation of three-dimensional subject matter on a flat, two-dimensional surface. Armed with a basic knowledge of perspective you can check whether a drawing is spatially correct. Furthermore, you will be able to overcome problems encountered when drawing awkward shapes, such as ellipses. Linear perspective may seem complex at first, but the basic rules are very easy to follow. By using perspective to orientate correctly the basic shapes that make up a subject – squares, circles and triangles (see page 19) – you can be certain that your drawn image corresponds with your subject and that its orientation is as it should be.

BASIC RULES OF PERSPECTIVE

The basic rules of perspective show that all lines running parallel to one another when seen on a receding plane meet at the same point in space known as the vanishing point. In simple perspective the vanishing point is always on a line that runs horizontally across the viewer's field of vision at eye level. All perspective lines that originate above eye level run down to meet the vanishing point, while lines that originate below eye level run up to meet it.

SIMPLE SHAPES USING LINEAR PERSPECTIVE

Imagine looking down slightly, on to the top of a cube. Notice how, if the two sides of the cube's topmost surface are extended they meet at the same vanishing point. This is known as 'one-point' perspective. But if the cube is turned so that two sides and the top of the cube can be seen, the perspective changes. Extending the top and bottom lines of one side of the cube until they meet at their vanishing point gives the correct

Single point: In this simplified diagrammatic drawing, the vanishing point of the chopping board and the cube are shown as one and the same.

perspective for that side of the cube. Repeating the process gives the perspective for the other side of the cube. Then joining up the two top edges to their respective vanishing points gives the top surface in perspective. This is known as 'two-point' perspective. When looking at several objects grouped together some may share vanishing points, while others will have their own, depending on their orientation.

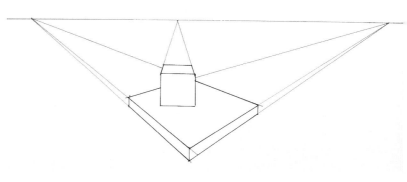

You can draw the ellipses seen in cylindrical and cone-shaped objects in perspective by first drawing the shape as a cube. Divide the top and bottom of the cube using diagonals to find the centre of each side. Use these lines to plot the curve of the cylinder's top and bottom.

AERIAL PERSPECTIVE

There is one other type of perspective, known as 'aerial' perspective. This concerns the effects of the atmosphere and its influence on the landscape: not only do objects become smaller the further away they are, but they also become less distinct. It is a powerful tool that can make the difference between a good or bad drawing, and is achieved by making detail and textures less distinct, by reducing tonal contrast and by using cooler colours.

Multiple point: The orientation of the board is such that two edges can be seen rather than one, so the drawing requires three vanishing points: one for the cube representing the jug, and one for each side of the chopping board.

Creating depth: This sketch illustrates the basic rules of aerial perspective. The colours are cool in the background, where there is less contrast and less detail evident. Greater detail and warmer colours are seen in the foreground. The fence posts become smaller as they recede back in space.

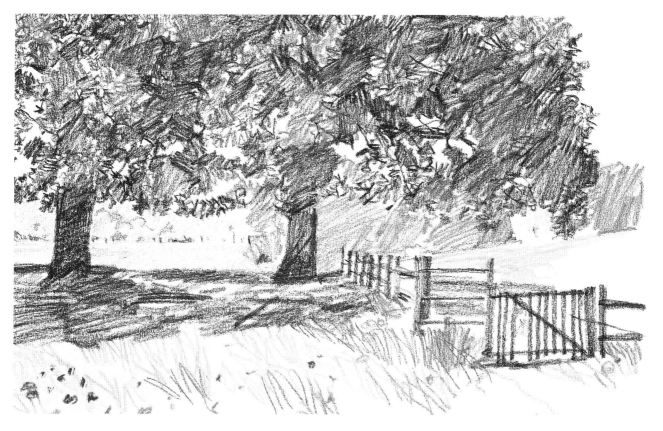

DRAWING THE JUG AND BOARD

Although different in shape, both the jug and the chopping board in this exercise can be drawn using the same principles of linear perspective. The trick is to represent the round jug as a simple box in order to position it properly, in perspective, and with the correct orientation and volume. All distances can be judged either by eye or by taking a measurement.

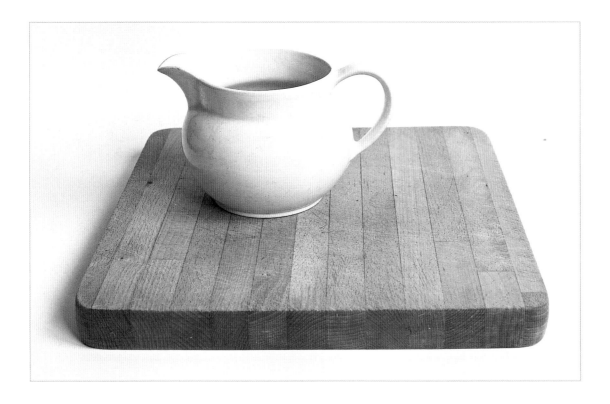

1 Very roughly establish the approximate position of your subject on the paper (see page 18), allowing enough room at the top for the extended perspective lines. Establish the depth of the chopping board by taking a vertical measurement and draw the front and back edges as two lines running parallel to one another using the terracotta pencil. Bear in mind that, quite often, the vanishing points for some or all of your perspective lines will end outside the picture area.

2 You now need to establish eye level, which runs across the field of view, parallel to the two lines already drawn. You can do this either by eye or by taking a measurement from the back edge of the chopping board to a position that is at your eye level. Hold your pencil up at an angle that matches the angle of the left-hand side of the chopping board. Mark the position and angle of this line on your drawing, extending it up to the eye-level line. Gauge the width of the board along its bottom edge, either by eye or by taking a measurement, and draw a line up from the right-hand corner so that it meets the eye-level line at the same point as the line marking the left-hand side of the board. Any other perspective lines used on the drawing, if extended to the eye-level line, must converge at this point.

3 You have drawn the surface of the board correctly in perspective. Now estimate and establish the thickness of the chopping board, and drop two vertical lines to indicate the two ends. Join these together with a horizontal line, and you should have a shape resembling a take-away pizza box.

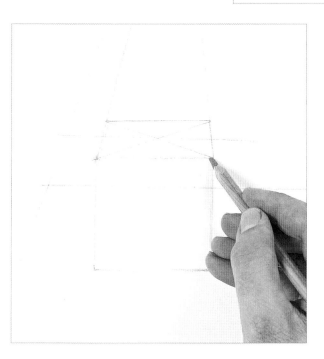

4 The next step is to draw a box, in perspective, that will serve as the foundation for the jug. Draw a horizontal line where the front edge of the bottom of the jug sits on the chopping board. Establish another horizontal line at the point where the front edge of the top of the jug rests. Now drop a vertical line to mark the position of the left-hand side of the jug and do the same for the right-hand side where the handle meets the bowl. You should now have a square. Extend a line from each top corner of the square up to the vanishing point. Estimate the depth of the jug's opening and draw a horizontal line joining the two lines just drawn. You should now have a drawing of a solid cube in perspective. Find the centre of the topmost surface of the cube by drawing in two diagonal lines that run from corner to corner. Run another horizontal line through the centre point to establish the axis of the handle and the spout.

5 By imagining that the cube is transparent, you can draw in its base by extending lines up from the front bottom corners to the vanishing point and then dropping verticals from the back two top corners. Draw a horizontal line where they meet to indicate the back rear edge of the cube. Find the centre of the cube's base by drawing in the diagonals. You can now draw the ellipse representing the open top of the jug in perspective, by marking a curved line that touches each centre point on the front, back and two sides of the top of the cube. The same can be done for the base of the jug, although it is only necessary to show the side nearest to you.

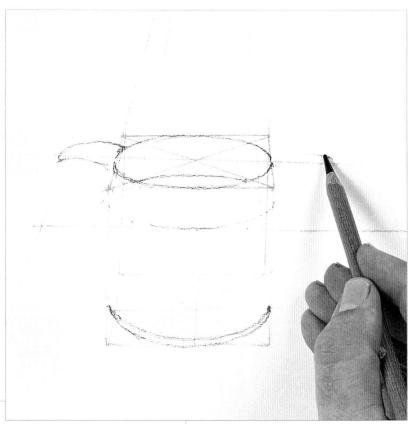

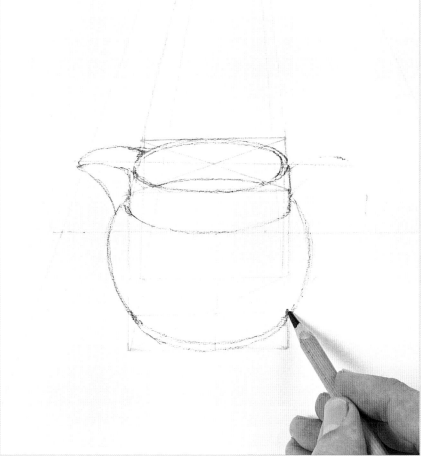

6 Draw in the spout and bowl of the jug carefully, by eye, taking care not to make it too fat. Measure the width if you wish, although it should be possible to judge the curvature by relating it to the vertical construction lines that represent the front edges of the cube.

7 Now draw the handle, using the negative shape between the bowl of the jug and the curve of the handle to assess the shape correctly (see page 19).

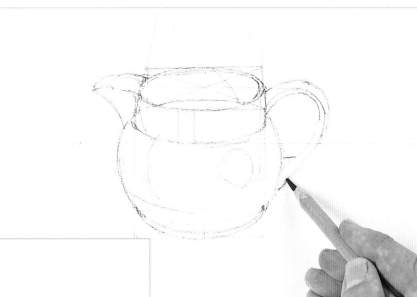

8 Draw in the curved edges at the front of the chopping board: notice how this changes the position of the end verticals. The chopping board is made from several pieces of wood that have been glued together in parallel strips. To show these in perspective simply draw the lines that separate them in such a way that, if they were extended, they would all converge at the vanishing point used for the rest of the drawing.

9 The finished drawing demonstrates how seemingly complex shapes can be rendered accurately by adhering to the basic rules of linear perspective.

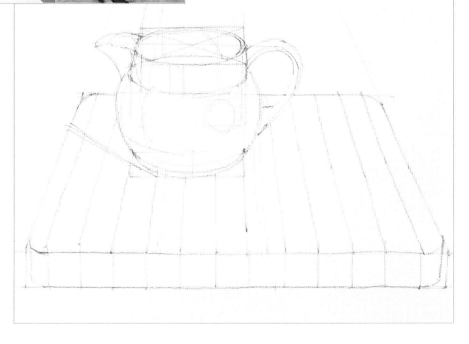

step 3 line

focus: **onions and garlic**

Materials

White cartridge paper, 300 gsm, 140 lb

Sheet of scrap paper

2B graphite pencil

Dip pen

Medium steel nib

Reed Pen

Black Indian ink

Water

Putty eraser

Generally, all drawing tools render marks that are essentially linear. Even chalks (see page 13), which can produce large areas of uniform tone or colour, are used in the first instance to draw lines. The 'line' is a remarkable graphic invention, used for a variety of purposes, yet is something that is rarely given much thought. For example, how often do you doodle absent-mindedly with little consideration for what you are drawing? In the right hands, however, line becomes a powerful graphic device, showing not only the shape and form of something, but also hinting at the direction and quality of light, surface pattern and texture, even capturing movement.

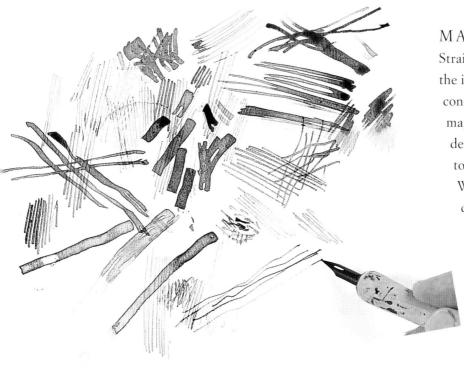

MAPPING OUT A DRAWING

Straightforward line work is very important in the initial stages of a drawing, as it is used to construct simple shapes (see pages 18–23), map out perspectives (see pages 24–29) and develop an underlying framework on which to 'hang' tone or colour (see pages 36–51). While this linear framework frequently disappears beneath subsequent work, finished drawings that leave the construction and layering exposed can have a beauty of their own.

Test your marks: As you work, use a sheet of scrap paper to test your marks. You will find this particularly helpful when working with pen and ink.

THE QUALITY OF LINE

Line quality can vary for a number of
different reasons. Perhaps the most
obvious is density: how light or dark a line
appears. This depends on both the ease
with which the drawing tool makes its
mark and the pressure applied to the
tool by the artist. Another consideration
is line width. Drawing tools are usually
sharpened to a point, which wears
down as the line is made, depending
on how soft the drawing material is. By varying the
applied pressure and the angle at which the drawing tool makes contact
with the paper, an experienced draughtsman can draw a continuous line that
becomes both thicker or thinner and lighter or darker.

Varying line width: When using drawing materials like
graphite, charcoal or chalk, the line width can be varied by
altering the angle at which the drawing tool meets the
paper. With practice, it becomes possible to alter the line
width without pausing to change your grip. This results in
fluid, unbroken line quality.

The speed and determination with which a line is made can also be used
to good effect. A mark that is made slowly tends to appear hesitant and
indecisive, while a line drawn quickly has a feeling of urgency and strength.
Such techniques can be helpful when depicting the characteristics, or even
the surface texture, of an object (see pages 52–57).

Linear variations

This example shows how charcoal has been used to draw six very different lines.

A line with a fast, fluid stroke that was made by keeping the hand
rigid and moving the whole of the arm.

This line is bold and assured. The charcoal was held close to its
point so that the maximum amount of pressure could be applied.

The stroke here is more hesitant. Its jerky nature comes from using
the hand and the fingers to change direction constantly as the
stroke was made.

A broken line, made by lifting and returning the charcoal to the
paper mid stroke.

This line was made reasonably quickly with the charcoal held
at a distance from its point, so that only the minimum pressure
was applied.

Here, the charcoal was turned in the fingers to present more or
less of it to the paper as the line was drawn. The line is fluid and
varies in thickness.

DRAWING ONIONS AND GARLIC

Onions and garlic are ideal subjects for a drawing using line. The dry outer skins have pronounced linear markings that travel around the form acting as contour lines. Following these lines makes the subject relatively easy to draw.

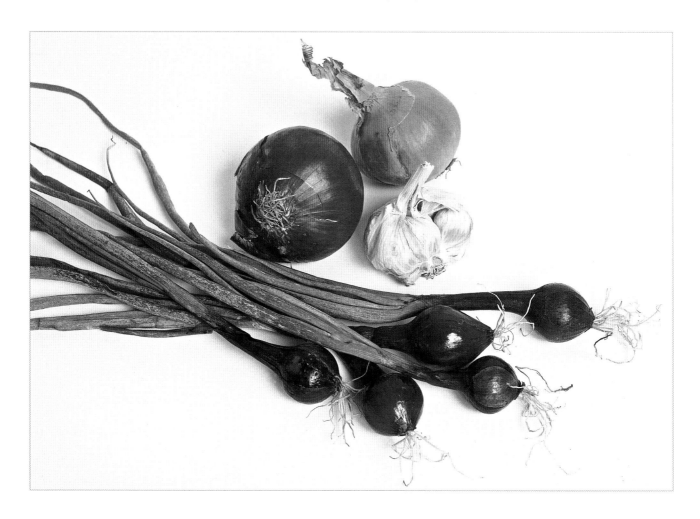

1 Draw, roughly, the shape and position of the onions and garlic using the 2B pencil, but avoid any detail at this stage (see pages 18–23). You can erase the soft pencil line later, once the ink has completely dried.

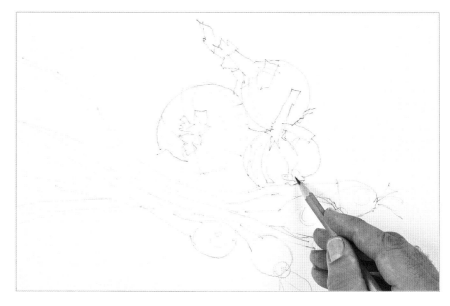

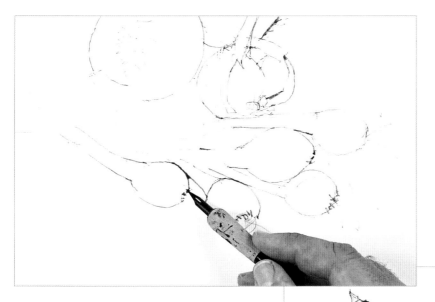

2 Use the pencil drawing as a guide to redraw the objects with the dip pen and ink. Many people find ink intimidating: it is a bold medium and more or less permanent. It may help to dilute your ink with water so that a paler, subtler line is produced. You can always use it at full strength in the later stages of the drawing.

3 Do not follow your pencil line slavishly, but use the ink to redraw the onions and garlic. Turn the pen as you make each line, applying more or less pressure to vary the thickness of the line. Use thicker lines in those areas that appear darker in tone or require emphasis.

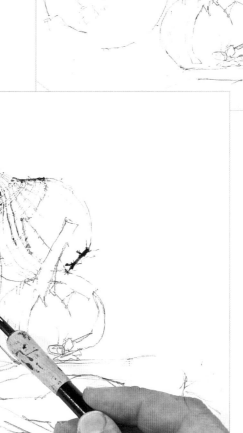

4 As you work, explore the inner contours of each form, drawing the linear markings on the dry skin that follow each object's shape.

5 As your drawing builds up, vary the speed at which you work. Lines drawn quickly will appear more fluid and can be used to show the grace of the form, while lines that are drawn slowly look slightly jagged and help render cracked and broken skin.

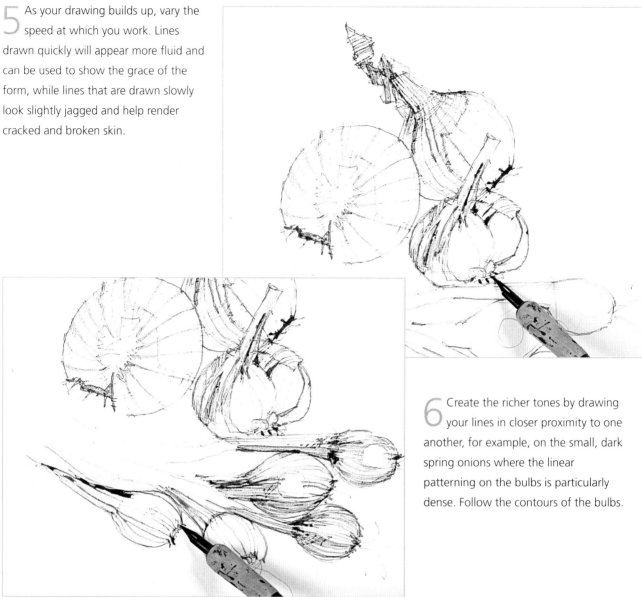

6 Create the richer tones by drawing your lines in closer proximity to one another, for example, on the small, dark spring onions where the linear patterning on the bulbs is particularly dense. Follow the contours of the bulbs.

7 Use the reed pen to draw the stems of the spring onions. This delivers a wider mark that breaks into two lines when the nib becomes splayed – perfect for capturing the stems. Draw the finer, less dense lines by turning the pen round and using the edge of the nib.

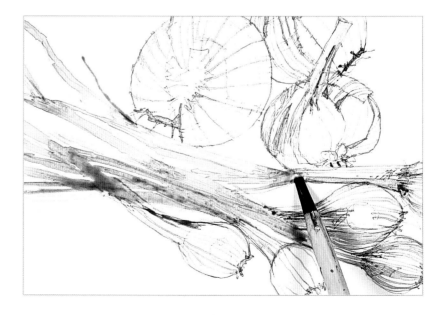

8 Use the same pen to draw in the thin, wiry roots of the spring onions. Use just the corner of the nib so that the line made is relatively thin, and vary direction constantly as you work. Allow the finished drawing to dry overnight before erasing any pencil lines.

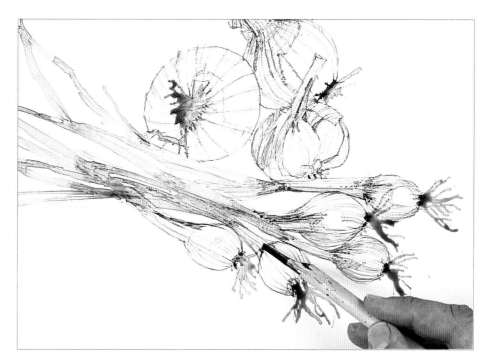

9 This relatively simple exercise shows how you can use linear marks alone to describe not just the shape and form of an object, but also its volume, tone and texture.

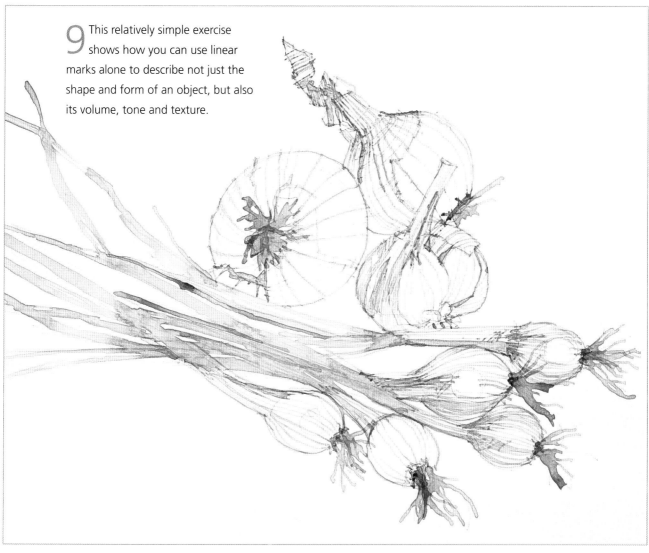

step 4 tone

focus: aubergine, pear and lemon

Materials

Mid-grey pastel paper, 160 gsm/90 lb

Medium-sharp charcoal pencil

White chalk stick

Fixative

White pastel pencil

Blending stump

Tone is also known as 'value' and is an indication of the degree, direction and quality of light falling on an object. Variations in tone enable us to see the form and substance of something, and rendering the correct tonal sequence, or progression, is critical when it comes to making a drawing look realistic. Tone is sometimes referred to as 'light and shade' but in reality it is much more than this, because the relative dark or light of an area of tone is also profoundly affected by the colour of the object the light is falling on.

QUALITY

Tonal values run from white through to deep black by degrees that run into thousands. We can only realistically perceive, and in turn use, a handful of these different values – try drawing a tonal scale that runs from deep black to pure white and you will have difficulty making more than ten successive steps. Indeed, it requires just three tonal values to make something appear three-dimensional: a light tone, a mid tone and a dark tone. When rendering tone, it is useful to remember that the contrasts between light and dark are greater in strong light, while in soft, even light, tones appear to be of a very similar intensity and predominantly from the middle of the tonal scale.

A tonal scale: On white paper, you can make all of the tonal variations using a black drawing tool. When the colour of the paper acts as the mid tone, however, you need a black drawing tool to make the darker values and a white drawing tool to make the lighter values.

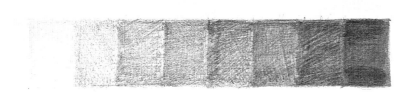

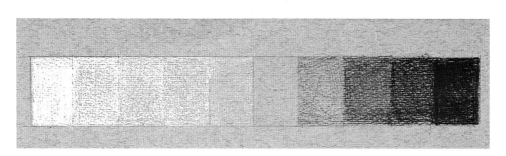

CREATING TONE

You can create tone in a number of different ways, depending on what drawing material you are using. With soft, dusty pigmented materials that smudge easily variations in tone can be achieved by pushing and blending the dusty pigment over the paper using a dry finger or a blending stump (see page 16). The technique, although successful, can result in drawings that look soft and bland.

You can also blend harder materials like graphite in this way, but you will have more success making tonal variations by altering the pressure you apply to the tool as you draw. With drawing materials like pen and ink, where the tool makes a mark that varies little, if at all, in width, you can build up tone using mark density – that is by drawing a series of hatched and cross-hatched lines. Tonal variations can also be rendered using other marks, including dots or dashes. In practice, artists regularly use a variety of these methods in the same drawing.

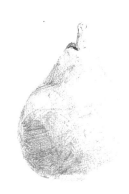 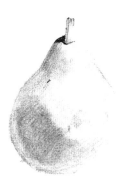 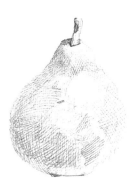

Three ways to create tone:
The pear on the left was drawn using graphite, applying a loose, scribbled hatching technique. The middle pear was drawn using charcoal and a smudging and blending technique. The pear on the right was drawn using dip pen and ink, together with a precise, cross-hatching technique.

Creating variations in tone can take a little practice, especially when trying to render a gradual, almost imperceptible, transition from light to dark. You can make the task easier to some extent, by holding the drawing tool close to its point when making dark marks, and higher up the barrel when making lighter marks.

Light pressure: It is easier to create light tone by holding the drawing tool at a distance from its point.

Heavy pressure: To make darker tones, which require greater pressure, hold the drawing tool near its point.

TONAL TRANSITION

On angular objects with several different surfaces, the degree of tone alters significantly according to whether the surface faces more toward the light or away from it. On rounded surfaces the tonal transition is more gradual, with some surprising variations owing to reflected light from the surface on which the object rests.

DRAWING THE AUBERGINE, PEAR AND LEMON

For this exercise, an aubergine, a pear and a lemon are positioned on a sheet of grey paper. Each has a distinctly different colour to that of its neighbour. The tone values of each object are influenced not only by the quality of the light falling on it but by the intrinsic colour of the object and the white surface it is resting on. It is easier to judge the depth of tone required against a mid-tone paper than on white.

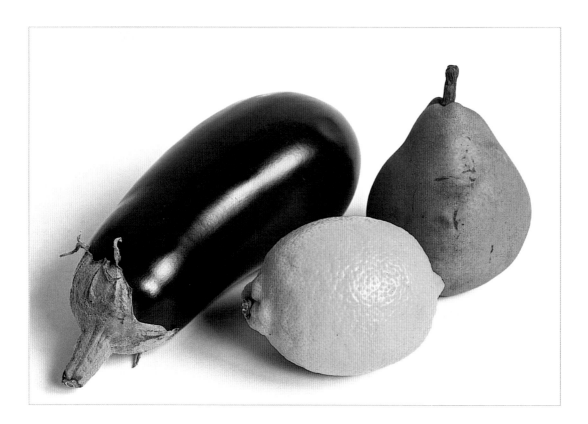

1 Using a medium-sharp, charcoal pencil, sketch in the position and basic shape of each object (see pages 18–23). Keep your line work fluid and light. Once you have established the shapes of the objects, mark on each the approximate points at which light tone turns to dark.

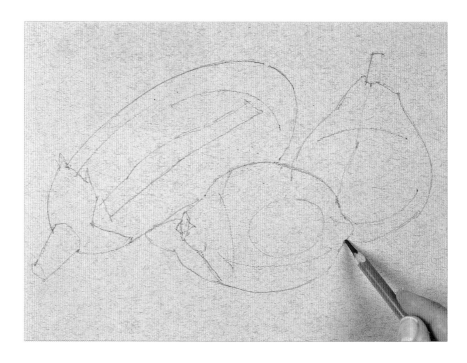

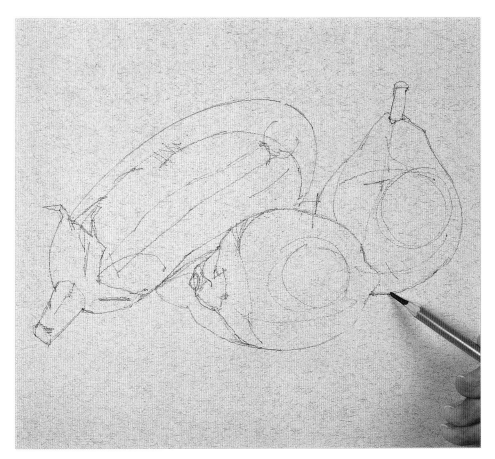

2 Still using simple line work, redraw the objects more carefully, correcting the shapes and giving more definition to the areas of shadow and highlight. Do not make the line work too dark at this stage.

3 Begin developing tone on the aubergine, stalk first followed by the dark mass of the fruit itself. Although the colour of the aubergine is very dark, notice how light the area of reflection is along its side and the strip of reflected light along its top. Remember when assessing tonal value that it is always easier to darken an area than it is to lighten it. Also bear in mind that the grey of the paper works as the mid tone against which all other tones need to be balanced.

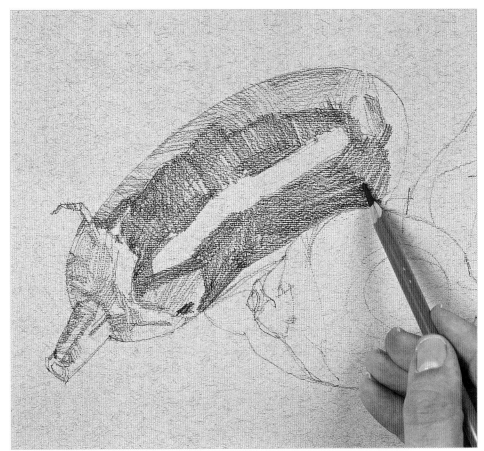

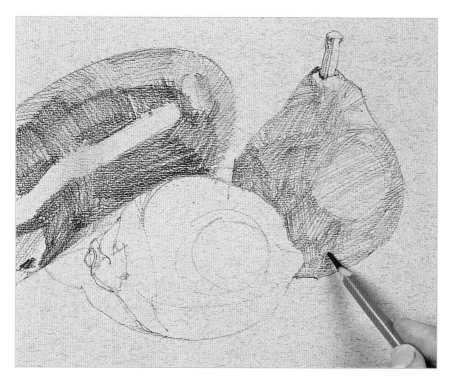

4 Turn your attention to the pear, which is a reasonably dark mid tone. Use a series of loose, scribbled crosshatched marks to portray the relative lights and darks. Notice how subtle changes in the tonal value indicate a change in surface orientation.

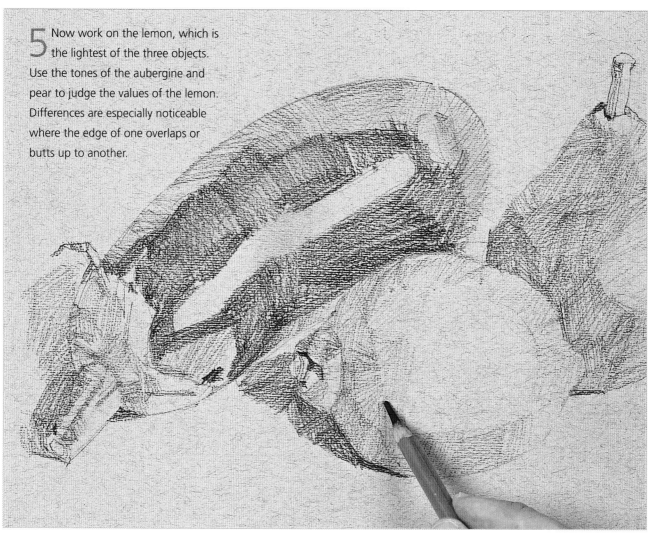

5 Now work on the lemon, which is the lightest of the three objects. Use the tones of the aubergine and pear to judge the values of the lemon. Differences are especially noticeable where the edge of one overlaps or butts up to another.

6 Use the side of the white chalk stick to block in the white background. Work up to the edges of the three objects carefully and leave the paper grey where there are cast shadows. The whole tonal balance changes immediately, with the values of the applied tone appearing darker now that they are read against a lighter background. You can apply a coat of fixative at this point to prevent your work from smudging.

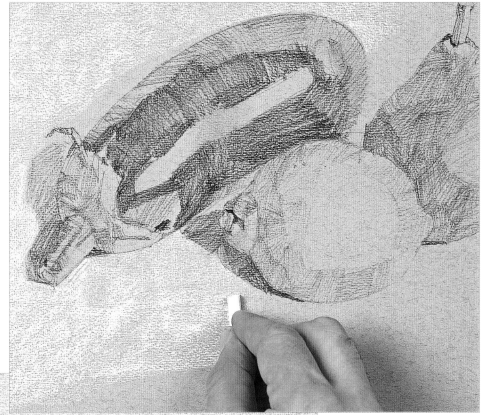

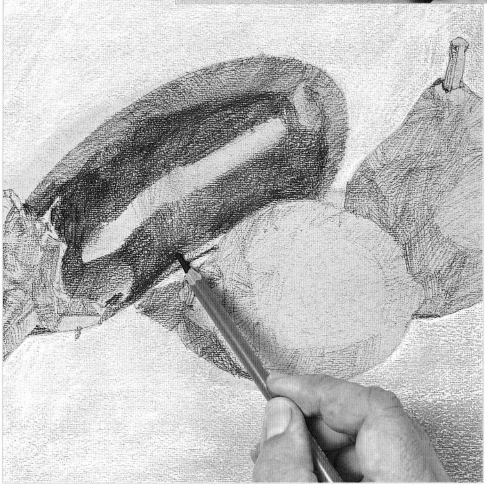

7 Reassess the tonal values of the objects. Here, it is clear that the aubergine is too light. Build up tone where necessary: by making the tones on the aubergine more dense, you can redefine the shape of the lemon, pushing it to the forefront of the composition.

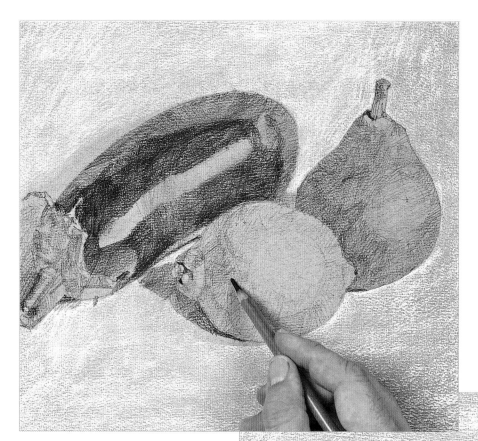

8 Revisit the areas of tone on the pear and the lemon and consider how you can improve the tonal values. Add tiny bits of detail as you go, in order to increase the illusion of realism.

9 Use the white chalk and the white pastel pencil, respectively, to draw in the highlights and to develop those tones that are lighter in value than the mid tone of the paper. Use light, cross-hatched linear marks to achieve the more subtle tonal values, and apply more pressure to render the brightest highlights on the pitted lemon skin and the smooth aubergine.

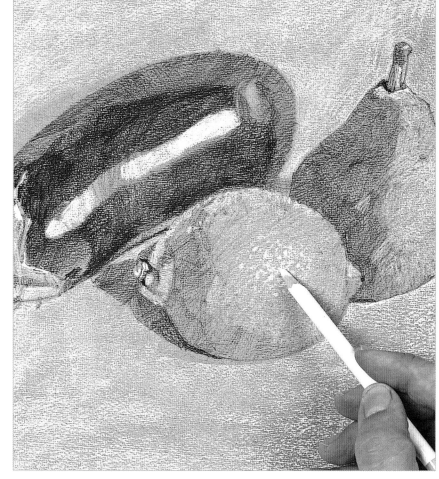

10 All that remains is to consolidate the white background, which you can do by applying more white chalk to the paper, and rubbing it into the surface firmly using a blending stump.

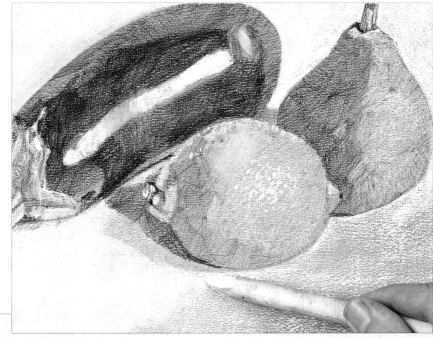

11 The finished image demonstrates how the tonal variations of each object are influenced not only by their own shape and colour, but also by the direction of light and the shadows they cast on each other.

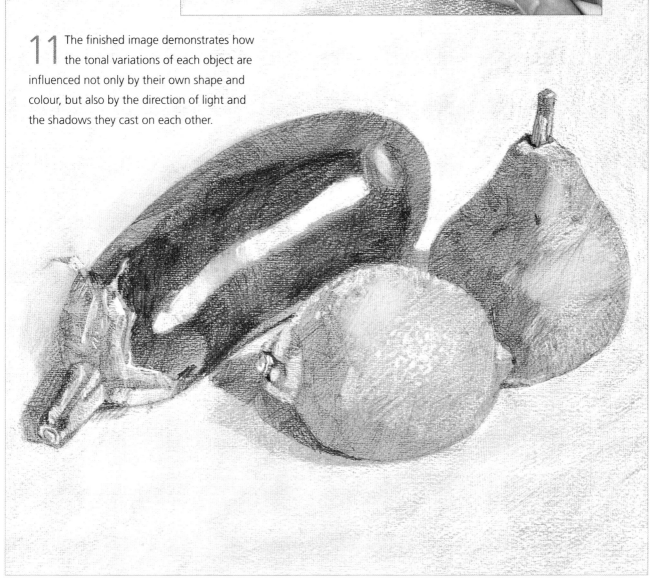

step 5 colour

focus: **apple, lemon and pepper**

Materials

White cartridge paper, 300 gsm/140 lb

Pastel pencils:

- *Cadmium red*
- *Crimson*
- *Cadmium yellow*
- *Lemon yellow*
- *Yellow ochre*
- *Cadmium orange*
- *Mid green*
- *Light green*
- *Dark violet*
- *Indigo*
- *Ultramarine blue*
- *Dark grey*

Everything has an intrinsic colour, which is affected by the intensity and quality of the light falling on it. When it comes to representing colour in a drawing, much depends on the materials used. For the most part, drawing materials are both monochromatic and linear in application. Colour is introduced using some form of dry pigment such as chalk or coloured pencil, which differs distinctly from paint in that any mixing of colour takes place on the paper and not on a palette prior to application.

WHAT IS COLOUR?

Everything has colour, but it is necessary for light to fall on an object in order to see that colour. White light consists of the seven colours of the visible spectrum and is a form of electromagnetic radiation. The seven colours are red, orange, yellow, green, blue, indigo and violet. Each operates on a different electromagnetic wavelength. Every object absorbs a number of electromagnetic wavelengths, while reflecting others. We 'read' the reflected wavelengths as the colour of the object: a green field is perceived as being green because the green wavelengths are reflected while the others are absorbed. We see black when all of the wavelengths are absorbed, and white when all are reflected.

The light spectrum: The seven colours of the visible spectrum that make up white light.

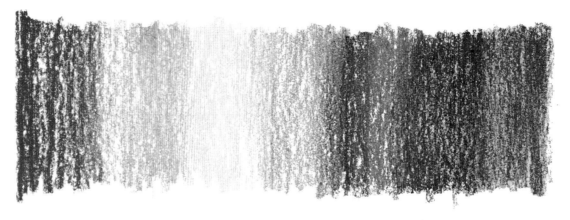

Colour terminology

A distinct terminology is used when discussing colour, which, if learnt, makes a complicated subject much clearer and more easily understood. The most common terms relating to drawing and drawing materials are listed below.

Colour wheel: The colour wheel presents colours in a circular sequence that corresponds to the order of spectrum colours that make up white light (see opposite). The device is useful for looking at, and making sense of, colour relationships.

Primary colours: Red, yellow and blue are primary colours. They cannot be made by mixing other colours.

Secondary colours: Mix together any two primary colours and the result is a secondary colour. Red and yellow make orange, yellow and blue make green and blue and red make violet.

Tertiary colours: Tertiary colours result from mixing a primary with the secondary colour next to it in equal measure.

Complementary colours: Complementary colours are those that fall opposite one another on the colour wheel. When placed next to each other they have the effect of making one another look brighter. The effect is very different when the colours are mixed together, however. This has a neutralizing effect on the colours and results in a range of greys and browns that echo the colours seen in nature.

Colour temperature: Colours are generally considered to be either warm or cool. Red, orange and yellow are considered warm, while green, blue and violet are considered cool.

Hue: Is simply another name for colour. Ultramarine, cerulean blue and cobalt blue are all hues albeit similar.

Value: Is a term used when discussing tone and describes the relative light or darkness of a colour. Yellow is light in value, while Prussian blue is dark in value.

Saturation: This describes the relative intensity of a colour. Colours that are similar in hue will have different intensities or brightness. Cadmium yellow is a highly saturated bright yellow while Naples yellow is not.

Harmony: Certain colours work better together than others, and are called harmonious. There are several different groups of these. Monochromatic harmony is achieved by using various tones of the same colour. Analogous harmony uses those groups of colours that are close together on the colour wheel. Complementary harmony is achieved by using groups of colours that appear opposite one another on the wheel.

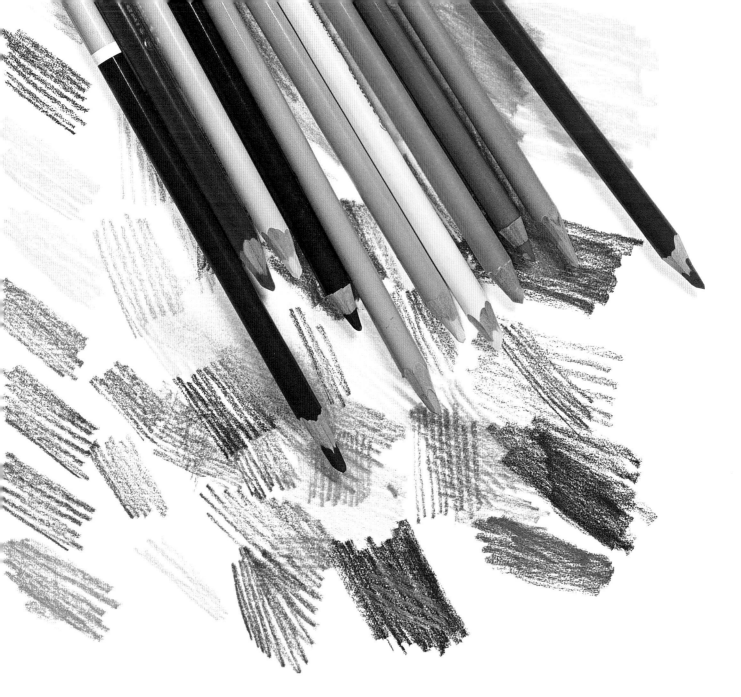

A limited range: With a little practice you will discover how a seemingly limited range of coloured pencils can, in fact, become remarkably versatile.

USING COLOUR

In nature, pure brilliant hues are rarely seen: colours are invariably modified by other colours around them and can be difficult to pin down and mix. Getting the colour right can be a frustrating exercise. Although daunting at first, it is easy to see with the exercise that follows that remarkably few different coloured pencils are needed to produce a drawing. Trial and error when using coloured or pastel pencils will always produce results and it is advisable to try colour mixes and marks on a sheet of scrap paper before committing them to your drawing.

In this example, colour density has been achieved by increasing the pressure applied.

Here, the density is increased by building colour up in layers.

PRACTICAL CONSIDERATIONS

One of the main problems when using colour on drawings is how to build up the required density of colour without clogging the paper's surface texture with pigment. There are several different ways of solving the problem. The first is to work on coloured or tinted paper. This adds density to the colours you are using and makes them appear much brighter than they would if applied to a white paper. An alternative to tinted paper is to work reasonably lightly to begin with, until you are certain your colours are correct. Try to achieve your desired mixes in as few layers as possible.

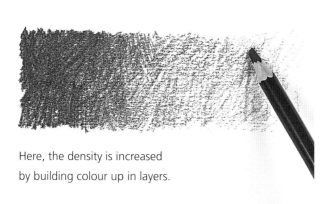

Paper colour: The colour paper you choose depends on your subject, but has the added advantage of creating a distinct mood and binds everything together creating a colour harmony.

DRAWING THE APPLE, LEMON AND PEPPER

These three objects have been chosen for their strong individual colour and the reflective qualities of their skin. The colour of each is influenced not only by its actual surroundings and the light source but by the reflected colours of the other fruit.

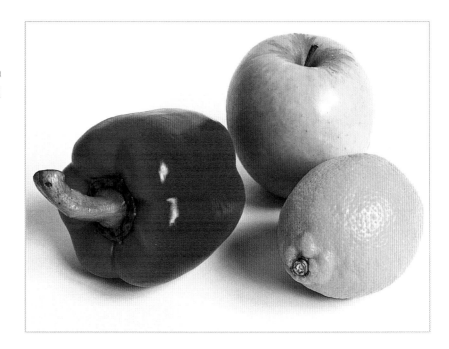

1 Begin by sketching the general shape of each object. This is to position the objects in relation to one another (see pages 18–23). These lines will be covered by subsequent work so draw lightly at this stage. Choose colours that correspond roughly to the colours of the objects: cadmium red for the pepper, a mid green for the apple and cadmium yellow for the lemon.

2 Use this light sketch as a guide to redraw the objects, refining and correcting the shapes as you work. Seek out areas of shadow and changes in colour and tone: use a simple line to define these areas (see pages 30–35). Pick out the highlights in the same way. Use an indigo pencil to outline the shapes made by the cast shadows. See, here, how the area of reflected colour from the red pepper has been defined on the apple and the lemon.

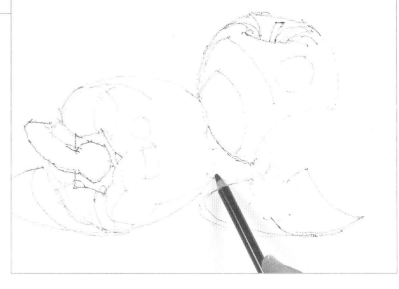

3 Turn your attention to the pepper. Use the cadmium-red pencil to block in and establish its overall colour. Do this by seeking out the contours of the pepper's form and use a series of directional strokes that follow those contours (see pages 30–35). Do not make the colour too dense at this stage. Leave any highlights showing as white paper.

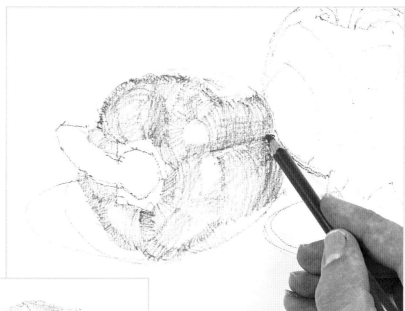

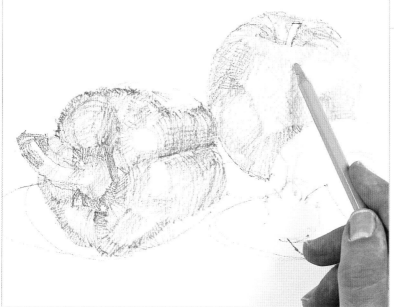

4 Continue this process with the pepper stalk and the apple – making strokes that follow the contours of each. Use the mid green to colour the darker areas and progress to a lemon yellow for the lit side of the fruit. Overlay the yellow with soft strokes of light green. Use cadmium red for the reflected colour of the pepper and yellow ochre for the brown markings around the stalk. If an area appears too dark or overworked smudge it gently with a finger to remove some of the pigment and rework it.

5 Now work on the lemon. Use cadmium orange to fill the area of reflected colour from the pepper. Use yellow ochre where the lemon is in shadow and cadmium yellow to establish the colour of the rest of the lemon. As before, leave the highlights as white paper.

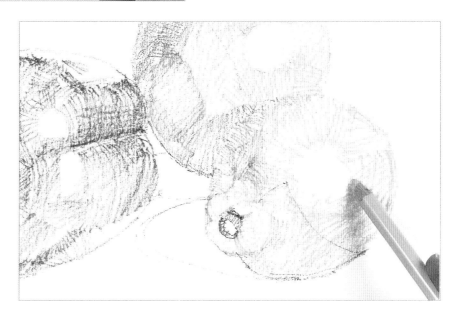

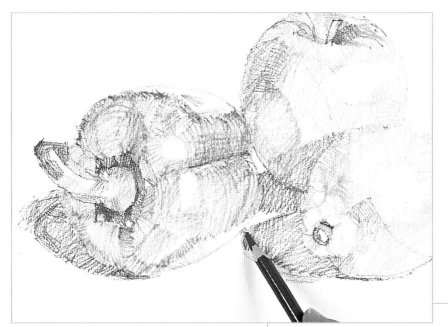

6 Start to add to the shadow areas. Use a dark grey for the main areas of shadow cast on to the white surface. You will modify this shadow later using additional colours, so do not be tempted to make it too dark. Use the same grey to add a darker tone to the shadow areas on the apple and lemon.

7 Now return to your subject. Use cadmium red to consolidate the overall colour of the pepper, still working in strokes that follow the contours. Use a darker, crimson pencil to intensify the colour in the areas of shadow, and a dark violet for the darkest shadows. Rework the side of the pepper facing the light, using a cadmium orange pencil to increase the depth of colour.

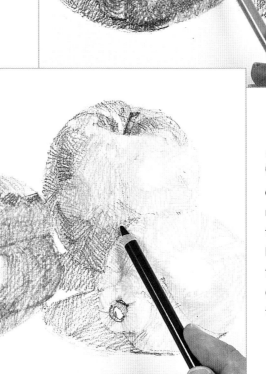

8 Rework the apple in the same way. Add more cadmium red to the area of reflected colour and overwork this using the mid green. Apply lemon yellow to the side facing the light and use indigo to darken the shadow cast by the lemon.

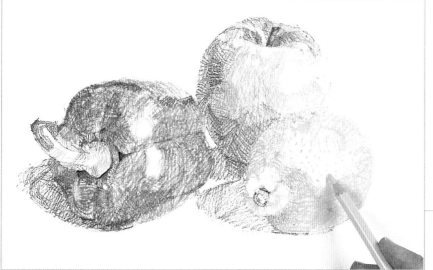

9 Deepen the colour of the lemon using cadmium orange and yellow ochre. Carefully apply a little light green to the belly of the fruit and pick out the mottled texture of the skin using cadmium yellow.

10 Return to the shadows cast on the white paper. Carefully crosshatch over the grey using the same colours as you used for each object: red on the shadow cast by the pepper, for example. To complete the effect, introduce a cool luminosity to the area with the addition of ultramarine blue.

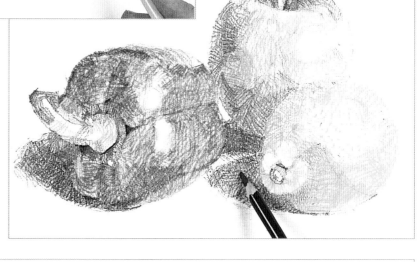

11 The finished drawing demonstrates that a complex range of colours can be produced by building up layers using a relatively limited palette.

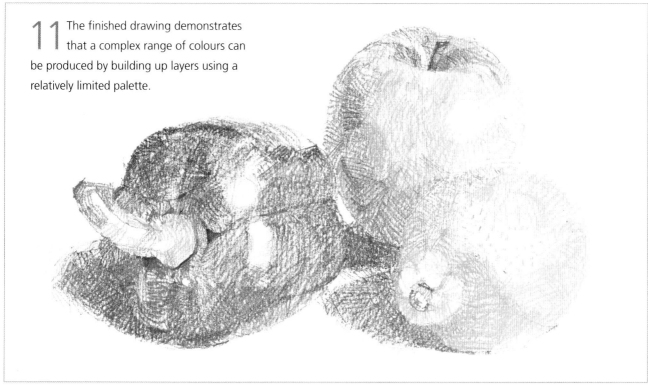

step 6 texture

focus: **pepper, courgette and melon**

Materials

White cartridge paper, 300 gsm/140 lb

2B graphite pencil

Putty eraser

Every surface has a texture, which, in most cases reveals more information about the form of an object – soft and smooth, hard and spiky, rough and dry. Rendering texture accurately in a drawing can be challenging and requires a certain degree of experimentation and invention. Instead of trying slavishly to draw texture as it actually appears, you are more likely to find success in devising marks and techniques that give an 'impression' of the texture.

TECHNIQUES

In order to make convincing textural marks you need to know what your chosen drawing tool is capable of, and you will only find this out by experimenting. Take a sheet of scrap paper and fill it with different textural marks. See what happens when you alter the pressure or the way in which you hold the drawing tool. Attack the paper aggressively or make gentle tentative marks. Try using different shaped drawing tools.

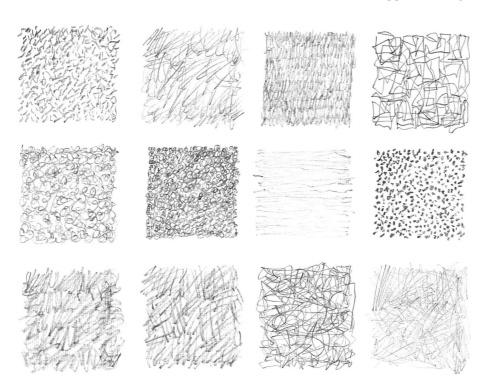

Textural marks: The full range of textural marks that you can make is determined only by your inventiveness. By using a range of different shaped drawing tools, a variety of speeds and altering the pressure when making marks, you will broaden your repertoire further.

DRAWING SURFACES

The texture of your drawing surface is important. A specific style of mark made on a smooth surface will look different when made on a rough surface, so it's important to choose a paper with qualities that will contribute to the drawn image. However, bear in mind the drawing material you are using: you will find it difficult to render a dip-pen drawing on very rough paper or to use charcoal on a very smooth surface.

Choosing papers: When drawing objects with texture your paper choice can be important. Opting for a rough paper for a rough textured subject will save time and produce a better result.

WORKING IN LAYERS

It is not always possible to create the textural effect you want in one layer. By working in two or more layers you can build up the density of a texture. In order to do this you may need to apply fixative between the layers. Without fixative, friable drawing materials, such as charcoal or chalk, build up but do not adhere to the surface and are easily smudged.

ERASING

Erasers can be very useful when creating texture in a drawing. They make it possible to work back into areas of tone revealing the paper surface and creating linear or textural marks that have a completely different quality to marks made using pigment or the drawing tool itself. The melon in this exercise is a good example of this. Consider the light textures and patterns on the surface of the melon. If using the drawing tool alone, you would have to work around the lighter areas in order to render them accurately. By using an eraser you can apply tone to the entire surface of the melon and can 'rub' in the lighter textures and patterns with the eraser.

Soft erasers:
You can mould soft putty erasers into shape. They are best used on materials like graphite, but can become dirty very quickly.

Hard erasers:
Harder, vinyl and plastic erasers do not become dirty quite so fast and make crisp precise lines. They can easily be cut into a range of shapes.

DRAWING THE PEPPER, COURGETTE AND MELON

The objects chosen for this exercise all have textured or patterned surfaces typical of many fruits and vegetables. Unlike man-made patterns, natural patterns and textures tend to be more random and it can be a challenge to render them in an interesting way.

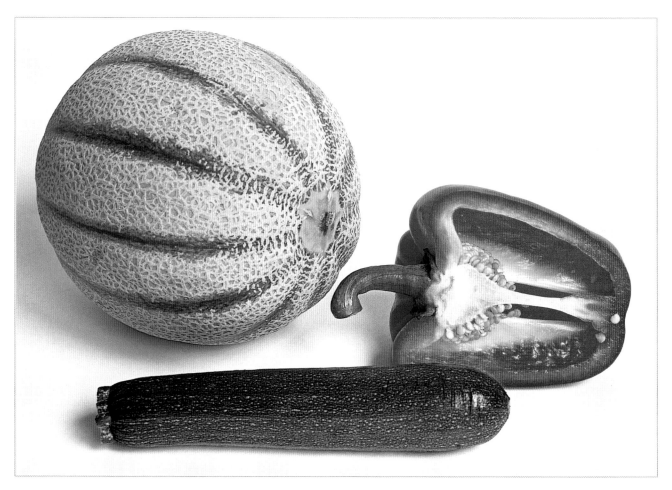

1 Rough out the shape and position of each object using fluid, loose line work. Concentrate on getting the initial shapes right at this stage (see pages 18–23).

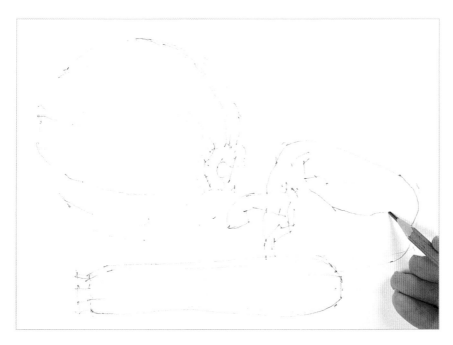

2 Redraw using the rough shapes as a guide, and seeking out any linear marks that can be made: notice how these give a clue to the form of each object by following the contours – for example, the dark ridges on the melon.

3 Add tone to the dark ridges of the melon, using reasonably firm pressure and varying the direction of the scribbled marks. Fill in the overall tone of the melon, again using multi-directional, scribbled marks but do not attempt to draw in any pattern or texture at this stage.

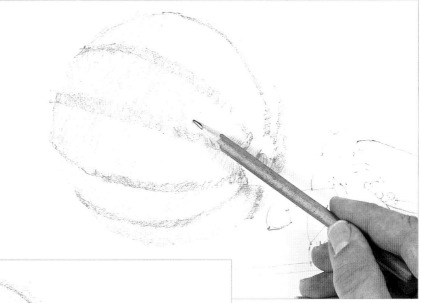

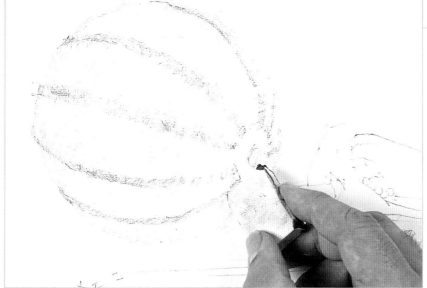

4 Once the tones are correct use a corner of the putty eraser to work back into these tonal areas. Use a jerky scribbling motion that best describes the surface of the melon.

5 You can now use the pencil to apply pattern. Darken sections on the surface of the melon, using the light tracery made by the eraser as a guide.

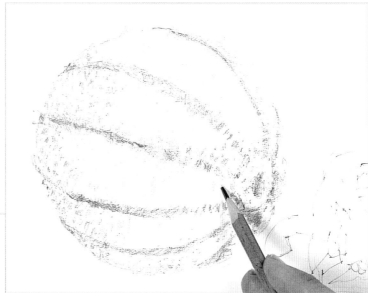

6 Draw in the pattern on the short stem of the courgette. To convey the texture of the body, use a circular scribbling motion to make a series of elongated oval marks over its entire length.

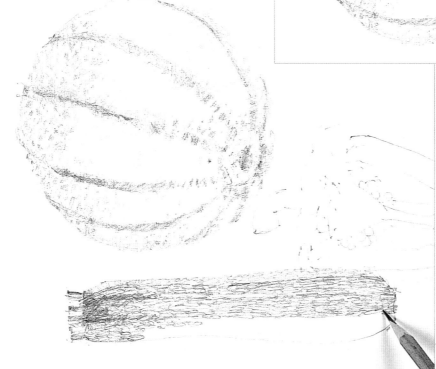

7 Draw the stem of the pepper using linear marks that describe the striations running down the curved stalk. The outside skin of the pepper is smooth and reflective so apply overall tone that follows the curves of the contours. The internal walls of the pepper have a uniform pitted surface, which you can render by using a heavy, circular scribbling motion.

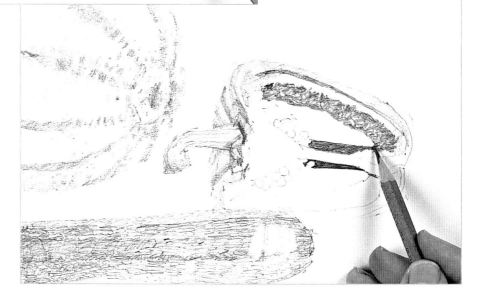

8 Now draw the dark areas between and around the seeds and apply less pressure to make a series of elongated oval marks capturing the lighter internal texture of the pepper. Draw the cut surfaces by making directional strokes that follow the object's shape.

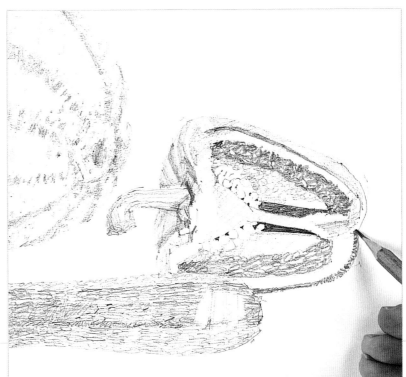

9 You can see from the finished drawing that it is possible to create a wide range of textures using a number of different drawing techniques.

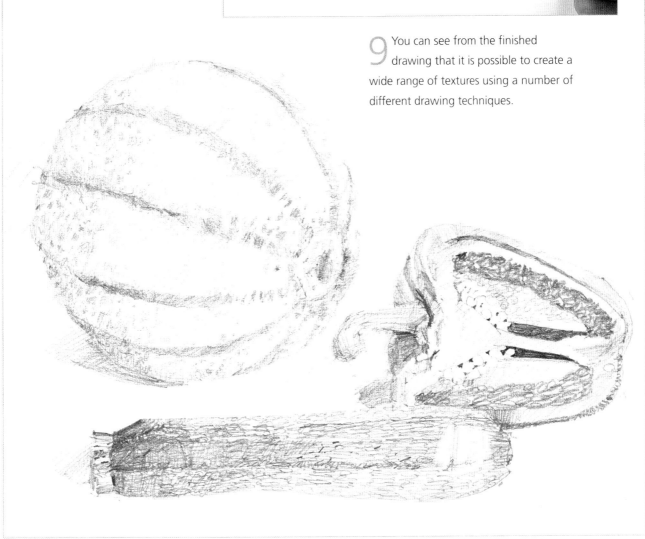

step 7 pattern

focus: **checked cloth**

Materials

White cartridge paper, 300 gsm/140 lb

Lead holder

Drawing leads:

• *Terracotta*

• *Sepia*

• *Black*

Capturing the pattern of an object can be a powerful way of describing its form. An object may have a very regular and repetitive pattern when seen 'flat', but which changes dramatically when seen from an angle or distorted in some way. This is particularly true of a pattern printed on, say, fabric or paper that has been draped over a three-dimensional object. Consider the checked cloth in this exercise: the patterned surface is two-dimensional when flat, but becomes distorted in such a way that the form of the underlying three-dimensional object – in this case an orange – can be 'read'.

CAREFUL OBSERVATION

In order to capture the effect on the surface pattern of one object that has been draped over another, it needs to be drawn quite carefully. In this exercise, there is a chance that the drawing as a whole will become confused and the viewer will be unable to read the shape of the orange beneath the cloth.

SUBTLE CHANGES

Often, changes in pattern are very subtle, yet there can still be sufficient change in direction for you to 'read' the situation. Repeated and geometric patterns work best, as a change in the uniform, grid-like appearance of the pattern is quickly noted. Linear patterns and checks are particularly good. Abstract and random patterns work less well, because the design shapes are often unfamiliar and it can be difficult to assess whether a distortion is due to a change in direction or is part of the design itself.

Distortion: It is difficult to read distortion on fabrics that have an abstract or random pattern.

Pattern: The shape of a pattern or motif alters as it follows the contours of an object, and enables the shape of that object to be read.

DRAWING THE CHECKED CLOTH

The check-patterned cloth used in this exercise is draped over an orange.
The intention is to show how the distorted pattern reveals the folds in
the fabric, but also gives clues as to the shape of what lies beneath.

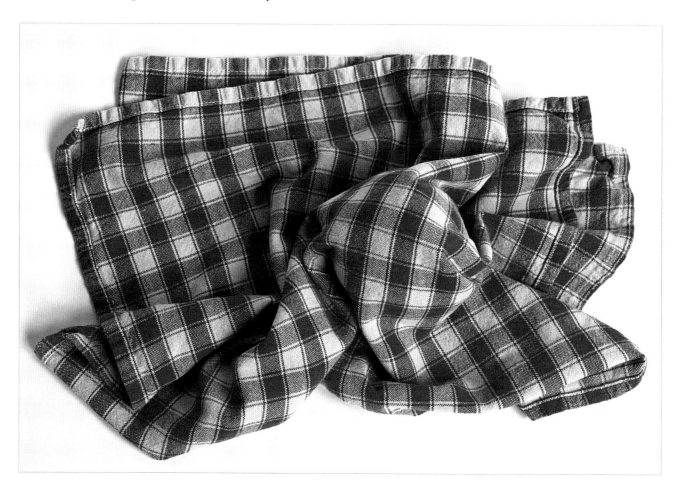

1 Use the terracotta lead to draw in the overall shape of the cloth using simple line work (see pages 30–35). Keep the line light: these leads can be difficult to erase and using a light line at this stage allows you to cover up any mistakes with subsequent work.

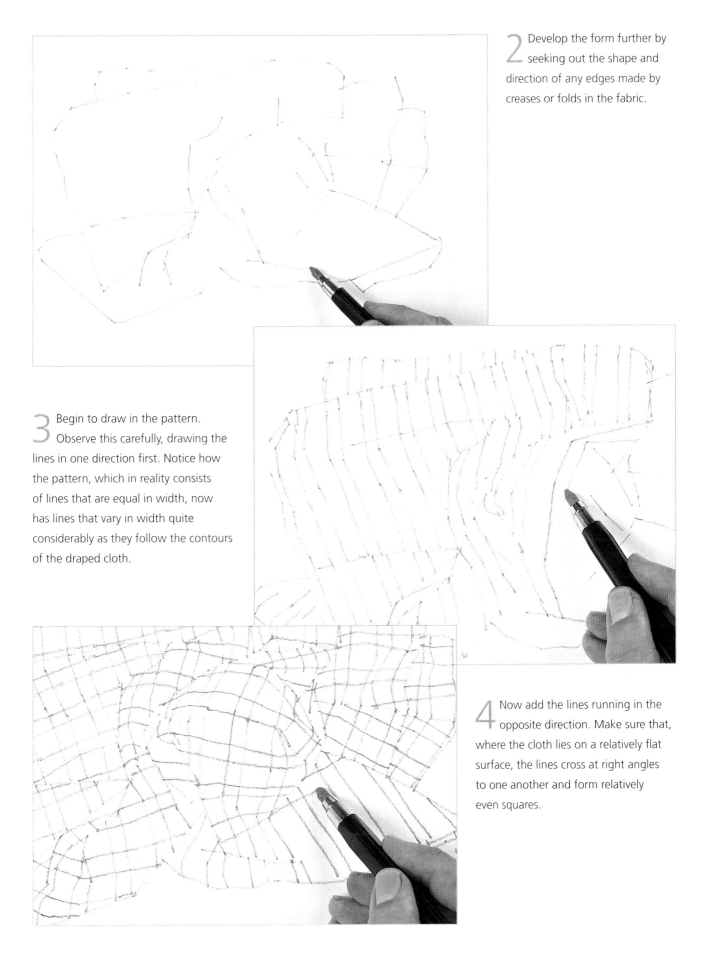

2 Develop the form further by seeking out the shape and direction of any edges made by creases or folds in the fabric.

3 Begin to draw in the pattern. Observe this carefully, drawing the lines in one direction first. Notice how the pattern, which in reality consists of lines that are equal in width, now has lines that vary in width quite considerably as they follow the contours of the draped cloth.

4 Now add the lines running in the opposite direction. Make sure that, where the cloth lies on a relatively flat surface, the lines cross at right angles to one another and form relatively even squares.

5 Once the linear pattern looks correct, you can block in the main bands of pattern with scribbled marks, still using the terracotta lead.

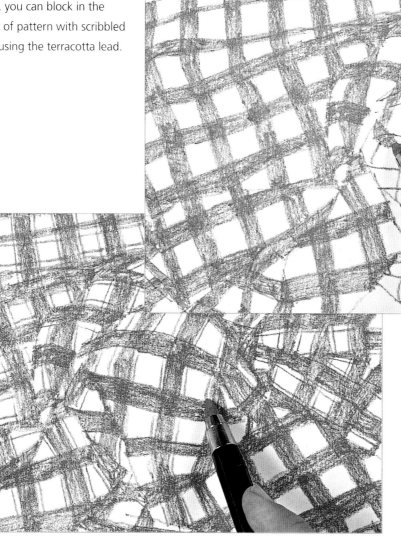

6 Now complete the thinner lines of the checked pattern. As before, pay careful attention to how these lines relate to each other and the folds of the cloth.

7 Use the sepia lead to darken the squares of the check. Draw each one carefully, as many of them will have become distorted by the movement of the cloth.

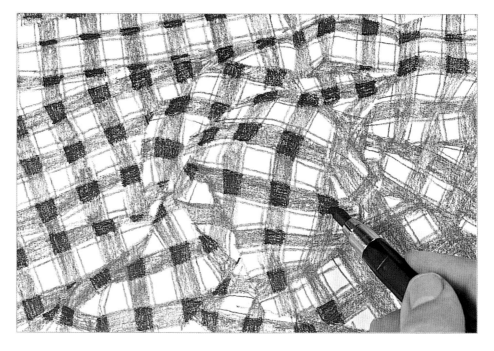

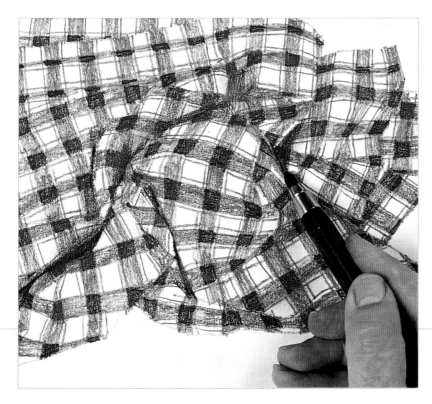

8 Now use the black lead to scribble in dark tone, deep within the tight creases and folds of the cloth, giving more definition to the form of the orange below.

9 The finished drawing simply demonstrates that it is essential for the distorted pattern of the cloth to be rendered accurately, in order to read the form that lies beneath.

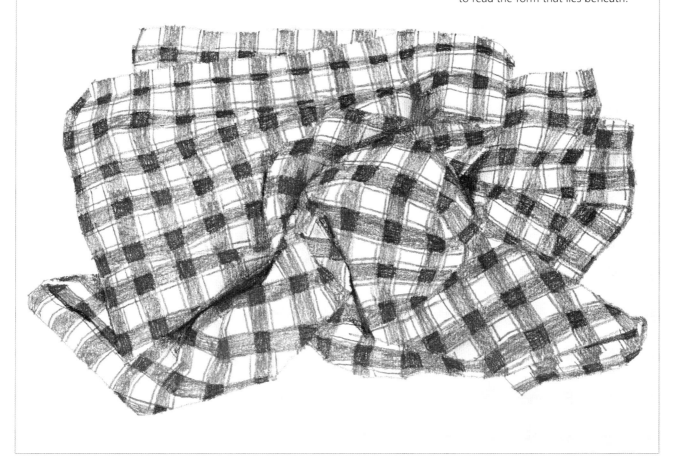

step 8 advanced techniques

focus: **jug, bread and knife**

Materials

White cartridge paper, 120 gsm/60 lb

3B graphite stick

2B thick graphite stick

Putty eraser

Ruler

Sheet of scrap paper

Canvas board

Rough wooden board

Using a mask: A sheet of torn or cut paper can be used as a mask in order to create a distinctive edge quality to an area of tone or texture.

There are several drawing techniques that, although not necessarily traditional, are nevertheless fun to use. Some of them work better with certain drawing materials than with others. They will bring a different quality to your work and, in some instances, may help turn a pedestrian drawing into something much more exciting.

MASKING

Applying tone up to an edge or line requires a certain degree of control to prevent marks from going into an area where they are not wanted. In many cases, this means that you are working very slowly and using the drawing tool in such a way that the marks you make run parallel to the edge rather than at an angle to it. This can result in a rather drab 'filled in' look. By using a mask, made either from paper or card that has been cut or torn to shape, you can draw freely up to, and if necessary, over the mask to achieve the effect you want.

FROTTAGE

Taken from the Italian word meaning 'to rub', this is a useful technique for creating textural effects. The effect is achieved by placing the paper – which needs to be relatively thin – over a hard, textured surface – say brick, old wooden floorboards, wire mesh or coarse fabric. When you draw on the paper, you pick up the texture of the surface below.

Quick textures: This drawing surface has been placed over a canvas board in order to create a frottage effect.

SGRAFFITO

Taken from the Italian word meaning 'to scratch', this technique involves scratching through layers of pigment using a sharp tool, in order to reveal either the original drawing surface – or a previously applied layer of pigment – beneath. The technique works best with dense, heavily pigmented tools, such as charcoal and chalk, which leave a relatively thick physical layer of pigment on the paper.

Scraping away pigment: Powdery, pigmented drawing materials can be scraped into, as can dry marks that have been made using ink.

DRAWING THE JUG, BREAD AND KNIFE

The very different textures of the objects in this exercise present specific representational problems. The advanced techniques used here offer possible solutions. However, be aware that frottage techniques can be used successfully only on thin paper.

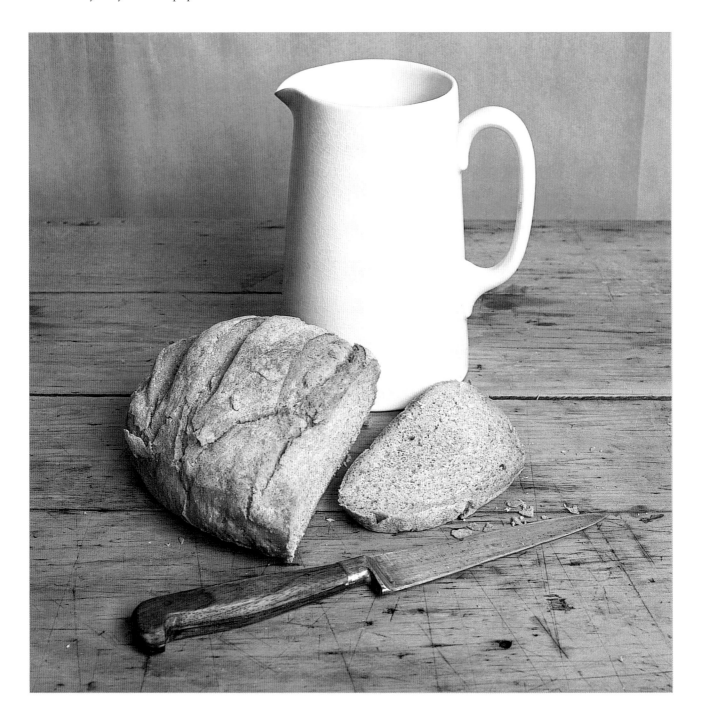

1 Sketch out the shape and position of each object in the group using the 3B graphite stick and a light line (see pages 18–23).

2 Redraw the shapes, developing and refining them as you work. Avoid adding any detail at this stage, as much of that will be provided by the techniques you use later.

3 Still using the 3B graphite stick, begin to develop the light and medium tonal values seen on the white jug (see pages 36–43). Hold the stick high up the barrel to help you apply the light pressure needed to make the marks.

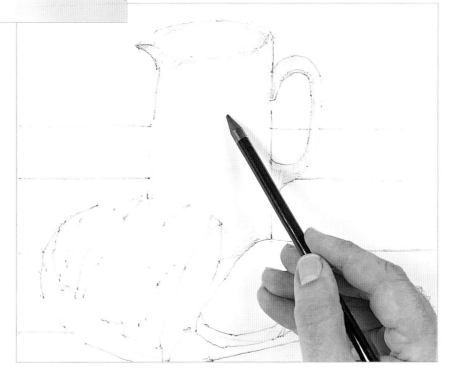

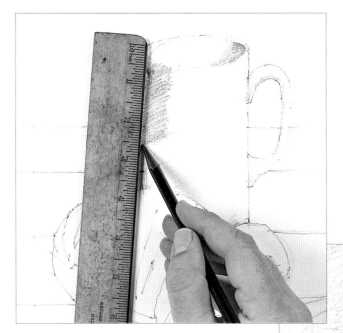

4 Consider the darker strip on the side of the jug that is furthest away from the light. Instead of working freehand, which requires you to draw carefully up to the edge of the jug, use a ruler to create a mask. Hold the ruler in place along the edge of the jug and scribble loosely and rapidly up to the ruler, to create a crisp edge.

5 Now establish the mid-tone background, making multi-directional, scribbled strokes with a relatively uniform pressure. Use the ruler to mask the edge of the jug where it abuts the background if you wish.

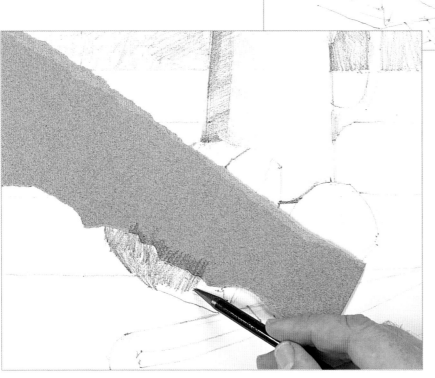

6 When it comes to drawing in the dark shadow on the side of the bread you can use a masking technique again. Give the bread a rough edge by using a torn sheet of paper as the mask.

7 To render the pitted surface of the bread and the texture within the slices, place an artist's canvas board beneath your paper and use the 2B graphite stick to scribble over the surface. The graphite will pick up the texture, leaving a wonderfully rich and interesting series of marks perfect for representing the surface of the bread.

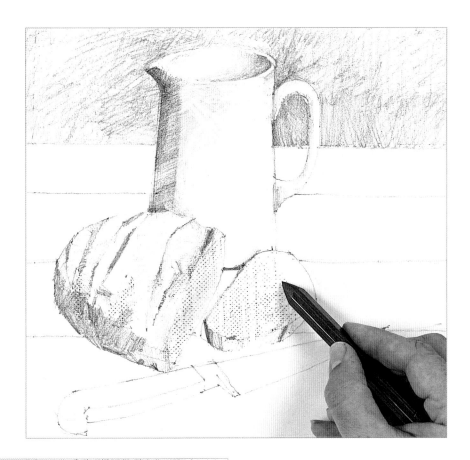

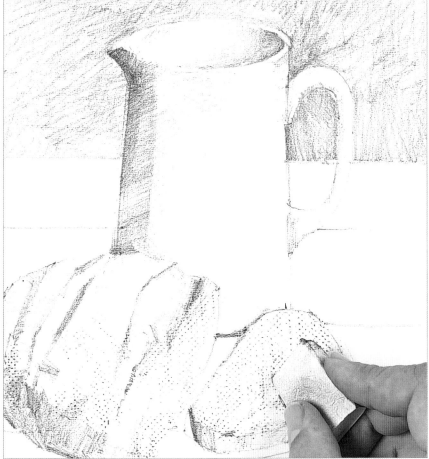

8 Remove the canvas board and complete the texture of the bread by working into the drawing using loose graphite marks and erasing techniques (see page 53).

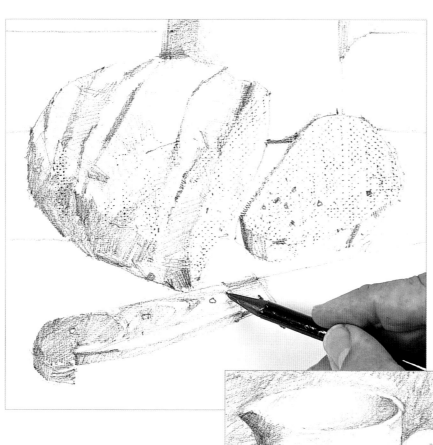

9 Now add tone to the handle of the knife, taking care to draw in the grain of the wooden handle so that it follows the contours of the wood.

10 Place the rough wooden board beneath your paper now, to draw the tabletop. Use the 3B graphite stick, rubbing in the direction of the grain, to transfer its image on to your drawing.

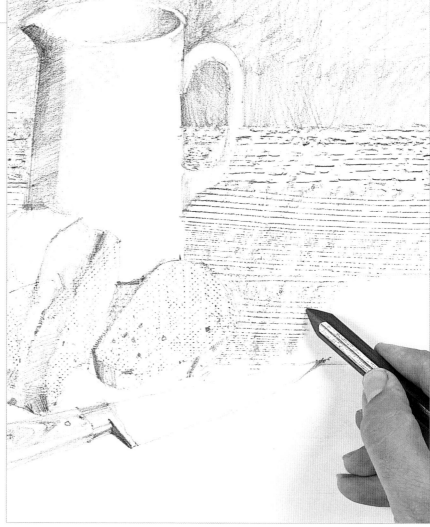

11 Define the individual strips of wood that make up the tabletop by applying lines of darker tone. Apply darker tone, also, to create the shadows beneath the objects.

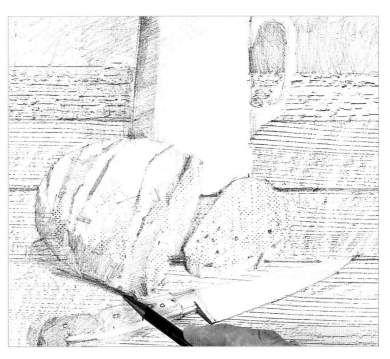

12 The finished drawing demonstrates how the smooth finish of the porcelain jug, the pitted rough texture of the bread and the linear surface of the wood grain can be successfully achieved using a variety of advanced techniques.

step 9 composition

focus: arranging the elements

Materials

White cartridge paper, 300 gsm/140 lb

Medium charcoal pencil

Putty eraser

The composition of a drawing is the way in which you arrange the subject matter within the confines of the picture area. Good composition persuades a viewer to focus on those elements that you deem most important and to 'read', or travel through and around, the image in a specific way. All aspects of drawing discussed so far in this book – scale, perspective, tone, colour and texture – influence composition.

RULE OF THIRDS

A very simple system of arranging the space within a rectangle – the usual shape of a picture area – is known as the 'rule of thirds', which, once mastered, can be used instinctively. The basic principle here is to divide the space into thirds both horizontally and vertically. Placing important elements on or around the grid lines, or where they intersect, invariably results in a pleasing composition.

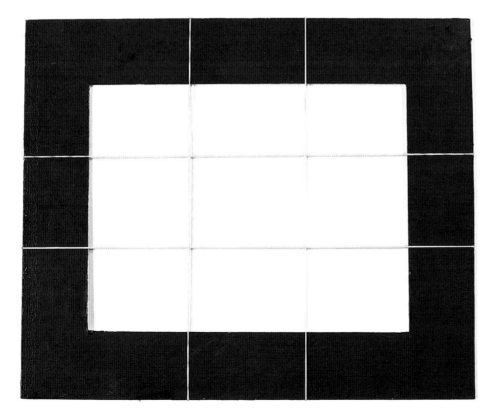

Using a viewing frame:
In order to look for possible compositions, you can make a simple viewing frame by cutting a rectangular aperture in a sheet of card and stretching four rubber bands across so that the aperture is divided equally into thirds both horizontally and vertically.

FORMAT AND CROPPING

The first thing to consider when making a drawing is its format, because this will have a direct influence on your composition. There are three main formats:

• Landscape: a rectangle with the longest side running horizontally.

• Portrait: a rectangle with the longest side running vertically.

• Square: while the proportion of the two rectangular formats can be altered, the square format always remains square, no matter how large or small.

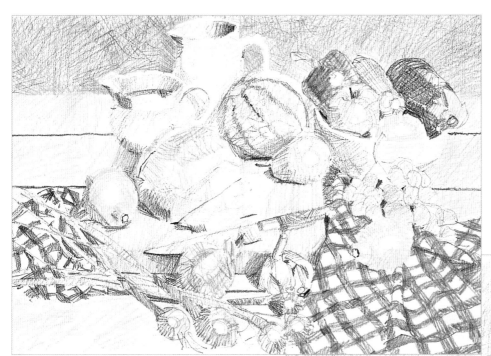

Horizontal format:
A horizontal rectangular format persuades the eye to view a drawing from side to side.

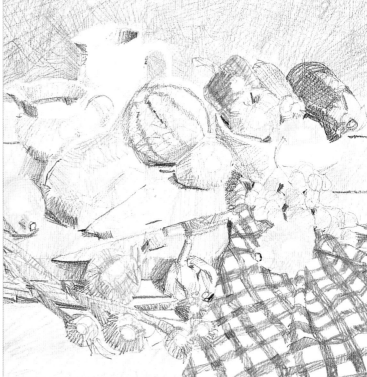

Vertical format:
A vertical rectangular format persuades the eye to travel up and down the drawing.

Square format: A square format persuades the eye to spiral around the image but ultimately it is drawn to the centre.

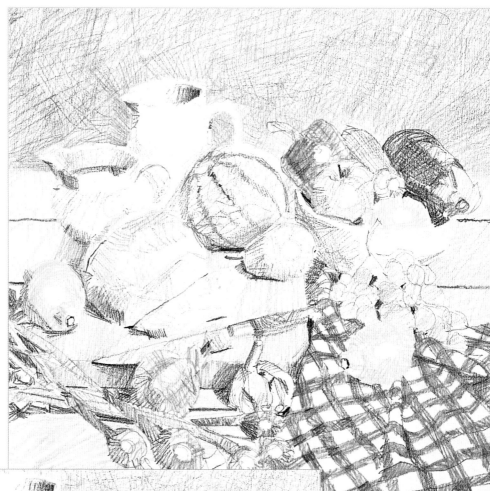

Tight crop: Cropping tight into a subject tightens the overall composition and introduces an almost abstract feel to the piece.

BALANCE

Balance is achieved by using what is referred to as 'point and counterpoint'. For example, a large object or mass might be balanced by a much smaller object or mass that is much brighter in colour; a complex arrangement of objects might be balanced by a simple but heavily textured area. There are various ways of introducing point and counterpoint: thick with thin; black with white; bright colour with texture; complex with simple, the possibilities are many.

ANGLE OF VIEW

A still-life arrangement can be seen from a full 360 degrees, which means that the possibilities are many when it comes to deciding on composition. Seen from above, and at a distance, the objects appear to be spread out with plenty of space around them. The objects can be seen more or less in their entirety and there is a distinct feeling of depth to the image. Seen from the side, however, the exact same arrangement appears tighter, with the objects creating interesting shapes as they appear one in front of the other. Such an image, although just as valid as the first, appears flatter and without any great sense of depth.

USING THUMBNAILS

In order to decide on the right composition for a drawing, an artist might prepare a series of small compositional sketches, known as thumbnails. These need only be large enough to give a quick impression of what the final composition will look like.

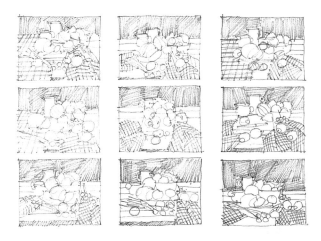

Explore the possibilities: Thumbnails help you to arrange the elements within the picture area and assess various compositional options.

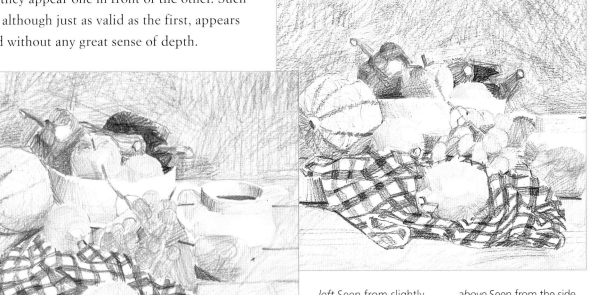

left Seen from slightly above this arrangement has depth.

above Seen from the side the arrangement appears to have less depth.

step 10 bringing it all together

focus: **still-life drawing**

Materials

Beige pastel paper, 160 gsm/90 lb

Fixative

Sheet of scrap paper

Ruler

Pastel pencils:

- White
- Mid grey
- Light grey
- Dark grey
- Cadmium red
- Crimson
- Cadmium orange
- Cadmium yellow
- Lemon yellow
- Naples yellow
- Olive
- Light green
- Mid green
- Lime green
- Indigo
- Violet
- Light violet
- Light blue
- Burnt sienna
- Burnt umber
- Yellow ochre
- Light ochre
- Terracotta
- Black

The artist can manipulate a still life, arranging content, lighting, colours and composition to suit, and this makes it a perfect project from which to learn. Here, a range of typical objects give a variety of shapes, textures and colours to render using a wide variety of drawing techniques.

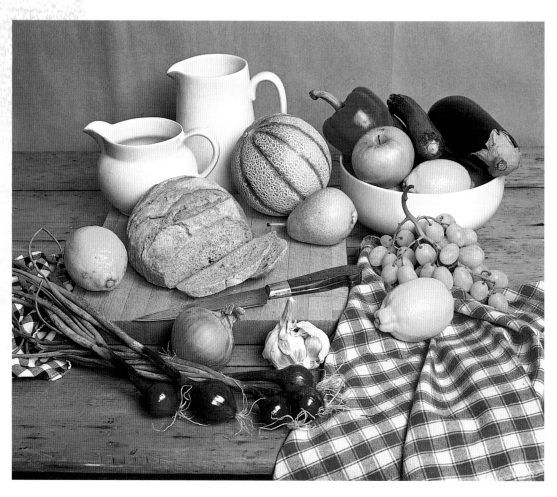

The order in which colour is added is not entirely arbitrary. In this case, the addition of colour begins in the top left-hand corner and progresses in a left-to-right, top-to-bottom direction. This is because the artist is right-handed and working in this direction enables him to always rest his hand on an area that has not been freshly drawn on.

Stage 1: proportion, shape and perspective

1 Use the white pastel pencil to sketch in the approximate shapes and positions of the main elements (see pages 18–23). Take a few measurements to assess the relative size of the objects and their positions in relation to one another. Use a light fluid line.

2 Use very simple shapes at this stage. The idea is to get the composition right, and this is the best time to make any alterations in position. Do not be too concerned about the white line showing up where it is not wanted. Lightly brushing over it will reduce its presence and subsequent pastel pencil work will obliterate any of the initial construction lines.

3 Once you are happy with the composition, you can develop the shape of the objects. In each case use a colour that loosely corresponds with that of the object. When drawing the white jugs, use perspective to achieve the correct shape of the ellipses and orientation of the jugs (see pages 24–29). As you work, mark loosely the extent and position of any major areas of tone together with any highlights.

4 Using the relevant coloured pencils, work over the whole image, redrawing and redefining the shape of each object. Use your initial sketch as a guide but do not slavishly follow the lines made previously. Relate each object to its neighbour, taking measurements if needed, as you go. Use contour lines to show the direction of surfaces and mark any major changes in light and shade (see pages 36–37).

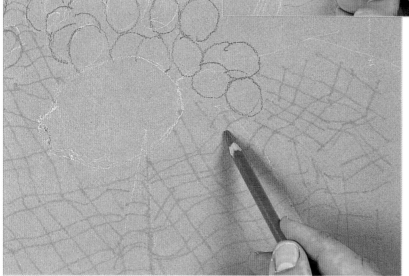

5 Draw the cloth carefully, noting its position, shape and the direction of pattern (see pages 58–63). Draw all of the lines running in one direction before drawing any lines running in the other direction.

6 Stand back and take a look at your drawing. So far the work has been concerned with establishing the correct positions and shapes of the objects. There is already a feeling of depth, helped by the addition of a few contour lines and perspective. This line work will not interfere with any subsequent work and should disappear as you continue to build up the drawing. At this point you can give your drawing a light coat of fixative to prevent smudging.

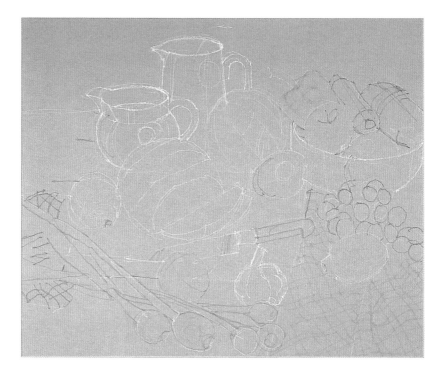

Stage 2: establishing colour and tone

7 The most important thing to remember as you add colour and tone is to avoid a 'filled in' look. Begin by adding white to the two ceramic jugs, and using a mid grey for those areas in shadow. Keep the pastel work 'open' and do not attempt to completely obliterate the background colour. Your colours will deepen as you apply more layers of pigment.

8 Progress to the fruit and vegetables in the white ceramic bowl. Use cadmium red, crimson and cadmium orange for the pepper itself and olive, light green and mid green to establish the colours on its stem. You can use the same colours for the courgette and apple. To achieve the glossy skin of the aubergine, use indigo, violet and light blue. Establish the colour of the lemon using cadmium yellow and lemon yellow. Scribble in the highlight using Naples yellow. You can also use Naples yellow for the highlights on the apple, while the highlight on the pepper should be white.

9 Establish the lemon next to the bread using the same colours you used for the lemon in the bowl. Now draw the loaf of bread, using burnt sienna and burnt umber for the side of the loaf in shadow, and yellow ochre and Naples yellow for the rest of the crust. Draw the 'white' of the bread using a combination of light grey and light blue. Draw the pear using lime green and mid green with white for the highlights. Use a dark grey for the blade of the knife and yellow ochre for the brass around its middle. Work on the linear pattern that curves around the melon using mid green, scribbling in Naples yellow to suggest the pattern and texture on its surface (see pages 52–57).

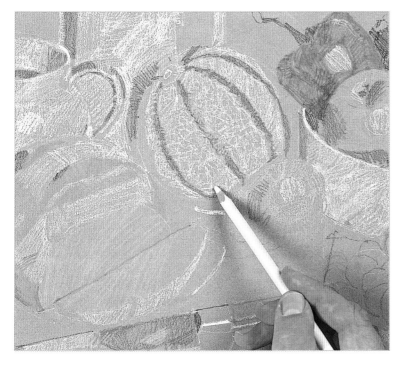

10 Pick out the linear pattern on the skin of the garlic using white and dark grey (see pages 30–35). Draw the foliage of the small onions using mid green and use crimson for the bulbs. Turn to the onion, using yellow ochre, burnt umber and cadmium orange. Use light violet for the shaded areas.

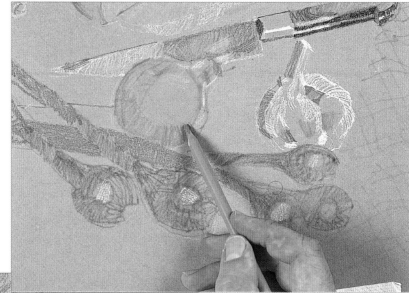

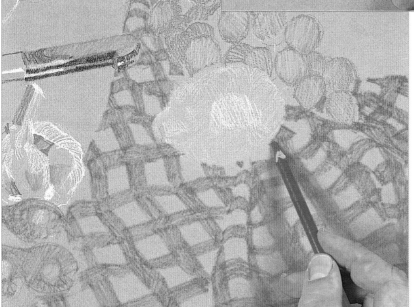

11 With a careful eye on their positions on the red checked cloth, draw the grapes, using light green, and the lemon using the same colours as in steps 8 and 9. Using cadmium red, carefully block in the linear pattern on the cloth.

12 Start to draw the pattern on the cloth to the left of the composition, using black. Remember to look at the way that the pattern follows the folds of the cloth.

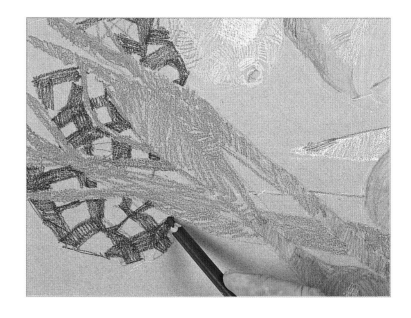

13 The colour of all of the major elements has now been established. Stand back from your drawing and notice how the colour of the paper ties the whole drawing together, working behind the colours to unify them and help create an overall colour harmony.

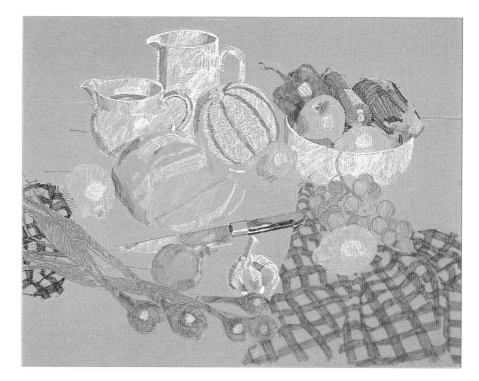

14 Establish the colour of the wall behind the still life. Using a light ochre, work across the area, drawing blocks of hatched and crosshatched lines to build up the colour. Notice how the still-life objects immediately appear to advance as the lighter wall colour is added around them.

15 Repeat the process, using the same colour, to establish the colour of the chopping board.

16 Use burnt sienna to draw the shadow cast by the onion, then continue with the light ochre pencil to work around the objects at the front of the tabletop.

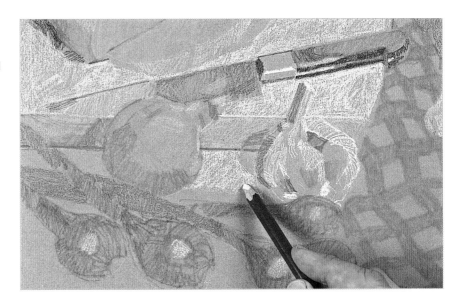

17 Complete the background blocking by using the yellow ochre pencil to establish the colour of the tabletop at the rear of the setup. Stand back from your drawing. The objects now appear to stand firmly on the surface rather than floating in space. The feeling of depth is more pronounced, as the tabletop appears to advance towards the viewer. This in part is due to using the darker colour at the rear of the table and the lighter colour to the fore. Apply another light spray of fixative. This will deaden the lighter colours somewhat, but will allow more layers of colour to be applied without smudging.

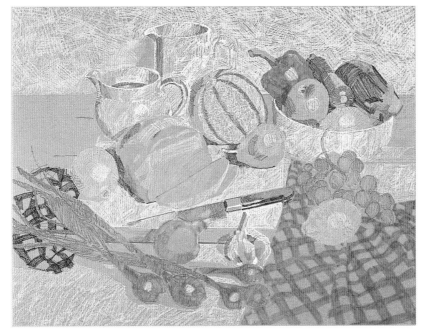

18 You can now rework the colours across the image. The fact that the spray fixative reduces or 'knocks back' the colours actually works to your advantage. It means that, in effect, the amount of colour you use is 'doubled' up. You can see this clearly as you begin to apply a second layer of colour. Here, the white being applied looks clearer and brighter than the white that had been drawn previously. The build-up of the pigment has a certain amount to do with this, but the process of fixing also helps.

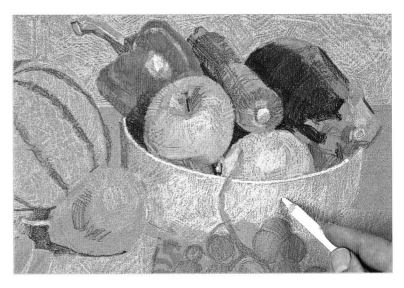

19 At times you may find that no single colour is quite right, as here, when it comes to the grapes. You need to mix the right colour carefully – with sharp pencils – by laying one over the other. Use light green, mid green and light blue, drawing linear strokes that follow the contours of each grape (see pages 20–23). Try your colour mixes on a sheet of scrap paper before committing yourself.

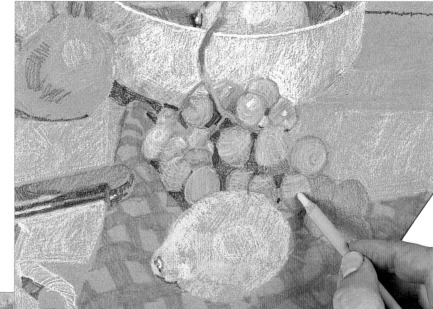

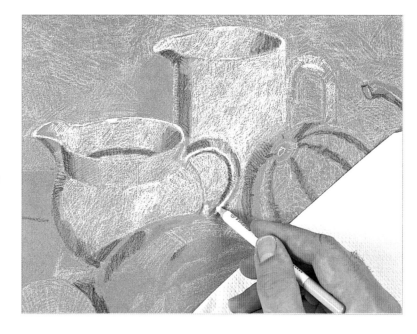

20 Using cadmium red, draw in the lines of the pattern that fall either side of the thicker stripes on the cloth. Where the pattern overlaps, deepen the colour by using crimson. Use white for the lighter squares.

21 Return to the two ceramic jugs. Use the white pastel pencil to re-establish the highlights and use the light blue, mid grey and yellow ochre to draw in the areas of reflected light and shadows. Although the image has been fixed you may still soften the focus or sharpness of the image by rubbing it with the side of your hand. Working with a sheet of paper towel beneath your hand should prevent this from happening.

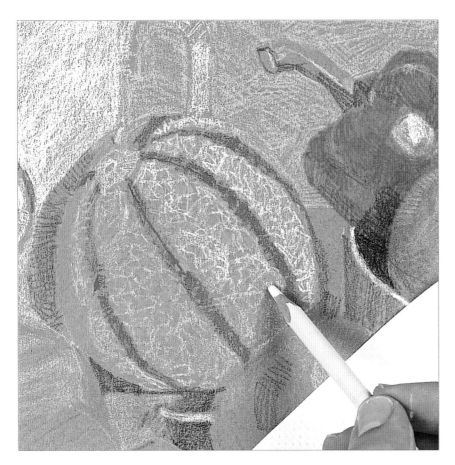

22 Use a combination of mid grey and mid green pencils for the light green that shows through the lighter pattern on the melon. Redraw the linear pattern as before using Naples yellow (see pages 50–57).

23 Use lime green on the topmost part of the pear and scribble a band of cadmium orange down the topmost edge to capture the shadow cast by the melon.

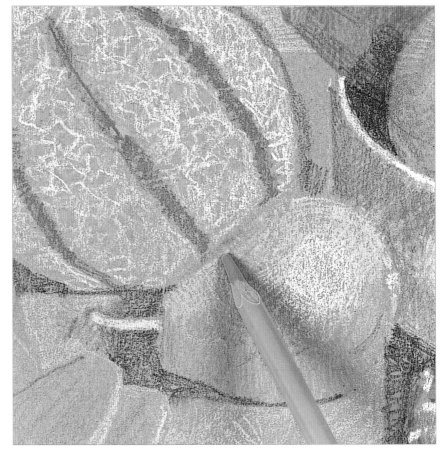

Stage 3: establishing texture and detail

24 Return to the crusty loaf of bread. Scribble crosshatched lines of burnt umber and light ochre that follow the uneven surface, and use terracotta and Naples yellow to render the dusting of flour. Colour the inside of the bread with yellow ochre, adding darker textural marks using the dark grey.

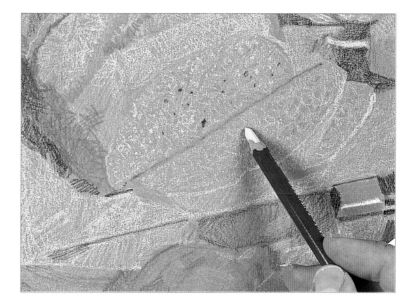

25 Deepen the colour of the lemon by the loaf by crosshatching layers of cadmium yellow, lemon yellow and a little light green. Use Naples yellow for the highlights and work carefully around the stalk area in black.

26 Capture the reflective quality of the knife blade by 'glazing' light blue over the dark grey that was applied in step 9.

27 Enrich the colour on the onion using more burnt umber, worked over indigo. Use the same mix of colours for the deep shadow cast by the onion on to the edge of the chopping board and the tabletop.

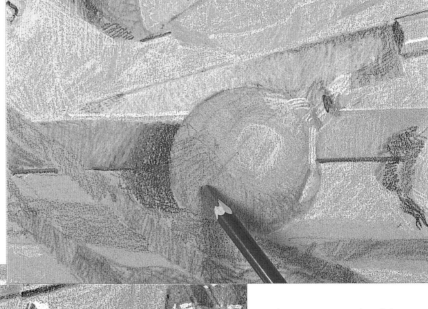

28 Capture the slight pink bloom on the bulbs of garlic using light strokes of crimson. Apply dark and mid grey where there are shadows and Naples yellow where there are highlights. Use indigo to define the dark interior and shadow beneath the garlic bulb.

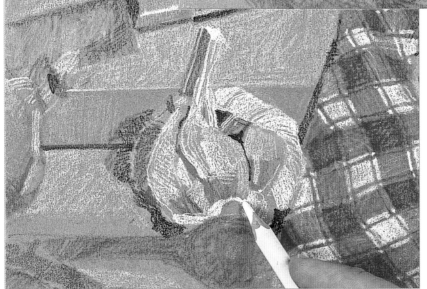

29 Return to the black-checked napkin. Apply mid grey over the black to draw in the lighter grey squares and use white to define the lighter squares.

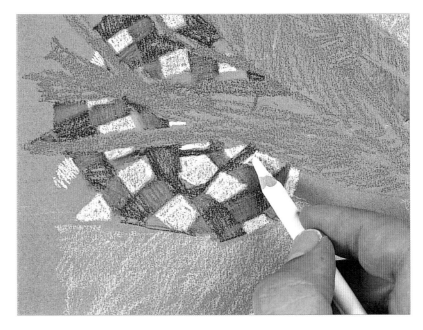

30 Redraw the stems of the small onions that are in shadow using dark green. Use lime green to 'glaze' over the mid green on the lighter coloured stems, and deepen the others using scribbled applications of light green.

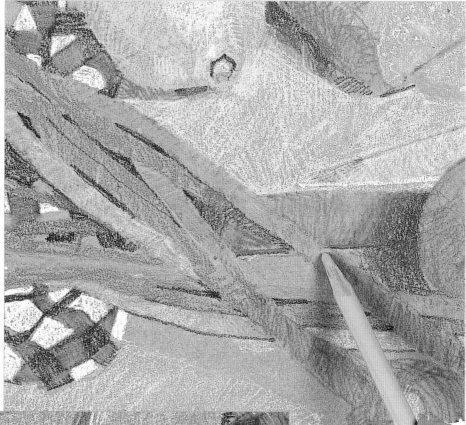

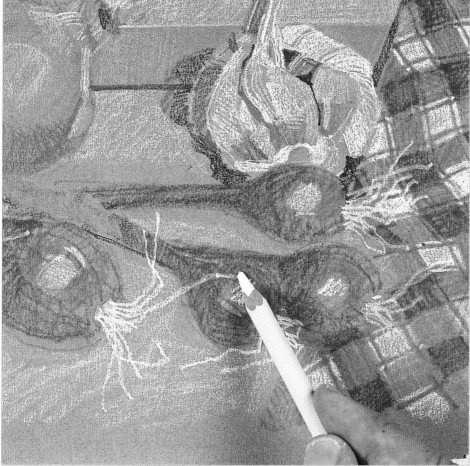

31 Give the small onion bulbs more form using crimson, indigo and cadmium red. Apply linear marks of Naples yellow to define the roots.

Stage 4: finishing touches

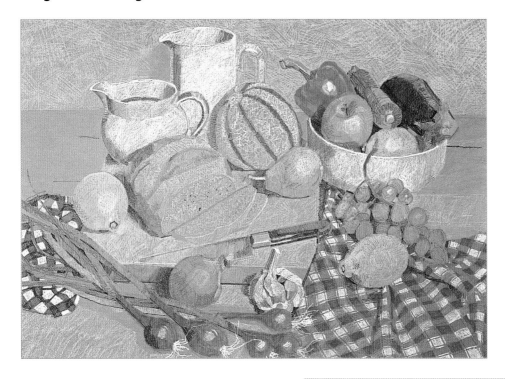

32 Step back and assess progress so far. While the colour and shape of the objects themselves appear satisfactory, the tabletop and background now look soft and appear to lack 'bite'. Now is the time to intensify and deepen the colour of both and add detail to the tabletop.

33 Create a crisp edge between the wall and the table by working yellow ochre up to a ruler, which should act as a mask. Leave the colour of the support showing through to represent the shadow on the wall cast by the jug: add a little dark grey to darken the area slightly.

34 Use yellow ochre and Naples yellow to draw linear marks that run along the tabletop, giving the impression of the grain and pattern of the wood. Use black to define the edges of individual lengths of wood.

35 Use burnt sienna to draw the strips of wood that make up the chopping board. Pay particular attention to the angle at which the lines run, making sure that they match the perspective of the edges of the chopping block (see pages 24–29).

36 See how the pitted surface of each lemon shows up clearly where light reflects off its surface. Draw this in with the white pastel pencil, applying more pressure as you make the precise marks.

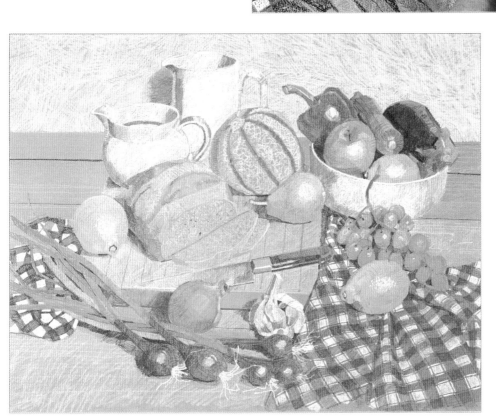

37 All of the techniques from the previous nine steps have been used to complete this project. You may be tempted to fix the finished drawing, but fixative does tend to reduce the intensity and brightness of the lighter colours. It is better to protect the work with a sheet of tissue or tracing paper and place it carefully in a drawer or portfolio until it is framed.

watercolour
in 10 steps

before you begin

choosing the right materials

To achieve results that you can be proud of, you need to use good-quality materials. The pleasure of a stroke of paint on paper only comes from a brush made especially for the art, quality paints, and paper created to extract the best from them both. To learn and progress, you need to gain satisfaction from your work and investing in the best tools and materials will help you to achieve this. The good news is that only a few items will be needed to get going.

Once you have put a brush into water and paint onto paper, you will be captivated. The fusion of colours as they burst into one another on the paper will have you hooked. Buy the few good-quality materials recommended in the shopping list – a brush, some watercolour paper and a few paints – and you will soon be on the way to painting in watercolour.

Some paint colours have different names (see alternatives in brackets, below) but are in fact very similar (see page 99). Any good art materials stockist should be able to advise you if you have problems identifying the colour required.

Shopping list

A4 pad of 'not' paper, 30 cm x 21cm
 (12 in x 8¼ in), 300 gsm/140 lb

Masking tape

Masking fluid

Drawing board (piece of wood or
 polystyrene, approximately
 60 cm x 90 cm/2 ft x 3 ft)

Prop for drawing board (block of
 polystyrene, book or house brick)

Small selection of brushes, including
 a size 12 half-synthetic sable brush
 and a size 6 round brush

Cheap, flat hog-hair brush, size 6,
 for correcting mistakes

Cheap small brush for applying masking
 fluid

2 mixing palettes

Putty eraser

Basic palette:

Phthalocyanine red (or Quinacridone
 red/coral)

Quinacridone gold

Ultramarine blue

Alizarin crimson

Lemon yellow

Phthalocyanine blue (or Winsor/phthalo
 blue)

Guest paints:

Cobalt Blue

Indigo

Dioxazine violet (or Winsor violet
 dioxazine or Carbazole violet or
 Permanent mauve)

Brown madder

Quinacridone red

Payne's grey

Permanent rose

Quinacridone magenta

Cobalt turquoise

Winsor green

Prussian green (or Cobalt turquoise)

Translucent orange (or Winsor/
 pyrrol/warm orange)

Transparent yellow

Green gold

Burnt sienna

Raw sienna

PAPERS

Using the right paper for your watercolour painting will help you to produce good results but the selection on offer can be confusing. Beginners in watercolour tend to think that they do not deserve the more expensive watercolour paper: cartridge, or drawing, paper will do fine, they think. Unfortunately, thin paper with no texture to it will not respond well to washy paints, distorting and drying unevenly; it will disintegrate if you try to wash away a stray spot of colour. As you will see, watercolour paper is tough and can withstand reworking, lifting off paint, scratching out of highlights and many other attacks on its surface and still look pristine. Let us look at the options.

Surface texture

There are three main types of paper used for watercolour painting: hot-pressed, cold-pressed, known as 'not' ('not hot-pressed'), and rough. Hot-pressed has a smooth surface and is generally used for pen and line work and detailed, often small-scale painting with drier applications of paint. 'Not' has a slightly textured surface, which gives the stroke an interesting edge. Rough paper is just that. It has a visible texture to it, often with dips in which the paint collects, giving the stroke a shimmering depth. There are many degrees of roughness from the various manufacturers, and handmade papers offer a further selection of textured surfaces.

Hot-pressed paper: This does not absorb paint so if the brush is loaded ready for a broad stroke the paint will tend to puddle, drying slowly and unevenly with a hard edge. You can see the dark puddles of collected paint here. This paper is mostly used for detailed work where one layer of dryish paint is required. Botanical flower painters use it for their stunning work, building up one thick layer of paint with a small brush and tiny brushstrokes.

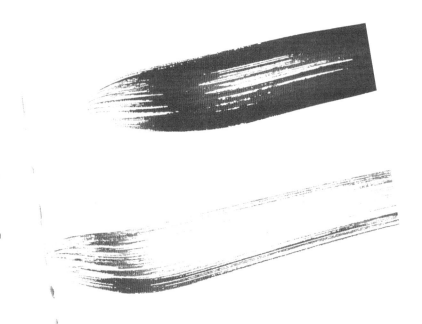

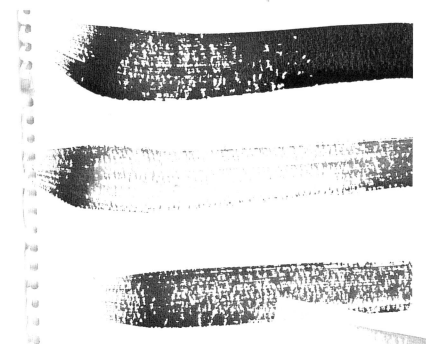

'Not' paper: This is a useful all-rounder that absorbs the paint evenly, which makes it easier to control washes. The surface is robust enough to survive repeated rescue operations, which makes it a good choice for beginners.

Rough paper: This can be wonderful, emphasizing the typical watercolour broken edge of the brushstroke and creating texture. You can see how the paper has soaked up the paint, breaking up the stroke almost immediately. It encourages impressionistic painting and imprecise edges.

Paper weight

Watercolour paper comes in various weights described in grams per square metre or pounds per ream (500 sheets) – 300 gsm paper is equivalent to 140 lb. Light papers are to be avoided if you want to paint in wet washes of paint: the paint cockles the paper into ripples causing the paint to dry unevenly in the dips. Heavy papers are expensive. What you want is the heaviest paper you can use without having to stretch it. You will want to avoid stretching paper at this stage, as it involves soaking the paper and fixing it to a board. If you are using a medium-sized sheet, 300 gsm (140 lb) is adequate. Fix it to a board along all four edges with masking tape to keep it flat. Masking tape will also create an attractive border around your painting because it prevents the paint from reaching the paper.

Cockled cartridge (drawing) paper:
With a wet wash and too thin paper, the paper dries cockled with the paint concentrating in the dips. Don't panic! If your paper does cockle, if you have taped it to a board and it is 300 gsm (140 lb) or over, it should return to its former perfect flatness once dry.

Pad of paper or single sheet

Pads of watercolour paper come in the various types, spiral bound or just taped at the top. Smaller ones are useful for watercolour sketching on the move, where you will be painting smaller areas with restricted washes. Sheets from larger pads can be torn off and taped onto a board. A pad option, useful for travel, comes glued around all four sides so that you can paint straight on to the paper and it will not cockle with a wash. All these different pads come in various sizes, weights and textures.

Many artists prefer to buy paper in large single sheets, tearing or cutting them to the size they want. Most art stores have a good selection of such papers made by various manufacturers. The surface of the paper differs between the top ('right') side and the underside ('wrong'). Good papers have a watermark that is visible if you hold them up to the light. Checking that the watermark is the right way around will confirm which is the right side of the paper.

BRUSHES

Brushes come in an overwhelming range of sizes, shapes and hair types. They vary in size from ultra fine 000 – up to a generous 14 and beyond. Tradition has the watercolourist laying flat washes with large brushes, flat or round, treating broad areas with a medium round brush and using a small brush for detailed work at the end. In fact, as we show in this book, most watercolour painting can be happily executed with a large round brush, using the tip for detailed work and, with a little pressure, extracting the paint stored in the body of the brush for washes.

If, right from the start, you use just the one large round brush, you will quickly discover its potential and save yourself much wasted time, interrupted concentration and money. Using a larger brush will also keep your washes broader and prevent you from getting bogged down in fine details.

Artists, however, all end up with their own personalized collection of brushes and painting tools. In due course, you will try them all – round, flat, filbert, rigger – and you may find the odd one that suits your style or subject matter.

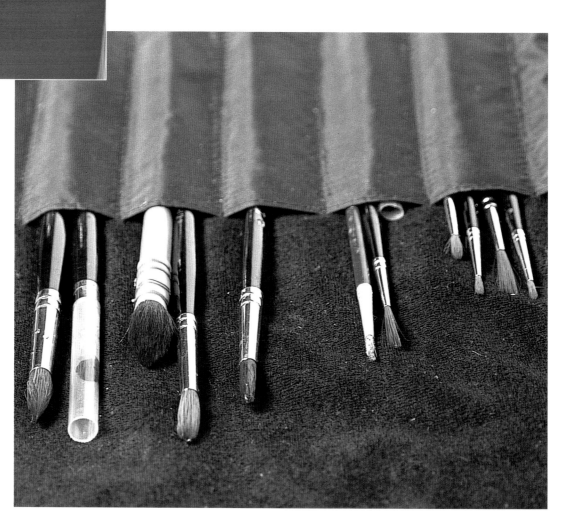

Brush shapes

The shapes of different brushes have evolved for certain jobs. The round brush can paint details and carry large amounts of paint; the flat is useful for laying flat washes or cutting in around a complicated shape. There are many other shapes and their uses will suggest themselves as you expand your techniques.

Using your brush

Try out your brush, putting it through its paces. Keep your hand relaxed and let the brush do the work. See how many different marks you can produce: try delicate dots and broad sweeps.

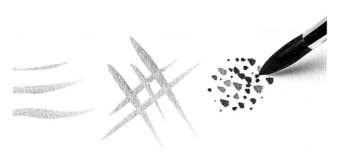

Brush tip: Delicate marks can come from the very tip of the brush. Hold it upright, with minimal pressure using your fingers rather than your wrist to manipulate the brush.

Broad stroke: Use the body of the brush for broader washes, applying gentle pressure to squeeze out the paint that is stored here. Keep the brush upright.

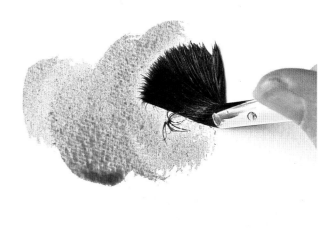

Curves: Use the natural spring of the hairs to follow a curve.

Rolling: Roll the brush from side to side for an interesting effect.

Synthetic or sable?

Brushes that are a mixture of sable and synthetic are much cheaper than all-sable brushes and are better able to take the rough treatment a beginner might unintentionally give them. Sable brushes are expensive but, if looked after carefully, can last a lifetime. They have a springiness that means the brush returns to its shape after every stroke and this makes them responsive. They also carry more paint without losing their shape.

Shaping a brush: Clean your brush gently in cold water after use and dry it by blotting with a tissue. Shape the brush into a point with your fingers and dry out upright in a jam jar or pot.

Looking after your brushes

Don't use your good brushes for mixing, loosening up paint in pans, applying masking fluid, or working at mistakes. In fact, nothing where the hairs are rubbed or scrubbed or twisted into extreme positions. Use cheap or old brushes for these jobs to preserve the life and shape of your good brushes.

Other painting tools

You will discover a wonderful range of tools to paint with alongside your brushes. A toothbrush is good for stippling or spattering (see page 109); the edge of a credit card dipped in paint can be used for any straight line – a fence post or flower stalk; and small real sponges create interesting textural effects (see page 130).

Brushless painting: You can create different effects by using (left to right) the edge of a credit card, a natural sponge and a toothbrush.

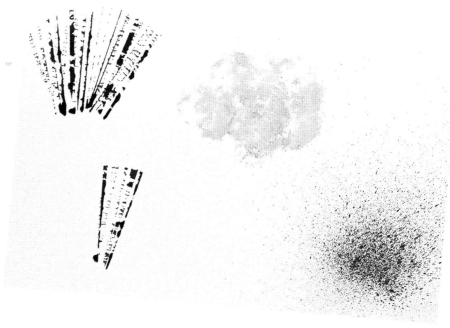

PAINTS

Watercolours are available in tubes and pans – the small blocks of solid paints found in a traditional paint box. Which type you prefer depends on personal preference – just make sure the paint is of good artist's quality. Cheap paints have a larger proportion of filler, which means less pigment so the colours are not as vibrant and your results will not be as good.

In this book we mainly use tubes. It is easier to mix a quantity of paint with tubes as the paint comes out soft and ready to go whereas the dried pans need to be worked to release the paint. However, some artists like to have a wider choice of colours ready for use as found in a conventional paint box.

Palette of six colours

A basic palette of colours can be mixed to produce almost any colour required. Artists vary in their choice of a basic palette, choosing colours that suit their subject matter – landscape, marine or flowers, for example. Some artists use the same basic palette for all their painting, and others add 'guest' colours for certain subjects: for example convenient ready-mixed greens, such as Hooker's Green, for a landscape.

The still life in this book requires a basic palette of six colours (see shopping list, page 92) – warm and cool versions of each of the primary colours, red, blue and yellow. Having the two versions of each colour makes it possible to mix a far wider range of hues (see mixing chart, page 103) and alternating warm and cool colours in your painting will give it light and depth. In addition, the colours in our palette are transparent. Transparent paints fully take advantage of the white paper beneath, which can shine through the superimposed glazes giving them a particular brilliance.

Buy the 'guest' colours recommended in the Shopping List only as and when required.

Getting to know your colours

Each colour has a character of its own, so you need to try them out and get to know them. You will notice differences as soon as you squeeze out the paint on to your palette or work the paint in the pan. Even though the paint manufacturers have tried to standardize them, some are more oily looking, others drier; some have a grainier texture than others. Some are good mixers, some are strong (a touch of phthalocyanine blue, for example, will take over almost any other colour so it has to be introduced carefully). Some colours stain the paper more quickly than others – a problem if you want to correct a mistake and take paint off the paper.

Mix the six colours in the basic palette with a little water as shown on page 100, and try them out across the page.

PREPARING TO PAINT

If you are using tubes, squeeze out small blobs of paint from your chosen selection of colours into separate wells on a mixing palette. This is your main palette and the colours should be kept pristine. Each colour will be mixed with a little water. Use another mixing palette for mixing together colours from your main palette. The rule is that only clean brushes, or a brush reloading, can take paint from the main palette. In time it becomes second nature.

Mixing paints on a palette

For users of paint boxes, any mixing can be done on the fold-out area most boxes come with, mixing larger washes in the wells in the lid. There are other purpose-made palettes available at art stores but for larger mixes of paint, any receptacle will do – yogurt pots and other food packaging provide numerous options. Make sure they are thoroughly cleaned of any grease.

Box of pans: When getting ready to paint with a paint box of pans, loosen up the paint first with an old brush.

Main palette

Set out your palette with your chosen colours. The idea is to have these colours ready for use, diluted only slightly to make them easy to handle.

1 Squeeze a small amount of each colour into the wells. Here, the six bowls of a flower palette are very convenient for laying out the basic primary colours, ready for mixing.

2 With a clean brush, transfer water from your clean water jar to the well. Tap the brush on the side of the well to release it and work it carefully into the paint. Mix so that you have a strong yet manageable colour that you can dilute or combine with other colours on the mixing palette.

Mixing palette: Primary colours from the main palette are mixed together here to form secondaries and beyond (see Colour wheel, page 105).

Mixing palette

Your mixing will take place on a mixing palette, taking paint from the main palette with a clean brush and adding water.

Water jars

Watercolours should be kept clean and pure otherwise the true beauty of these paints will be lost. The secret is to have two jars of water, one for clean brushes – used for diluting the paint – and one to wash dirty brushes.

Cleaning your brush

Before cleaning your brush, always take off as much paint as you can back into the palette by scraping the brush against the side. Now dip it in the cleaning water and shake to release the paint. Press it against the bottom a few times and dry it on some clean tissue.

Tissue

Tissue or paper towel is important to the watercolour painter. Most artists will paint with a brush in one hand and a tissue in the other. It has many functions; among others, use it to dry the paintbrush, to mop up stray paint, to take back too much paint and to soften edges. It is invaluable.

Water jars: Choose a reasonably large jar so that you do not have to keep changing the water, and preferably one that is made of glass. Plastic containers are knocked over easily.

step 1 exploring colour

focus: **understanding and combining colour**

Materials

Paper for sketching
Watercolour paper, 300 gsm/140 lb
HB clutch pencil
Round brush, size 12
Flat hog-hair brush
Toothbrush
Clean brush
Tissue/kitchen paper
Watercolours:
- *Lemon yellow*
- *Phthalocyanine red*
- *Cobalt blue*
- *Quinacridone gold*
- *Ultramarine blue*
- *Alizarin crimson*

Mixing colours is an art in itself. As a budding watercolour artist, you should start to look at colours around you and think how you might mix them using your basic palette. Try some ideas out and you will find that the outcome is not always what you expected. For example, as you will see below, red and blue do not necessarily produce a rich purple. We will look at different ways of combining colours, including some less obvious techniques for mixing. By trying out the various combinations in your palette, you will learn to predict the outcome. This will save time when you are looking for the perfect match while you are painting.

Predicting colours: Touching rich but cool cobalt blue into a wash of fiery warm phthalocyanine red produces a wonderful inky blue-black but not a rich purple as you might expect (see page 104).

COLOUR CHARTS

These charts show you how some colours mix good clear colours and other tend toward a muddy grey. Muddy colours, otherwise known as neutrals, have an important place in watercolour painting but it is nice to be able to call on them when required, rather than end up with them by mistake. Until mixing becomes second nature, make a chart of the various combinations of the six colours in the basic palette so you can refer to it when searching for a particular hue. Keep it to hand when you start painting, as this chart will be invaluable to you. At first, you will refer to it constantly; after a while less so and finally it will get buried under a pile of paintings.

Hues: Look at the variation in the hues mixed by warm and cool versions of the same colour. This is a good reason for choosing a warm and cool version of each primary.

Granulation: You can see the granulation of the paint in the mixes with ultramarine blue.

COLOUR THEORY

Understanding colour theory lets you make decisions without having to learn by rote. The colour wheel, right, shows you how the basics work. The three primary colours, red, blue and yellow when mixed, here, spattered together with their neighbours, produce secondary colours – orange, purple and green. These are all good clear colours. The neutralizing of these colours – when they tend towards grey – comes when you mix all the primaries together. This also happens when you mix opposites (known as complementary colours) – red with green, purple with yellow, and orange with blue. This is because you are in effect mixing the three primaries (red + green = red + blue + yellow). Therefore, if you mix a warm red that tends towards orange with a cool blue that tends towards green, you will not end up with a juicy purple but dark grey, because again you are mixing the three primaries. Depending on the proportions and dilution, you can also achieve a blue-grey or a pink-grey. Remember this, as you will need these coloured neutrals.

Colour mixes: You can see in these colour mixes that by mixing on the palette ultramarine blue (a warm blue tending towards purple) and alizarin crimson (a cool red tending towards purple) a good purple results (left, bottom). On the other hand, mixing phthalocyanine blue (a cool blue tending towards green) with alizarin crimson (tending towards purple) you end up with a dark blue-grey (left, top).

Colour wheel: The three primaries have been spattered over a semi-circle, masking off the other half: first yellow, then red, and finally blue. The three colours chosen were lemon yellow, phthalocyanine red and cobalt blue. The red and yellow make a fine warm orange, and the blue and yellow a good grass green, but the cobalt blue, which tends towards green, has produced a dull purplish grey. Notice that being able to see the constituent colours makes the resulting colour look more alive. All these findings will prove useful in your painting. Complementary colours are those opposite on the colour wheel: blue and orange; red and green; and yellow and purple. Try this colour wheel with a different set of three primary paint colours.

HOW TO MIX COLOURS

With watercolours, you can mix on the palette or on paper. If you wanted
a green colour either you can combine blue and yellow paints together
in a palette or you can mix on the paper by superimposing layers of
transparent paint, yellow over blue, to make green, or running the colours
together to make wet in wet (see opposite). The colours shown in the
chart on page 103 can be mixed in your palette and applied to the paper,
or the constituent colours can be mixed on the paper by superimposing
transparent layers of paint: a layer of yellow, covered with a layer of red
will look orange if applied wet on dry (see page 108). Try mixing yellow
and red in the palette and applying it to the paper and then try the same
mix optically on the paper. You can see that the optically mixed orange
has more life with more of the constituent colours visible.

Mixing in the palette

It may seem obvious how to mix colours in the palette but here are a few
useful tips. Add a strong colour into a weaker one, dark into light. Do
not mix the colours together too completely: a mixed colour with the
constituent colours still visible will have more life to it.

Mixing on the paper

There are a number of useful techniques that can be used for mixing paints optically on the paper. These four techniques form the basics of painting in watercolour: wet in wet, wet on dry, dry brush and spattering. There are many other techniques but most of them are variations of these four. Once you have mastered these techniques they can be adapted to produce almost any effect you will need for watercolour painting.

Wet in wet

This technique involves laying down a wash of paint in one colour and then, while the first wash is still wet, adding a second colour. Wet in wet is useful for mixing colours on the page but it produces a host of other effects depending on the dilution of the paint and the time left before the second colour is added. For example, it is useful for blending colours softly into one another. Try some other permutations with different dilutions and with the first layer damp rather than wet – you will achieve a range of effects.

Very wet: Adding wet paint to wet paint will mean that the two colours will fuse into an even mix. By moving the board, you can make sure the added red paint reaches every part of the yellow. Too wet and the wash will be unmanageable.

Less wet: Once the first layer has been painted, leave until the paint stops glistening and then add the second colour. Touch the colour in with the tip of the brush, allowing it to mix. This can be alarming with extreme colour combinations, rather like a moving kaleidoscope. Don't worry. The paint will settle and dry more evenly blended and much paler.

Damp: Here the first application of yellow is allowed to dry for a longer time until it could be described as damp. This time, when you add the red the brushstrokes remain intact – soft-edged and blending with the yellow but not spreading over the whole area.

Keeping control: When painting wet in wet, you can control the mix of washes by tipping the board, or by lifting off with a dry brush or a tissue. With the board tipped up, the paint tends to gather in a pool at the bottom of the painted area. Clean and squeeze off your brush on a tissue then lift off the extra paint by touching the side of a brush gently into the pool.

Wet on dry

This technique involves mixing paint by allowing the first colour to dry on the paper before applying the next colour. You can try this with different dilutions of paint, imitating the mixing in the chart. When dilute transparent washes of paint are used, this technique is called glazing.

Glazing: Paint a wash of dilute blue in a square. Leave it to dry. With a clean brush, take a pale wash of yellow and carefully paint it over the blue. Make the strokes clean and without fuss or you will disturb the blue wash. The result, where the two washes cross, will be a patch of green.

Dry brush

For the dry-brush technique, the first layer is painted flat and allowed to dry. For the second layer, add very little dry, undiluted paint to a clean dry brush and dab off any excess on a tissue. Gently scrub over the top of the first layer. It is more effective dark over light. The dry-brush layer can be executed with the bristles of the brush splayed, as shown in Example 1; lightly stroked over (scumbled), as in Example 2; or stippled with a hog-hair brush, as shown in Example 3. The result mixes the colours optically and produces an interesting textural effect.

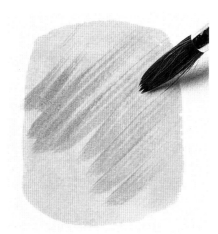

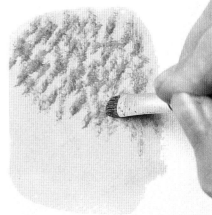

Example 1: A dry-brush layer is applied with the hairs of the brush splayed between thumb and forefinger.

Example 2: A second layer is applied lightly over the dry yellow paint, again using a dry brush.

Example 3: A hog-hair brush is used to lightly stipple with dry paint.

Spattering

You can use almost any brush for this mixing technique but a toothbrush works well. Remarkably different effects can be achieved by altering the dilution of the paint, spattering wet in wet (see page 107), or spattering onto a flat wash.

(see page 107)

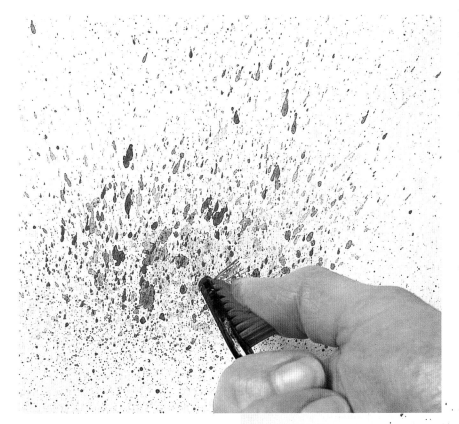

Learning to predict the outcome of mixing two colours on the page takes time. It is truly the wonder of watercolours that you can never be sure and therefore have to be able to deal with unexpected results as part of the process. In the end, if the dried combination of two colours is not what you expected, you can wash them off with a clean brush and water, or superimpose with another wash of paint. This is a good reason for taking the build up of washes slowly.

Toothbrush: Dip the brush into the paint and pull back the bristles with your thumb. Allow to dry and then spatter the next colour over the top.

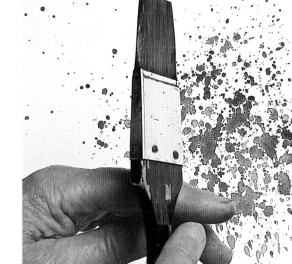

Flat brush: A 2.5 cm (1 in) flat brush produces larger spots of paint. Knock it against your other hand.

step 2 preparatory drawing and sketching

focus: apple

Materials

Paper for sketching

Watercolour paper, 300 gsm/140 lb

HB clutch pencil

Round brush, size 12

Clean damp brush

Tissue/kitchen paper

Watercolours:

* *Lemon yellow*
* *Quinacridone gold*
* *Alizarin crimson*
* *Dioxazine violet*

Any artist will tell you that sketching an object is the quickest way to sear the image onto your retina; to judge what it is that makes this object recognizable. Most watercolour artists can draw as well as paint. Their sketching leads to a confidence in their knowledge of a subject, which makes it possible to distil the essence of the subject into a painting. Here we will look at ways of sketching, and at the reasons for producing an under-drawing for your painting.

Setting up your subject:
Set up your apple on a flat surface with a good directional light source, preferably strong, natural light from a window, shining at an angle.

THE UNDER-DRAWING

Most watercolour artists map out their painting with an under-drawing that will then be painted over. Some artists produce a carefully considered, detailed drawing while others set off painting with the help of only a few hurried lines to plot the composition.

Your under-drawing must not be too heavy or it will show through the paler washes of the painting. Use an HB or 2H pencil with a sharp point but keep your hand relaxed, so that you don't incise the line into the paper. Try not to use an eraser, as it will spoil the surface of the paper. Rework the line if it is not right. You can carefully erase any lines that interfere at the end of the painting process. If you are worried about drawing onto your clean piece of good paper, you can always practise on another piece and transfer it by tracing. If the paper is thin enough, place it under your good paper, hold it against the glass of a window and let the daylight shine through. Now you can trace the image.

Don't panic!

If your drawing is too small or you want to scale-up an image from a magazine, use the enlarging option on a photocopier and then trace that onto your good watercolour paper.

1 Study your apple carefully. When you draw it, try to record what is actually there – you will notice, for instance, that apples are rarely round. The apple will look more realistic if you include any slight distortions and irregularities. Take special care with the stalk and the well in which it sits. An HB pencil will allow you to feel your way around the form, making smooth movements without catching on the paper.

2 Use a harder pencil now and copy the outline of the apple. Keep your pencil on the paper, assessing each angle as you come to it. When you are drawing, think about what makes it an apple: in this case, the shiny, reflective skin. The apple is hard and has a certain weight, too, and this shows in the harsh, clear outline. Imagine if you were drawing an apple carved from wood or one made from sponge. How would they differ? Draw the apple from various angles, life-size if possible. You will see that it is more obviously an apple when you can see the strange sculptural descent to the stalk at the top.

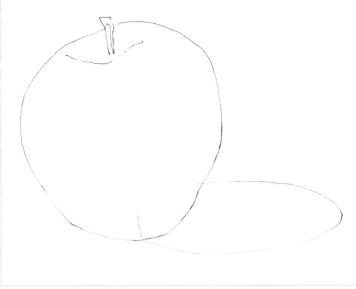

3 Look at the apple from the point of view of tone, particularly the deepest shadows and brightest highlights. Some artists map these out, tracing the outline of the areas of extreme tone, highlights and darkest shadow, and include this in their under-drawing.

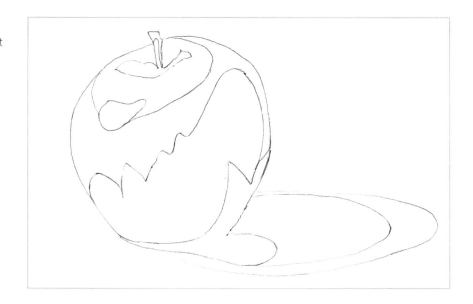

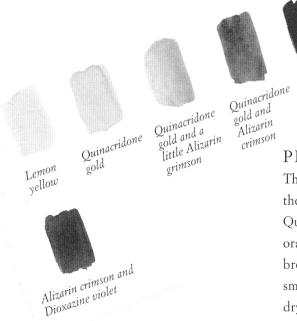

Lemon yellow

Quinacridone gold

Quinacridone gold and a little Alizarin crimson

Quinacridone gold and Alizarin crimson

Alizarin crimson

Alizarin crimson and Dioxazine violet

PREPARING TO PAINT

The apple is a cool yellow with crimson-red markings. For the painting, the yellow part will range from cool Lemon Yellow to warmer Quinacridone Gold. When Alizarin Crimson is mixed with the Gold, an orange-yellow results, and when it is mixed with Dioxazine Violet, a brown-red. Try out some of the wet-in-wet techniques required for this small painting (see page 33). Experiment with leaving the first wash to dry for different lengths of time before adding the second.

Palette and mixes used:
Lemon yellow; Quinacridone gold; Quinacridone gold and Alizarin crimson; Alizarin crimson; Alizarin crimson and Dioxazine violet; Dioxazine violet

Blending wet in wet: The gradations of colour from yellow to red suggest adding the colour wet in wet. Try some colours out before you begin. First, try the cool lemon yellow with the warm quinacridone gold yellow. Then add the quinacridone gold and alizarin crimson mix. If the paint is not too dilute and is allowed to sink into the paper a little before adding the next colour, it will not spread too much.

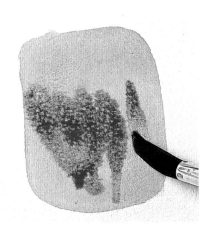

PAINTING THE APPLE

Have your apple ready drawn up on your good paper, which you will need to tape to your board. Prepare your colours as shown on page 100. The highlight along the shoulder of the apple will be taken back to the white paper with a clean damp brush once the first yellow layer has gone down. This apple study is an exercise in wet in wet, adding paint in wet, to almost dry. There is always some uncertainty when working wet in wet. You may have to try this a few times before you get it right.

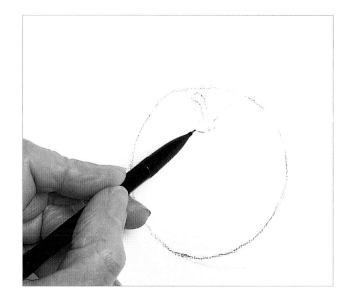

1 Finish off the under-drawing, in this case a simple outline.

2 Cover the apple with a first wash of yellow, a mixture of lemon yellow and quinacridone gold. Keep the board at an angle so that the paint drops downwards. Before it dries too much, add a mixture of quinacridone gold and a touch of alizarin crimson to the lower two thirds. It will merge with the yellow. If the paint gathers in a pool at the bottom of the apple, take it off by gently touching it with a clean damp brush.

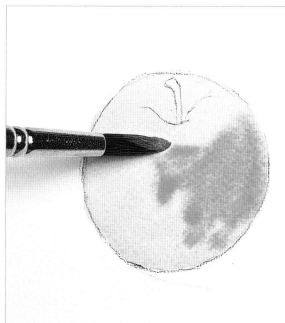

3 The apple has a soft-edged highlight that should be removed; do this with a clean, damp brush. Touch down with the side of the brush, not the tip, and lift off cleanly. Because the paint is wet, it may creep back so you might have to repeat this a few times. Watch it closely while it dries.

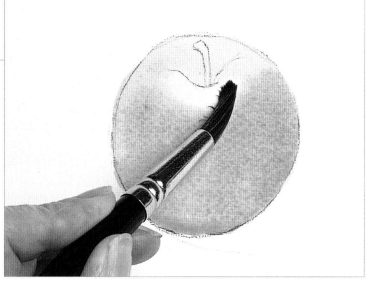

4 Do not let the paint dry completely as the next layer needs to go on once the paint has started to lose its shine but remains wet. Paint this layer of quinacridone gold and a little more alizarin crimson onto the lower part of the apple. The colour will bleed into the yellow creating a soft transition between the two colours.

5 Wait until the paint becomes damp, before you add pure alizarin. The brushstrokes will merge with the layer below but will be visible. It looks rather dark when it first goes on but it will dry paler. Use the linear markings on the apple to help describe its round shape.

6 When the stalk end of the apple is dry, mark out the shadows with dilute dioxazine violet. Take stronger dioxazine violet to build up the shadows on the base of the apple.

7 For the shadow on the table, paint the area first with water. Touch in a little dioxazine violet and encourage it to spread over the pre-wetted area. Now take your brush and bring a little of the apple colour from the base of the apple into the shadow and allow them to merge.

8 Build up the richer tones at the darkest points, where the apple meets its shadow, with a touch more Dioxazine Violet.

9 Carefully paint in the stalk with a dry mix of Quinacridone Gold and Dioxazine Violet. Do not paint it too solidly as the light will play on the texture and shape of the stalk. Blot it with a tissue if it looks too rigid.

10 The finished apple is good enough to eat. The area of shadow and deeper tone on the apple has been built up successfully wet in wet with pure colour to achieve a vibrant result.

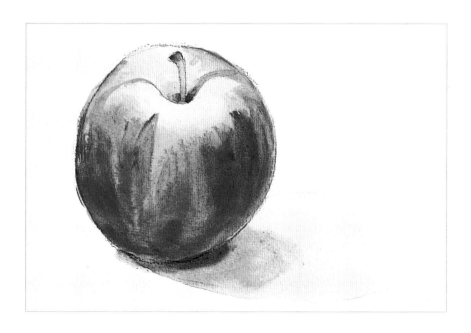

step 3 tone

focus: **bunch of grapes**

Materials

Paper for sketching
Watercolour paper, 300 gsm/140 lb
Masking fluid
HB clutch pencil
Round brush, size 6
Clean damp brush
Old brush to apply masking fluid
Tissue/kitchen paper
Watercolours:
- *Quinacridone gold*
- *Phthalocyanine blue*
- *Cobalt blue*
- *Brown madder*
- *Dioxazine violet*

Watercolour is a transparent medium that requires several layers of colour to build up depth and tone. Before you start a watercolour painting you need to assess the different tones – a tonal sketch will help – and as you start, leave the highlights and lighter parts of the painting free of paint, or covered with pale washes; then you build up the darker tones and shadows with successive layers of paint. This method is known as working from light to dark. With opaque mediums, like oil paint, you work the other way around, starting with the darks and adding the highlights last.

Reflective skin: The grapes have a dark, reflective skin which means that the highlights show up brightly.

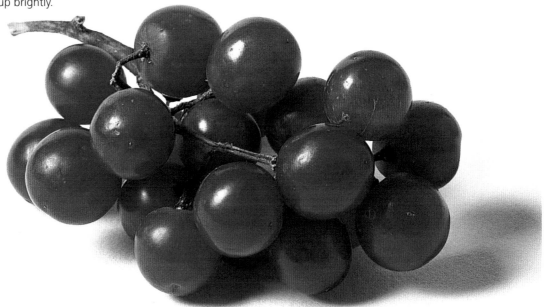

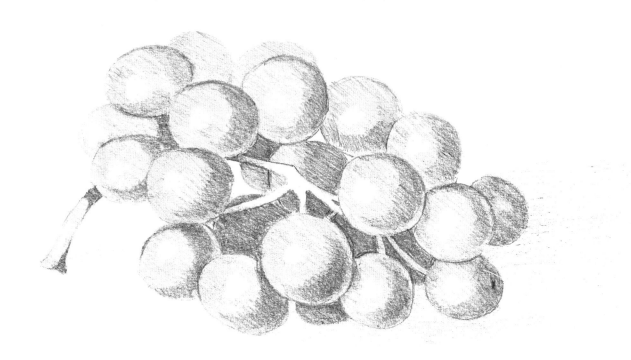

TONAL SKETCH

The watercolour painter's first job before painting is to locate the highlights. A tonal sketch can help you locate the highlights, mid-tones and shadows, which will help you to plan your painting.

Pick a small bunch of grapes and look at the individual grapes. Simplify the range of tones into three areas: the highlights, the mid-tones and the deepest shadow. A black and white photocopy of a colour photograph will simplify the tonal spread and will help you to see the distribution of tone.

Look at the form of the bunch – its shape. It has a front, back and sides. Consider this when planning your composition. Introducing a shadow cast by the bunch of grapes on the table helps to place it on a surface, giving it shape and volume.

Direction of light

It is important when planning a painting to work out where the light is coming from and to make the highlights and shadows fit in with this. For this bunch of grapes, the light is coming from the left, behind the artist. It is useful to indicate this with an arrow on your sketch so that you remember it as you draw. The highlights on the grapes are all in the same place, a small dot of light. Because the light is coming from the left, a shadow is cast on the white table surface to the right and slightly behind the grapes.

The light cast is strong and the grapes have a shiny reflective skin so that the highlights are clear-edged and bright. The highlight on the apple in Step 2 preparatory drawing and sketching, see pages 110–115, was softer, as the light was not as strong and the skin of the apple not as reflective. This information will help you decide how you will create the highlights. For the apple, the highlight was lifted off once the first wash had been laid down for a softer effect. For the grapes, the highlights will be reserved from the outset with masking fluid (see below), which produces a hard-edged patch of white paper.

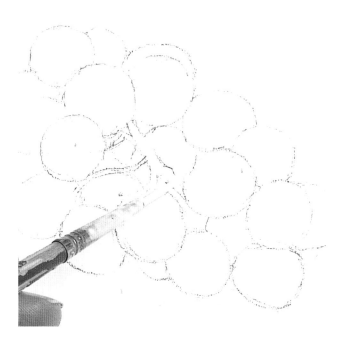

Masking fluid

It is very easy to paint over highlights once you get into the spirit of your painting, especially if there are as many as with these grapes. It is a good idea to reserve them with masking fluid, a rubbery liquid applied with a brush that you paint onto the highlights or any small details such as the stalk, which might otherwise get lost. The fluid dries and is then impervious to paint. At any point, as long as the surrounding paint is dry, you can remove the mask with a putty eraser (or a clean finger).

Applying: Use an old paint brush to apply masking fluid as it will ruin a good one. Masking fluid has to be applied rather than painted on; it does not run free. Make sure it has dried before you start painting.

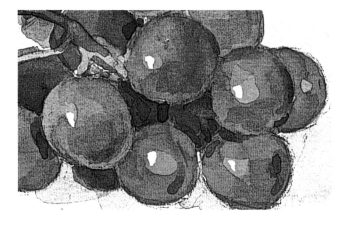

Translating tone into colour

Avoid making a colour darker by adding black. You can create areas of darker tone by superimposing layers of the same mixture of paint or combining the three primaries. You will see from the finished painted sketch on page 121 that the grapes are built up not by adding grey and black for the shadows but by adding reds, browns and purples. The mix sometimes leans more towards the reddish Brown Madder and sometimes the bluer Dioxazine Violet. This means that the final painting is filled with light and colour and is not dull and lifeless.

The build up of colour and tone follows the simplified tonal sketch on page 117, with only three layers of paint describing the pale, mid-tone and dark areas. You will notice also that the grapes are not painted a uniform colour; they are warmer and redder at the front, bluer and cooler at the back. This effect is explained in more detail in Step 6 lost and found edges, see pages 134–139.

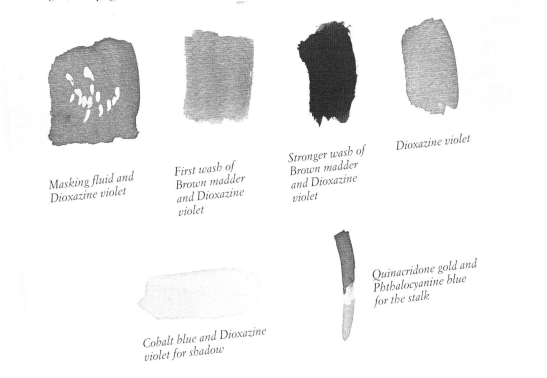

Masking fluid and Dioxazine violet

First wash of Brown madder and Dioxazine violet

Stronger wash of Brown madder and Dioxazine violet

Dioxazine violet

Cobalt blue and Dioxazine violet for shadow

Quinacridone gold and Phthalocyanine blue for the stalk

PREPARING TO PAINT

Trials: Try out ideas for your painting on a spare piece of good paper: mixes, techniques, and any problem areas.

The mixes of paint used for the grapes are brown madder and dioxazine violet in a dilute wash for the pale areas, plain dioxazine violet for the next wash and finally a stronger mix of madder brown and dioxazine violet for the darker areas. The increase in tone comes from a build up of washes rather than an increase in the strength of the paint. The stalk is a mix of quinacridone gold and phthalocyanine blue and the shadow cobalt blue and dioxazine violet.

PAINTING THE BUNCH OF GRAPES

Reserving the highlights with masking fluid as this will allow you to concentrate on the slight challenge that painting these grapes entails.

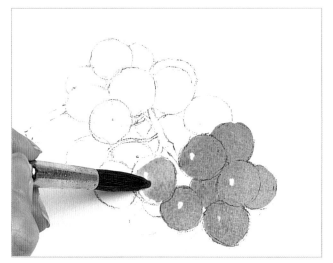

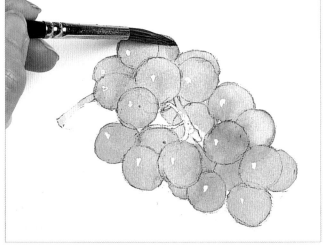

1 Paint the first warm reddish wash on the foreground grapes (over the masking fluid). Make your brush do the work. You will find it will fill in each grape, describing the round form, with little effort from you. The less you work the paper, the better the results will be. Practise on a spare piece of paper first.

2 In this first wash, be aware of the form of the bunch of grapes, rather than the individual grapes. Paint the grapes at the back bluer and cooler, which pushes them back. See how this first wash varies in colour and tone. You are not aiming for a consistent flat wash. Use a pale wash of quinacridone gold and phthalocyanine blue to define the stalk.

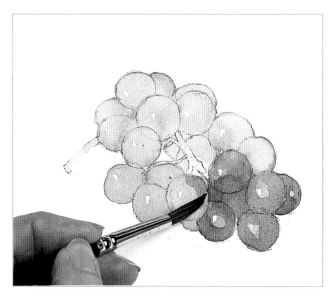

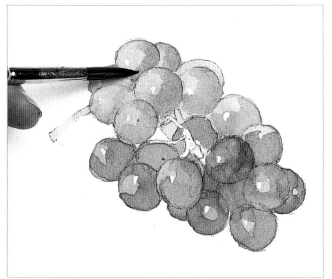

3 When the first wash is dry, add the second. Do not cover the whole grape with this second wash but leave an area of the pale wash visible around the highlight and to one side. The curved paint strokes of this mid-tone shadow start to build the spherical form of the grapes.

4 Build up the grapes at the back with the same mix of paint. Encourage the paint to go on unevenly, suggesting differences in the shapes of the grapes and the reflected light around them. This variation will greatly energize your painting. Allow to dry.

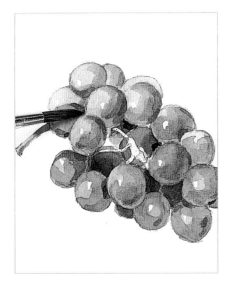

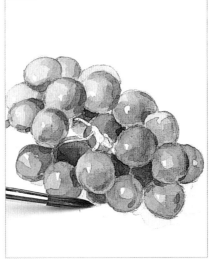

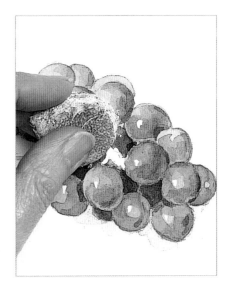

5 With a browner mix, paint in the touches of darker shadow on the grapes and stalks, particularly where they touch one another. With an eye to balancing the tones, the patches of this darkest purple should match the areas of whitest highlight. Paint over the interstices to make them darker. This throws the picture into relief, pushing the grapes forward and allowing the eye to go deep into the bunch.

6 Use a pale wash of cobalt and dioxazine violet to paint the shadow the grapes cast on the white surface of the table. Allow it to peter out at the edges.

7 Once the painting is quite dry (test carefully), use a putty eraser or specially cleaned finger to rub off the masking fluid.

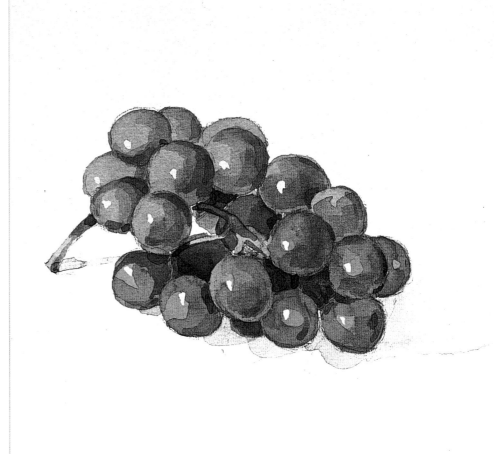

8 Add the finishing touches. The newly uncovered stalk in the centre of the bunch can be painted, bringing it up to the same tone as the surrounding grapes but preserving its integrity. Trace the shadow cast by the main stalk on the table in the same mix as the rest of the shadow. The painting is finished. Stand back and admire your masterpiece.

step 4 watercolour layers

focus: **orange**

Materials

Paper for sketching

Watercolour paper, 300 gsm/140 lb

HB clutch pencil

Round brush, size 6

Clean brush

Tissue/kitchen paper

Watercolours:

• *Cobalt blue*

• *Phthalocyanine blue*

• *Phthalocyanine red*

• *Quinacridone gold*

• *Payne's grey*

A good watercolour painting is usually built up in a number of layers of superimposed colour working from light to dark. This means that the first layers comprise pale, dilute washes of colour, mapping out the painting. Successive layers can be added while the paint is still wet or damp (wet in wet, see page 107), or once the first layer is dry (wet on dry, see page 108). The gradual build up of paint helps to create texture, three-dimensional form, and depth of colour and tone, which cannot be achieved in the same way with just one layer.

Textured skin: The light shining on the orange highlights the pitted skin and irregular outline.

BUILDING TONE IN LAYERS

You can build up tone in layers by simply adding successive layers of the same dilution of paint. Building up tone gradually in this way allows you to go carefully and can stop you from painting an area of tone that is too extreme. This happens all the time and first dabs are always tentative.

Grey layers

To help with the idea of building up watercolour layers, try it out first with some patches on a piece of spare paper. Build up three tones of grey, from light to dark, with superimposed washes of dilute Payne's grey – a blue-grey that comes ready mixed.

Patches: First paint your pale grey on three patches across the page. Once dry add another layer of the same mix to patches 2 and 3. Allow to dry and add a third layer to patch 3. Your results will be as shown here.

PREPARATORY STUDY

Use this technique to explore the tonal range of the orange, from light to dark, building it up in layers. (See Step 3). The highlights will be the white of the paper; the first layer of paint will be the pale mid-tones; the second layer the dark mid-tones; the third layer the dark tones.

First aid

If you can see that the first dabs are too dark, don't panic. You can take them back by drying off your brush, then touch down onto the wet paint and the paint will come back up into the brush. If the layer is dry underneath, blot gently with a tissue.

1 Sketch the outline of the orange and then paint in the first layer of pale grey, leaving dots of white paper where the light catches the texture of the skin. The result resembles an orange but it needs to look more three-dimensional. Allow to dry.

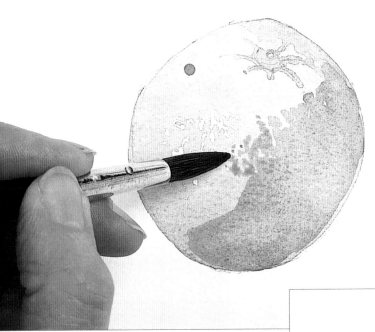

2 Build up the darker mid-tone areas with a second layer of the same grey mix, avoiding the pale areas where the light touches the orange. Do not forget the shadows at the top in the creases and on the stalk end. It will look dark but will dry paler. Make the edge between the greys uneven to hint at the texture.

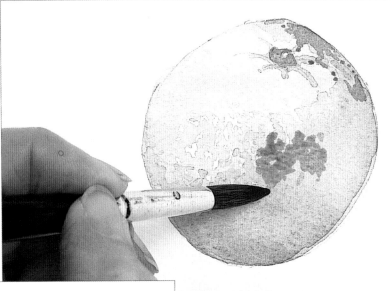

3 Finally, add another layer of tone in the area of the darkest shadow at the front and side of the orange and on the stalk end, stippling it on for a textured effect.

4 You can see how the tone and three-dimensional form has developed from the build up of layers.

PREPARING TO PAINT

In Step 1 exploring colour, see pages 102–109, we saw how colours can be mixed on the palette and by superimposed layers on the paper. Let us look at how a combination of these techniques work for this orange by trying out some colour combinations built up in layers.

Colour choice: Mix three tones of orange, from paler orange-yellow to darker red-orange – variations of quinacridone gold with phthalocyanine red.

Building up texture: Practise by stippling the three shades of orange onto a piece of paper, superimposing one layer upon another so that the colours shine through, building up the pitted texture of the skin.

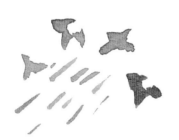

Delicate details: Use the very tip of the brush to paint in the characteristic stalk end using a mix of quinacridone gold with a minute touch of cobalt blue. Even with a big brush, delicate details are possible with the springy tip. With a small area, take off most of the paint on your brush, even dabbing it on a tissue, or you will swamp the area with wet paint.

Dropping paint into a wet area: One way of controlling the spread of a wash is to wet the area with a clean brush and water and then drop the colour in. The colour spreads out in an alarming manner covering only the area you have wetted. You can do this over dried layers of paint or around a finished painting (see Step 9 creating drama, see pages 152–157). Work with the paper flat. Allow the water to be absorbed by the paper before adding the blue colour and leave it to spread without disturbing it. It will dry as you can see here, flat but with a characteristic edge.

PAINTING THE ORANGE

Now pull together what you have learnt to paint the orange, built up in layers of watercolour. Start by drawing the orange as described in Step 2 preparatory drawing and sketching, see pages 110–115. Then mix enough of the three shades of orange for the painting.

1 Load your brush with the orange-yellow mix, and start with the highlight area, which is applied with a stippling stroke with the tip of the brush. This will suggest the texture of the orange. Then let the brush do the work, taking the paint around the curved edge of the orange, pressing gently into it so the hairs bend.

2 Carefully take the paint around over the rest of the orange in a smooth layer. When the orange is quite covered except for the stippled highlights, allow the paint to dry.

3 With the redder wash stipple on the paint in the shadow area. Work it into the folds of the skin around the stalk end at the top, and over the right-hand side of the orange, using the stippling motion that visually blends this layer into the first one. Allow to dry.

4 Add the even deeper glow of reddish orange that comes out in the shadow area with stippled touches of the transparent, more intense, redder mix, building up the tone. The tone in the shadow area is intensified through a build up of colour. Allow to dry.

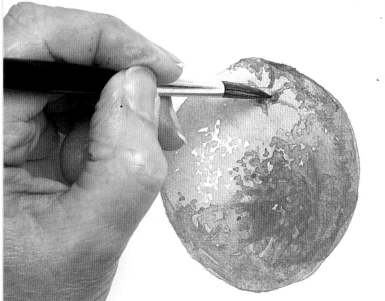

5 Now with the tip of the brush and a touch of the dry greenish mix, carefully fill in the stalk end.

6 Now once the orange is dry, complement it with a background wash. Lay the painting flat and wet the area around the orange with clean water applied with a clean brush. Once the water has been absorbed by the paper and no longer glistens, touch in the blue around the orange desisting from painting it in. It will spread dramatically without any help, finally drying to a smooth blue.

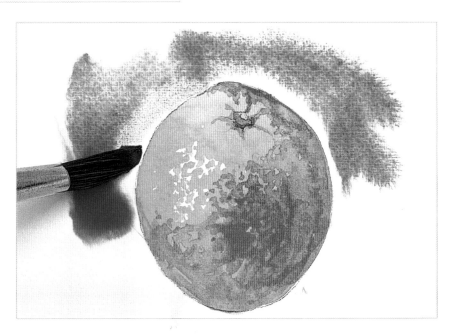

step 5 texture

focus: **pear**

Materials

Paper for sketching

Watercolour paper, 300 gsm/140 lb

HB clutch pencil

Round brushes, sizes 6 and 12

Flat hog-hair brush

Sponge

Tissue/kitchen paper

Watercolours:

- *Quinacridone gold*
- *Lemon yellow*
- *Phthalocyanine blue*
- *Dioxazine violet*
- *White gouache*

Mottled effects: Note how the mottled effects on the skin of the pear show up best in the mid-tones.

Painting in flat measured strokes can lead to some dull results. Here we look at some inventive techniques to create different textural effects, such as dry brush for mottled effects and spattering for patterns of light. The eye needs to be entertained as it travels around your painting and textural techniques help to inform and, at the same time, add variation to the brushstroke. In this simple painting of a pear, the aim, apart from celebrating its perfect shape, is to show off its attractive russet skin. It is an ideal vehicle for practising textural techniques.

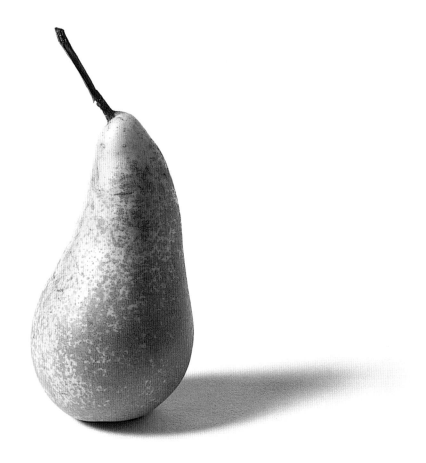

LAYERS OF TEXTURE

As you are probably beginning to realize, painting in watercolour is a juggling act. You are always doing a number of things at the same time. This also applies to building up layers of texture. As you build up texture, you are also building up tone, modelling form and mixing colour optically. Whatever one's intentions, it is hard to think of all these things at the same time. Luckily, most of them come together without too much effort.

Building up tone with texture

With successive layers of sponging and stippling, you are using the build up of texture to build up the tonal values in the same way as seen in Step 3 tone, see pages 116–121: first, a pale wash, second, a mid-tone wash, third, the darker shadows. A tonal sketch is useful to establish the distribution of light and shade on your pear before you start and will help you to decide where exactly you place the textural marks.

Modelling with textural marks

You will also be modelling your pear with the textural marks, building them up in the shadows and sponging and stippling more sparsely where the light falls.

Idea swatches: When you try out your ideas, make a series of patches, allowing them to dry, so that you can try out a number of ideas. Try adding sponge marks to a damp first layer so that the marks are less defined.

Mixing colour through broken techniques

As we saw on page 108, colour can be mixed optically by superimposing layers of paint and it is particularly effective when the second layer is broken in textural marks. With this pear, the colours are all within the same range, but the build up of textural marks creates the deep russet green.

Which technique?

In painting, there are always a number of ways of arriving at the same outcome. How you decide to create a certain effect will depend on the area that needs to be covered. A smaller area than this pear might have suggested dry brushing or stippling. You can always try out some ideas before you start.

You do need to be careful, however. What is important about this pear is that, although the texture of the skin is created with sponging and stippling, the crisp, hard outline is necessary to describe the nature of the pear and must be carefully preserved. If you allowed the texture to spread over the boundary of the pear, it would make it appear soft and woolly. Sponging the whole of the pear could be risky as you approach the edges, as a sponge is a little difficult to control. Combining it with a layer of stippling makes it possible to cover the area effectively, using the stippling close to the edge of the pear.

Don't panic!
If you do go over the edge of your pear, let the paint dry then very carefully, with a clean damp brush, work at the paint until it comes away. Blot with tissue.

Sponging: A small piece of natural sponge is ideal – it will be more expensive to start with but will last forever. Dip it into the paint and press down lightly, lifting off cleanly.

Stippling: Over a dry layer of quinacridone gold and phthalocyanine blue, try out the stippling stroke using the tip of the brush. If the paint is too wet, the stipple loses its identity.

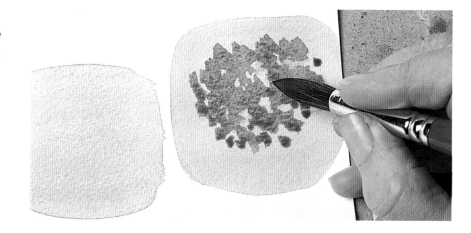

PREPARING TO PAINT

The glorious green-gold of the first layer is a mix of quinacridone gold and phthalocyanine blue. The sponging mix leans more towards the blue and has dioxazine violet added for the darker stippled layer. There has to be a contrast in tone between the layers or the technique will not work. For the stalk, add more violet. Start with the cool lemon yellow for the background and come down to warmer quinacridone gold. A glaze of violet works for the shadow.

Sponge

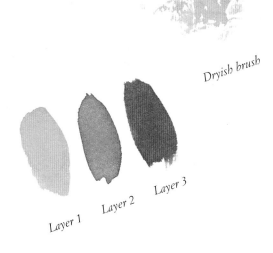

Dryish brush

Layer 1 Layer 2 Layer 3

More trials: Dry brush is an option too. Here we have tried out sponging, top left, and dry brush, top right, to compare them. The sponging suits the markings on the pear better. Opposite are the three intended layers, from the left: quinacridone gold with a touch of phthalocyanine blue (layer 1); with added blue (layer 2); with added dioxazine violet (layer 3).

PAINTING THE PEAR

The juggling act begins. Keep it simple and do not allow yourself to be sidetracked by too much detail. Note the direction of the light and the soft highlights down the side, which you will lift off at various stages.

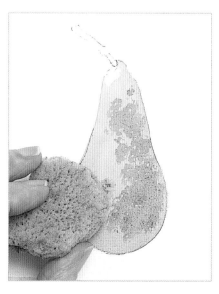

1 Start with a strong wash of quinacridone gold with a touch of phthalocyanine blue. Lay the wash on in as few clear strokes as possible. Do not worry if the wash looks a bit uneven; it will flatten out as it dries and it will have the textural marks superimposed on top.

2 Before the wash dries, lift off a soft-edged highlight from the top of the pear with a tissue. Work the tissue into the shape that you want – here a rather small delicate ellipse.

3 Allow the first wash to dry (or speed it up with a hairdryer) and then take a sponge and dip it into the same mix with a little more blue. Delicately sponge the pear making sure enough of the lighter first wash shows through.

Don't panic!

If your first wash is not strong enough, allow it to dry and add another over the top.

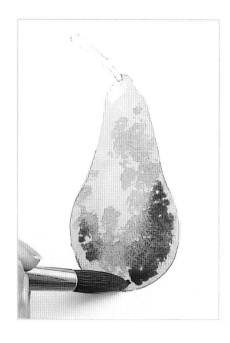

4 Allow to dry then, with a darker mix with violet added, stipple over the sponged area, building up the texture and tone. See how an area has been left paler near the bottom edge of the pear where you might expect the darkest shadow. This pale area is there in reality. It is important in describing the shape of the pear. Keep looking at your real pear or the photograph to see these variations in tone. The stippling adds to the interesting pattern of the pear skin.

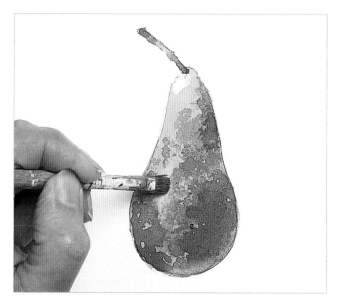

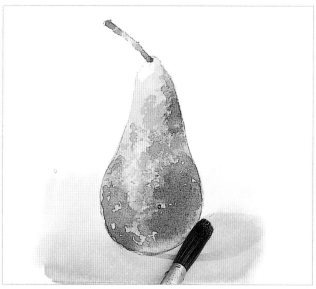

5 Lift off the highlight describing the curve of the rounded base of the pear with a coarse hog-hair brush. Make sure the brush is clean and dried off on a tissue. Go carefully, as you do not want the highlight too white; you only want to go down to the first wash. Paint in the stalk with a little more violet added to the green mix. Blot it with a tissue to make sure the colour is not too consistent. Allow to dry.

6 A yellow graduated wash goes in for the background (see page 152). Start with a dilute wash of cool lemon yellow, and add a stronger warmer mix of quinacridone gold as you go down the page. Once this wash is dry, add the shadow of the pear – a simple violet glaze (see page 108) over the yellow.

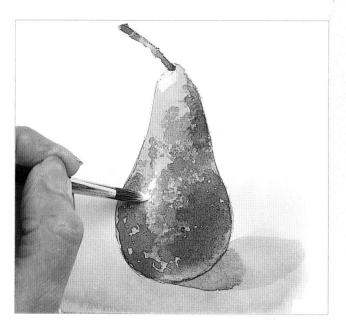

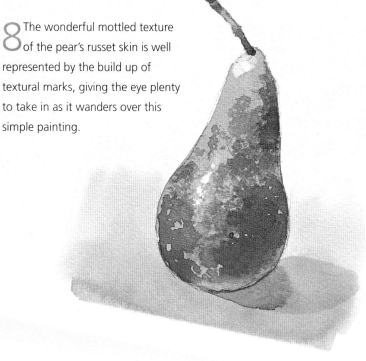

8 The wonderful mottled texture of the pear's russet skin is well represented by the build up of textural marks, giving the eye plenty to take in as it wanders over this simple painting.

7 Add a second violet wash wet on damp closer to the pear, slightly straying over into the pear to darken the edge. The artist decides that the highlight is not bright enough. A few touches of white gouache add the sparkle required. Smudge it with your finger if it looks too bright.

step 6 lost and found edges

focus: **bananas**

Materials

Paper for sketching

Watercolour paper, 300 gsm/140 lb

HB clutch pencil

Round brush, size 12

Flat hog-hair brush

Tissue/kitchen paper

Watercolours:

• *Lemon yellow*

• *Quinacridone gold*

• *Phthalocyanine blue*

• *Dioxazine violet*

In this step, you will be taking a huge leap towards emerging as a watercolour artist by considering lost and found edges. By edges, we mean where one thing ends and another begins: the boundary of an object. If you were to paint a solid, no-nonsense line around each banana in the painting it would look simplistic; this is not how nature behaves. Distortions of light, reflected colours, variations in the shape of the bananas mean that the edge comes into focus and disappears as it is seen against variations in colour and tone beyond. The artist therefore needs guile in setting about 'finding' and 'losing' edges. Success will give your painting subtlety and the look of experience.

Observing edges: In the photograph you can see that the pale edges are stark against the dark interstices and sometimes 'lost' where the tone and colour of the banana matches that of the background.

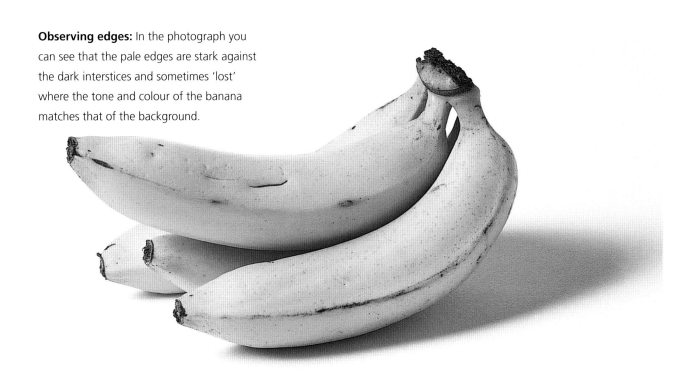

COLOUR CONTRASTS

Edges are easily made to stand out if there are contrasts of colour. This would be straightforward if one banana was yellow and the other blue but subtle differences in colour work just as well. You will see how the artist starts with a cool blue-yellow for the banana at the back and uses the warmer yellow for the front ones. This creates a sense of recession, but it also separates the bananas. You can employ this technique for one object of many, as for this bunch of bananas, or simply within the variations of a wash along an edge.

Tonal contrasts

You can find an edge by contrasts in tone: by placing a pale object against a darker one, or vice versa. If the banana is the positive shape and the colour beyond the negative shape, this can mean building up the negative shape by increasing the tone or colour there so that the edge of the positive shape stands out. You can see how the edge of the banana is found in Step 8 of the painting on page 138.

Just as you can build up the tone in the negative shape, you can also reduce the tone and increase the contrast in the positive shape by taking back the paint and making it lighter along the edge. You can foresee this and leave a lighter area as you apply your washes or you can lift off with a damp brush or tissue as in Step 6 of the painting on page 137.

Shadows

Shadows give you a good excuse to provide contrast and bring out an edge. Not only cast shadows as you can see in Step 9 on page 138, but also in shadows that describe the form. The middle banana is given a shaded edge where it curves away across the top and, coincidentally and conveniently, where it is seen against the white background. The yellow edge of the banana might otherwise be lost. The convenient markings of the banana along the edges also help here.

This area of dark and light is balanced with a similar area at the other end of the bunch, where a chink of light seen through the stalks is contrasted with shadows built up on the bananas.

Slither of light

An artful trick is to 'find' an edge with a slither of light. This is where a suggestion of a highlight along an edge describes it graphically as with a white line. This needs to be subtle and indeed, in the finished painting on page 138, it is so subtle that you could easily miss it. Nevertheless, it is essential to the eventual success of the painting. Even in the first wash, halfway along the top of the foreground banana, a slither of white paper is left unpainted. This is intentional and you can see that this slither of light is preserved through further washes. Then when the darker markings on the banana are added, you may think it has been painted out but it is still there, subtly highlighting the edge of the foreground banana. Such a slither of light can be added at the end by scratching out with a blade (see page 145).

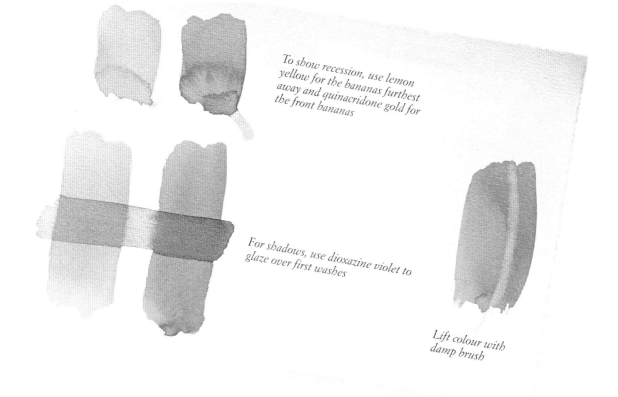

To show recession, use lemon yellow for the bananas furthest away and quinacridone gold for the front bananas

For shadows, use dioxazine violet to glaze over first washes

Lift colour with damp brush

PREPARING TO PAINT

You will need a warm and cool yellow for the initial washes. Look hard to see the variations in colour; it will greatly add to the liveliness of your painting. The pale green tips of the bananas will come from the addition of a touch of phthalocyanine blue to the lemon yellow. The lovely shadow glaze is pure, rich, transparent dioxazine violet and the darker markings and shadow are violet and yellow, too. Keep the wash leaning well towards the violet as it is going in over the yellow.

Shadow glazes

The shadows on the bananas will be glazed on with pale transparent dioxazine violet. Shadows made with the complementary colour always work best (here yellow and violet). Allow the first washes to dry before applying the shadow glaze. Make sure you apply it cleanly as, if you dab rather than wash the colour lightly over the area, you will disturb the wash below.

Lifting off thin highlight: We have lifted off before (see page 133), but with the thin clearer-edged highlight along the edge of the banana, you will need to allow the wash to dry first. Then with a flat hog-hair brush, clean and dried to dampness on a tissue, work your way along gently lifting the paint and dabbing it off with a tissue.

PAINTING THE BANANAS

Bananas are fun to draw because their form is expressed in clear-cut shapes. Take special care over the ends of the bananas as close observation is the key to painting convincingly and successfully.

1 Start with a cool wash of Lemon Yellow over the two background bananas, add quinacridone gold for the foreground one.

2 Be careful to paint within the pencil outlines and leave the slither of light between the foremost and middle-ground bananas. Note the tiny keyhole of light (white paper) near the joined ends of the bananas. Small details like this are important.

3 The tips of the bananas have a greenish lowlight to them. Add this once the initial wash has dried slightly, but is still damp so that the two colours blend. Take the green onto the joined ends. Keep looking at the bananas to see where the colour should go. Do not rely on your memory. Allow to dry.

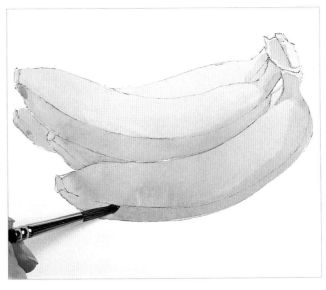

4 Test with your finger to make sure the paint is quite dry, then take a glaze of violet over the yellow in the shadow areas, starting with the stalk ends and coming down over the lower side of the middle banana. This helps to bring out the faceted shape of the banana, describing the edge dividing the banana lengthways. Be careful to conserve the slither of light between the bananas.

5 Apply the same glaze over the foreground banana. Note the angled shadow near the joined end. It is very clear on the photograph.

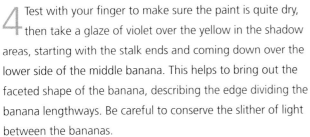

6 Look at the edges and make some adjustments. First, 'find' the top edge of the middle banana by subtly shading up against it with violet to contrast it with the white background. Next, the foreground banana needs some contrast along the internal edge. Lift off a gentle highlight with a wet brush. Blot with a tissue and allow to dry.

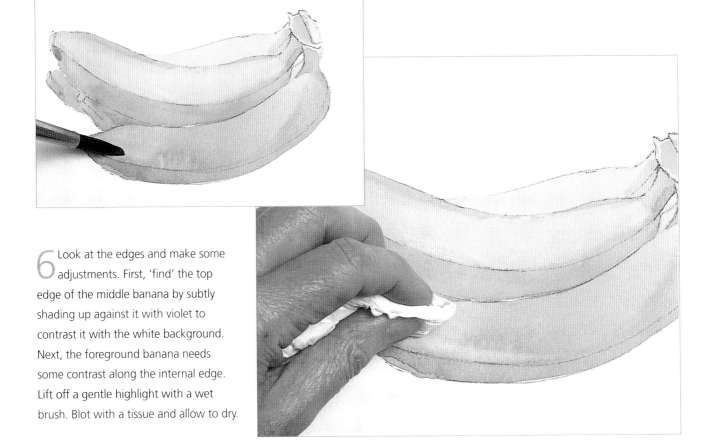

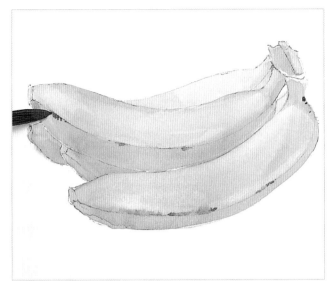

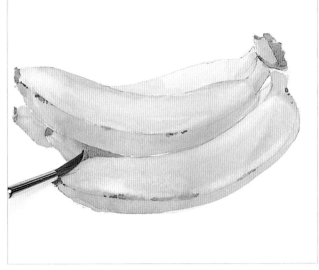

7 Finding the edges of a banana is easy because of their darkened markings. Again, look carefully, and try to imitate the irregularity of these markings. Use the very tip of your brush with dryish paint. Follow the pencil line but do not reinforce it; just add an uneven blot here and there along the line. Blot with a tissue or lift off with a clean brush if the paint looks too solid.

8 With a further violet wash, build up the tone in the space between the bananas to bring out the edges. The darks here are balanced with touches of the violet on the banana ends.

9 The shadow cast by the bananas on the white surface is painted with a violet glaze. Add the yellow-brown mix wet in wet where the shadow is darkest underneath to anchor it to the surface plane.

10 In the finished painting, you can see how the artist has gone on to make minute adjustments to make it work better: a touch here and there to balance or contrast. Run your eye along the edges and see how they have been contrived to be lost and found, coming in and out of focus – light against dark, dark against light, with patches between where the connecting edge disappears altogether. This keeps the eye moving across the painting, keeping it interested.

step 7 energy and light

focus: **jug**

Materials

Paper for sketching
Watercolour paper, 300 gsm/140 lb
HB clutch pencil
Round brush, size 12
Clean brush
Tissue/kitchen paper
Watercolours:

- *Lemon yellow*
- *Quinacridone gold*
- *Phthalocyanine red*
- *Dioxazine violet*
- *Phthalocyanine blue*

In photographs, subtle colours and tones are often simplified and sometimes lost; the artist's job is to put these colours back and bring in energy and light. Look carefully at any piece of white ceramic, preferably in daylight, and you will see how it picks up the delicate colour cast of the light itself and reflects the colour of surrounding objects. Like your piece of ceramic, this jug is hardly 'white' and can be described with colour rather than drab monotones. This phenomenon does not restrict itself to white ceramics; it applies to all painting.

Subtle colours and tones: Look carefully and you can see the colours in this seemingly monochrome photograph. Look, too, at the range of delicate tones.

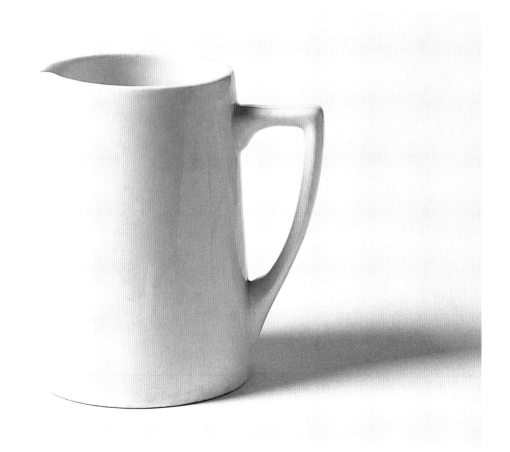

COLOUR OF LIGHT

You first have to imagine where your jug is standing. Is it in the warm golden light of a summer's day or the cool blue/yellow light of winter? Perhaps it is sitting on the window sill bathed in the warm pink glow of the evening sun or standing pale in a darkened room, lit by flickering firelight. You can decide. All these lights have a different colour cast and will influence your first washes of colour.

Energy from colour

Complementary colours (see page 105), when used in conjunction, will energize your painting. These colours do not have to be starkly placed next to each other; there are much more subtle ways of introducing them into your painting. If you start with the cast of the light, the shadows can be complementary; a yellow light will have a complementary violet shadow. For this jug, the theme continues with some play between the orange-yellow of the shadows and the cool blue background.

Reflective surfaces

The white jug is shiny and reflective. First of all this means the colour of the prevailing light will bathe it. It also means that surrounding colours will reflect off it. You can see in the photograph how the white of the table reflects off the side of the jug, creating a paler stripe of tone, breaking up the area of shadow down the right-hand side. If the jug had been sitting on a red cloth then this would be reflected in the jug. A blue sky can be seen in reflective surfaces in the countryside, in the highlights on reflective leaves, and in stretches of water.

Strong light will produce hard-edged highlights and shadows on hard shiny surfaces. Highlights and shadows will be softer-edged if the light is weaker.

Scraping back: Lost highlights can be reinstated by scraping back to the white paper with a sharp pointed scalpel. Take it gently, though you will find you need to be quite firm to have any effect. Try hard not to destroy the surface of the paper – something which is easier said than done!

Lifting out with a tissue: This produces a soft edge and can create subtle shapes by working the tissue.

PREPARING TO PAINT

The cast of the light has been chosen as a cool lemon yellow with some phthalocyanine red added in the shadows. Layers of transparent glazes (dioxazine violet and phthalocyanine blue) build up the shadow gradually and then a cool blue background makes a pretty contrast and throws up the outline of the white jug.

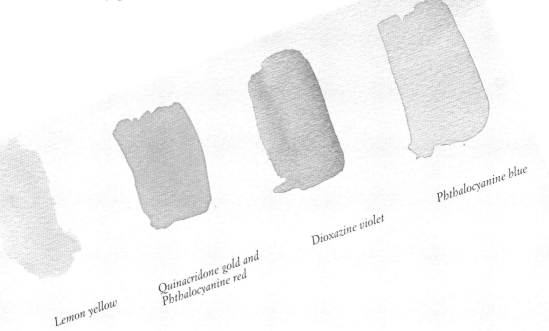

Lemon yellow

Quinacridone gold and Phthalocyanine red

Dioxazine violet

Phthalocyanine blue

Colour trials: Trying out the colours on the paper you are going to use is helpful as paper shades vary from bright white to tones of cream and can qualify pale watercolour washes.

PAINTING THE JUG

The first yellow washes represent the warm cast of the light. These washes vary from cool blue-yellow to a warmer orange-yellow, helping to model the shape of the jug. Adding the transparent violet and blue glazes deepens the contrasts so that multitudes of subtle mid-tones develop from the variations in the yellows beneath. Look carefully before you start: the light is coming from the left, creating a soft-edged highlight down the smooth reflective surface of the jug. However, there is also reflected light from the white surface on which the jug stands, which explains the lighter area down the right side.

1 Use a cool lemon yellow for your first dilute yellow wash. Leave the white of the paper clean for the highlights that appear inside the jug, along the top rim and on the handle.

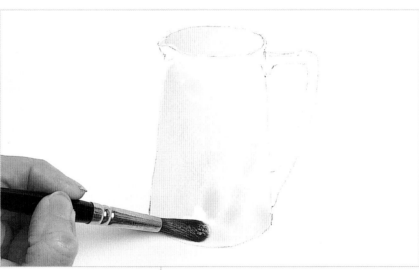

2 For the eye to believe it is a white jug, it needs to be predominantly white. Adjust the highlight down the front, lifting off the paint with a tissue. Allow to dry.

3 The second wash is a warm yellow – quinacridone gold with a touch of phthalocyanine red. Apply it over the area of darker shadow on the right, inside the jug, and also where the handle meets the main body of the jug. Note, on the far right, the band of reflected light is left uncovered.

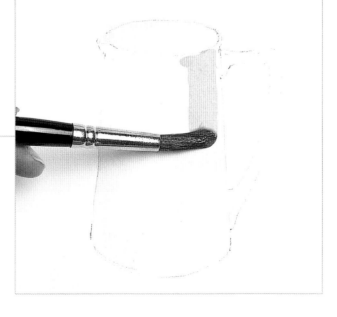

4 The jug is hard and shiny but it is a soft light, so soften the edges of the highlight. Run a clean brush, first dried out on a tissue, down the edge. Take off paint with the side of the brush held at a low angle. Allow to dry.

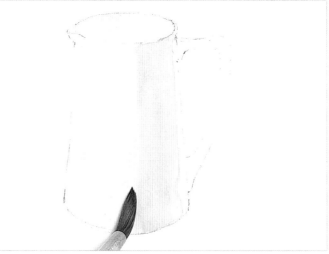

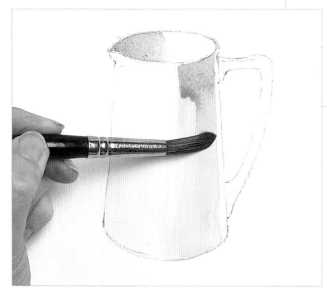

5 Build up the shadows with a glaze of complementary violet over the dry yellow washes, inside the jug first and then down the side. Do not entirely cover the yellow; allow the edges to show. This allows you to see the constituent complementary colours.

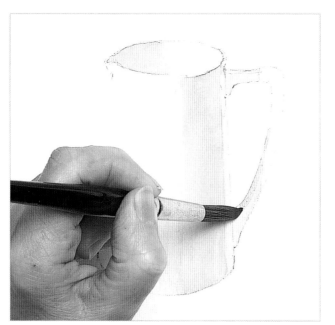

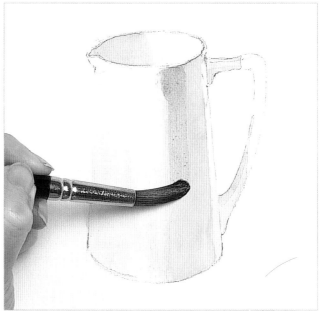

6 Use the very tip of the brush for the delicate shape of the handle. Look back at the jug (or photograph) to check you have the shape of the shadow correctly painted. Adjust with tissue or you can use a brush.

7 Build up the darkest areas of shadow with a further glaze, this time of Phthalocyanine Blue – inside the jug, down the centre at the right side and on the handle. Try to distribute these dark tones around the jug for some tonal balance. If you are uncertain about how dark to go, take it slowly in two or more layers, but allow each one to dry before adding another.

8 The shape of the jug is defined by the background wash of Phthalocyanine Blue; the positive shape (of the jug) comes from the negative shape (of the background). When the jug is dry, add the cool background blue, which links visually with the complementary orange-yellow of the shadows on the jug. You do not want this wash too wet on your brush or it will be difficult to control. Paint it carefully, making sure you paint around the highlights on the rim and down the right-hand side of the body of the jug.

9 Concentrate on the edges again. 'Find' the edge between the handle and the body of the jug by increasing the tone on the handle with more violet.

10 The highlights on the rim have become blurred with paint. They need to be sharp-edged and bright to put across the reflective nature of the hard ceramic glaze. Do this by scratching out with a scalpel. The brightest highlights will be where the light strikes the jug.

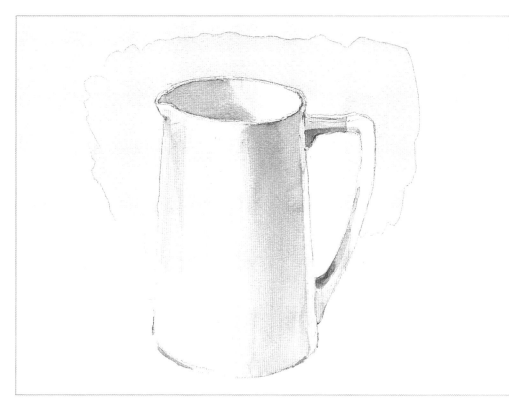

11 You can feel the warm summer sun on this jug; quite a different jug to the one in the photograph. This one exudes energy and light, which come from the use of complementary colours and the use of pure transparent washes.

step 8 editing information

focus: **cloth**

Materials

Paper for sketching
Watercolour paper, 300 gsm/140 lb
HB clutch pencil
Round brush, size 12
Clean brush
Small sponge
Tissue/kitchen paper
Watercolours:
- *Quinacridone gold*
- *Phthalocyanine blue*
- *Dioxazine violet*

A simple white cloth, laid out on a table should be just that: simple. Watercolour painting is about giving clues. You do not have to paint every little detail, in this case every crease, every shadow; in fact, as you will see, you do not have to paint the whole cloth. It will be a better picture if you edit out information that is not absolutely essential. First, the artist must decide on a focus for the painted sketch, then how to put across the nature of the cloth – the material, the folds – in as simple a manner as possible. The tonal range, the modelling and the colour of the cloth will be manipulated and simplified. This editing process is something that, in due course, will become second nature.

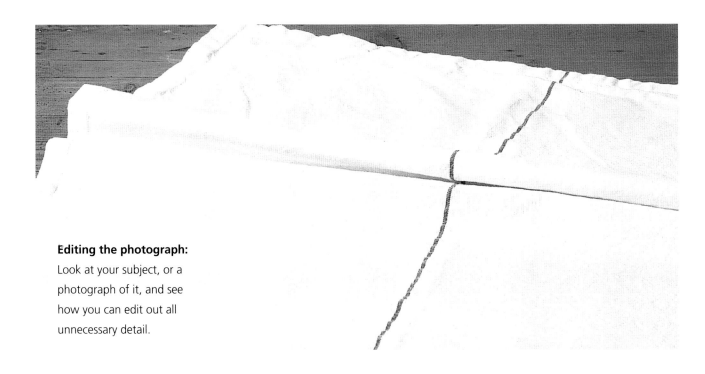

Editing the photograph:
Look at your subject, or a photograph of it, and see how you can edit out all unnecessary detail.

SELECTING AREAS OF FOCUS

You will notice how the artist has started by simplifying and also manipulating the information available – the actual shape of the cloth is slightly changed to make a better picture. The artist has looked at the cloth and decided on the most interesting aspect of it: where the two folds meet at the edge forms an unusual shape so this becomes the focus of this simple painted sketch. As these two folds are the focus of the piece, they are exaggerated and given more of a central role. This gives the cloth some shape and gives you something to work on. The vast area of creased cloth in the foreground is edited out. Other details, such as creases and the sewn hem along the edge, are also ignored.

In the still life in Step 10 composition, see pages 158–173, you will notice that the folds have been further arranged to fit in with the composition. The horizontal folds lead the eye into the painting from the left, as does the blue line in the cloth from the front. Again, the cloth and its folds have been manipulated to make the most of them and any information that is not essential to the composition has been edited out.

Simplifying tonal values

The artist is aware that in the still life the cloth will be playing a secondary role. Working up the contrasts would draw attention away from the true focus of the painting. A weaker light will reduce the extremes of contrasts and make the highlights and shadows paler and soft-edged, allowing the cloth to remain in the background.

Simplifying colour

As with the jug (see Step 7 energy and light, see pages 140–145), the shape of the cloth, particularly the interesting outside edge, is described and given prominence by the addition of the startling background colour. A strong golden yellow is chosen for this, taking its cue from the wooden table on which the cloth is laid but making the yellow more vibrant and removing any detail that indicates that it is a wooden table. The cloth is white so will therefore take on the colour cast of the light. A cool blue is chosen for the shadows, as if reflecting the sky.

Simplifying the modelling

The shape of the folds is described by the edge of the cloth, exaggerated by the background yellow, and also by the blue line in the material, which is therefore given prominence. This means that the shadows on the folds are kept as simple as possible, only giving enough information to make sense of their shape.

PREPARING TO PAINT

The shadow glaze is a mixture of the blue with a touch of violet to neutralize it. These shadows will model the folds in the cloth. To describe the edge of the cloth, use Quinacridone Gold for the strong yellow of the wooden table. For the stripe down the cloth, use a stronger version of the shadow mix.

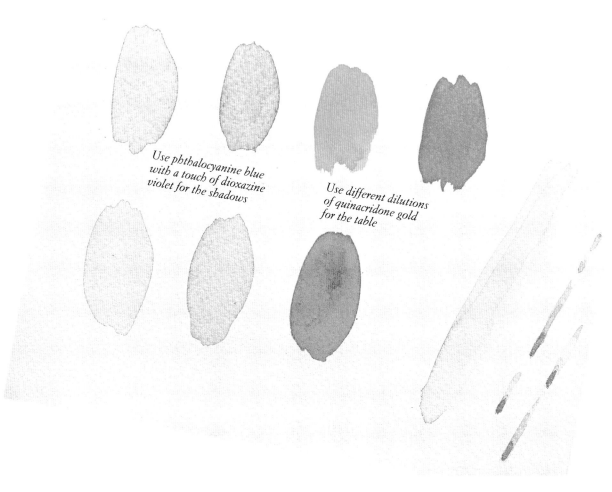

Use phthalocyanine blue with a touch of dioxazine violet for the shadows

Use different dilutions of quinacridone gold for the table

Lifting off with a tissue: The blue line in the cloth will look more natural if it is not painted as a solid stroke. As it is transparent violet, it will be qualified by the shadow colours underneath, which will vary the tone. You can further break it up by lifting off paint with a screwed up tissue. Take care to turn the tissue before you dab again or you will end up adding paint where it is not wanted.

PAINTING THE CLOTH

For this project, the drawing is important and the pencil lines play a part in the final painting. This does not mean that they have to be any darker than usual, but you will be aware of them, if only subconsciously, in the final painting.

1 First, wash in the cool, neutral, glazed shadows. While still wet, soften the edges by running along them with a clean, slightly damp brush.

2 The next band of shadow, filled in on the flat cloth beyond, acts as a negative shape, defining the crisp positive highlighted edge of the main fold.

3 Make the shadow on the foreground fold slightly darker because it is closer, and with a hard top edge and softened bottom edge.

4 Soften the hard edge along the top of the front fold in places with a clean, damp sponge to vary the focus.

5 Once quite dry, add the high-strength background yellow, paler in the background and stronger in the foreground, bringing out the edge of the cloth. Tip the board the other way so that the high-strength colour travels and merges with the more dilute colour at the top. If you allow more dilute wash to drip down into the higher strength one, 'cauliflowers' will form – hard-edged, foliage-shaped patterns that will disturb the even wash.

6 Add the blue line on the cloth. Start at the back, with the colour more dilute to suggest distance into the picture space. As you come forward, make it darker and slightly wider.

7 You do not want the line to look too consistent so blot with a tissue at intervals. As it is a transparent glaze, it will vary in tone according to the shadow washes beneath but you may need to intensify the colour over the shadow parts to make this clearer.

8 With the very basic information provided, the eye can read this painted sketch as a piece of cloth with folds. By simplifying the information, there is no confusion and it is clear what the artist is painting.

step 9 creating drama

focus: **background**

Materials

Paper for sketching

Watercolour paper, 300 gsm/140 lb

HB clutch pencil

Round brush, size 12

Clean brush

Sponge

Tissue/kitchen paper

Watercolours:

- *Quinacridone gold*
- *Phthalocyanine red*
- *Phthalocyanine blue*
- *Dioxazine violet*

Adding a background colour can enhance your painting. It can help to describe the object as a negative shape as with the jug (see Step 7 energy and light, pages 140–145) and cloth (see Step 8 editing information, pages 146–151), or thrust an object forward emphasizing the three-dimensional as with the orange (see Step 4 watercolour layers, pages 122–127). For the pear (see Step 5 texture, pages 128–133), the background represents the surface on which it stands and its shadow falls, setting the pear in its three-dimensional space. A background can also set the painting's mood, through colours and dramatic techniques.

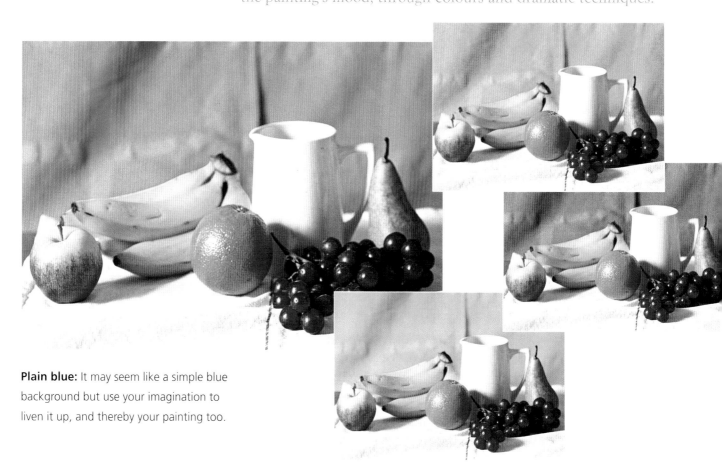

Plain blue: It may seem like a simple blue background but use your imagination to liven it up, and thereby your painting too.

MOOD

Colour and texture in the background can set the scene for your painting, whether it is for a surreal dreamscape or a down-to-earth flower arrangement. With colour, suggestions of summer warmth will come from sunny yellows and similar warm colours and the resulting sensation will be light-hearted. Cool blues and deep violets will inspire icy temperatures and dark thoughts. Moving into the realms of psychology, you can use your imagination to put across an idea – misty washes for calm; strident flashes for chaos. The options are infinite.

Movement

Background colours do not have to be flat and static; they can be built up in layers, using complementary colours to produce dark browns and coloured greys, allowing the colours to mingle unevenly to produce some movement. If you superimpose violet over yellow, touches of the pure constituent colours can be left to catch the eye and give the background area some movement and life. Movement can also come from explosive mixes of paint as in the demonstration, pages 155–157.

Focus

The background can play a part in creating a focus, particularly by building up contrasts around the focal point. In the still life (see Step 10 composition, see pages 158–173), the focus is the jug. The background here is deepest in tone, contrasting with the bright highlights of the white jug, and drawing the eye to these depths of tonal value.

Drama

A sense of the dramatic, incorporating movement and energy, can be put across with colour and with explosive techniques. This was the aim with the demonstration below. You can see how the outcome is difficult to predict and for the still-life painting (see Step 10 composition, see pages 158–173) the more fail-safe method of superimposing layers wet on dry was chosen because it is easier to control. Many other techniques can give an exciting background. Use your imagination and see what happens.

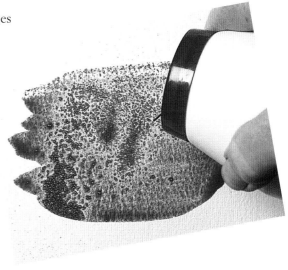

Salt: For a mottled effect that is less fabricated than a stippled surface you can use salt. Once you have laid down a wash, sprinkle salt over the area. The salt will only affect the wet area, so as long as the rest of your painting is properly dry you can restrict this salting to the background area. Rock salt and ordinary table salt will produce different effects. Allow to dry before wiping off the salt crystals.

Wax resist: Gently rub the stub of an ordinary white candle over the surface of the paper. The roughness of the paper breaks up the candle 'stroke'. Once you paint over the top, you can see where you put the candle because the waxed area repels the paint. This effect is most dramatic when the wax conserves the white paper but it can also be interesting to conserve an initial dried wash.

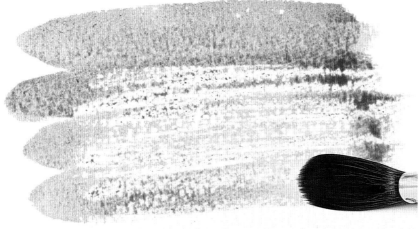

PREPARING TO PAINT

The first warm yellow wash is quinacridone gold with a touch of phthalocyanine red to further warm it up. The purplish-blue is phthalocyanine blue and dioxazine violet; a more dilute mix for the first application, followed by a stronger mix. Make sure the gold spatter mix is not too dilute or it will disappear into the blue wash.

PAINTING THE BACKGROUND

Your aim is to produce a dramatic background and, indeed, the process is a small drama in itself. Be brave! Have everything ready before you start, as you will need to move fast. Make sure you have plenty of paint ready-mixed as you will not have time to stop and remix. The plan is to wet the area with a sponge and brush, wash in the first yellow colour on the left, then quickly mop in dark purplish blue on the right to merge with yellow at the edges. Add a stronger mix of the same wet in wet. Finally spatter in a strong mix of quinacridone gold.

1 To give you something to paint around, draw a rough outline of the still life we will be painting in Step 10 composition (see page 162). Wet the broad area of the background with a sponge, using a brush with water for the more intricate parts around the still life (see detail).

2 Allow the water to sink in but do not let it dry out. Touch in the warm yellow on the left, allowing it to spread.

3 Quickly mop in the dark purplish blue, encouraging it to blend with the yellow. Tip the board to take the colour where you want it to go.

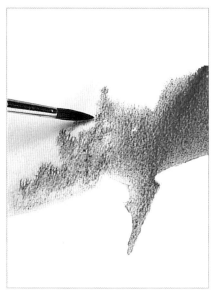

4 The blue is not spreading enough into the yellow so the artist takes more blue over to the yellow with the very tip of the brush and a spidery stroke.

5 If the paint dribbles or collects along the edge, take it away with a squeezed out brush.

6 Keep going! To increase the depth of tone around the top of the jug, add a still stronger purplish-blue mix wet in wet. Try not to disturb the wash below; drop the paint off the tip of the brush. Tip the board again to control the spread of colour.

7 One final addition: a spatter of quinacridone gold at intervals across the background area is another way of building up texture and tone at the same time. Your gold mix should not be too dilute. Load your brush and then tap it down on another (clean, dry) brush – gently, or you will cover a wide area with droplets of paint. Continue to tip the board to control the blending of the colours until the paint has settled. Do not be tempted to touch it with a brush. Let it dry and see what happens.

8 The result, when dry, is certainly dramatic. There is a sense of movement and light behind the jug.

step 10 composition

focus: **still life**

Materials

Paper for sketching
Watercolour paper, 300 gsm/140 lb
Masking fluid
HB clutch pencil
Round brush, size 12
Old brush to apply masking fluid
Tissue/kitchen paper
Atomizer
Watercolours:

• *Phthalocyanine red*
• *Alizarin crimson*
• *Quinacridone gold*
• *Lemon yellow*
• *Ultramarine blue*
• *Phthalocyanine blue*
• *Dioxazine violet*

You are now ready to paint the still life. First, however, you must consider the options for the composition, bringing together the various parts of the still life and considering some ideas on how to decide on the final arrangement. You will want the result to be pleasing and yet challenging. Your composition will need rhythm and movement even though it is a still life. In the course of trying various options, you will consider how the elements – the fruit, jug and cloth – link with each other. You will see how you can control the way the viewer looks at your composition by leading the eye along pathways of light and colour. You will be considering the light; the direction it is coming from as well as the strength. Finally, you will look at cropping the arrangement to enhance the elements in the picture and to concentrate the natural energy of the composition.

Natural harmony: You can move the elements of your still life around until they feel right – then you can work out why there is a natural harmony.

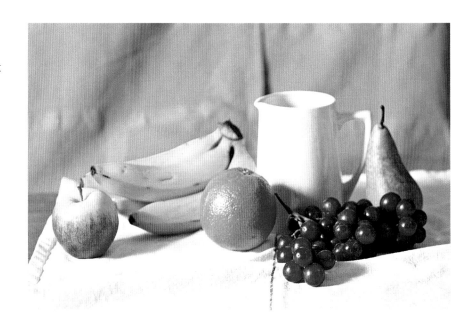

ARRANGING THE ELEMENTS

There are so many ways you could arrange these five pieces of fruit, the jug and cloth. What you are looking for is an arrangement where each element is seen to its best effect and yet is linked with the other parts, so that they all work together in a perfect whole.

Directional lines

The individual pieces can be linked by directional lines, that is lines that are already there in the composition – such as along the edge of the cloth, or the curve of the banana. Such lines can also be created by folds in the cloth or shadows, and indeed can be introduced in the painting process by directional brushwork. It is a good idea to link these directional lines in a circle so that the eye travels around the painting, lingering for a while.

Example 1: With this first arrangement, the eye travels in from the left, nicely picking up the edge of the cloth. It then smacks into the horizontal upright of the jug. Once beyond this, the fruit has either lost its identity, like the bananas and grapes, or is arranged stiffly in a row. The eye hops unhappily from one item to another. It then finds the stark edge of the cloth on the right and gratefully makes its escape.

Example 2: As before, the eye picks up the edge of the cloth, travels into the orange and down the top edge of the banana to the grapes. Now it picks up the stalk of the grapes leading on to the pear, up to the apple, along the edge of the cloth again to the jug. Without realizing it, the eye has passed through all the various elements. The arrangement however, is not quite right. It does not hold together and the wonderful shape of the pear is lost.

Example 3: Here, the structure behind the idea is more geometrical, looking at the lines made by the edge of the table, the cloth and the diagonal made by the arrangement of fruit with the jug standing at the end with its back to us. It would be worth exploring this idea.

Example 4: This arrangement looks more natural. The fruit sits in interesting positions and is visually linked even though each element retains its individuality. The arrangement has a symmetry and balance and yet the dominating jug is not in the middle. The eye is taken in from the left as well as from the front along the blue line in the cloth.

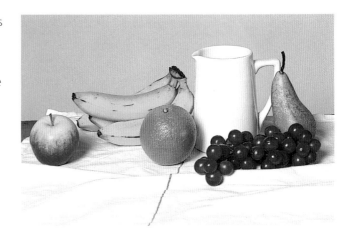

Viewpoint

You can make a dramatic change in your still life by altering your viewpoint. It need not be too extreme to make a difference.

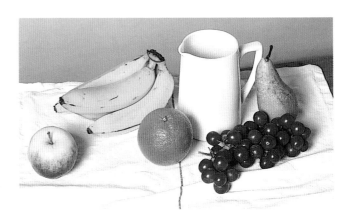

Example 1: Seen from above, the height of the jug is lost, as is the interesting shape of the bananas. The arrangement loses its energy and appears to fall apart.

Example 2: Try looking at an arrangement obliquely from the side. This can often open up some unexpected shapes and conjunctions. Moving slightly to the right side isolates the apple in an interesting way and the angles on the cloth edge and blue line are good.

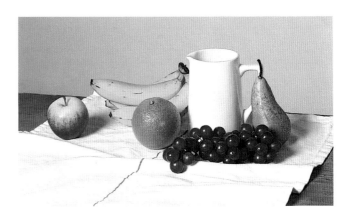

Example 3: An oblique view from another angle completely changes the arrangement. The outline of the pear lounging against the jug is particularly interesting. This is a viable option.

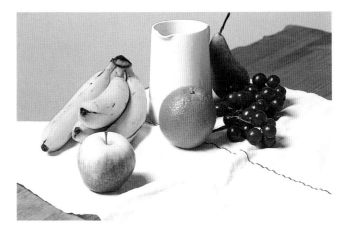

Manipulating the light

Changing the angle and the strength of the light will also change your composition. The angle of the light will affect the shadows which are useful in linking the various elements. Altering the strength affects the balance and mood of your painting.

Example: The light is bright here and raking in at an angle from the left. It casts good shadows that help to link the fruit. It also has the effect of increasing the depth of the painting. Compare it with Example 4 at the top of page 160, where the light is coming from behind the viewer. The arrangement looks flatter and without shadows the elements are more isolated. Bright light has the effect of exaggerating light and dark, cutting out the range of mid-tones.

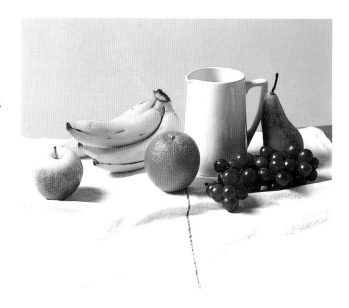

Cropping

Cropping into your frame to focus on a certain part of your composition can dramatize the subject in an interesting way, concentrating the energy in a smaller space. Make a small frame with some white paper and try cropping some of the other arrangements to see how this can transform a rejected composition.

Example: You will find that by cutting an element of the composition with the frame, as here with the apple and grapes, it pins them in the foreground and pushes the rest of the composition back.

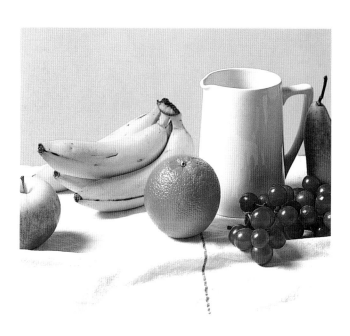

PREPARATORY WORK

Having decided on the composition of the still life, there is some further preparatory work to be done. First, sketch the composition to produce a simple outline to be used as the under-drawing. Next, you will need to make a sketch to look at the distribution of tone so that it can be manipulated to make the best of the composition.

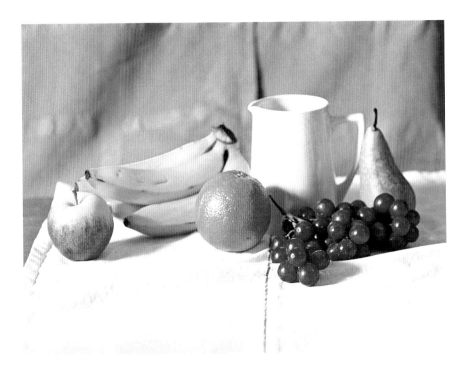

Under-drawing

While preparing the under-drawing the artist makes final decisions about cropping and, even at this stage, makes some adjustments to the arrangement chosen for the still life. These small changes are made to help the picture work, encouraging the viewer to look at the painting from all angles.

The elements of the still life are slightly adjusted: the bananas are separated from the jug, creating a visual break at this point so that the eye travels down to the orange and around the other elements in a circle back to the jug. There are extra grapes to make more of this element and the pear is given more body so that it gains visual weight.

Also important for the composition is the manipulation of the cloth: the folds are exaggerated, a second blue line has been added for extra emphasis and the lines, which provide another pathway into the composition, are taken in at a more interesting angle. The corner of the cloth visible behind the apple is edited out because it interferes with the purity of the apple's outline and is distracting.

Once you are happy with the drawing, transfer it to the paper you will use for the painting (see page 111).

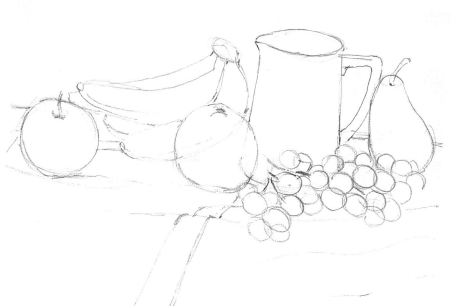

Tonal sketch

For this sketch, you are looking at how the light and shade models the different parts of the still life. First, shade in the mid-tones, leaving the lit areas as the white of the paper. Add the darkest areas of shadow last. The harsh light shining down at an angle from the left casts interesting shadows. This means that the highlights will uniformly be on the left and the shadows will fall on the right. The pear is in the shadow of the jug but will still have a lighter and darker side according to the light source.

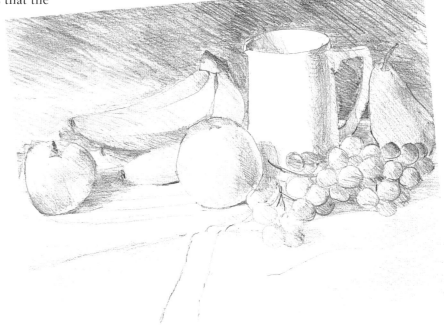

Subtle adjustments

Having established the reality of the light and shade as it appears in the photograph, you can now alter it subtly to make sense of your painting. Note how the artist has increased the tone above the jug so that this becomes the area of highest contrast – the dark background balancing the white highlights on the jug. This acts as a focus, drawing the eye into the composition. The shadows between the elements of the composition are edited to emphasize them as links between the apple and the bananas, and the orange and the jug.

Little points of extreme dark tone are added. If you look at the photograph of the still life at the top of page 162, you will see that these exist: the stalks of the apple and grapes; the ends of the bananas; where the apple, bananas and orange meet with their shadows on the cloth; and the interstices of the bananas. The artist has then gone on to add the tiny triangular gap between the pear and the handle of the jug and the tops of the grapes against the pear. This galvanizes this area, which otherwise becomes too neutral in tone.

PREPARING TO PAINT

Before we start painting, it is worth looking at the slightly different approach necessary for this larger painting with its varied collection of fruit. If you paint each piece of fruit individually, the painting will not have harmony: it will not hang together. It has to be approached as a whole, starting as you did with the smaller studies, with general overall washes and working up to more detailed treatment but this time over the whole composition of fruit.

PAINTING THE STILL LIFE

You are now ready to paint. Every part of the painting has been carefully studied and practised. The first brushstroke can be daunting, but you will be starting with general washes to set the tone. As you have practised this in a number of the study paintings, it will not be a problem. We will work in five stages: the first three stages concentrate on building up colour, tone and structure, the fourth stage deals with giving the painting its three-dimensional effect, and the final stage is for fine tuning.

Stage 1: colour

1 The work area is set up. The paper with the under-drawing is fixed to the board with masking tape. In front of the artist is the actual still life. Place the tonal sketch and other references such as colour photographs of the still life and various details photographed when working through ideas for the composition at the top of the board. Mix strong versions of the selected colours in plastic pots. Lay out the colours on a sheet of watercolour paper laid out on the table next to the pots of colour.

2 After setting up, the first step is to mask off fiddly areas of highlight that will be difficult to paint around when the first washes go on. Paint masking fluid onto the handle and rim of the jug and the highlight at the base of the pear stalk, then mask a few stippled highlights on the orange with the tip of the brush, as well as the point of highlight on each grape and the stalks. Allow the masking fluid to dry thoroughly before you add any paint.

3 The general washes are now applied. These next steps need to take place quickly so have paints and water near to hand. Use an atomizer to spray the paper with clean water. This wets the paper quickly and evenly.

4 Wash cool lemon yellow over the yellow fruit, and the reflected colour on the jug. It will spread beyond the fruit into the background. That is fine.

5 Before the yellow wash dries, add warmer quinacridone gold in the background above the jug, into the mouth of the jug and down the shadow side, the base of the pear and the grapes. As the paint goes on, it looks rather alarming. Do not worry. It will even out and dry paler.

6 Any stray dribbles of paint can be lifted off with a tissue. Here the small but important points of light, seen through the handle of the jug, are wiped clean of paint. You can see the quinacridone gold has been taken down to the white cloth to suggest the warmth of the light.

7 While the surface is still wet (respray with water if necessary, keeping the atomizer far enough away from the paper to apply just a light spray), seek out areas of warm reds with phthalocyanine red. Now allow your initial washes to dry. You can speed this up with a hairdryer but wait until the colour has settled and been absorbed into the paper or the jet of air will move the paint.

8 This is a moment of calm after the action of the washes. Assess your progress before moving on to Stage 2. As promised, the washes dry paler and more evenly blended. Check that areas of highlight have been conserved as white. Lift off with a wetted brush if not.

Stage 2: tone

9 Soften any hard edges or 'cauliflowers' (see page 150) that have developed with a wetted sponge – stroke gently.

10 Continue with the washes. Spray the surface again with water and this time add cool Phthalocyanine Blue along the top of the background so that it drops downwards and over the far left- and right-hand sides, over the pear and cloth. It is interesting to see how the colours combine to make a range of neutral greens and blue-greys.

11 We are about to move fast again, building up the colour wet in wet. First, the dioxazine violet is washed over the grapes, and the shadows. A mixture of quinacridone gold and lemon yellow goes over the orange and bananas with phthalocyanine red added to the orange to bring out the warmth and to keep it in the foreground. Take this wash over to the shadow on the jug, linking them with colour. Do not forget to leave the strip of light down the edge of the jug. The colour looks extreme but it will mellow when it dries.

12 Give the apple a touch of yellow on the top and then paint some alizarin crimson on in descriptive strokes as practised in the study. The crimson bleeds into the violet of the shadow. Paint the bananas have been painted warm yellow in the front and leave them cool green-yellow at the back. Allow to dry.

13 Stop and assess your work for balance and tidy up any splashes or hard edges. In the next stage, we remove the masking fluid and deal with edges.

Stage 3: structure

14 Remove the masking fluid with a putty eraser (or clean finger). Just rub lightly and it will come away.

15 The paint has dried strong and hard along the bottom edge of the shadow of the apple. First, lightly work with a clean, damp, hog-hair brush to loosen the paint and soften the edge, then blot with a tissue to remove the loosened paint.

16 Now we model with colour. Stronger colour is added wet on dry, defining the shape of the fruit with the brushstroke. First, work on the grapes with a mix of alizarin crimson and dioxazine violet. Use the brush to express the curve of the grape so that you do not disturb the underlying washes. Paint around the highlights – do not worry if the brush strays as they do not need to be bright white and some will be brighter than others. The blended colours of the washes beneath this layer of purple help to keep the colour uneven, which is closer to reality.

17 Work on the orange: stipple on more phthalocyanine red, building up the colour and tone. Do not take the paint right up to the edge on the shadow side.

18 Build up the tone of the shadow of the orange on the jug with complementary dioxazine violet. Take the violet glaze, wet on dry, down the right-hand shadow side of the jug, over the shadows on the handle (see detail).

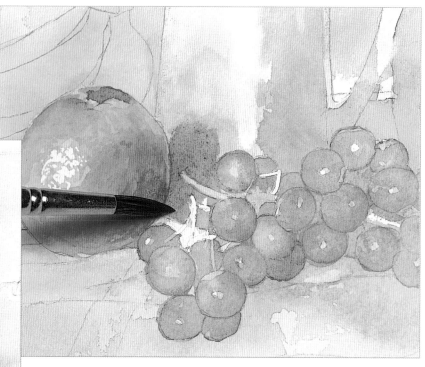

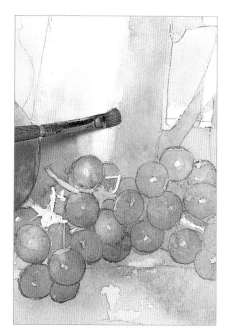

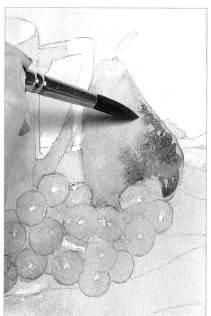

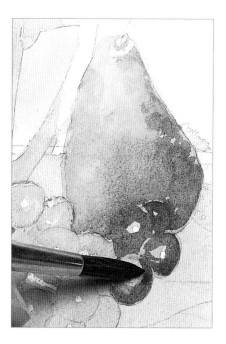

19 If the shadow edge down the middle of the jug has dried too hard, use a hog-hair brush to soften it with a little water.

20 Apply a general under-wash of quinacridone gold and dioxazine violet and a touch of phthalocyanine blue to the pear. Let it dry off a little and then stipple a stronger mix of the same for the shadow.

21 Add more colour to the grapes, then take a little of the colour across to dab onto the pear or allow the colours to run together. This will give texture to the skin of the pear and link these two parts of the painting.

22 Turn to the shadows on the cloth. Start at the top with a glazing mix of dioxazine violet and phthalocyanine blue. Take the shadows horizontally across, to balance the verticals in the still life. For the lower part, clean your brush and squeeze it gently in a tissue. Add a little dilute glaze colour and scrub it over the shadow parts, holding the brush sideways. This will produce a layer of broken colour.

23 Now work on the left side of the painting to bring it to the same level. First, wet the apple with water and allow it to sink in. Then add directional strokes of a mix of quinacridone red and alizarin crimson to strengthen the colour and describe the shape of the apple. The red does not run into the paler under-washes at the top because the board is on a slope. Add a dab of the red in the stalk well.

24 Glaze the bananas with dioxazine violet, as practised on page 138, picking out the shadows. Then paint the tips in brown, a mixture of dioxazine violet and quinacridone gold. Now let it dry once more so you can assess your progress.

25 Study your painting. It should now be looking good but it may lack punch. The structure – the three-dimensions – of the still life needs more attention. Do not worry. Once the background goes in, it will show up the outline of the still life and increase the three-dimensional effect. Finer details such as stalks will also strengthen the painting.

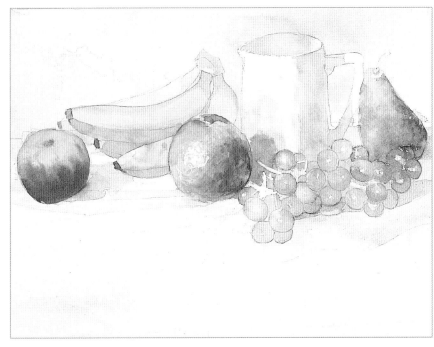

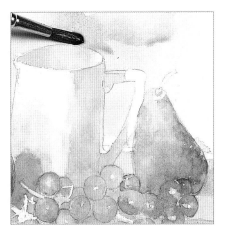

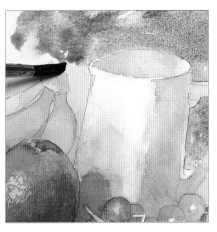

Stage 4: the third dimension

26 Now comes the rather dramatic step of adding the background. Start gently, wet on dry, with a mix of phthalocyanine blue and a little dioxazine violet. Use this as a first wash and feed in stronger colour wet in wet.

27 Add the violet and the blue alternately, but keep the colour warmer on the left, cooler on the right. If you stray, let it dry and remove with a hog-hair brush and a little water, or scrape with a blade as shown on page 141.

28 The area around the jug will need to be darker to contrast with the paleness of the jug, making this a focal point. Add stronger colour here, wet in wet.

29 Now we build up the structure, concentrating first on the grapes. The grapes behind will be cooler and bluer, the ones in the foreground, warmer and redder. Add another darker curved stroke on the grapes for a more three-dimensional effect.

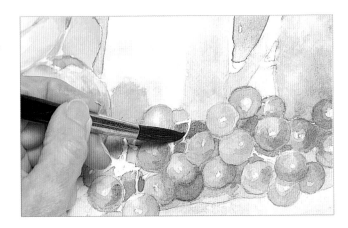

30 The bananas get the same treatment as the grapes, building up the shadows with further glazes of violet and blue as in the study (see page 136–139), and adding more yellow to strengthen the colour. They are in the background though, so not too detailed. Use the dark brown for the negative space between the tops of the bananas and for the touch of dark shadow at the base of the orange.

31 Add the final details to enhance the structure. With the tip of the brush, paint the apple stalk and the grape stalks with a mix of dioxazine violet, quinacridone gold and phthalocyanine blue.

32 Add more shadows on the cloth – use a mix of phthalocyanine blue and dioxazine violet.

Stage 5: finishing touches

33 Assess your progress. If you have lost your objectivity, try looking at your painting in a mirror. This is a particularly useful technique in the final stages.

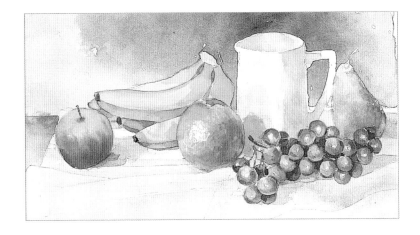

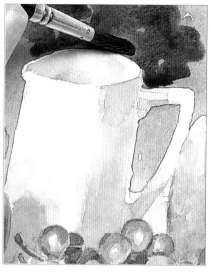

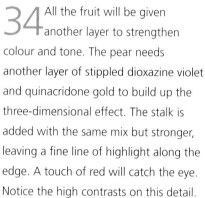

34 All the fruit will be given another layer to strengthen colour and tone. The pear needs another layer of stippled dioxazine violet and quinacridone gold to build up the three-dimensional effect. The stalk is added with the same mix but stronger, leaving a fine line of highlight along the edge. A touch of red will catch the eye. Notice the high contrasts on this detail.

35 Now the fine tuning: the shadows on the jug are strengthened and then the background area behind the jug is given another layer of dioxazine violet, phthalocyanine blue and quinacridone gold. Don't forget to pick out the tiny triangle between the pear and the jug handle as well as the left side of the jug and the bananas, which were isolated in the tonal sketch.

36 Add final touches of dark brown across the painting to match up with the pear stalk: at the base of the apple stalk, the ends of the bananas, the interstices of the grapes and finally the calyx of the orange. It is a good moment to check your tonal sketch to see what objective decisions you made at the beginning. Finally, add the blue lines on the cloth as practised on page 151.

37 The effort put into the painting has paid off. It is finished and, once dry, you can carefully remove it. This has a startling effect and you can see that the gradual build-up of glazes on the cloth has produced a subtle area of colour, with the blue lines leading the eye deep into the picture space to the area of high colour in the still life beyond. Here the layers of pure colour pulsate with energy, drawing in the eye, and the moody blues in the background add drama and movement beyond, throwing the fruit and jug forward in a powerful three-dimensional effect.

oils
in 10 steps

before you begin

choosing the right materials

The materials you need for oil painting are available at most, if not all, art stores. The shopping list below covers the essentials, and those materials necessary for completing the projects in this book. If well looked after, all your basic equipment will last for a long time; you will need to replace paint, mediums and solvents as you use them, but will find that a set of oil paints will produce a considerable number of paintings. Your most regular purchase will be a surface on which to paint and, here, you get what you pay for (see Painting surfaces, page 181). All art materials made by reputable manufacturers are good quality and, as a general rule of thumb, you should pay the most that you can afford: you will not be disappointed.

Shopping list

Soft charcoal pencil

Medium charcoal pencil

Hard charcoal pencil

Stick charcoal

HB graphite pencil

2B graphite pencil

Red pastel pencil

Eraser

Fixative

2.5 cm (1 in) flat synthetic-fibre brush

18 mm (¾ in) flat synthetic-fibre brush

12 mm (½ in) flat synthetic-fibre brush

6 mm (¼ in) flat synthetic-fibre brush

3 mm (⅛ in) flat synthetic-fibre brush

2.5 cm (1 in) flat bristle brush

12 mm (½ in) flat bristle brush

6 mm (¼ in) flat bristle brush

3 mm (⅛ in) flat bristle brush

Small synthetic-fibre fan blender

Silicone paint shaper

Small trowel-shaped painting knife

Turpentine

Alkyd painting medium

Oleopasto or painting butter

Acrylic gesso primer

30 x 40 cm (12 x 16 in) MDF Board x 2

30 x 40 cm (12 x 16 in) prepared canvas board

25 x 30 cm (10 x 12 in) prepared canvas board x 3

36 x 46 cm (14 x 18 in) prepared canvas board

25 x 40 cm (10 x 14 in) prepared canvas board

60 x 75 cm (24 x 30 in) prepared canvas board

50 x 50 cm (20 x 20 in) MDF board

50 x 60 cm (20 x 24 in) prepared canvas board

Oil paints:

Titanium white: PW6

Cadmium red: PR108 (available in light, medium and dark)

Quinacridone red: PR192 (available in a range of shades and names – Colour Index numbers PV19, PR122, PR207 and PR209)

Cadmium yellow light: PY35

Cadmium yellow: PY37

Ultramarine blue: PB29

Pthalocyanine blue: PB15 (also called Winsor and Monestrial blue)

Raw umber: PBr7

Burnt umber: PBr7

Viridian green: PG18

Dioxazine purple: PV23

Ivory black: PBK9

OIL PAINT

Essentially, oil paint is made by combining a dry pigment with an oil binder. Most manufacturers offer two grades of paint – student and artist quality – where the cost of the paint is dictated by the cost of the raw pigment used to create it. Artist-quality paint consists of a greater range of colours, containing greater concentrations or more expensive pigments and so tend to be more expensive. It should be noted that all oil paint is intermixable regardless of brand or quality.

The various pigments used to create oil paint exhibit certain inherent characteristics. Some are very strong with a great tinting strength and so need to be used sparingly. Others are less strong and have a very low tinting strength. Some pigments are transparent, which makes them ideal for glazing techniques (see pages 208–213), while others are opaque and have very good covering power.

As you work, keep the screw top and thread of each tube clean. Replace the top properly after use to avoid the paint becoming stiff. To loosen a tight top, either turn it using a pair of pliers or hold it beneath running hot water. Finally, always squeeze the tube from the bottom.

Palette colours

There are hundreds of different colours available, which can cause confusion when choosing a palette. All artists work with a limited range of different tube colours – usually between 10 and 16 in number. Chosen carefully, and with a little practice, these should enable you to mix every colour ever needed.

Basic palette: An ideal starter palette, these twelve colours are artist-quality paints. For the equivalent in student-quality paints, which may use different pigment mixes, consult a stockist who will advise you as to the closest alternative.

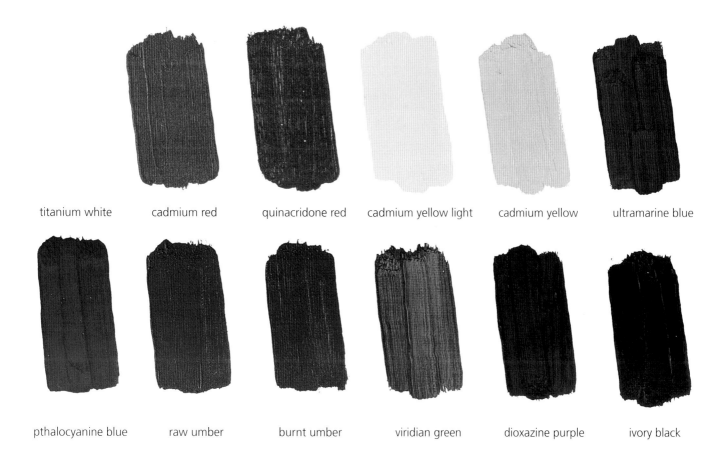

| titanium white | cadmium red | quinacridone red | cadmium yellow light | cadmium yellow | ultramarine blue |

| pthalocyanine blue | raw umber | burnt umber | viridian green | dioxazine purple | ivory black |

The list of 12 colours on page 176 is a good starter palette, and will enable you to mix a full range of colours to suit every eventuality. All of the colours are made from a single pigment, which helps to create cleaner, brighter mixes. There is also a good mix of 'warm' and 'cool' colours (see Colour terminology, page 197). Of course, as you develop your own preferences, you may find yourself adding to or substituting some of the number on the list.

When it comes to laying out your palette colours, get into the habit of using the same sequence every time you paint. Eventually you will learn instinctively where each colour resides. The sequence is entirely up to you: the colours could run lightest to darkest, or warm to cool.

The Colour Index code

Although many colours provided by different manufacturers are identical, some with the same name may differ slightly, while others with different names are, in fact, very similar. The reason for this is that the pigment formulae for the colours tend to differ from brand to brand. When looking for specific colours, therefore, you are advised to look for the pigment code given by the Society of Dyers and Colourists and the American Association of Textile Chemists and Colourists, and not the name given to the paint by the manufacturer. This 'Colour Index' code is universal and is printed on the paint tube label along with the colour name.

Colour Index code: The same colour paint from different manufacturers can have a different name. Look for the universal Colour Index code on the tube to be sure of the exact colour you are buying.

BRUSHES

Brushes for oil painting are made either from natural hair or synthetic fibre. The most common type of hair used is a natural bristle obtained from a hog. This is reasonably hard-wearing and better-quality brushes have a natural split at the end, known as a 'flag', which helps hold and distribute the paint. Brushes made from softer natural hair, such as sable, squirrel and mongoose, are expensive and less resilient than hog. If you require soft brushes you may find it better to use those made from synthetic polyester. Synthetic-fibre brushes are available in all of the traditional shapes and are reasonably hard-wearing if looked after.

Brushes are sold in a range of shapes and sizes, from very small to large and numbered in progression as size increases. There is no standard to the sizing, so two similar brushes from two different manufacturers may be numbered differently. The size of brush you use relates directly to the size of the painting you are working on.

Oil paint is corrosive and, with time, will ruin your brushes unless they are cleaned well and looked after. Once a painting session is over, wipe the surplus paint from the brush with a rag or a paper towel. Remove excess paint from flat brushes by placing them on a flat surface and scraping a palette or mixing knife down the bristles towards the tip. Once rid of excess paint, rinse all brushes in solvent to soften and remove any remaining paint. Pay particular attention to accumulations at the point where the brush fibres disappear into the ferrule. Once clean, work a little detergent into the fibres and rinse well in lukewarm water. Reshape the bristles and leave to dry, resting upright in a pot or jar.

Brush shapes

Paintbrushes come in many shapes and sizes. Their names may vary slightly from manufacturer to manufacturer but the following brush shapes are the most common.

Round

Pointed or domed and made from soft natural hair or synthetic fibre, rounds can hold a lot of paint and are used for line work, detail and drawing in paint. Larger rounds are used to loosely block in large areas of colour.

Flat

Flats have square ends and long bristles. They are easy to control and are used for precision work, blocking in large areas of colour and for blending. The side of the brush can be used for detail and fine linear marks.

Bright

A flat brush with short bristles, stiffer to use than a long flat. Used to build up thick layers of paint, for impasto work (see pages 220–227) and precise detail.

Filbert

Named after the nut of a similar shape, the filbert is flat with a domed tip. It is very controllable and used to draw detail and block in large areas of colour.

Fan blender

Used to blend areas of paint together, to create textural effects and for dry brushwork – useful when painting landscapes. Avoid mixing paint on the palette with the fan as you will quickly spoil its shape.

PAINTING KNIVES AND SHAPERS

Knives

There are two types of knife associated with painting. The first is the palette or mixing knife. Made from plastic or stainless steel these knives have a long, flat blade, which is sometimes cranked to a different level than that of the handle to avoid getting paint on the hand. These knives are used for mixing paint, for cleaning used paint off the palette and for scraping paint off the painting surface. They can also be used for applying large flat areas of paint onto the surface. Various shaped painting knives are available for more detailed work, the blades of which are rounded, pointed or angled to enable the application of paint in a distinct way. Always clean knives while the paint is still wet.

Shapers

Paint shapers resemble traditional brushes but, instead of using bristle or hair, the tips are made from a solid, flexible piece of silicone rubber. Various shaped tips are available, which are either soft and pliant or stiff and firm. Shapers are generally used with brushes or painting knives to extend the mark-making repertoire. They are easily cleaned using white spirit or turpentine.

DILUENTS, MEDIUMS, ADDITIVES AND VARNISH

Diluents

Diluents, or thinners, are liquids that thin the paint, making it easy to brush out and apply to a surface.

They are also used for cleaning brushes and equipment after use. The two main types of thinner are turpentine and white spirit. Distilled from pine resin, the best turpentine to use is double-distilled. White spirit is distilled from coal. It is much cheaper than turpentine and evaporates at a faster rate. Many artists use turpentine in their paint mixes and white spirit for cleaning brushes and palettes.

Mediums and additives

Mediums and additives are used to alter or enhance the characteristics of the paint, and are incorporated into the paint as the colours are mixed on the palette. They can increase the flow of the paint, speed up the drying time, or increase transparency. They are suitable when using glazing techniques, or for creating a matte or gloss finish once the paint has dried. A useful group of additives are the alkyd mediums. These speed up the drying process and increase the transparency and brilliance of the colours. A thick alkyd medium is also available with added silica for increasing the thickness and bulk of the paint, making it ideal for impasto techniques (see pages 220–227). It is most important to use mediums and additives carefully and to follow any technical instructions provided. Always use them sparingly, avoid mixing mediums and always follow the 'fat-over-lean' rule (see Step 1 Foundation, pages 184–189).

Varnish

Available in matte and gloss finishes, varnish is used as a covering to protect the painted image against dirt and atmospheric pollution. Applying varnish also unifies the colours. Oil paint needs to be completely dry before applying a coat of varnish. Many artists choose not to varnish their paintings.

SIZING AND PRIMING

Oil paint is corrosive and will, in time, cause the surface on which it is painted to deteriorate unless it is properly protected. This is done by 'sizing' and 'priming' the surface in order to create a protective barrier between the paint and the surface.

The advent of acrylic paint has provided various mediums that are ideal for preparing a surface for oil painting, and which do away with the more traditional process of sizing and priming. They are very simple to use and quick to dry; once dry they remain flexible and do not crack. If you wish to prepare a surface where the natural colour of the support material shows, you can apply a coat of clear acrylic matte medium. Acrylic primers are usually referred to as acrylic gesso. They can be used straight from the pot, diluted to ease application and two to three coats should be sufficient for most surfaces. They can be coloured using acrylic paint.

PAINTING SURFACES

The surface upon which a painting is made is known as the support. It can be made from fabric, paper, wood or metal. Paper and card surfaces are most often used for sketching and preparatory work, while canvas and wood are favoured for painting.

Canvas

The two types of canvas most commonly used are made from linen and cotton. Available in a range of 'weights' or thicknesses, linen is a beautiful material to work on: it is very strong with an irregular 'tooth' or texture, and has a neutral, dull, ochre colour. Once prepared and stretched, linen has a bounce or play that positively invites the application of paint. Far less expensive to buy than linen, cotton canvas is commonly known as 'cotton duck'. It is off-white in colour and has a more mechanical weave than linen. Cotton is very tough and, like linen, available in a range of weights.

Both types of canvas need to be prepared on a wooden frame, known as a 'stretcher'. Smaller pieces can be glued to a flat wooden panel. You can buy canvas and stretcher pieces yourself, but there are so many prepared stretched canvases available that, for the beginner, preparing your own is perhaps an unnecessary exercise.

Wood

Until the advent of canvas, hardwood panels were the traditional support for oil paintings. Today there are various wooden sheet materials that make very good painting supports. Easy to prepare and inexpensive to buy, they include plywood, hardboard and medium-density fibreboard (MDF).

Plywood is made from various types of wood, such as mahogany, birch and poplar. Thin sheets of the wood (ply) are laminated together to form large sheets that can be cut to size. Various thicknesses are available: thin panels over 30–40 cm (12–16 in) in any dimension need to be attached to a wooden framework in order to prevent warping.

Hardboard, or masonite, is made from wooden fibres glued together to create a sheet. Hardboard is available as 'tempered' or 'untempered'. Tempered hardboard is very hard and smooth on both sides, while untempered hardboard is less hard and slightly absorbent. The reverse side of untempered hardboard has a rough, coarsely patterned surface. Both sides can be painted on.

MDF is a relatively new surface. The sheets are available in a range of thicknesses, are not prone to warping and are similar to linen canvas in colour. The boards are inexpensive to buy and smooth on both sides. MDF is very stable and only prone to deteriorate if allowed to become wet.

Paper and card

Any paper can be painted on, if it is sized and primed (see page 180). Heavy, rough-textured watercolour papers are particularly effective. It is also possible to buy paper that has already been impregnated in order to prevent the oil in the paint corroding the paper fibres. This paper has a textured surface that resembles the weave of a canvas. Card can also be used and, like paper, needs to be effectively sized and primed. Prepared 'canvas' boards are available made from card with a canvas-like paper laminated to the surface. These are found in a range of sizes and different textures.

PALETTES

The surface on which colours are arranged and mixed is called the 'palette'. It should be flat and large enough to accommodate both your range of colours and the resulting mixes. For this reason, it pays to buy the largest palette that you find manageable. Traditional oil-painting palettes are made from hardwood and are rectangular or kidney shaped, with an indentation and a hole at one end for gripping by the thumb of the hand that also holds the brushes. Melamine-covered wooden palettes and plastic variations are also available, as are disposable palettes, which consist of a block of tear-off sheets of oil-proof paper. Before use, traditional wooden palettes should have linseed oil rubbed into the surface to seal the wood and to prevent the oil from being sucked out of the paint.

ADDITIONAL EQUIPMENT

Art stores are full of additional equipment and materials, much of which is unnecessary. One item that may be helpful is an easel. There are many types and designs available, and choice depends very much on how you paint, what you paint, where you paint and your budget.

Easels for studio work tend to be the most sturdy, as they often need to accommodate larger painting surfaces and do not need to be transported from one place to another. Easels for work on location are smaller and tend to fold down into a compact, more easily transportable size. They also often have adjustable legs, which enable the easel to stand firmly on uneven ground. Beginners would do well to invest in a box easel – a compact unit combining an easel with adjustable legs and room for holding paints, solvents and mediums. The whole easel folds into a compact unit and is carried using a strong handle on the side of the box.

Other useful equipment includes empty food tins, or small jars, into which solvent can be poured for cleaning brushes, and rolls of paper towel on which to wipe brushes, clean palettes, generally mop up any accidental paint spills, and to wipe away excess paint from the surface if making a correction. You may also wish to buy small cups, called 'dippers', which clip to the side of a palette for holding solvent and painting medium.

step 1 foundation

focus: **tomatoes**

Materials

Medium charcoal pencil
30 x 40 cm (12 x 16 in) MDF board
 prepared with gesso
Soft cloth
Fixative
6 mm (¼ in) flat synthetic-fibre brush
12 mm (½ in) flat synthetic-fibre brush
2.5 cm (1 in) flat bristle brush
Turpentine
The palette:
* *Titanium white*
* *Cadmium red*
* *Cadmium yellow light*
* *Cadmium yellow*
* *Raw umber*
* *Viridian green*
* *Ivory black*

Oil paint dries, not by evaporation, but by a process known as oxidation. The paint absorbs oxygen from the air, which causes chemical changes to take place, altering the physical and chemical properties of the paint and causing it to harden and dry. The more oil content the paint has in the form of binder, or added slow-drying painting medium, the longer it will take to dry and the more flexible that dry paint layer will be.

For this reason, oil paintings are executed using what is known as the 'fat-over-lean' rule (also known as flexible over inflexible). During the oxidation process, oil paint first expands slightly and increases in weight, then begins to lose weight and contract as it dries. If 'lean' paint (paint with no added oily medium, mixed only by adding a diluent, or a fast-drying alkyd medium – see also, Diluents, mediums, additives and varnish, page 180) is painted over 'fat' paint (paint with added oily painting medium), the lean paint will dry first but will crack as the fat layer of paint beneath expands and then contracts as it cures and dries.

Fat-over-lean: The fat-over-lean rule is easy to follow: when painting in layers, simply begin with an underpainting that is more fluid, has less of an oil content and is faster drying than the paint to follow. Then, gradually increase the oil or painting-medium content with each subsequent layer.

UNDERDRAWING

Although you can begin a painting simply by applying paint, many artists like to begin with a drawing. This acts as a guide and can be as simple or as complex as you wish. The drawing is invariably made from life or is a copy from a previously made drawing, painting or photograph. Whatever the source, it enables you to plan out the composition, making adjustments and corrections at an early stage. It is worth noting that too complex a drawing can actually inhibit the painting process by persuading you simply to 'fill in' the drawing rather than using paint and brush to explore and develop the subject beyond the lines of the drawn image.

You can make an underdrawing using any number of drawing materials, although you should avoid marker pens, as the dye tends to rise and read through even relatively thick layers of paint. Most artists prefer to use either graphite, charcoal, thin oil paint or thin water-based paint. Friable (crumbly), pigmented materials like charcoal, chalk or pastel, may mix with thin paint applied on top, altering the paint colour. If this is a problem spray with a thin coat of fixative prior to applying any paint.

Underdrawing: These underdrawings have been made using (from left to right) graphite, charcoal and thin oil paint.

UNDERPAINTING

An underpainting consolidates the drawing and loosely establishes the main areas of tone and colour, thereby providing a firm foundation on which to continue. Unless you are working on a coloured background that was either made when the surface was primed or added afterwards by applying a wash of thin water-based colour or thin oil colour, you will be faced with the stark white of the painting surface. Underpainting enables you to cover this quickly and will help you gauge the relative tone and colour of your subject more accurately. Underpainting is not obligatory but, when applied, should follow the fat-over-lean rule, using only paint mixed either with a diluent or a fast-drying alkyd painting medium.

Underpainting: The pigment of the underdrawn charcoal mixes with the first layer of paint, discolouring the paint colour slightly.

PAINTING THE TOMATOES

A bunch of tomatoes is positioned on a napkin. The underdrawing provides enough information to act as a guide for the subsequent addition of paint. The underpainting is applied in simple blocks of colour that provide a good foundation for subsequent applications of colour. Turpentine is added to the colour mixes throughout.

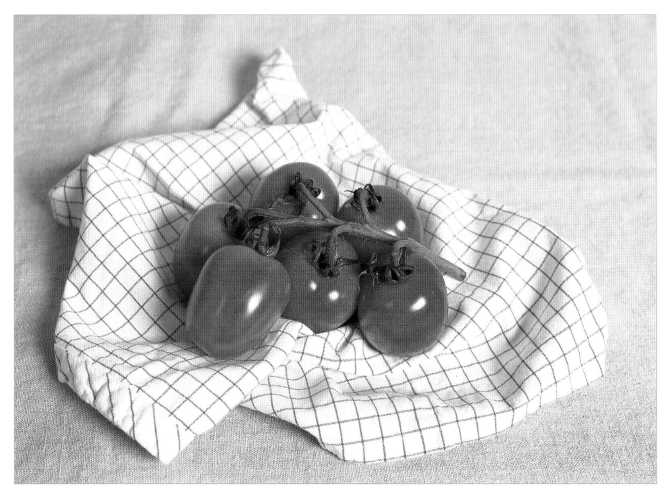

1 Establish the underdrawing. Loosely position the main elements of your composition on the board using the charcoal pencil. Work lightly, drawing simple shapes. If you make a mistake, simply correct it and work on. This outline will be completely covered with paint, so any errors will be lost.

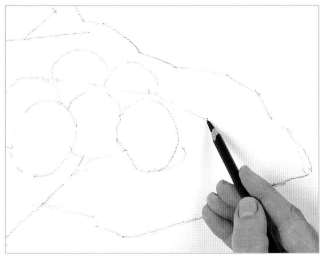

2 Develop the drawing further. Outline any highlighted areas and carefully draw in the pattern on the cloth. This is important, as it shows the way in which the napkin is folded and will act as a guide when paint is applied.

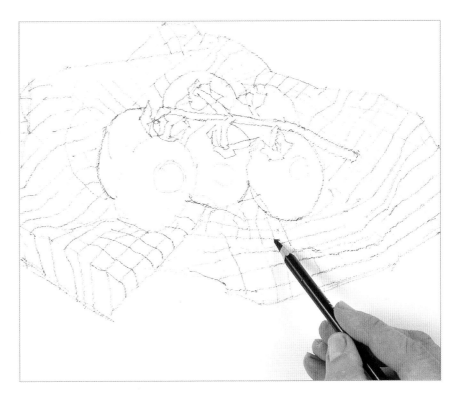

3 Use a soft cloth or kitchen paper to wipe over the design, removing any excess charcoal from the board. If the drawing is left unfixed, the black charcoal pigment may mix with the oil paint and darken the colours. If you do not want this to happen give the drawing a light spray with fixative.

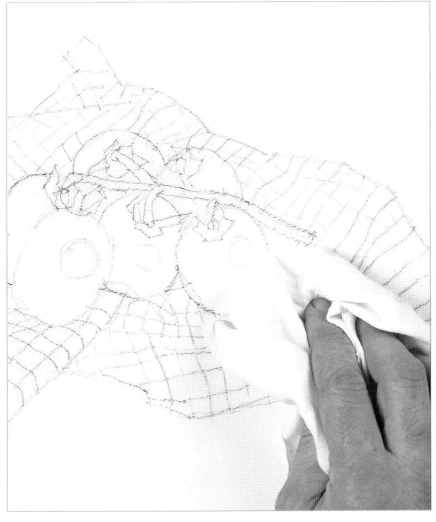

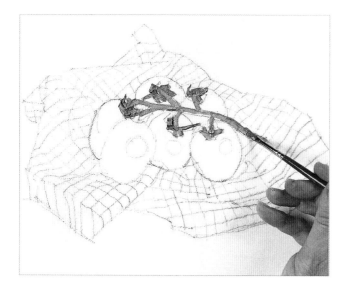

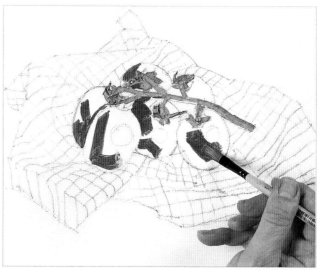

4 Now establish the underpainting. Paint the green tomato stem first. Use viridian green, cadmium yellow, titanium white and raw umber to create a range of greens that approximate those seen. Apply these to the stem using the 6 mm (¼ in) brush, making precise, simple brushstrokes.

5 Next, mix a deep red using cadmium red, cadmium yellow light, raw umber and a little of the previously mixed green. Using the 12 mm (½ in) brush, paint in the darker parts of the fruit.

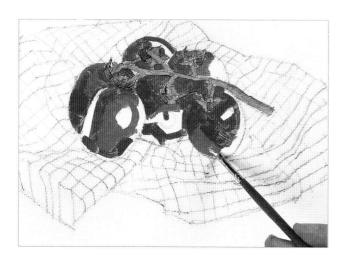

6 Mix a lighter red using cadmium red, cadmium yellow light and a little titanium white, and apply using the 6 mm (¼ in) brush. Keep using simple, direct brushwork and do not become concerned about blending colours together.

7 Make warm grey mixes using ivory black and titanium white into which you add a little of the red mix used on the tomatoes. Using the 12 mm (½ in) brush loosely now, suggest those areas of the cloth that are in shadow. Lighten the mix by adding more white and paint the mid-tone areas. The linear pattern continues to show through the paint and acts as a guide for future applications of colour.

8 Add raw umber to ivory black and a little titanium white, and use the 6 mm (¼ in) brush to paint in the dark shadow on the tabletop beneath the napkin. Add a little cadmium yellow to this mixture, along with plenty of titanium white, to produce a light ochre. Use the 2.5 cm (1 in) brush and loose brushstrokes to apply this to the area surrounding the cloth, carefully working up to the edge of the cloth and the painted shadow.

9 With the tablecloth complete, you have now finished the underpainting and have established both the main areas of colour and the composition of the piece – a very solid foundation on which to build the rest of the painting.

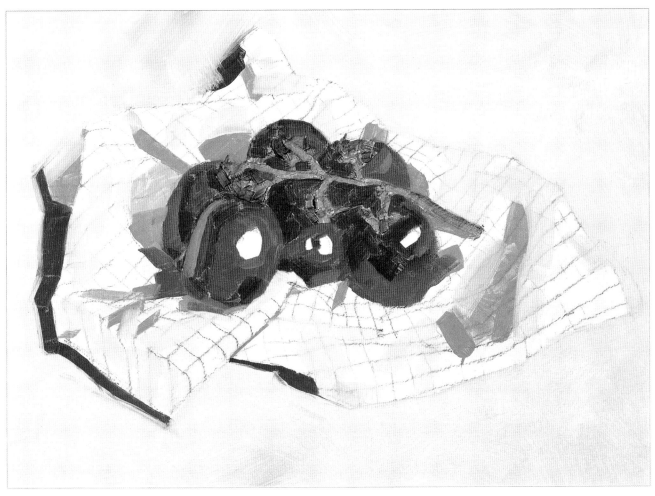

step 2 tonal underpainting

focus: **pear, apple and lemon**

Materials

30 x 40 cm (12 x 16 in) prepared
 canvas board

2B graphite pencil

6 mm (¼ in) flat synthetic-fibre brush

12 mm (½ in) flat synthetic-fibre brush

Turpentine

Alkyd painting medium

The palette:

• *Titanium white*

• *Ivory black*

Monochromatic, or tonal, underpainting is an alternative to the loose, full-colour underpainting used in the previous project (see Step 1 Foundation, pages 184–189). Known as a grisaille, the name is derived from the French *gris* (grey) and means 'grey picture'. Traditionally, the technique was applied prior to using glazing techniques (see pages 208–213), but a tonal underpainting can also be used as preparation for further applications of paint that are not necessarily to be applied as glazes.

The idea is to establish the image using tone only, so that it resembles a black-and-white photograph. The forms are usually modelled to quite a high standard and, as with an underpainting made using full colour, the process also allows the artist to establish and make corrections to the composition.

CREATING A GRISAILLE

When painting a grisaille, it is essential to follow the fat-over-lean rule (see page 184). Unfortunately, ivory black oil paint is particularly 'fat', so only use paint thinned with a solvent or a fast-drying painting medium for this exercise. An alternative is to prepare the underpainting using fast-drying acrylic paint. This is ideal as it removes any problems that might arise if using paint with too high an oil content. Acrylic paint does not use oil as a binder and dries relatively quickly. Note that, while it is perfectly safe to use water-based materials like acrylic paint under oil-based materials, you should never use them over oil-based materials.

If preparing a grisaille strictly as a base for glazes it is usually painted in a 'high key' – that is, without using any really dark tones. The reason for this is so that the glazed colours can be seen against the darker tones. You can use tones of any single colour when painting the grisaille (not just black and white), but be aware that the colour you choose will have a direct, and pronounced, effect on the colour of your glazes as you apply them.

Tonal underpainting: The grey tones for a grisaille are achieved either by mixing the greys using black and white paints (far left) or by using just black paint and a thinner with the white of the support to achieve the tones (left).

PAINTING THE PEAR, APPLE AND LEMON

The fruit is arranged side by side on a table. The low viewpoint creates an ordered, slightly regimented composition lit from the right. The tones are mixed so that they are not as dense or as dark as those seen on the actual objects. Turpentine and alkyd painting medium is added to the mixes throughout.

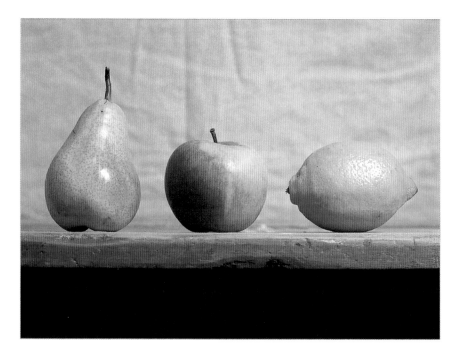

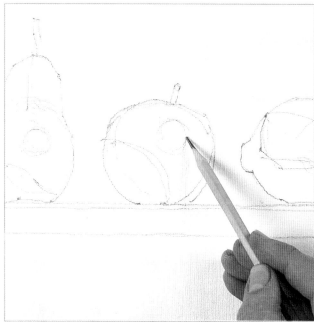

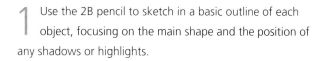

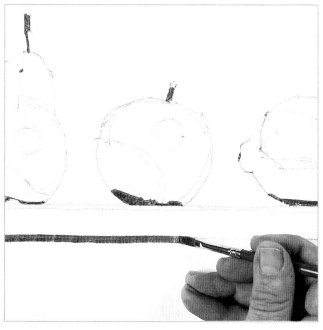

1 Use the 2B pencil to sketch in a basic outline of each object, focusing on the main shape and the position of any shadows or highlights.

2 Use the 6 mm (¼ in) brush to mix a darkish grey, using ivory black and titanium white, thinned with a little alkyd medium. Paint in the stalks of the fruit and the dark area beneath each piece where it rests on the tabletop. Use the same mixture to paint in a line that represents the bottom edge of the tabletop.

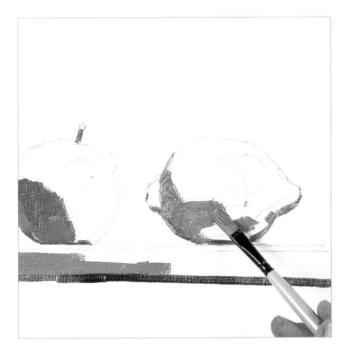

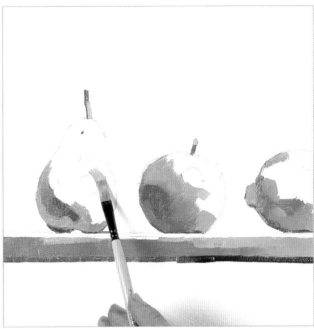

3 Taking the 12 mm (½ in) brush, add a little titanium white to lighten the mix. Use this to carefully paint in the dark shadow tone on the side of each piece of fruit that is facing away from the light. Paint in the dark tone that can be seen on the edge of the table as well.

4 Now lighten the mix further with more titanium white and block in the dark mid tone on the fruit. Brush this gently up to, and slightly into, the darker tone to blend the two together and soften the point at which they join. Use the same mix to complete the edge of the table.

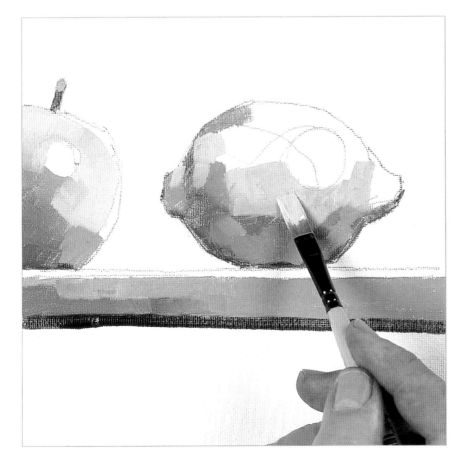

5 Add more titanium white and match the mix to the mid tone of each fruit. As before, work the paint up to the previously applied mixes, working around any highlights.

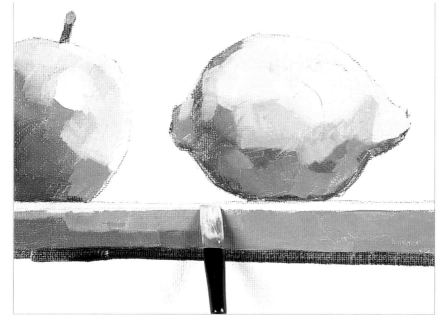

6 Add more titanium white and complete blocking in the tonal transition on each fruit. Using the corner of the brush, add a few dabs of tone into the highlighted area on the lemon to suggest the pitted texture of its skin. Use the same mix to make short, vertical brushstrokes to the topmost part of the table's edge.

7 Note how the mid tones on the fruit match those on the fabric draped behind them. Use the brush, loosely, to block in these areas of tone.

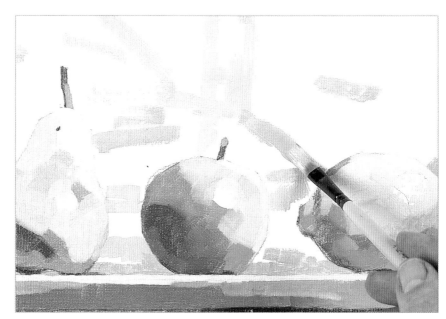

8 Now mix a very light grey and carefully block in the rest of the background fabric. Brush the paint out well so that it mixes with the previously applied tone and softens and lightens it slightly.

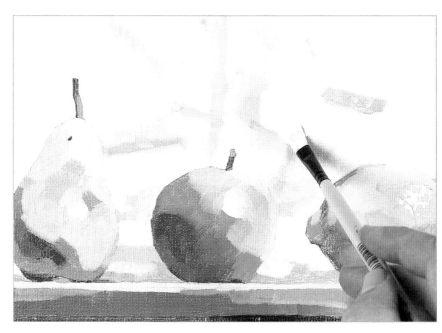

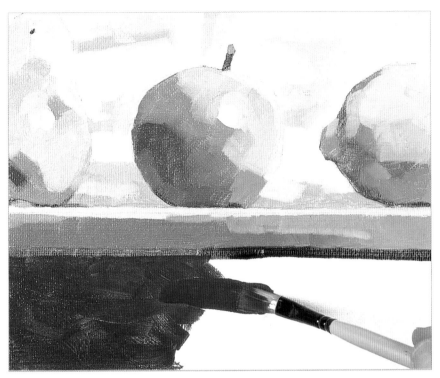

9 Finally, mix a very dark grey and use it to block in the dark area underneath the table.

10 The completed image shows how the various tones of the underpainting can be achieved using relatively few grey mixes, thereby providing an ideal foundation on which to start building up colour.

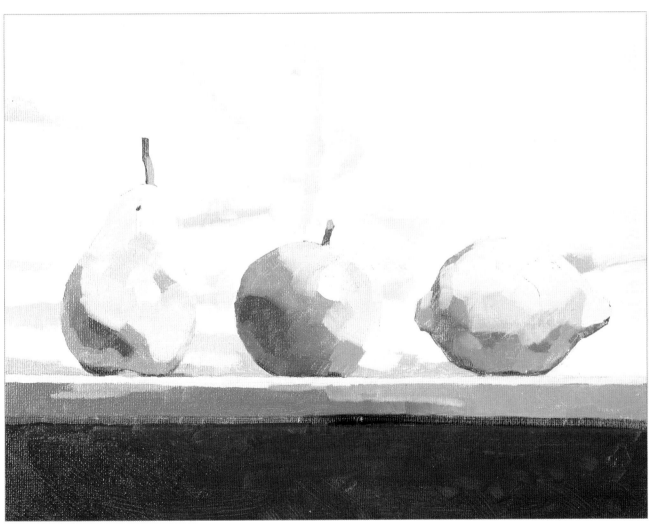

step 3 colour

focus: **peppers**

Materials

25 x 30 cm (10 x 12 in) prepared
 canvas board

2B graphite pencil

Fixative

6 mm (¼ in) flat synthetic-fibre brush

12 mm (½ in) flat synthetic-fibre brush

Turpentine

Alkyd painting medium

The palette:

• *Titanium white*

• *Quinacridone red*

• *Cadmium yellow light*

• *Pthalocyanine blue*

Mixing black: To mix black, add all three primary colours together.

Mixing greys and browns: Mix complementary colours then add white.

It makes both financial and practical sense to work with only a limited palette of colours. For many people who teach painting, the addition of black might be seen as controversial, as it can sometimes result in dull mixes, but used judiciously it can also be extremely useful. Working with a limited range of colours has the additional benefit of teaching you about colour mixing as you learn to approximate and mix the colours that you come across around you.

WHAT IS COLOUR?

Everything has an intrinsic colour, and we depend on the light falling on an object for its colour to be seen. White light consists of the seven colours of the visible spectrum and is a form of electromagnetic radiation. The seven colours are red, orange, yellow, green, blue, indigo (blue-violet) and violet. Each colour operates on a different electromagnetic wavelength. That we see an object's colour depends on some of these wavelengths being absorbed by the object while others are reflected back to the viewer. For example, a red apple is perceived as being red because red wavelengths are reflected while all others are absorbed; black is seen when all of the wavelengths are absorbed, and white when all are reflected.

MIXING COLOURS

Mixing pigment colours together is known as 'subtractive' colour mixing. This is because the more colours you add, the duller and closer to black the result. In order to avoid this, it is important to arrive at the correct colour mix by using as few different colours as possible. It is for this reason that the beginner's palette colours are all made from a single pigment. The project that follows uses just three primary colours plus white and demonstrates that, by mixing elements of these colours, a wide range of neutral greys and browns can be created.

Colour terminology

Distinct terminology is used when discussing the properties of colour. If learnt, this terminology makes what can be a complicated subject much clearer and more easily understood.

Colour wheel: This is a diagram that shows colours in a circular sequence that corresponds with the order of spectrum colours that make up white light. It is useful for looking at, and making sense of, colour relationships and terminology.

Primary colours: Red, yellow and blue are primary colours and cannot be made by mixing together other colours.

Secondary colours: Mix together any two primary colours and the result is a secondary colour. Red and yellow make orange, yellow and blue make green, and blue and red make violet.

Tertiary colours: Tertiary colours result when a primary is mixed in more or less equal measure with the secondary next to it. Resulting in red-orange, orange-yellow, yellow-green, green-blue, blue-violet and violet-red.

Complimentary colours: Complementary colours are those colours that fall opposite one another on the colour wheel. When placed next to each other they have the effect of making one another look brighter owing to what is known as simultaneous contrast. The effect is very different when the colours are mixed together. This has a neutralizing effect on the colours, resulting in a range of greys and browns.

Colour temperature: Colours are generally considered to be either 'warm' or 'cool'. Red, orange and yellow are considered warm, while green, blue and violet are considered cool. The issue is complicated somewhat in that each colour has warm and cool variants depending on its colour bias.

The colour wheel: This 'wheel' shows primary, secondary and tertiary mixes.

Hue: This is simply another name for colour. Ultramarine blue, cerulean blue and cobalt blue are all hues albeit a similar colour.

Value: This is a term used when discussing tone, and describes the relative lightness or darkness of a particular colour.

Saturation: This describes the relative intensity of a colour. Colours that are similar in hue will have different intensities. Cadmium yellow is a highly saturated bright yellow while Naples yellow is not.

Harmony: Certain colours work better together than others, and are called harmonious. There are several different groups of these. Monochromatic harmony is achieved by using various tones of the same colour. Analogous harmony uses those groups of colours that are close together on the colour wheel. Complementary harmony is achieved by using groups of colours that appear opposite one another on the wheel.

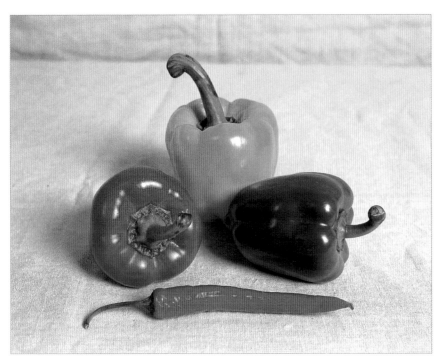

PAINTING THE PEPPERS

Three different-coloured peppers and a chilli are arranged in a simple composition and are painted using just three primary colours and white. This is an excellent exercise, forcing the artist to think very carefully about the colour mixes made. Remember that very small additions of colour can change a mix dramatically. Turpentine and alkyd medium are added to the mixes throughout.

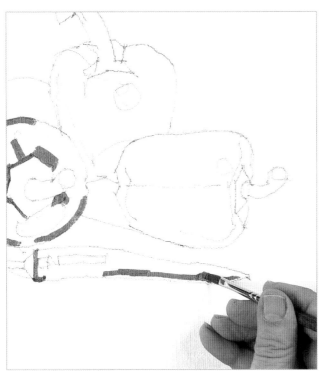

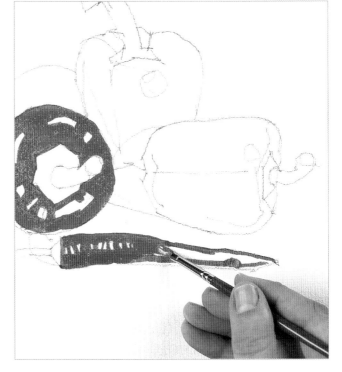

1 Use the 2B pencil to sketch in the position of the four objects. In order to prevent the graphite mixing with the paint colours, spray the drawing with fixative. Mix quinacridone red with cadmium yellow light to create a warmer red, and subdue this by adding a little pthalocyanine blue. Apply the colour to the darker areas of the red pepper and red chilli using the 6 mm (¼ in) brush.

2 Add more red and yellow to the same mix to create a warm, bright, red and use this to block in and establish both the red pepper and the chilli. Work around those areas that catch the highlights, leaving the white of the support to show through.

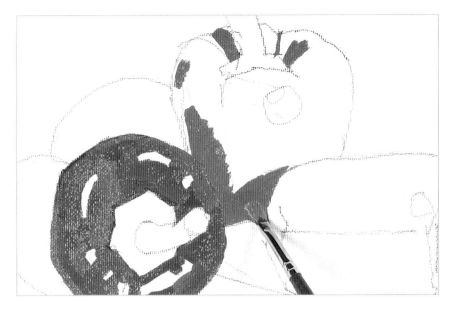

3 Add a little yellow and titanium white to the red mix and work the colour around the edge of the red pepper where the shiny skin picks up reflected colour from the cloth. Now work this colour, over the red previously applied, in those areas around the highlights. Add more yellow to the mix and use this to paint the areas on the orange pepper that are in shadow. Now darken the mix with a little blue and use it to paint in the darkest colour on the skin of the orange pepper.

4 Mix a clean, bright orange using just red and yellow and block in the mid tones on the orange pepper. Lighten the same colour slightly, using a little titanium white and more yellow, and use this to block in the lighter mid tones on the orange pepper.

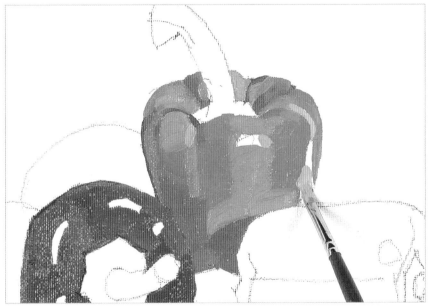

5 Mix a mid-green using the blue and the yellow. This will be very bright so take some of the mix and subdue it gradually by adding red until you have produced a rich, dark green. Use this to block in the darkest passages that can be seen on the stems of the peppers and chilli, and the darkest areas on the green pepper.

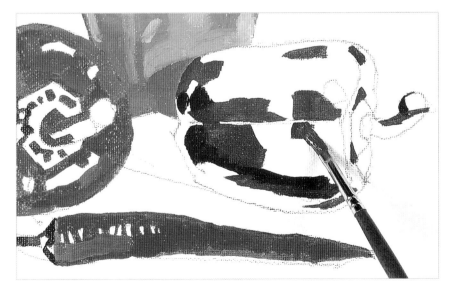

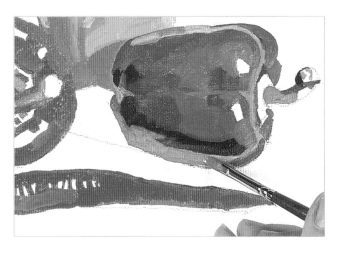

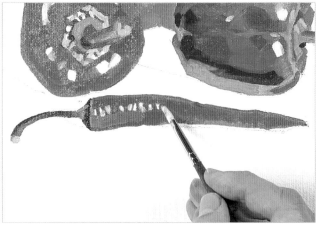

6 Add a line of the dark orange to the top edge of the green pepper to suggest the reflected colour from the orange pepper behind. Taking a little more of the mid-green mix, add more yellow and titanium white. Use this to paint in the mid tones on both the skin of the green pepper and all four stalks. Modify the same mix further with more titanium white to create a light, but subdued, green for the lighter colours around the green pepper's edge.

8 Mix a rich, dark brown by adding small amounts of all three primary colours together with titanium white. This neutral colour provides the basis for the shadows cast by the peppers as well as the base colour for the deep cream cloth. The quantity of each colour used in creating the dark brown needs to be adjusted carefully by adding a little at a time until the colour is correct. Switch to the 12 mm (½ in) brush and use to create a thin line of the colour beneath each pepper and the chilli.

7 The peppers should now be complete. The highlights are still too bright, however, and need to be subdued. Do this by mixing titanium white with a small quantity of the main colour for each pepper. Apply carefully to the unpainted highlights using direct, sure strokes. For small, tight areas turn the brush on its side and use one corner of the flat end.

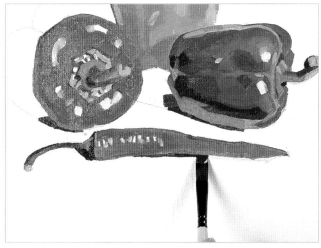

9 Add a little titanium white into the mix to lighten it slightly, then use this to create the shadows cast by the objects, adding a little green to the shadow cast by the green pepper, a little orange to the mix for the shadow cast by the orange pepper, and a little red to the mix for the shadow cast by the red pepper.

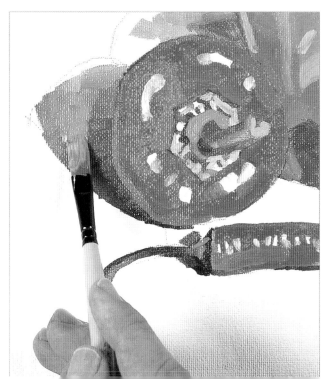

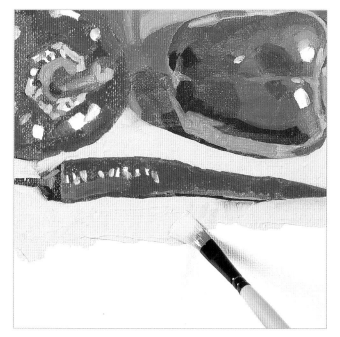

10 For the colour of the cloth, add plenty of titanium white to the original dark-brown mix from step 8 to lighten it. You may find that a little red, yellow or blue needs to be added in order to push the mixture in the right direction. Note how a very small amount of added colour will alter the mix considerably, so add tiny amounts at a time. Carefully cut in around the peppers and their shadows using crisp, direct brushwork, redrawing each object and correcting its shape if you feel you need to.

11 The finished image illustrates how close variations of many colours – including a range of neutral browns – can be made using just three carefully chosen primaries.

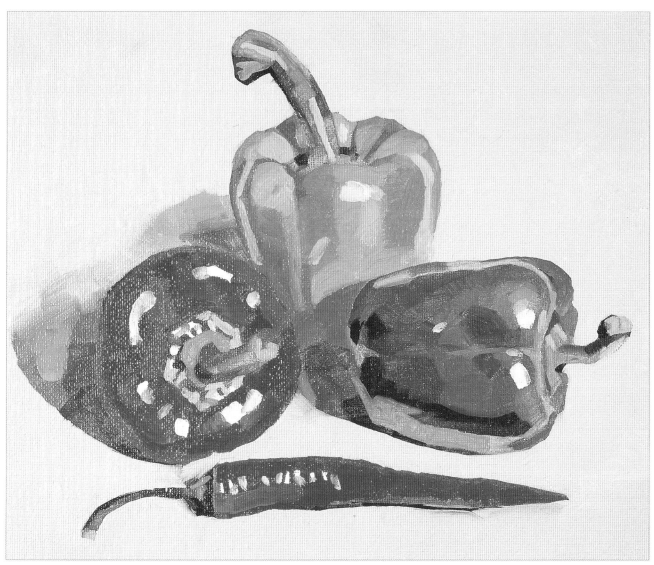

step 4 alla prima

focus: **garlic and onion**

Materials

25 x 30 cm (10 x 12 in) prepared
 canvas board
2B graphite pencil
6 mm (¼ in) flat synthetic-fibre brush
Small trowel-shaped painting knife
Turpentine
Alkyd painting medium
The palette:
• *Titanium white*
• *Cadmium red*
• *Cadmium yellow*
• *Ultramarine blue*
• *Raw umber*
• *Burnt umber*
• *Ivory black*

Roughly translated, the Italian expression *alla prima* means 'at the first', and is the term used for a traditional method of painting in which the work is completed – usually in a single session – by painting directly onto the surface without first underpainting. The technique involves using paint that is of a creamy consistency and direct, 'wet-into-wet' brushwork.

Paintings executed using alla prima techniques often have a unique freshness and spontaneity, and are brought to life through the expressive brushwork and exciting colour combinations. This method can be very stimulating and exciting but, for all its apparent spontaneity, nevertheless requires both focus and a clear idea of what it is you want to achieve.

WORKING WET INTO WET

For this method, you construct a painting by applying paint 'wet into wet'. Although colour mixing generally takes place on the palette, a certain amount also inevitably takes place on the support, as wet areas of paint are worked into one another. This mixing should not be confused with blending, where colours and tones are worked together to create smooth transitions (see Blending, pages 214–219). Brushwork should always be direct, unfussy and economical. A painting is usually executed in what can be described loosely as three distinct stages: underpainting, alla prima and adding detail and texture.

UNDERPAINTING

The underpainting establishes the main elements of the composition and should be carried out in a very loose manner using a limited palette or a single colour. Although underdrawing and underpainting can both be very helpful, it is important not to detract from the sense of spontaneity. With any kind of preliminary drawing or underpainting, it is a natural instinct simply to follow it with subsequent work and this should be avoided. Keep drawing to a minimum, preferably using unfixed charcoal

or graphite. Alternatively, use paint thinned with a solvent or mixed with a fast-drying alkyd medium. Brush the paint out well so that it appears relatively 'dry', although it is, of course, still wet.

WORKING ALLA PRIMA

Apply the paint using direct fluid brushwork, mixing colours on the palette and keeping any mixing on the support to a minimum. You can add painting medium to the paint at this point if necessary. Construct the picture gradually, loosely applying broad areas of colour, then work into this with further applications of paint, using direct, sure strokes of the brush. You can usually ignore small details, or simply hint at them using clever brushwork and small flicks or dabs of paint.

ADDING DETAIL AND TEXTURE

Once you have established the image, you rework it, introducing relevant detail with precisely placed brushmarks and dabs of colour or tone made using smaller brushes. To add texture or to 'draw' details you can use a technique known as 'sgraffito' (from the Italian *sgraffire*, meaning 'to scratch'). Using the edge of a painting knife or scraper tool, or even the end of the paintbrush or your fingernail, scrape the surface of the paint to create raised lines or marks with the same intuitive expression of painting alla prima. Avoid overworking, as this will compromise the freshness of the piece.

Wet into wet: The colours are applied 'wet into wet', which means that a certain amount of colour mixing takes place when one colour is worked into the next.

Making corrections: You can make corrections simply by scraping or wiping away the offending area with a mixing/palette knife or a rag. You can then repaint the area.

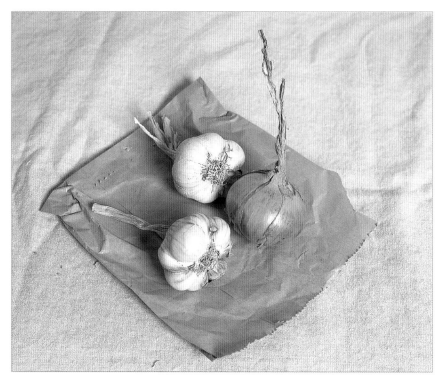

PAINTING THE GARLIC AND ONION

Two bulbs of garlic and an onion are placed on the brown paper bag in which they were bought. The shape of the bag contains the three objects, framing them against the hessian cloth and holding the simple composition together. Turpentine and alkyd painting medium are added to the mixes from step 3 onwards.

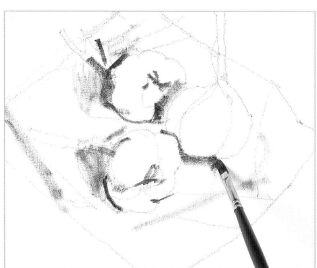

1 Position the objects with a very simple pencil sketch before strengthening the darkest areas using a relatively 'dry' dark mix made from ivory black and raw umber. Add just enough diluent to make the paint workable. Use direct, sure brushstrokes throughout, and avoid 'tickling' or playing with the paint once it has been applied.

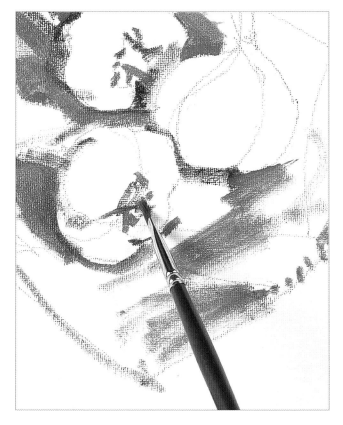

2 Add a little titanium white to the mix to lighten it, and use this to paint in the shadow areas and the dark detail seen around the roots on the bottom of each bulb of garlic.

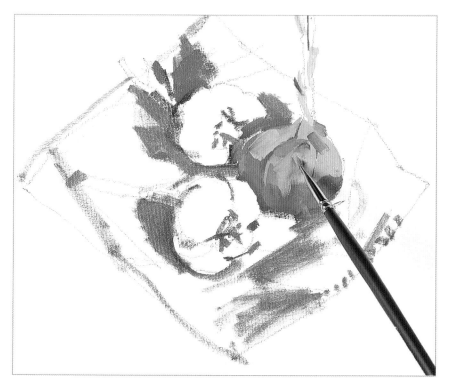

3 Make a deep, reddish-brown by mixing together burnt umber and cadmium red and lighten with a little cadmium yellow. Use this colour to block in the lower half of the onion, making directional strokes that follow its contours. Lighten the mix by adding more cadmium yellow and titanium white and use this new colour to paint in the top half of the onion and to render its dry, twisted stalk.

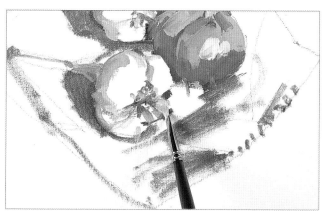

4 Now mix the colour for the garlic. Take some of the lighter onion colour, add more raw umber and a little ultramarine blue. Lighten with titanium white. Work the colour around the contours of the garlic and add a couple of dabs to the side of the onion to suggest the highlighted area.

5 Make a light and a dark version of a cool brown using raw umber and titanium white into which you add a very small amount of ultramarine blue. Use the lighter shade to block in the paper bag and the darker shade to suggest those parts of the bag that are facing away from the light or that are shaded by the garlic. Use the brush carefully to cut around the shape of each garlic bulb, redrawing and redefining the shapes, which now begin to show form.

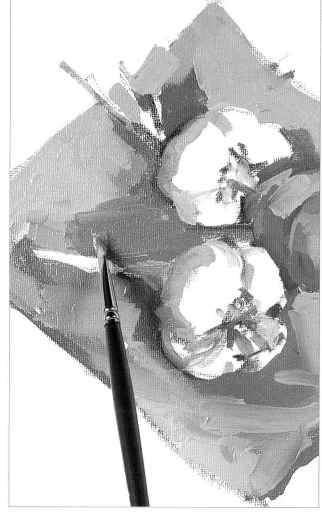

6 Mix a dark brown using raw umber and ivory black, and apply around the edge of the paper bag to create shadow. This has the effect of visually lifting it slightly from the background. Use the same colour to add some darker passages within the shaded areas between the garlic and the onion.

7 Turn your attention to the colour of the tablecloth. Mix what is left of the paper-bag colour with plenty of titanium white and just a little ivory black to knock back, or deaden, the colour slightly. Work carefully up to the edge of the bag and use the very corner of the brush to paint the serrated edge.

8 Lighten this mixture slightly by adding titanium white, and use to paint the dry, twisted garlic stalks. Using strokes that follow the contours, paint in the light skin of each garlic bulb. Allow the white of the support to show through in places, as this will help to suggest the light, linear pattern that can be seen on their skin.

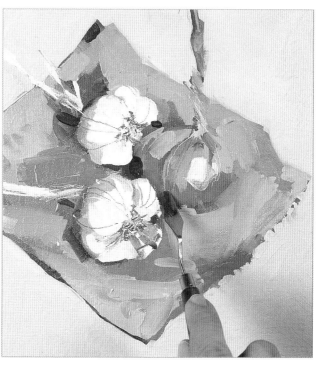

9 Reinforce this effect by adding a few dark lines with graphite pencil.

10 Add further detail by scraping into the wet paint using the end of a painting knife (see 'sgraffito' under Adding detail and texture, page 203): add pattern to the twisted stalks, scratch in the garlic roots and add linear marks around the forms of both the garlic and the onion.

11 The final image bears the fresh, spontaneous appearance that is characteristic of an alla prima painting, in which the expressive brushwork brings the subject to life.

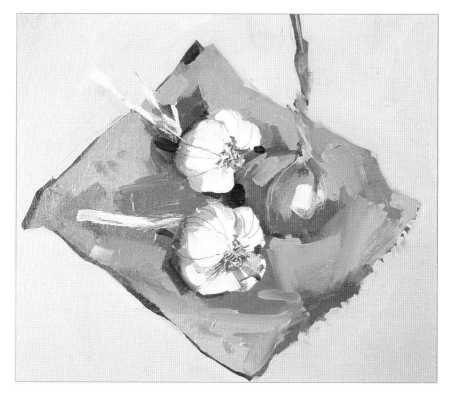

step 5 glazing

focus: **bottles**

Materials

30 x 40 cm (12 x 16 in) MDF board
 prepared with gesso
HB graphite pencil
6 mm (¼ in) flat synthetic-fibre brush
12 mm (½ in) flat synthetic-fibre brush
2.5 cm (1 in) flat synthetic-fibre brush
Alkyd painting medium
Glazing medium
The palette:
* *Titanium white*
* *Cadmium red*
* *Cadmium yellow*
* *Ultramarine blue*
* *Raw umber*
* *Viridian green*
* *Ivory black*

Tone: If you paint the grisaille using the correct tones, subsequent thin, coloured glazes will read as colour over the darkest tonal areas.

Traditionally, working with glazes requires the preparation of a monochromatic grisaille or tonal underpainting (see pages 190–195). Once the grisaille is dry, thin washes or layers of colour are applied one over the other. The process used to be an extremely long one, with each glaze or layer of paint needing to dry completely before the next could be applied. Today, with the advent of relatively fast-drying alkyd mediums, the process can be carried out much more quickly.

Although traditional glazing techniques are now seldom used, the principle of working over a tonal underpainting with thin applications of colour, which are then modified using glazes, has been adapted over the years and is now common practice. You can also apply glazes to images painted using other methods, such as impasto (see pages 220–227). However, you must always apply the fat-over-lean rule (see page 184) and mix the glazes using a glazing medium that will remain flexible over the less flexible underpainting.

Using glazes

As you apply each coloured glaze, the colour density becomes greater and correspondingly darker. For this reason, you paint the traditional grisaille in a high key. This means that the darkest tone, if seen on a full tonal scale from white to black, should be no darker than a mid-grey.

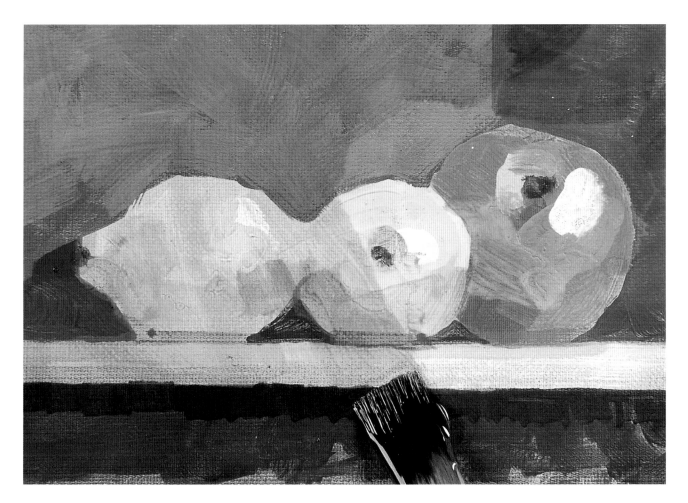

BRIGHTNESS OF COLOUR

Glazed colours often look brighter than those that have been mixed on the palette. Combine red and yellow to create orange and apply it to your surface. Now create a yellow underpainting, allow it to dry and apply a red glaze over the top. Notice how the second application is much brighter. The reason for this is that, when two colours are mixed together the purity of each is compromised and the resulting mixture is always darker. This also explains why it is better to work with paint colours that have been created from a single pigment whenever possible.

GLAZING TO CREATE COLOUR HARMONY

Another use of a glaze is to create an overall colour harmony, and the technique simply involves the overall application of a coloured glaze to the dry image. You need to choose the colour with care, however, as it can have a profound, and immediate, effect on the appearance and mood of the piece. You can change an overall colour cast to read as warmer or cooler or use a glaze to subdue harsh colour or tonal contrasts.

Deepening colour: The only thing you cannot do with a glaze is to make an image appear brighter, as a glazed colour will always slightly darken existing colours.

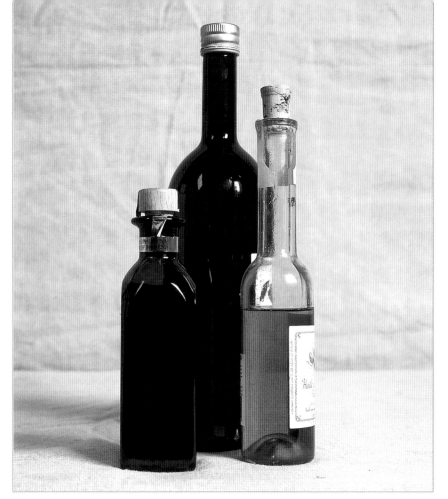

PAINTING THE BOTTLES

Three bottles are arranged in a group. The smooth, reflective surfaces provide the perfect subject for illustrating the glazing technique. The underpainting is made using oil paint and fast-drying alkyd medium, but the process can be speeded up by using acrylic paint, which will dry in minutes rather than hours. Alkyd painting medium is used in the mixes for the underpainting while glazing medium is used for steps 4 to 9.

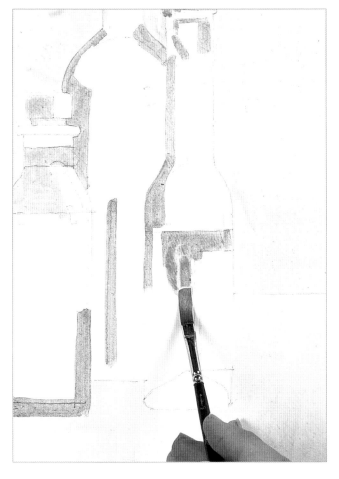

1 Start by drawing a light, relatively precise, pencil drawing before setting to work on the tonal underpainting. Mix a very light grey using ivory black and titanium white with added alkyd medium and, using the 2.5 cm (1 in) brush, block in the tone of the background, working carefully around the shape of the bottles. Lighten the mix slightly for the tablecloth.

2 Switch to the 6 mm (¼ in) brush. Using a slightly darker mix, carefully paint in the mid tones seen on the bottles, the reflections and the changes in tone where the liquid is. Mix these tones so that they are slightly lighter than in reality.

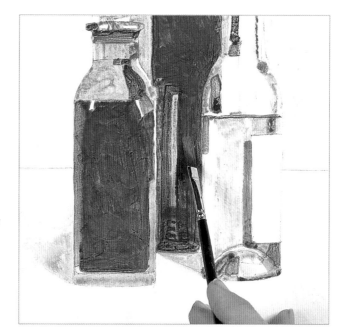

3 Darken the mixes and block in the darkest tones, working around any lighter areas of reflected colour or tone. Allow the white of the gesso ground to show through to represent highlights. Once the tonal underpainting is finished, leave it to dry. If you have used quick-drying alkyd medium and the painting is placed in a warm environment, it could be sufficiently dry in 24–48 hours.

4 Now you can begin to apply the coloured glazes. Start by mixing a light ochre, using cadmium yellow, raw umber and a little cadmium red. Apply this to the cork stoppers and screw cap, using the 6 mm (¼ in) brush. Note how the tonal underpainting reads through the transparent glaze, describing the form.

5 Mix a deep orange using cadmium red and cadmium yellow, and use this to paint in the contents of the clear glass bottle on the right. Apply a viridian green and raw umber mix to the tall bottle in the centre and the smaller bottle on the left.

6 Mix a dull ochre glaze for the background. Use raw umber and cadmium yellow, and add a little cadmium red and ultramarine blue. Add a little titanium white, but use this sparingly to avoid making the mixture too opaque. Apply using the 12 mm (½ in) brush.

7 Use the same colour on the clear glass bottle, working around any white reflections. Use a lighter version of this mix to block in the cloth. Once completed, the image must be allowed to dry thoroughly, which will take anything from 24–48 hours, if placed in a warm environment.

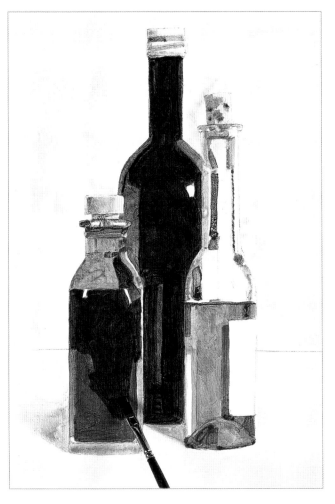

8 Check that the painting is dry before resuming work. Mix a deep, dark green using viridian green, ultramarine blue and raw umber, and repaint the dark green bottles using the 6 mm (¼ in) brush. Only paint the very darkest areas.

9 For the contents of the clear bottle, mix a deep orange using cadmium red and cadmium yellow into which you add a little raw umber.

10 Use titanium white to carefully repaint any highlights on the bottles that you might have inadvertently covered with any coloured glazes.

11 The finished image demonstrates how the grisaille technique is employed to establish the tonal variations, while a series of thin glazes are used to build up the colour of the painting.

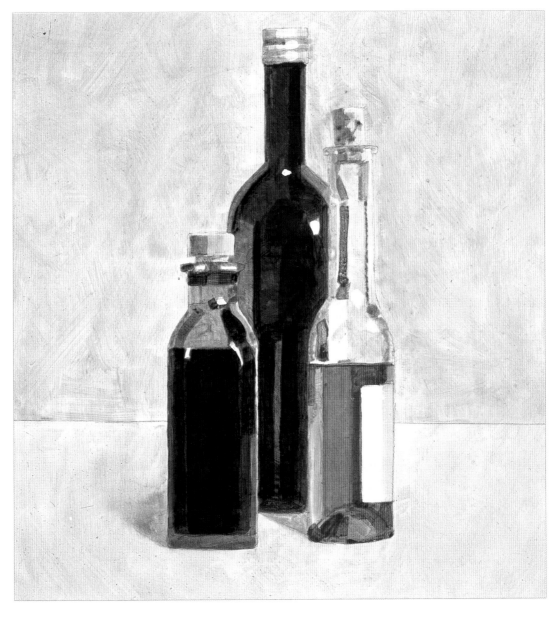

step 6 blending

focus: **three pears**

Materials

25 x 30 cm (10 x 12 in) prepared
 canvas board
2B graphite pencil
6 mm (¼ in) flat synthetic-fibre brush
12 mm (½ in) flat synthetic-fibre brush
Small synthetic-fibre fan blender
Turpentine
Alkyd painting medium
The palette:
- *Titanium white*
- *Cadmium red*
- *Cadmium yellow light*
- *Cadmium yellow*
- *Ultramarine blue*
- *Raw umber*
- *Viridian green*
- *Ivory black*

The 'invention' of oil paint, during the early years of the Renaissance, changed the way in which artists worked and how they looked at things. It was introduced at a time when artists were becoming interested in 'illusion' and optical trickery, and sought to paint images with an almost lifelike quality. Oil paints, with their potential for blending and creating imperceptible transitions from one colour or tone to another, made this more easily achievable.

USING BLENDING

Light falling on an object describes its form. The side facing the light source is invariably brighter in tone and colour, while the side facing away from the light source is darker. The change from light to dark is often a smooth transition of tone and colour rather than an abrupt change, and blended paint allows you to show this. Furthermore, the extended drying time of oil paint allows you to achieve this in an unhurried and considered way, adding or removing paint and modifying the result until satisfied. Blending can be overdone, however, and can look surprisingly flat and uninspired. Remember that you are creating a painting, not a photograph, and it can be advantageous to allow the character and quality of the painted mark to show.

Preparing to blend: The two colours for blending are mixed to produce a third colour, which is then placed between them on the painting surface before the points at which they all join are blended. The paint is applied relatively loosely at this point.

ROUGH BLENDING

Blending two or more colours or tones together requires a degree of preparation. Mix the two different colours or tones on the palette and apply them to the painting, side by side. Now work over the point at which they join using a flat brush and multi-directional strokes, mixing the two different applications of paint together.

An alternative approach is to mix a third tone or colour, which is part way between the two original mixes. You can achieve this simply by mixing amounts of both together on the palette. Apply the third tone or colour at a point between the two original mixes and blend as above to work the three applications of paint into one another.

SMOOTH BLENDING

In order to create a very smooth transition from one colour or tone to another you simply take the same process a step further. Firstly, apply the paint and rough blend as above. Clean and dry the brush and rework the area using softer, more considered brushstrokes. Keep removing paint from the brush as you work, by wiping it onto a rag or paper towel, but do not rinse in solvent, as this will ruin the blended effect. Flat-bristle or soft-hair brushes are best used for smooth blending. Alternatively, use a fan blending brush designed for this very purpose but avoid using it for mixing paint on the palette as this can spoil its shape, and take extra care in removing paint from the brush so as to avoid build-up.

Rough blending: When blending, multi-directional brushstrokes result in a more satisfactory blend than brushstrokes that all move in the same direction.

Smooth blending: For smooth blending, rework the area and remove excess paint from the brush until you reach a satisfactory transition from one colour or tone to the next.

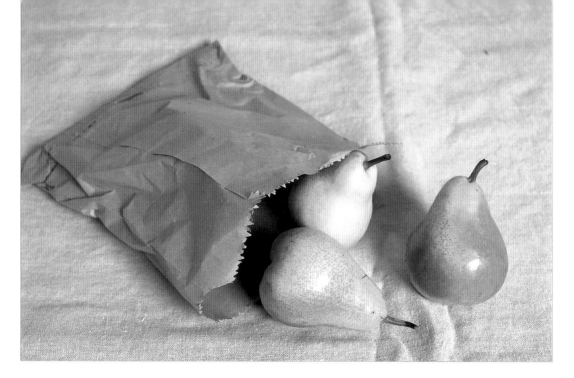

PAINTING THE THREE PEARS

Three pears spill from the bag in which they were bought, making a perfect still-life composition. The curved graceful forms of the pears contrast with the hard, crisp edges of the brown paper bag. Turpentine and alkyd painting medium are used for the mixes throughout.

1 Draw in the shape and position of the pears and the bag using the 2B pencil. Keep the drawing simple and relatively light. Mix a bright green using viridian green and cadmium yellow light. Take a little of this and add titanium white to lighten and then a little raw umber to subdue it. Variations of this mix provide the basic green colour range for all three pears. Paint in the green of the pears using the 6 mm (¼ in) brush.

2 Add cadmium red and raw umber to a little of this base green and use this colour to add the red bloom to each pear. Work the paint up to and into the green, softening the point at which they join using a clean brush.

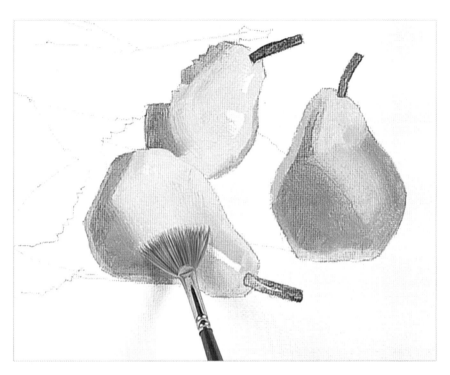

3 Carry out further blending, if needed, using the fan blender.

4 Return to the 6 mm (¼ in) brush. Make a light brown by mixing raw umber and cadmium yellow with a little cadmium red. Make this mix lighter or darker as required by using titanium white or ivory black and raw umber. Use variations of this mix to paint the paper bag, carefully taking each folded facet and crease in turn. Use a very dark mix for the inside of the bag.

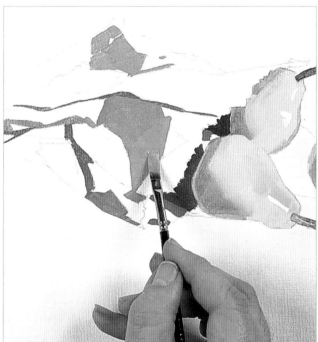

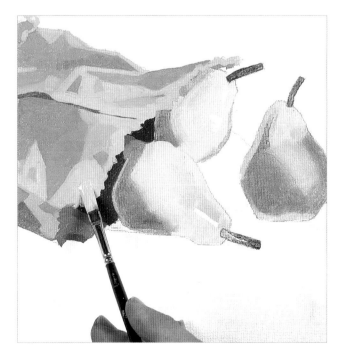

5 Add plenty of titanium white to the mix for the lighter passages, and continue until the bag is completely painted. Use the corner of the brush to paint the serrated edge of the open bag.

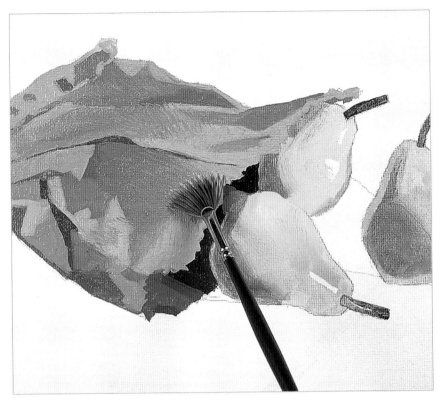

6 Use a clean fan blender to soften and blend together the join between the tones in those areas of the paper bag where the creases have less definition. Take care not to overdo this, or the creased and crumpled effect of the paper will be lost.

7 Mix a dark brown using raw umber with a little ultramarine blue. Add just a little titanium white and, with the 6 mm (¼ in) brush, paint in the shadow beneath and around the pears and the bag. Use a few simple brushmarks to render the shadows on the slightly crumpled cloth.

8 Make the colour for the tablecloth by adding plenty of titanium white to the brown mix, and paint using the slightly larger 12 mm (½ in) brush. Brush the colour freely over the dark brushmarks that represent the slight creases of the cloth, and use it carefully to work up to and around the painted pears and bag, redefining their shapes if needed.

9 Use the smaller of the two brushes to paint in a few white highlights on the pears.

10 In this relatively simple exercise, the finished image demonstrates how the blending of colours and tones on the painting surface can result in a more lifelike representation of the subject.

step 7 impasto

focus: **cabbage**

Materials

36 x 46 cm (14 x 18 in) prepared
 canvas board
Soft charcoal pencil
Fixative
6 mm (¼ in) flat synthetic-fibre brush
12 mm (½ in) flat bristle brush
Small trowel-shaped painting knife
Turpentine
Alkyd painting medium
The palette:
- *Titanium white*
- *Cadmium yellow light*
- *Ultramarine blue*
- *Pthalocyanine blue*
- *Raw umber*
- *Ivory black*

The Italian word *impasto* means dough and describes a technique using thick, heavy applications of paint that stand proud of the support. Paintings that have been made using impasto techniques have a tactile quality, which invites you to run your fingers over the painted surface once it is dry. Such pieces are wonderfully expressive works, retaining the marks made with the brush, painting knife or paint shaper when the paint was applied.

MIXING IMPASTO PAINT

Oil paint used straight from the tube for this technique can take a long time to dry and can wrinkle and crack. It can also use up paint very quickly. The answer is to combine the paint with a suitable painting medium. Do not add oily mediums, which will simply prolong the drying time. If you intend to create a work that uses only moderately thick paint, use a thick, gel-like, quick-drying alkyd medium. If, on the other hand, you require very thick applications of paint, use a heavy-bodied impasto medium that contains silica.

SUITABLE PAINTING SURFACES

Always work on a surface that is substantial enough and has a medium or course texture. There are several reasons for this: the thick paint, on even a moderately sized impasto work, can be quite heavy and may cause sagging; impasto paint is often applied in a robust or rough manner which could damage a delicate surface; the rougher texture helps the thick paint adhere to the support; and the pronounced texture of the surface will inevitably read through in places, so contributing to the overall effect of the painting.

APPLYING THE PAINT

You can begin an impasto painting by first creating a drawing. Charcoal is an especially suitable medium for this. Work loosely to encourage direct applications of paint. If you wish, you can also make an underpainting using paint thinned with turpentine or another diluent, but no added oil. Allow the painting to stand for a while, so that the diluent content evaporates, before starting any impasto work. You can apply the paint using bristle brushes, painting knives and paint shapers. Many artists also use a number of other ways to apply the paint including bits of wood, rags, forks or even their fingers.

MAKING CORRECTIONS

You can easily make corrections by scraping off paint using a painting or palette knife. Either discard the paint or return it to the palette for reuse. Take care to keep your colours crisp and true and avoid overworking an area. A successful underdrawing or painting will lead the way for sure, precisely placed applications of paint. Remember, also, that you can scrape or scratch into the paint to create a wealth of linear marks and textural effects, known as sgraffito (see Adding detail and texture, page 203). Once the painting is finished, place it somewhere safe so that the surface remains untouched until it is completely dry.

Mixing impasto paint: A heavy-bodied impasto medium added to the paint will increase the bulk of the paint without altering the colour. It will also reduce the paint drying time.

Brushwork: Work directly, using sure, precise applications of paint. If you fuss too much, you will compromise the textural qualities inherent in a good impasto work.

PAINTING THE CABBAGE

A cabbage was chosen for this project. Its strong textured leaves demand
a bold approach, and impasto techniques enable the true sculptural
quality and character of the vegetable to be described.

1 Begin by using the soft charcoal to
describe the shape of the cabbage
and the arrangement of the leaves
around the central heart. Include the
shape and position of the main dark
shadows. Fix the drawing if you wish.

2 Work the underpainting. Mix a dark green using pthalocyanine blue, cadmium yellow light and raw umber. Use only turpentine to thin or dilute the paint. Subdue the colour using ivory black, and apply to those areas in deep shadow, using the 6 mm (¼ in) brush. Brush the paint out well: you do not want a thick build up yet and, since you will be applying another layer of paint over the top of this, you do not want this underpainted layer to be too wet.

3 Lighten the mix by adding more cadmium yellow light and titanium white, and use the colour to block in the overall colour of the cabbage with the 12 mm (½ in) brush. Scrub the paint on so that the brushmarks can be seen. Keep the paint relatively dry and apply in a thin layer.

4 You are now ready to apply thicker applications of paint over the top of this underpainting. Lighten any mix that is left on the palette using titanium white and cadmium yellow light. You can also begin to add alkyd painting medium to your mixes now. Using deft, precise strokes of the brush, establish the light veins that run across the cabbage leaves. Keep the paintwork thick by loading the brush fully with paint before making a mark and avoid brushing the paint out too much.

5 Mix a brighter, mid-green using pthalocyanine blue, cadmium yellow light and a little raw umber, with ivory black to subdue it slightly. Add titanium white and, using directional strokes, begin to establish the lighter parts of each leaf with the 6 mm (¼in) brush. Make precise, one-stroke brushmarks: if you scrub, or overwork, the paint you will pick up any previously applied paint that is still wet.

6 Now establish the darker tones. Mix a dark green using pthalocyanine blue, cadmium yellow light, raw umber and ivory black. With precise, deft strokes of the brush, work around each of the leaves in turn.

7 Lighten the dark green mix slightly by adding more cadmium yellow light and a little titanium white, and establish the rest of the colour on each leaf. Again, use precise brushstrokes and plenty of paint. Allow the lighter underpainting to show through in places, which will help describe the uneven texture of the leaves.

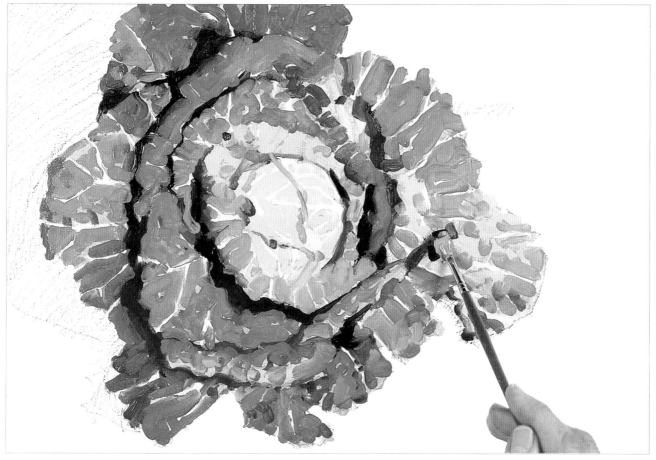

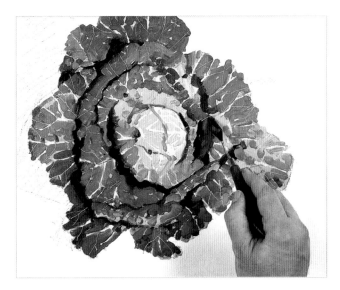

8 The paintwork should now look thick and juicy. You can work into areas by adding more paint, but beware of overdoing the brushwork or you will loose the definition and crispness that you have achieved. Use the point of the painting knife to draw into the wet paint, marking the very fine light veins that can be seen running across each leaf.

9 Use the edge of the same knife to apply crisp lines of dark paint to the leaves. Pick up a little dark-green paint using the edge of the knife, place the knife in position and make a precise stroke to leave a line of paint behind. Practise making these marks on a sheet of newspaper before committing yourself to making them on the painting itself.

10 The cabbage, although looking like a cabbage, appears to be floating in a white space and needs to be anchored firmly to its background. Mix raw umber and titanium white, with a little ultramarine blue. Use this colour to paint in the shadow on the left of the cabbage with the 12 mm (½ in) brush. Apply plenty of stiff, thick paint using short, fluid, multi-directional brushstrokes. Carefully work up to the cabbage leaves using the background paint to redraw the very edge of the leaves as required.

11 Lighten the mix using titanium white. Using the same brush as before, use multi-directional strokes to block in the rest of the background. Work up to the leaf shape as you go, redrawing the outline as required.

12 The finished image shows how the impasto technique can be used to great effect when the texture and surface characteristics of a subject are of equal importance to the artist as the colours and tones.

step 8 special techniques

focus: **marrow and garlic**

Materials

25 x 35 cm (10 x 14 in) prepared
 canvas board

Hard charcoal pencil

Fixative

6 mm (¼ in) flat synthetic-fibre brush

6 mm (¼ in) flat bristle brush

12 mm (½ in) flat bristle brush

2.5 cm (1 in) flat bristle brush

Turpentine

Alkyd painting medium

The palette:

- *Titanium white*
- *Cadmium red*
- *Cadmium yellow light*
- *Cadmium yellow*
- *Ultramarine blue*
- *Pthalocyanine blue*
- *Raw umber*
- *Ivory black*

The methods discussed here offer three different ways of applying paint, each rendering an effect that is difficult to achieve by other means. All are easy to use, although the effects achieved by optical mixing take a little time and patience.

SCUMBLING

For this technique you apply the paint in such a way that the paint layer or application underneath shows through in rough, irregular patches. Apply the paint using a stiff bristle brush and a brusque scrubbing, stippling, dabbing motion, or by rolling the brush over the support in a relatively haphazard way. You can also achieve a scumble using a rag or sponge. The paint used in scumbling techniques is usually of a stiff, 'dry' consistency although you can also use thinner, more fluid mixes of paint, taking care not to cover an area too thoroughly. Scumbling serves several purposes: you can use it to enliven a dull, flat area of paint; to represent textured surfaces; and to render the effects of dappled light. You can apply several scumbled layers, one over the other, but you must allow each layer to dry before applying the next.

Scumbling: Light colours can be scumbled over dark, and cool colours over warm. Colours that are similar in hue can be scumbled over one another, as can bright colours over dull ones.

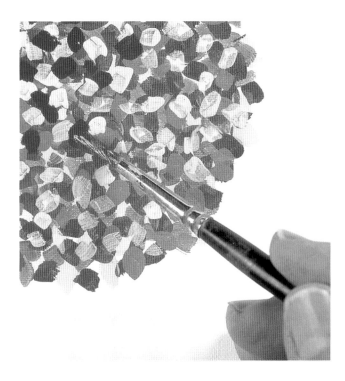

Broken colour: Areas of broken colour are those in which one, two or more applications of paint are made in succession, but are not blended with each other.

Optical mixing: Also known as pointillism, the optical-mixing technique takes time to do properly but is strangely satisfying to execute.

BROKEN COLOUR

While scumbling achieves a 'broken-colour' effect, the term usually refers to paint applied in small separate strokes that are not blended together. This is an important technique when working alla prima (see pages 202–207). Mixing the paint to a creamy consistency, you should keep the colours clean and bright, using direct brushwork and fluid, directional strokes that work around or follow the form of the object being painted. Paint applied in this way maintains a fresh, bright appearance and creates a jewel-like feel. Colour effects and transitions are achieved not only on the paint surface itself, but also in the eye of the viewer, as different areas of 'broken' colour appear to fuse together when viewed from a distance.

OPTICAL MIXING

The effect of pure colours fusing, or 'optically' mixing in the eye, is the central idea behind pointillism. Here, you place small dots or blobs of relatively pure hues in close proximity to one another. Like broken colours (see above) these dots seem to fuse together when viewed from a distance. You build up the small blobs or dots of colour steadily in layers: in order for each application of colour to remain absolutely 'pure', you allow one colour to dry before applying the next.

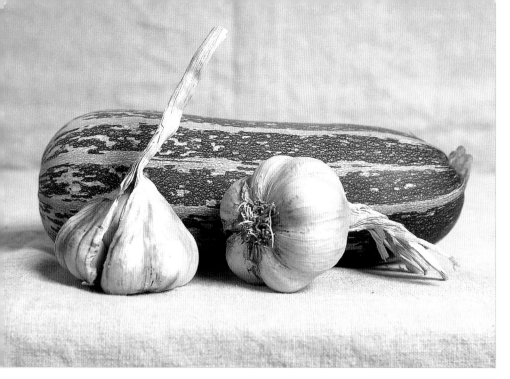

PAINTING THE MARROW AND GARLIC

The broken pattern on the marrow skin and the linear surfaces of the garlic provide an opportunity to explore scumbling and broken-colour techniques. Broken colour can be made wet into wet, but scumbling requires patience as it needs to be done on a dry or near-dry surface. Turpentine and alkyd painting medium are used in the mixes throughout.

1 Establish your composition using a hard charcoal pencil, which you can fix prior to painting, if required. Mix a bright green using alkyd painting medium, pthalocyanine blue, cadmium yellow light and raw umber. Lighten this by adding titanium white to create a pale green. Use the 6 mm (¼ in) bristle brush to scrub this onto the marrow. Gradually darken the mix around the base and stalk end of the marrow.

2 Mix raw umber, a little cadmium red, cadmium yellow and titanium white to create a pale ochre and apply as the base colour for the two bulbs of garlic.

3 Make the dull beige of the background by mixing raw umber with plenty of titanium white. As before, loosely scrub this over the whole of the area surrounding the three main objects in your painting.

4 Mix a darker, brighter green, again using pthalocyanine blue, cadmium yellow light and raw umber. Use this colour, with the 6 mm (¼ in) synthetic-fibre brush, to paint in the dark stripes on the marrow. You will be working into thin, wet paint so use very direct brushwork and do not be tempted to scrub the paint on, as it will simply mix with the previously applied layer. Now darken the green mix using ivory black, and use to paint in the stripes that are in shadow. Add a little cadmium yellow light and titanium white to create a slightly more acidic green, and work this into the lighter pattern.

5 Mix a dark ochre colour, using raw umber and cadmium yellow to which you add a little cadmium red. Add titanium white, then a little black to subdue the colour's intensity. Use this mix to paint in the dark areas on the garlic bulbs. Lighten or darken this mix as necessary using white or black, and paint in the various tones and colours that give the garlic bulbs form.

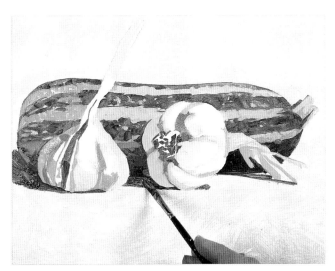

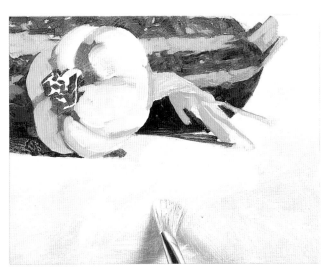

6 Still using the 6 mm (¼ in) synthetic-fibre brush, add the shadow beneath the marrow and the garlic using a mix made from raw umber and ultramarine blue.

7 Consolidate the background by using the same mix as in step 3, loosely working over it using a 2.5 cm (1 in) bristle brush. Leave your painting to dry. The fast-drying alkyd medium should allow this to happen in about 24 hours if the painting is placed in a warm environment.

8 Once dry, you can resume work. Mix a dark ochre using raw umber, a little cadmium yellow and a touch of cadmium red. Use the 6 mm (¼ in) synthetic-fibre brush to paint in the darks on the garlic bulbs. Use the very end of the brush to create the lines on the dry stem and the tangle of dry roots at the base of the bulb.

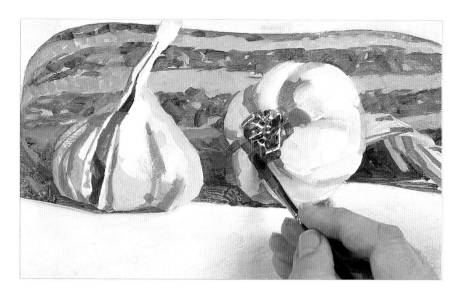

9 Add plenty of titanium white to this mix, but very little painting medium. Use this dry mix, and the very end of the brush, to create sharp textural lines on the dry garlic stems. Then, using the 12 mm (½ in) bristle brush, scumble over the lighter side of each garlic bulb using the same colour.

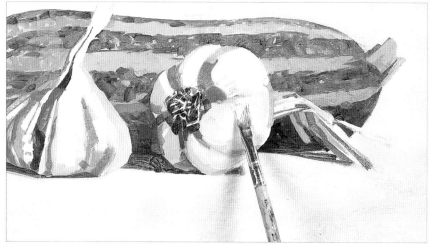

10 Mix a dark green using pthalocyanine blue, cadmium yellow light, a little raw umber and ivory black. Paint this onto the darker pattern on the marrow, creating a broken-colour effect using the 6 mm (¼ in) synthetic-fibre brush. Mix the same green again, this time making it much lighter by omitting the ivory black and adding more titanium white. Now use the broken-colour effect on the lighter patterned areas, overlapping dark-patterned areas with dabs of light green as appropriate.

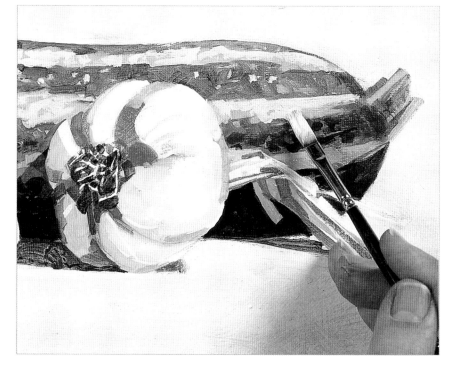

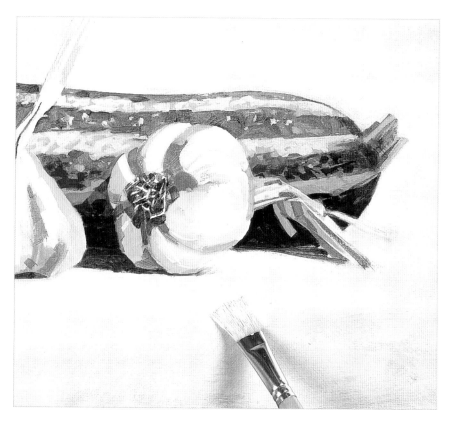

11 Remix and consolidate the background colour once more, using the larger 2.5 cm (1 in) bristle brush, making open, scumbled, brushstrokes to render a textural effect rather than a flat colour.

12 The finished image demonstrates how using the additional scumbling and broken-colour techniques can add a richness of colour and texture to a painting.

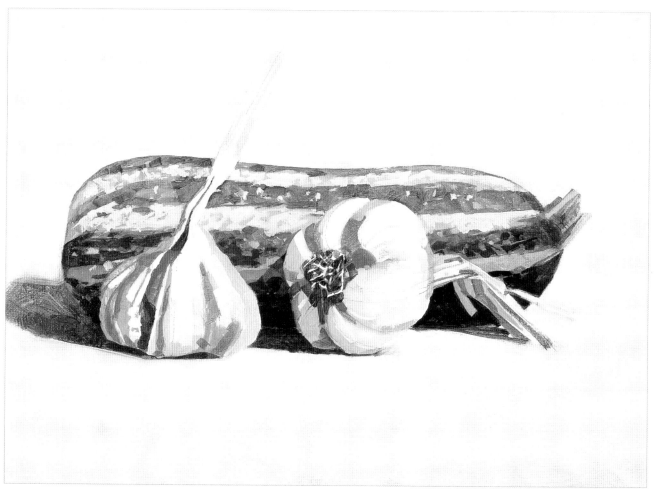

step 9 composition

focus: **arranging the elements**

Materials

2 L-shaped pieces of card
2 bulldog clips

Composition concerns the design of your picture and how you organize all of the elements within it. A good composition persuades the viewer to move through the image in a predetermined way, focusing on those elements that the artist feels to be important. Any element of a picture can have an effect on its composition – colour, tone, shape, scale, texture and perspective. Various formulae have arisen over the years to help the artist plan out an image, and one such formula is the rule of thirds (see page 236).

FORMAT

Your first consideration when working out the arrangement is to decide on the format or shape of the image, because this will have a direct influence on your composition. There are three main formats:

> **Landscape:** a rectangle with the longest side running horizontally.
> **Portrait:** a rectangle with the longest side running vertically.
> **Square:** while the proportion of the two rectangular formats can be altered, the square format always remains square, no matter how large or small.

BALANCE

Balance in composition invariably means playing one element off against another. A small, brightly coloured object could balance a large, flat area of colour; two small objects might balance the impact of one large object; a heavy texture might be balanced with a smooth texture; or a positive shape might be balanced with a negative shape. By using this 'point and counterpoint' principle, you will find that the possibilities are endless.

Landscape format: The landscape format persuades the eye to move across its area from side to side.

Square format: The square format is neutral. The eye tends to move from edge to edge, eventually spiralling in towards the centre.

Portrait format: The portrait format persuades the eye to move vertically up and down across the area.

THE RULE OF THIRDS

This principle is based on a classical formula known as the Golden Section. When using the rule of thirds you divide the picture area into thirds both horizontally and vertically. This division can be imagined or drawn onto the support using four correctly placed lines (see below). The theory is that, by placing important elements on or around the lines or the points at which they intersect, a pleasing composition results.

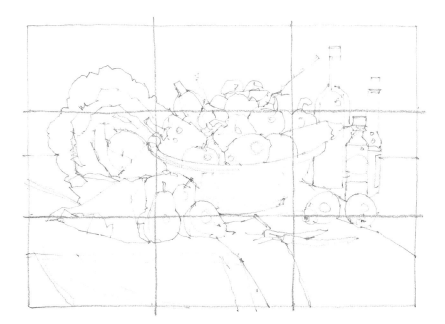

Deciding on the composition:
A landscape-format composition in which the picture area has been divided according to the rule of thirds.

Working out ideas: By making a number of sketched thumbnails before settling on your final composition, you can get a very good idea of what will work and what will not.

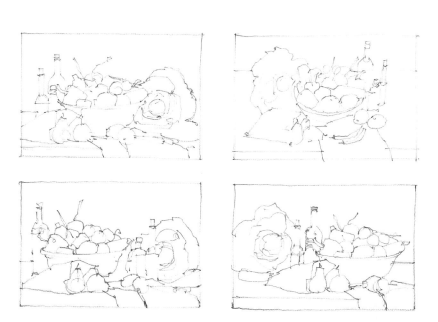

FOCAL POINT

All paintings should have at least one focal point – an element upon which you wish to focus attention. However, this should not be to the detriment of other elements within the image. In order to arrive at the focal point, you need to lead the eye on a predetermined path into and around the picture. You can do this in several ways, by connecting one element to another or by using a device known as a 'lead in'. Your lead in could be anything that literally leads the viewer in to the focal point – a log of wood, a road or a shaft of light.

BREAKING THE RULES

Many people have an instinctive sense of what makes a 'good' composition but, in some cases it pays to bend the rules a little. You can change an image dramatically by altering the viewpoint or the elements included in the arrangement, so try a number of different compositions before you begin work proper. Do this by making a series of simple, small sketches known as 'thumbnails' to work through a few possibilities.

MAKING A VIEWING FRAME

You can make a simple viewing frame by cutting two L-shaped pieces of card, and using them to 'frame' any format you like. Once you have a pleasing shape, simply hold the frame in place using two clips.

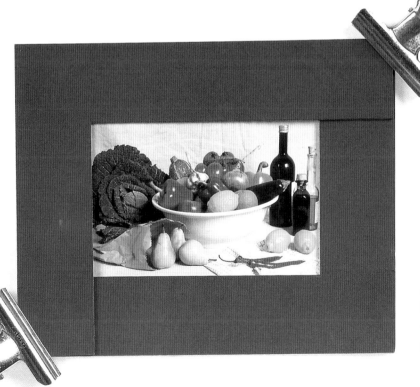

A simple viewing frame: You can hold the frame up and look through it to frame and check your composition before making any marks.

step 10 bringing it all together

focus: **still-life**

Materials

60 x 75 cm (24 x 30 in) prepared
 canvas board

Medium charcoal pencil

Red pastel pencil

Fixative

6 mm (¼ in) flat bristle brush

12 mm (½ in) flat bristle brush

3 mm (⅛ in) flat synthetic-fibre brush

6 mm (¼ in) flat synthetic-fibre brush

12 mm (½ in) flat synthetic-fibre brush

Turpentine

Alkyd painting medium

Small trowel-shaped painting knife

Red pastel pencil

The palette:

- *Titanium white*
- *Cadmium red*
- *Quinacridone red*
- *Cadmium yellow light*
- *Cadmium yellow*
- *Ultramarine blue*
- *Pthalocyanine blue*
- *Raw umber*
- *Burnt umber*
- *Viridian green*
- *Dioxazine purple*
- *Ivory black*

A still life has been constructed using articles bought on a typical food shopping trip. They have been chosen for their wide range of colours and textures. Arranged around a white bowl on a cloth-covered tabletop, the composition is constructed using the basic rule of thirds (see page 236). Nothing dominates: instead, attention moves in a loosely oval direction from one object to the next. The work is built up in three layers: a loose underpainting, a middle layer that consolidates the image and a final layer that reassesses and develops colour, tone and texture.

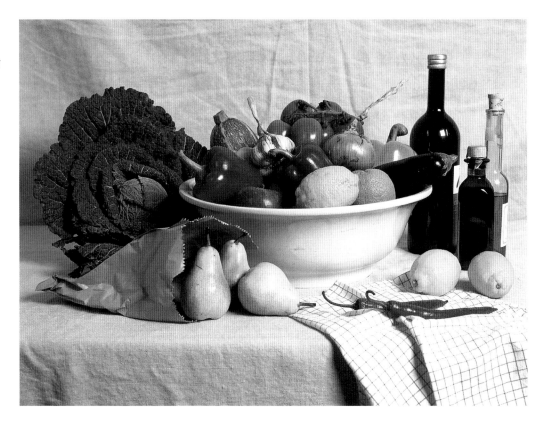

Stage 1: underpainting the composition

1 Using a sharp charcoal pencil, sketch in the composition on your canvas, using simple shapes and fluid strokes. Note that the composition is loosely based on the rule of thirds. Work lightly: holding the pencil high up the shaft will prevent you using too much pressure.

2 Rework the image once you have established the position of everything. Redraw and reposition each element in relation to its neighbour. As well as concentrating on the shape and scale of each object, draw in the shape and extent of any shadows, and the position of any major changes in tone and colour.

3 Step back to view your work. Your drawing can be as elaborate as you wish. The important thing is that you feel comfortable that enough information is included at this stage in order to guide you when it comes to applying the paint. If you wish, give the drawing a light coat of fixative to prevent the charcoal dust from mixing with the paint.

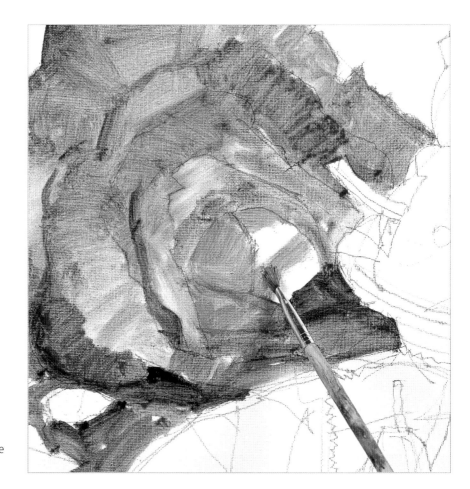

4 Now start on the underpainting. Keep your mixes 'thin' by adding plenty of diluent and a little alkyd medium. Begin by blocking in the cabbage using the 6 mm (¼ in) bristle brush and a range of greens made by mixing viridian green and cadmium yellow light, which you then modify using raw umber, ivory black and a little titanium white.

5 Move on to the pears spilling from the bag at the front of the composition, using cadmium yellow and titanium white together with a little green from the mixes used for the cabbage. Add a little cadmium red to warm up the mix for the reddish bloom on the skin. Leave the white canvas to show where there are highlights.

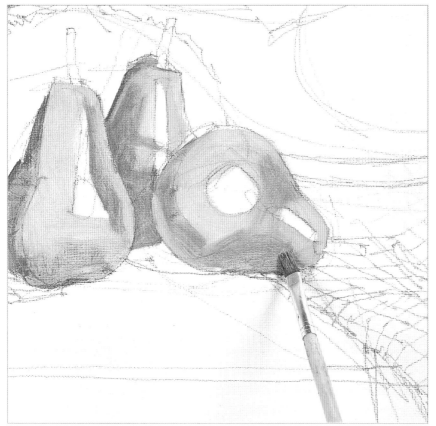

6 Paint in the paper bag with a range of light, ochre browns made using raw and burnt umber, cadmium yellow and titanium white. Add a little dioxazine purple to raw umber for the dark brown inside the bag. Work across the image, blocking in the fruit in the bowl and in front of the bottles. Make the red and orange mixes for the pepper using cadmium red, quinacridone red and cadmium yellow, darkened with a little green and raw umber. Use, also, the cabbage-green mixes; yellow and light pear-green mixes; and the brown paper-bag mixes for the onion.

7 Use light grey mixes to block in the shadows on the white bowl, adding a little yellow under the rim of the bowl to suggest reflected colour from the pears. Paint the aubergine using a dark-violet mix made from dioxazine purple and burnt umber with a little added ivory black. Create a dark blue-green for the bottles by adding viridian green and a little pthalocyanine blue to the aubergine mix.

8 Use light yellow and ochre mixes, similar to those used on the bag, for the corks and cap on the bottles. For the background and the tabletop covering, mix a light beige using raw umber, cadmium yellow and a little dioxazine purple, then add titanium white. Block in these larger areas using the 12 mm (½ in) bristle brush. Use a slightly darker version of this mix for those areas that are in shadow.

9 Lighten this last mix considerably with titanium white and, still using the 12 mm (½ in) bristle brush, block in the patterned napkin at the front of the image.

10 You have completed the underpainting. The image is now completely blocked in using thin applications of 'lean' paint. Both colour and tones are established and ready to be modified. Leave the painting to dry before proceeding – the addition of the fast-drying alkyd medium means that this should happen overnight.

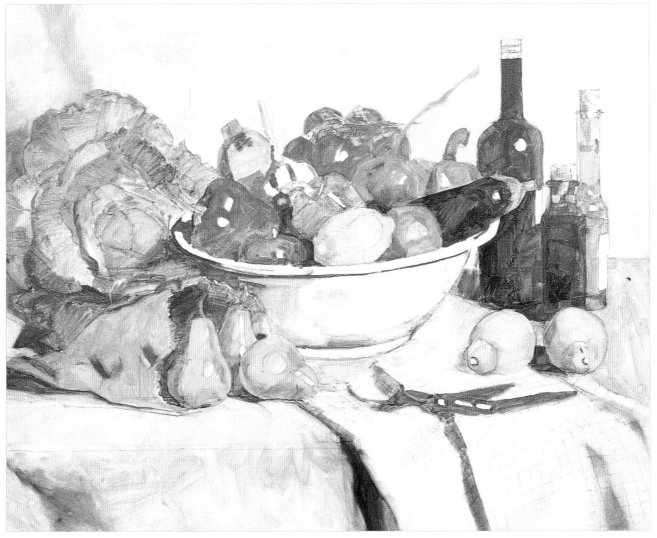

Stage 2: consolidating the image

11 Return to your painting, working across the image in roughly the same order as before. Begin by developing the colour of the cabbage, using similar mixes. Keep the paint to a creamy consistency this time, using alkyd medium and turpentine. Use the 6 mm (¼ in) synthetic-fibre brush to apply the paint. Allow the underpainting to show through in places if you wish.

12 Adapt your green mixes for work on the marrow and the green pepper. Paint in the stalk of the tomatoes now, the stalks of the two red chillies at the front right of the image and the stalk of the aubergine.

13 Mix a range of light browns using raw and burnt umber, modified using cadmium yellow, a little cadmium red and plenty of titanium white. Use this colour to paint in the facets of the creased and crumpled paper bag with the 12 mm (½ in) synthetic-fibre brush. For the inside of the bag, mix dioxazine purple and ivory black with raw umber.

14 Return to the 6 mm (¼ in) synthetic-fibre brush. Use the same mixes to develop the onion. Then, working with a range of deep reds and oranges, strengthen the colour on the tomatoes and the red pepper. Add some light green to the deep-red apple at the front of the bowl.

15 Consolidate the colours of the three pears with light yellow and green mixes. Add a little cadmium red and raw umber for the shadows. Add titanium white into the highlights and use raw umber for the stalks. Rework the lemons using bright-yellow mixes made using both yellows and a little cadmium red, modified with a little bright green. For the orange objects, use combinations of both reds and both yellows modified using a little dioxazine purple.

16 Make deep-violet mixes for the aubergine using dioxazine purple darkened with raw umber and modified using quinacridone red and pthalocyanine blue. Lighten the mixes by adding titanium white.

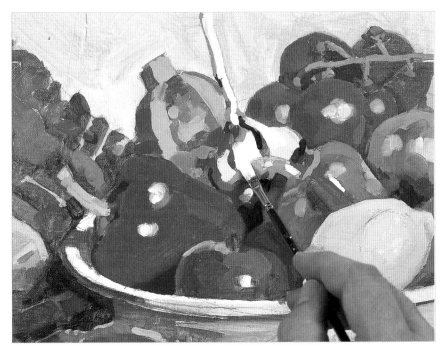

17 For the garlic, use subtle shades of titanium white modified using raw umber, cadmium yellow light, dioxazine purple and ultramarine blue.

18 Stand back from your work again. See how the objects now appear to have a real solidity and the colours and tones are beginning to look correct. The brushwork remains crisp and interesting.

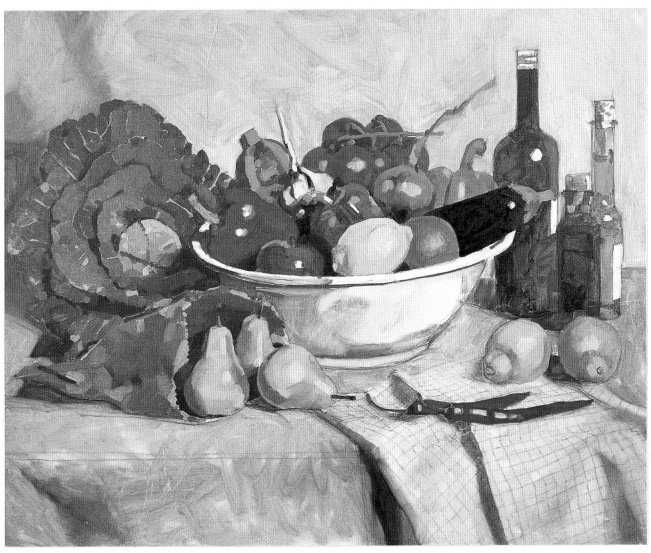

Stage 3: developing colour, tone and texture

19 Using the 3 mm (⅛ in) synthetic-fibre brush, develop the colour and detail on the bottle cap and corks. Use deep-yellow mixes for the cap but mix a more ochre yellow for the corks. Bring a little ochre down into the neck of the clear bottle.

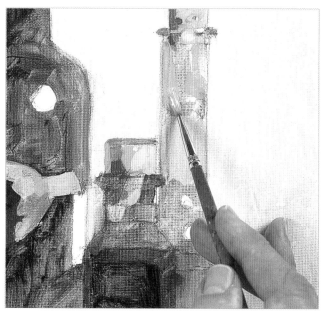

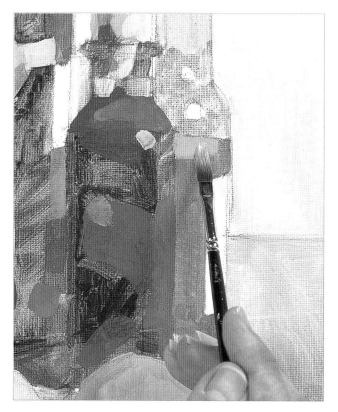

20 Make dark-green mixes from viridian green, raw umber and pthalocyanine blue, modified by adding cadmium yellow light. Use these, and the 6 mm (¼ in) synthetic-fibre brush, to suggest the lighter reflected colour on the two dark bottles. Repaint the amber contents of the lighter bottle using a mix made from cadmium red and cadmium yellow into which you add a little raw umber, then lighten using titanium white.

21 Using the 12 mm (½ in) synthetic-fibre brush, paint the darker colours on each bottle using mixes of viridian green, raw umber, pthalocyanine blue and ivory black. Work around the lighter reflections and highlights.

22 Turn your attention to the bowl. Paint the side that is in shadow and the area beneath the lip in a range of greys that are mixes of ivory black and titanium white, modified by adding a little raw umber and dioxazine purple. Add a little cadmium yellow light to this mix to create the patches of reflected colour and use a clean, pure titanium white for the side of the bowl facing the light.

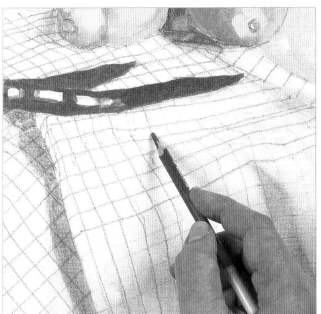

23 It can be difficult to draw fine lines with a brush, so use a red pastel pencil to draw in the pattern on the napkin. The effect is subtle and does not overpower.

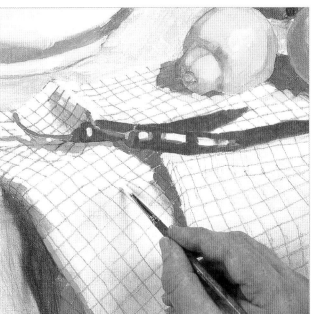

24 Return to the dark greys used for the bowl, and use them now to paint in the shadows on the napkin. Use titanium white to consolidate the overall colour and tone of the napkin. Apply the paint using the 3 mm (⅛ in) synthetic-fibre brush, working between the red pastel pencil lines.

25 Remix the deep beige colour used for the background and repaint this using the 12 mm (½ in) synthetic-fibre brush. Redraw the shapes of your objects and tidy up their edges as you work, if it seems necessary.

26 Use the same mixture, darkened considerably by adding dioxazine purple, raw umber and a little ivory black, to paint in the shadows beneath the cabbage and the brown paper bag. Use the smaller brushes to paint the thin shadow beneath the bag.

27 Lighten the background mix by adding titanium white and, using the 12 mm (½ in) synthetic-fibre and open brushstrokes, work this colour over the tablecloth. Where the tablecloth falls over the front of the table, lighten the colour by adding more titanium white.

28 Reassess the highlights now. If they appear too bright and strident tone them down a little using the appropriate colours, applied with the smaller brushes.

29 Step back from your work again. The colours are looking richer, the forms have solidity and there is a real sense of depth. It is a good idea to leave the painting to dry overnight at this point.

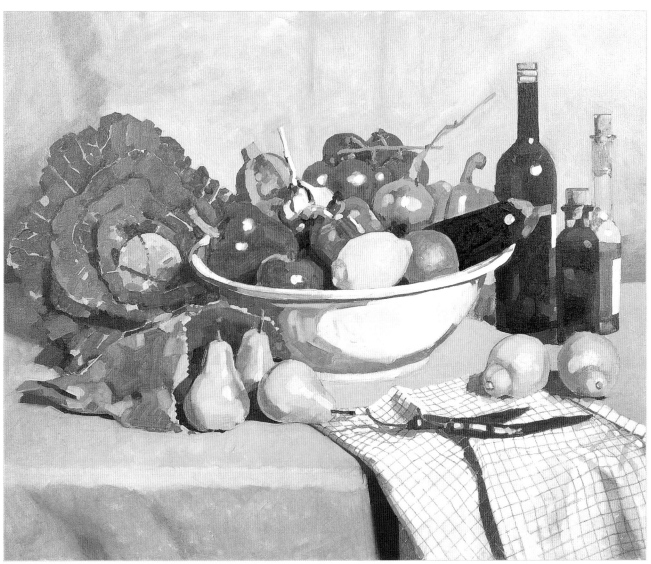

Stage 4: completing the picture

30 The textured surface of the cabbage requires more work. Remix a range of greens and darken the darks and lighten the lights of the cabbage using the 12 mm (½ in) synthetic-fibre brush. This has the effect of increasing the sense of form and the characteristic surface texture.

31 Render the veins that run across each leaf by using a sgraffito effect (see page 203). Use the palette knife to scratch through the wet paint applied in the previous step. You can achieve the same effect by using the pointed end of a wooden paintbrush or your fingernail.

32 Return to the 12 mm (½ in) synthetic-fibre brush. On those fruit that have a textured surface, like the lemons, apply the paint using a scumbled effect to represent the rough, pitted surface (see page 228).

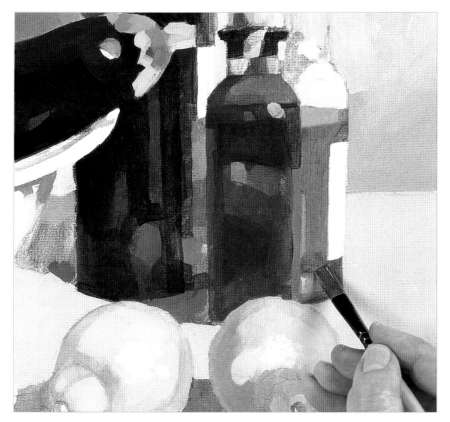

33 Darken the bottles. Mix a very dark green using viridian green, raw umber, pthalocyanine blue and ivory black. Use this as a thin glaze over the darkest reflections on the two dark bottles. Use a dark orange made from cadmium red, cadmium yellow and a little raw umber on the contents of the clear bottle.

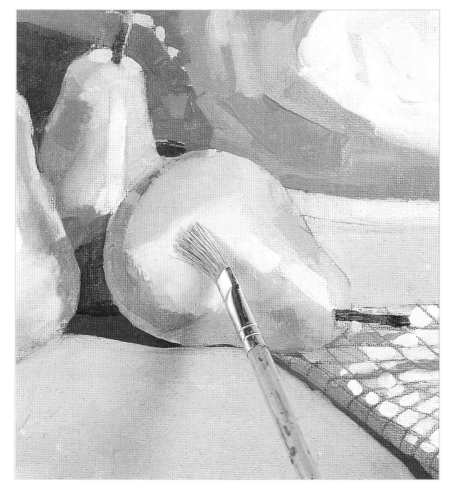

34 The tonal transitions from light to dark are still a little abrupt in places. Soften these by blending the paint, using loose but precise brushwork and the 6 mm (¼ in) bristle brush.

35 Intensify the reflected colour on the lighter fruit, especially the lemons, using a little glazed colour.

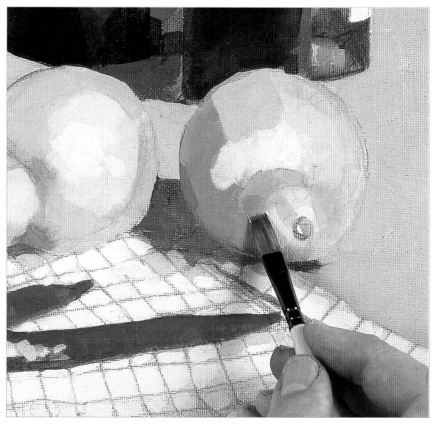

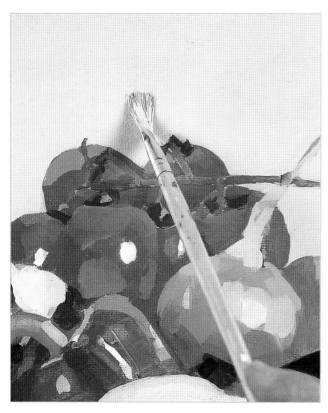

36 Repaint the background, using the 12 mm (½ in) bristle brush, making open brushstrokes that allow the previous colour to show through in places.

37 Lighten the mix and apply the same treatment to the tablecloth using the 12 mm (½ in) synthetic-fibre brush and multi-directional strokes.

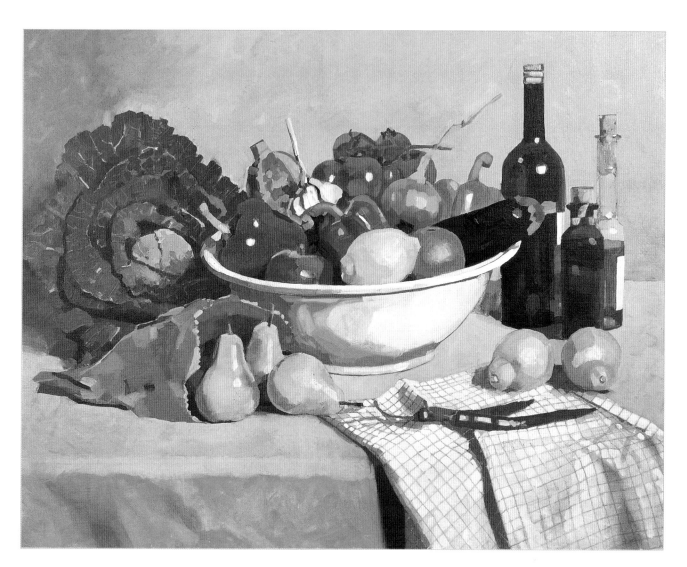

38 In completing the painting, you have used the majority of techniques demonstrated in the previous steps of the book. In addition to settling on a workable composition, you have established shape, tone and colour at an early stage, and have built up the colour in stages. As the painting progressed you used a range of techniques – including blending, scumbling and glazing – to achieve the desired effect.

acrylics
in 10 steps

before you begin

choosing the right materials

The materials that you need for painting with acrylics are available at most, if not all art stores; they are made by reputable manufacturers and are of good quality. In order to keep initial costs to a minimum, the shopping list below covers just the essentials and those materials necessary for completing the projects in this book. Initially you should buy only what you really need. Further materials may be purchased as and when necessary.

Shopping list

Acrylic paints:

Titanium white: PW6

Quinacridone red: PV19 (also called quinacridone magenta)

Cadmium red medium: PR108

Cadmium yellow medium: PY35

Lemon yellow: PY3 (also called primary yellow, hansa yellow, cadmium lemon)

Ultramarine blue: PB29

Pthalocyanine blue: PB15

Pthalocyanine green: PG36

Dioxazine purple: PV23

Raw umber: PBr7

Burnt umber: PBr7

Yellow ochre: PY43

Mars black: PBk 11

Painting surfaces:

25 x 30 cm (10 x 12 in) prepared canvas board (x 4)

25 x 40 cm (10 x 14 in) prepared canvas board

40 x 50 cm (16 x 20 in) prepared canvas board

60 x 75 cm (24 x 30 in) prepared canvas board

50 x 60 cm (20 x 24 in) prepared canvas board

25 x 30 cm (10 x 12 in) sheet of 535 gsm (250 lb) 'not' surface watercolour paper

55 x 75 cm (22 x 30 in) sheet of 638 gsm (300 lb) 'not' surface watercolour paper

25 x 30 cm (10 x 12 in) MDF board prepared with gesso

Brushes and paint applicators:

12 mm (½ in) flat synthetic-fibre brush

6 mm (¼ in) flat synthetic-fibre brush

3 mm (⅛ in) flat synthetic-fibre brush

18 mm (¾ in) flat bristle brush

12 mm (½ in) flat bristle brush

6 mm (¼ in) flat bristle brush

A size 8 round synthetic-fibre brush

Medium-sized rigger brush

Medium-sized bristle fan blender

Medium-sized watercolour wash brush

Small trowel-shaped painting knife

Spatula-shaped painting knife with angled end

Natural sponge

Mediums:

Matte

Gloss

Heavy gel

Texture pastes:

Black lava texture paste

Natural sand texture paste

Miscellaneous:

Hard charcoal pencil

HB graphite pencil

2B graphite pencil

Masking tape

Fixative

Scrap paper

Your art materials should last a long time if well looked after, and you should need to replace paint and mediums only as they are used up. Acrylic paint dries very quickly when exposed to air, so be fastidious about replacing tube caps and bottle tops, and also in cleaning your brushes and other tools. If you aren't your paint and brushes will very quickly become unusable. Your most regular purchase will be a surface on which to paint and here, as with many things, you get what you pay for.

ACRYLIC PAINT

Acrylic paint is made by suspending a pigment in what is known as an 'acrylic polymer emulsion' – a milky solution that dries clear and is soluble in water – and is applied to a surface mixed with water. As the water content evaporates, the emulsion binder dries relatively quickly to form a flexible and permanent clear film, which holds the pigment onto the support. Once dry, the paint is permanent and cannot be moved.

Acrylic paint is available in different degrees of thickness or viscosity. High-viscosity paint is relatively fluid and usually comes in bottles, medium-viscosity paint is stiffer and usually comes in tubes, while heavy-bodied acrylic paint is thicker still and usually comes in jars or tubs. You should select the type or viscosity according to the type of work you are doing, although the consistency of each can be altered using additives and all paint can be thinned further simply by adding water.

Paint is usually classified as either 'student' or 'artist' quality – the latter being more expensive than the former (see page 177). The two can be mixed together, however, as can acrylic paint from different manufacturers.

Paint tube labels give the name of the paint colour and the pigment type used, and may also state the degree of light-fastness – the extent to which the paint remains unaffected by light – along with the relative opacity or transparency of the colour. In order to create clean, bright mixes try, whenever possible, to use colours that have been made using a single pigment: the more pigments that are mixed together the less pure the resulting colours will become.

Because acrylic paint dries quickly it is best to put out only the colours you intend to use immediately, in quantities you know you will use: you can always add more! The milky appearance of wet acrylic paint often means that the colours look paler than the intended colour once dry and translucent. Although slight, this colour shift can be off-putting, but it will not be long before you learn how to mix your colours accordingly.

PALETTE COLOURS

In theory, it is possible to mix every colour you could ever need from three carefully chosen primary colours (see Step 2, pages 268–273). Most artists, however, work with a relatively limited palette, from which they mix all of the colours they need.

Our 'beginner's palette' consists of twelve single-pigment colours, plus white. The names of the colours may vary according to manufacturer, so the list opposite includes the relevant pigment codes (see Colour Index codes, page 178) in order to make finding the exact hues easier.

PAINTING MEDIUMS
AND ADDITIVES

There are countless painting mediums and additives available for altering the appearance of acrylic paint, or the way in which it behaves. Although acrylic paint can be used just with water, the true potential of the material can only be fully exploited by using such mediums. Some mediums are iridescent and can make the paint shimmer and sparkle, or resemble gold, silver and copper; some additives bulk out the paint and set it rock hard so that it can be sanded or carved into shape. The possibilities are plenty. For the purposes of this book, however, the mediums and additives listed suit more conventional applications.

The two most commonly used painting mediums are 'matte' and 'gloss', both of which you add to the paint as you work. They are slightly milky and fluid in appearance but dry clear. As their names suggest, matte medium dries to leave a matte finish while gloss medium imparts a gloss finish to the dry paint. The two can be mixed together to produce a finish with varying degrees of sheen. Gloss medium increases the transparency and intensity of the colours and some gloss mediums can be used as a final varnish.

Thicker versions of each type are available and add body to the paint, making them an ideal choice for impasto work (see Step 5, pages 286–291). The addition of these 'gel' mediums also increases the transparency of the paint. In order to bulk out the paint without affecting its opacity use an additive known as an 'extender': this does not affect the colour but does increase the volume of the paint. If you are using large quantities of expensive paint adding an extender to the mixes can cut costs.

The fact that acrylic paint dries relatively quickly can cause problems when working 'wet into wet' or blending large areas of colour (see Step 3, pages 274–279). 'Retarding' mediums prolong the drying time of the paint and keep it workable for much longer. 'Glazing' mediums increase the transparency of the paint and prolong the drying time slightly to enable the smooth application of flat glazes. 'Flow improvers' reduce the surface tension of paint that is very liquid, making it easier to brush out and prevent beading and puddling on the paint surface. Added to thicker paint, it will reduce the appearance of any brushstrokes. Always follow the manufacturer's instructions for quantities and mixing.

TEXTURE PASTES

For many years, artists have added sand, plaster or sawdust to oil paint in order to give it bulk and a physical texture. Along similar lines, manufacturers of acrylic paints produce a relatively large selection of texture pastes that hold various types of aggregate in an acrylic gel (see pages 300–301).

GESSO AND VARNISH

You can use acrylic paint on any suitable surface without prior preparation. If you wish, you can seal the surface by applying a coat of matte painting medium diluted with water. Alternatively, acrylic gesso primer provides a brilliant white surface on which to work. Coloured gesso is also available, or you can colour your own simply by mixing gesso with acrylic paint. Once a painting is finished and dry, you may wish to apply a coat of protective varnish. Gloss, matte and satin variations are available and can be mixed to create the desired surface finish.

BRUSHES, PAINTING KNIVES
AND OTHER APPLICATORS

Any kind of brush can be used with acrylic paint (see pages 96–98 and 178–179). The choice depends on the type of painting – or the technique used – and the intended effect. Whatever brush you use, be

Painting medium: Mix acrylic painting medium into your paint, along with water, until you achieve the desired consistency for the work you intend to do.

fastidious about cleaning it with soap and water once you have finished work and never allow paint to harden on the brush. Avoid leaving brushes resting on their bristles in water for long periods of time: it is far better to rest them in a tray of water with just the bristles or fibres and part of the ferrule submerged.

Palette or painting knives and paint shapers are alternatives to working with brushes. In fact, acrylic paint can be applied using almost anything to hand. Use natural and man-made sponges to render a range of wonderful effects, or experiment with cotton wool buds, cocktail sticks, bits of broken wood, foam rollers, broken combs or adhesive spreaders.

PALETTES

Whether you use a flat-surfaced palette or one with wells will depend on the consistency of your paint. The main requirement when working with acrylic paint is that it should not adhere permanently to the surface of your palette. This means using one made from plastic, formica, ceramic, metal or glass, or a 'disposable' palette (see page 182).

Unused paint needs to be cleaned from your palette after each work session and this can be wasteful, because it is very easy to put out more paint than you need. The solution is to use a 'stay-wet' palette, which allows you to keep colour mixes in a fluid state for a number of days.

PAINT SURFACES

Acrylic paint can be used on any surface that is permeable and non-greasy. This means that there is an extremely wide choice of surfaces, including all those traditionally used for oil and watercolour painting.

You can use any type of paper or card without preparation; or you can seal using a matte painting medium or prime them using an acrylic gesso. Paper intended for watercolour painting is resilient and makes an excellent choice (see pages 93–95).

As for wooden panels, hardboard, plywood and medium density fibreboard (MDF) are all suitable (see page 181), with MDF being the most adaptable. It has

a smooth surface and can be used sealed with painting medium or primed with gesso.

Linen canvas and cotton, known as 'cotton duck' are the two traditional fabrics used for painting (see page 181). As with other supports, you can seal both with painting medium or prime either using gesso. You can also buy canvas and cotton duck surfaces ready prepared in a wide range of sizes.

ADDITIONAL EQUIPMENT

Once you gain confidence in painting, it may be worth investing in a drawing board and one of the many different types of easel (see page 183). The drawing board offers a solid base on which to secure your paint surface as you work and, if you do not yet have an easel, can be propped up at an angle simply by raising one end on books or bricks.

step 1 basic paint application

focus: **red peppers**

Materials

25 x 30 cm (10 x 12 in) prepared
 canvas board

Hard charcoal pencil

Fixative

Matte acrylic painting medium

6 mm (¼ in) flat bristle brush

18 mm (¾ in) flat bristle brush

6 mm (¼ in) flat synthetic-fibre brush

The palette:

- *Titanium white*
- *Quinacridone red*
- *Cadmium red medium*
- *Cadmium yellow medium*
- *Lemon yellow*
- *Pthalocyanine green*
- *Dioxazine purple*
- *Raw umber*
- *Yellow ochre*
- *Mars black*

The fast-drying nature of acrylic paint makes it possible to create an image using several layers in one extended work session. The paint dries and hardens as the water content evaporates and the quality of the painted surface always remains sound.

ADDING PAINTING MEDIUMS

You can use acrylic paint straight from the tube, thinning it to the desired consistency using only clean water. However, most artists tend to work with an acrylic painting medium as well as water (see Painting mediums and additives, page 258). Available in either matte or gloss, you can add them either separately or together to produce varying degrees of sheen. The main difference between the two is that using gloss medium increases the transparency of the paint and, owing to its reflective qualities, tends to make colours appear brighter.

Adding painting medium: Add gloss or matte painting medium to acrylic paint at the mixing stage. The amount you add depends on the desired consistency of the paint and the intended depth of colour.

Gloss painting medium: This imparts a gloss finish to the dry paint (left) while matte medium imparts a matte finish (right).

well diluted with water and painting medium. Once the underpainting is dry, which happens very quickly, you can apply subsequent layers – as many as you wish and using thicker, more opaque, applications of paint – to build up the composition.

One of the very first things that you may notice when using acrylic paint is the slight shift in tone and colour as the paint dries. This happens because acrylic medium has a slightly milky colour when wet, which makes the paint colour appear lighter than it really is. As it dries, the acrylic painting medium becomes clear, allowing the true colour of the mix to show. This is particularly noticeable in light to mid-tone colours.

ACHIEVING DEPTH OF COLOUR

All acrylic colours are recognized as being intrinsically transparent, translucent or opaque. However, even those colours that are labelled opaque are not completely so, and you may need to apply several layers of a colour in order to achieve total coverage. This is particularly the case when using dark colours over light. Depth of colour is usually achieved by working in layers, often on a coloured, mid-toned ground known as an 'imprimatura'. The first layer broadly establishes the overall composition and provides a firm foundation upon which to develop the painting. The paint used in this 'underpainting' is invariably reasonably 'thin' and

WORKING EFFECTIVELY

The relatively fast drying time of acrylic paint is of huge benefit to the artist, however it also has its drawbacks. While it may only be a matter of minutes before you can paint over a newly painted area, this also means that you have a very limited amount of time in which to manipulate the paint should you wish to. This rapid drying time also affects the paint waiting to be used on the palette and any paint left on brushes. One way to keep the paint on the palette workable is to spray it once in a while with clean water, and you should always keep brushes in water. You may also wish to consider mixing a retarding or slow-dry medium with your paint. These slow down the drying time of the paint and enable you to blend and manipulate it for much longer.

Shifts in tone and colour: You need to adapt to the fact that a paint mix is slightly darker when dry (left) than wet (right). If you are unsure you can always test your mixes on a sheet of scrap paper, checking the colour and tone of each before applying them to your painting.

PAINTING THE RED PEPPERS

In this exercise you learn how to mix acrylic paint with water and a painting medium. You will discover how to achieve the desired paint consistency and will begin to learn how to compensate for the slight colour shift that occurs when the paint dries. The exercise also demonstrates how little colour you need to add in order to change the colour of a mix, how the paint handles, and how it brushes out onto the paint surface.

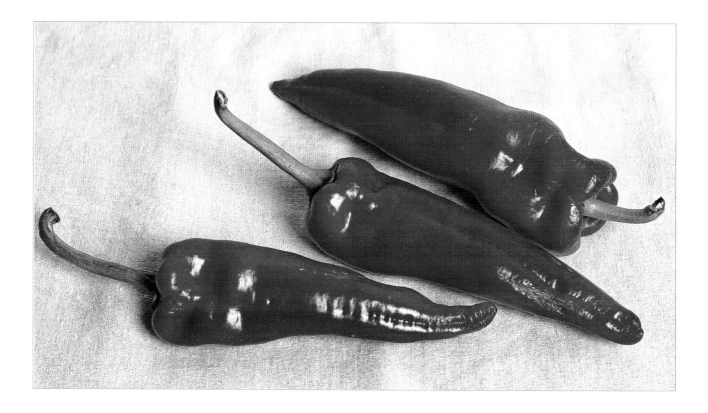

1 Sketch in the position of the three peppers using the charcoal pencil. Begin with basic shapes and elaborate once you are happy with the composition. Apply a coat of fixative to prevent the charcoal mixing with the initial thin layers of paint.

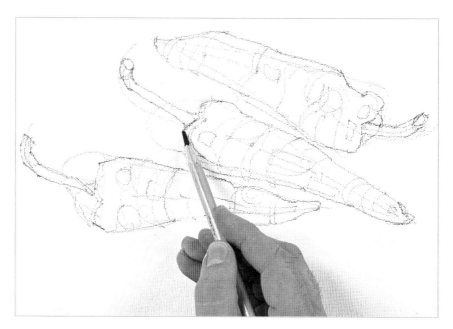

2 Add water and painting medium to your paint mixes throughout this exercise. Mix cadmium red with a little cadmium yellow and use the 6 mm (¼ in) flat bristle brush to block in the lighter areas of colour, avoiding the main highlights at this stage.

3 Mix an intense red using cadmium red and quinacridone red and use this, together with the previous mix, to establish the main shape and overall colour of each of the peppers.

4 Combine lemon yellow and pthalocyanine green to produce a light green for the pepper stalks. (Take great care when using pthalocyanine green: it is an incredibly strong pigment and can easily overpower your mixes.)

5 Establish the shadow area beneath each pepper using a dark brown made by mixing together raw umber with a little yellow ochre and a little dioxazine purple.

6 Now paint in the background. Mix a light ochre colour using plenty of titanium white with a little yellow ochre and raw umber and apply using the 18 mm (¾ in) bristle brush. As you work use the paint to redraw the shape of each pepper if required. All areas of the painting have now received a first layer of colour.

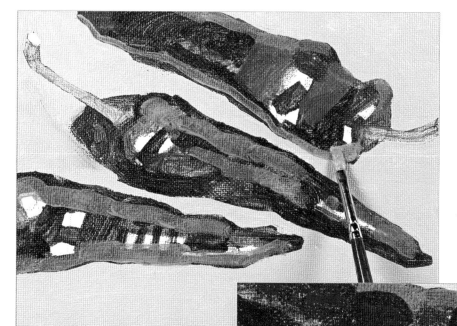

7 Your work from here will be more considered, and the brushwork more precise, as you focus more accurately on the colours and tones of the peppers. Begin by creating a light orange using cadmium red, cadmium yellow and a little titanium white. Use the 6 mm (¼ in) synthetic-fibre brush to apply this colour to those areas where reflected colour has lightened the red of the pepper skin.

8 Now turn your attention to the range of red mid tones that describe the uneven shape of each pepper. Mix these from quinacridone red, cadmium red, cadmium yellow and dioxazine purple.

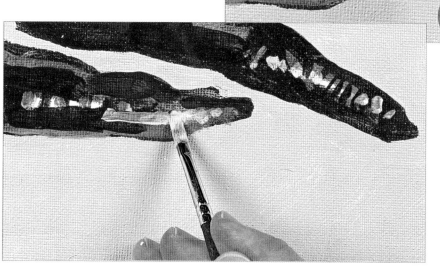

9 Add the highlights by painting a few dabs of titanium white onto the still-wet surface of each pepper.

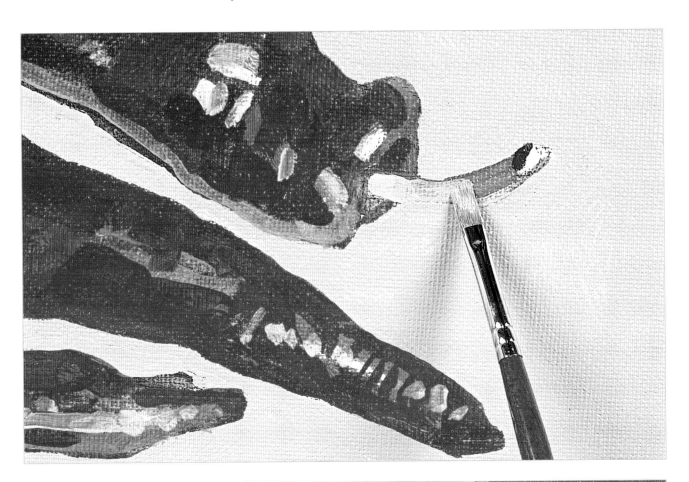

10 Now repaint the green stems. Start with a light-green mix made from pthalocyanine green and cadmium yellow. Subdue or lighten this by adding yellow ochre and titanium white to create a range of greens to match those on each stem. Add a little dioxazine purple to the same mix for the darker tones.

11 Rework the background. Begin by repainting and softening the shadows using a dark beige mix made from raw umber, dioxazine purple, a little mars black and titanium white. Leave the dark underpainting to show through to represent the very darkest area of shadow.

12 Remix the background colour by adding titanium white to what is left of the shadow colour and, using the 18 mm (¾ in) bristle brush, make multi-directional strokes to repaint the background. Work the colour into the still-wet shadows to soften their edges.

13 In completing this exercise, you will now know a little about paint handling and mixing to the right consistency by adding water and painting medium. You will also have learnt how to build up depth of colour and tone by working in layers.

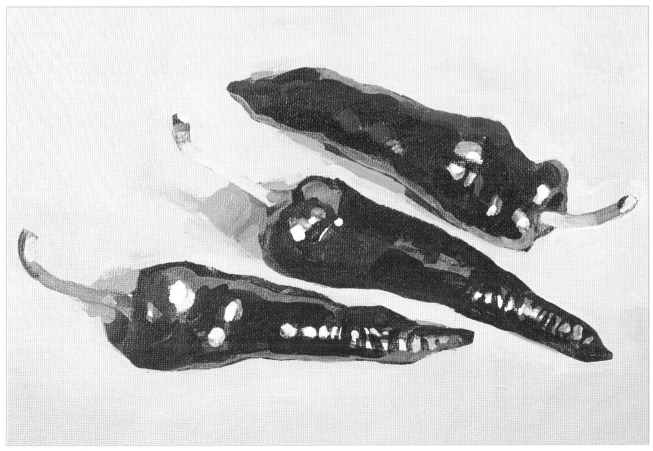

step 2 colour

focus: **carrots, garlic and tomatoes**

Materials

25 x 30 cm (10 x 12 in) prepared
 canvas board

Hard charcoal pencil

Fixative

Matte acrylic painting medium

6 mm (¼ in) flat synthetic-fibre brush

12 mm (½ in) flat synthetic-fibre brush

The palette:

- *Titanium white*
- *Quinacridone red*
- *Lemon yellow*
- *Pthalocyanine blue*

With a little practice, you can use the paints selected for the beginner's palette (see Palette colours, pages 99 and 177–178) to mix every colour you will ever need. In fact, it is quite possible to produce close approximations of most colours by using just three carefully chosen primary colours plus white.

WHAT IS COLOUR?

Light is made up of a form of electromagnetic radiation of varying wavelengths creating a visible spectrum of colours: red, orange, yellow, green, blue, indigo (or red-violet) and violet. We see a given object as red – say an apple – because all of the coloured wavelengths are absorbed, except red, which is reflected for us to see. When all of these wavelengths are added together the result is white. This is known as additive colour mixing.

Pigment colour behaves differently. Each time one colour is added to another, the colour intensity is reduced, and if all of the primary colours – or mixes made from them – are added together, the result is black. This is known as subtractive colour mixing because the more colours that are mixed together the more wavelengths are absorbed and the fewer reflected. For this reason, in order to keep colour mixes as pure and bright as possible, artists use a range of colours that have each been made using a single pigment.

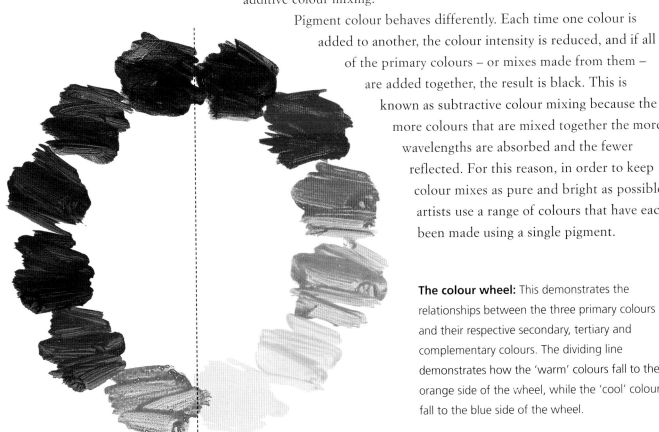

The colour wheel: This demonstrates the relationships between the three primary colours and their respective secondary, tertiary and complementary colours. The dividing line demonstrates how the 'warm' colours fall to the orange side of the wheel, while the 'cool' colours fall to the blue side of the wheel.

Simultaneous contrast (left): Using two complementary colours beside one another, as here with red and green, is known as simultaneous contrast and can often be used to good effect.

Neutralizing effects (right): Mixing two complementary colours together always results in a grey or a brown.

BASIC COLOUR THEORY

The three primary colours are red, yellow and blue. They cannot be mixed from other colours, but have to be manufactured using pure pigments. If you mix red and yellow the result is orange; yellow and blue make green; and blue and red make violet. The resulting colours are known as secondary colours. Combine a primary colour (red) with the secondary colour next to it on the colour wheel (orange) in equal parts, and the result is a tertiary colour – in this case red-orange.

The quality and intensity of secondary and tertiary mixes depend very much on those of the primary colours used to create them. There are several red, yellow and blue primary hues to choose from, and the secondary and tertiary mixes made from a combination of any three will be very different. Furthermore, every time you add two colours together, the resulting mix will always be less intense than the two colours used to create it.

Those colours that fall opposite one another on the colour wheel (see opposite) are known as complementary colours, because they complement one another and look brighter and more intense when placed close together. Mixing two complementary colours together produces a neutral colour because, in effect, you are combining three primary colours. Such mixes are very important, as they are similar to many of the colours seen in real life. By adding white you can produce a full range of greys and browns, and by carefully mixing all three primaries together in almost equal measures, you can make a good black.

COLOUR 'TEMPERATURE'

All colours are described as being either 'warm' or 'cool': the warm colours fall on one side of the colour wheel and the cool colours on the other (see opposite). However, colour temperature is slightly more complex in that each colour has a warm or cool variant depending on its colour bias: for example, cadmium red is considered a warm red because it leans towards yellow. In order to mix a full range of colours, therefore, you need a suitable warm and cool variant of each primary.

Manufacturers have developed almost perfect primary hues that are neither warm nor cool in bias and so are capable of mixing a full range of brilliant secondary and tertiary colours. These three hues are included in the basic palette.

Cool and warm primaries: These examples of the three primary colours demonstrate how each has variants that are considered cool (top) and warm (bottom).

PAINTING THE CARROTS, GARLIC AND TOMATOES

The purpose of this project is to practise colour mixing using three near-perfect primaries and white. In theory, it is possible to mix most colours from just these four. Working with them is a discipline that will teach you much about colour mixing. You will notice how a very small amount of added colour can alter a mix significantly, and you will learn how to mix neutral colours using complementary colour mixes.

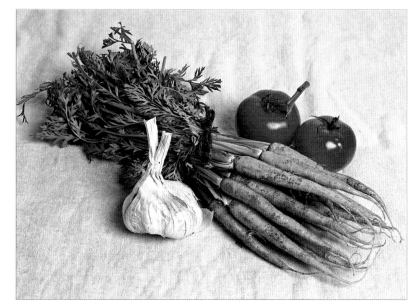

1 This composition is set on a diagonal axis. Sketch in the various components using the charcoal pencil and give the drawing a coat of fixative to prevent the charcoal dust from mixing with the initial layer of paint.

2 Add water and painting medium to your paint mixes throughout this exercise. Create a bright red by mixing quinacridone red with a little lemon yellow and apply, using the 6 mm (¼ in) brush, to block in the shapes of the two tomatoes. Add more lemon yellow to the mixture and use to establish the overall colour of the bunch of carrots.

3 Mix a bright, mid-green for the carrot leaves using pthalocyanine blue and lemon yellow. This will be very bright, so subdue it with a little quinacridone red. Add more quinacridone red to subdue the green mix further for darker leaves and the two tomato stalks.

4 Mix varying quantities of the three primary colours to make a neutral brown. You may need to experiment a little before achieving the desired colour. Add a little of this brown to titanium white to create a light beige for the background colour. Apply using the 12 mm (½ in) brush, and the 6 mm (¼ in) brush in confined areas. Darken this mix with a little more of the original brown and return to the 6 mm (¼ in) brush to establish the mid tones on the bulb of garlic.

5 Now create as near a black as you can by mixing quantities of the three primary colours together. To do this, you will need to add a tiny amount of each colour at a time until the balance is right. Mix a deep green using pthalocyanine blue and lemon yellow and add a little of your mixed black to create a dark green. Use this to paint in the darks deep within the recesses of the carrot leaves. Mix a mid-green (see step 3), add titanium white and rework the mid tones on the leaves.

6 Mix a range of reds using quinacridone red and the lemon yellow, varying the tone of each by adding a little mixed black or titanium white, and use these colours to repaint the tomatoes using the 6 mm (¼ in) brush and directional strokes.

7 Mix a bright orange from lemon yellow and quinacridone red. Use a little of this and the mixed black to create a deep brown for the shadows between the carrots. Add titanium white to the bright-orange mix to subdue the intensity of its colour and make it lighter. Use this to repaint the top of each carrot where it catches the light.

8 Mix a range of light greys and browns using all three primaries. Again, you may need to experiment with quantities to achieve the right mixes. Add titanium white to lighten the mixes and alter the tones for the garlic bulb. Use the same basic neutral mixes to block in the shadows around and beneath the vegetables.

9 Mix a fresh quantity of the background colour (see step 4) and repaint, carefully working up to, and around, each vegetable, redrawing and redefining the shapes as you work. Use multi-directional strokes across the area using the 12 mm (½ in) brush, and the 6 mm (¼ in) brush in confined areas.

10 Complete the form and detail of the foliage of the carrots. Mix a bright green using pthalocyanine blue and lemon yellow and add plenty of titanium white to subdue but lighten the colour. Use the 6 mm (¼ in) brush to flick in small dabs or fine lines of colour to suggest the stalks and fringed edges of the leaves.

11 In completing this exercise, you can see just how much can be achieved with only three colours and white. You will have practised your colour mixing and learnt much about colour by putting the theory into practice.

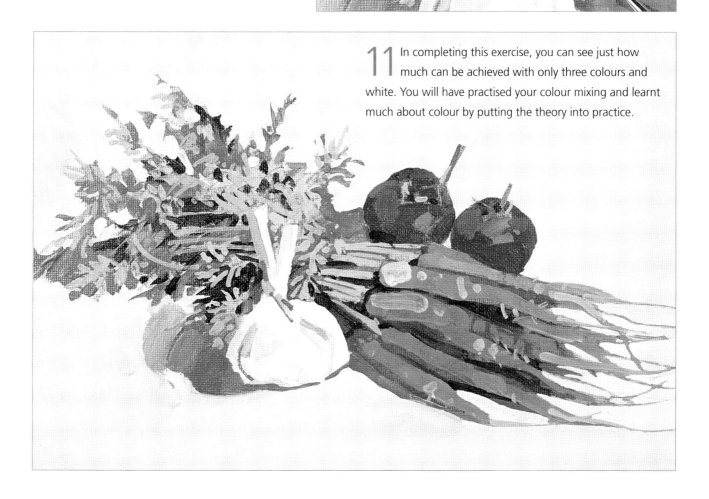

step 3 watercolour techniques

focus: **flowerpots and tomatoes**

Materials

25 x 30 cm (10 x 12 in) sheet of
 535 gsm (250 lb) 'not' surface
 watercolour paper

HB graphite pencil

A size 8 round synthetic-fibre brush

Medium-sized rigger brush

Medium-sized bristle fan blender

Paper towel

Scrap paper

The palette:

- *Cadmium red medium*
- *Cadmium yellow medium*
- *Ultramarine blue*
- *Pthalocyanine green*
- *Burnt umber*
- *Raw umber*
- *Yellow ochre*
- *Mars black*

By diluting acrylic colours with water alone, it is possible to create transparent washes of colour that resemble watercolour. The main difference is that, while watercolour remains to some extent soluble when dry, acrylic paint is permanent once dry and cannot be removed or modified by re-wetting.

USING ACRYLIC PAINTS AS WATERCOLOURS

In rendering acrylic paints to work as watercolours, it is important to choose colours that are considered translucent or transparent and to add plenty of water to the mixes to keep the paint fluid. Avoiding the addition of any white paint is also key. Furthermore, it is impossible to soften unwanted hard edges once the paint is dry, so you need to do any blending while your work is still wet. Using a retarding medium helps here, as does the addition of a flow medium (see Painting mediums and additives, page 258), although you must be careful when using either, as they can rapidly give your work the look of painting on blotting paper!

Thin washes of paint are generally applied using synthetic-fibre brushes, but you can produce a whole range of interesting effects and marks by utilizing bristle brushes, painting knives, paint shapers and sponges, not to mention implements like cocktail sticks, cotton wool buds, hair combs and toothbrushes. In addition to the watercolour techniques that follow, a number of paint techniques are discussed later (see Step 8, pages 306–313), which could equally apply here (masking, scumbling, spattering and sgraffito).

Wet into wet

Applying a wash onto an already wet surface is described as 'wet into wet'. The surface may be wet from a previously applied wash of colour or from a wash of clean water. Depending on how wet or damp the surface is, the colours run and bleed into one another and slowly diffuse over the surface. The effect is soft and amorphous, creating forms and shapes that are undefined and lacking focus. Wet-into-wet techniques are only partially controllable and are usually used together with wet-on-dry techniques.

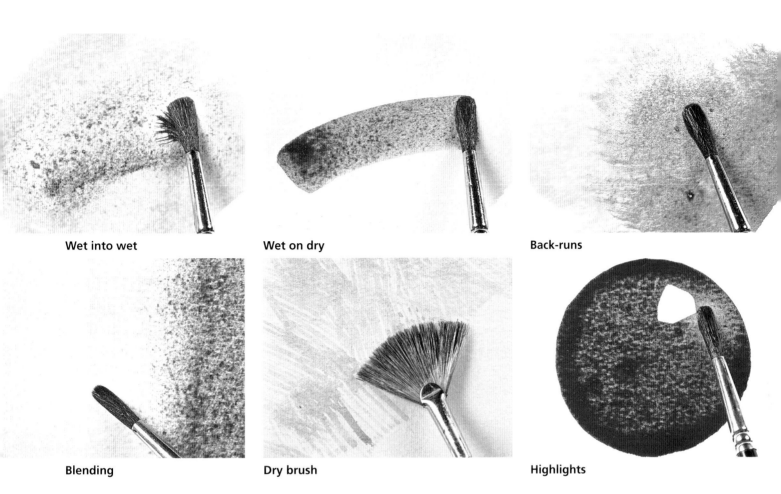

Wet into wet

Wet on dry

Back-runs

Blending

Dry brush

Highlights

Wet on dry

With 'wet-on-dry' techniques you apply a wash to a dry surface. The paint does not bleed but stays where it is put. This produces areas of colour with hard edges that are sharp in focus and clearly defined. You can use this technique to build up colour and tone, as each transparent wash qualifies and alters the (still visible) layer beneath.

Back-runs

Characteristic of wet-into-wet techniques, these watermark effects happen when you apply a fresh wash over a previously applied wash that is not completely dry. You can manipulate back-runs to a certain extent, perhaps using them to suggest pictorial elements in landscape work, for example.

Blending

Acrylic paint cannot be made resoluble once dry, so you have to carry out any blending or softening of edges while the paint is still wet. When an edge needs to be softened, one solution is to apply clean water along the extent of that edge and bring a coloured wash up to it. The colour then bleeds into the water becoming slightly lighter. This technique requires practice.

Dry brush

Dry-brush techniques are used for breaking up flat areas of colour and creating a range of textural effects. This is achieved by removing most of the wet paint from the fibres of the brush, before applying the minimum amount of paint to the paint surface. This results in a 'dry' mark, and is a useful technique for painting fabric, grass or the fur and feathers of animals and birds.

Highlights

The best way to create highlights is by preserving light colours or the white of the paint surface, which you do either by working around the desired area or by using a form of masking.

PAINTING THE FLOWERPOTS AND TOMATOES

The following exercise allows you to practise mixing thin, transparent washes of varying colour and tone without using white paint. You will also learn about wet-in-wet and wet-on-dry techniques, how to build up and modify colour using layers, and how to use a few different brush techniques to achieve different effects.

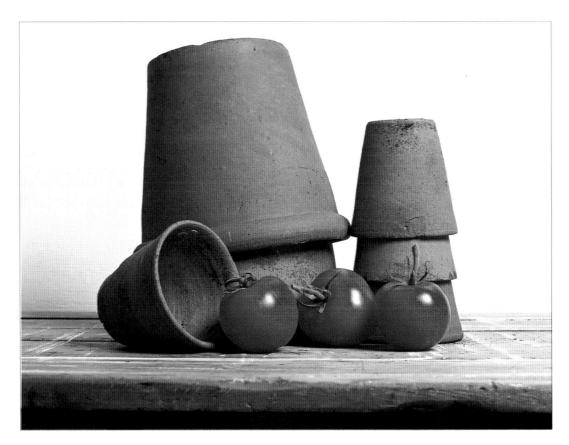

1 Use a heavyweight watercolour paper of 535 gsm (250 lb) so you will not have to stretch it first. Use the pencil to make a light drawing to act as a guide. Do not make your lines too dark or they will show through the thin washes of colour that follow.

2 The first wash consists of a light terracotta colour, which you make by mixing burnt umber, cadmium red and a little yellow ochre. Lighten the colour by adding water. If you wish, you can test the transparency and depth of colour of your mixes on a sheet of scrap paper before applying them to your painting. Using the size 8 synthetic-fibre brush, wash this colour over the flowerpots. Use water with all of your mixes for this project, but do not add acrylic painting medium or any white paint. Add a little yellow ochre and raw umber to the previous mix and use this to apply a wash over the tabletop. Do not be concerned if this colour runs into and mixes with the colour used to paint the pots.

3 Add a little pthalocyanine green to yellow ochre to create a light green, and use the rigger brush to apply this to the stalks of each tomato. Allow the green to dry before applying a light orange-red mix to each tomato. Make this by mixing together a little cadmium red and yellow ochre and apply, still using the rigger brush, leaving small areas of the white paper unpainted to represent the highlights.

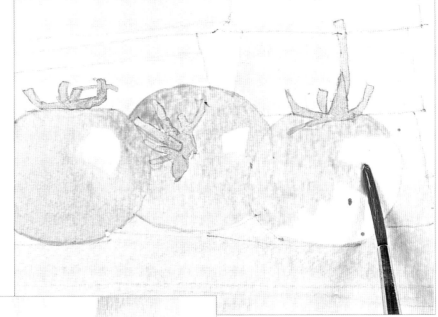

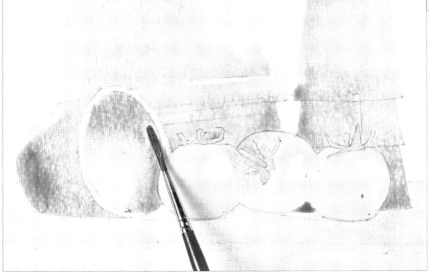

4 Allow the tomatoes to dry while you mix a deeper terracotta colour using burnt umber, a little cadmium red and a little yellow ochre together with plenty of water. Use this colour to repaint the mid tones on the flowerpots. In those areas where the colour is more intense, allow the paint to puddle a little and leave to dry naturally without disturbing it.

5 Meanwhile, mix a dark brown using burnt umber and mars black. Wash this over the area beneath the tabletop using the size 8 brush. Now mix a deep red using cadmium red and cadmium yellow and repaint the tomatoes using the rigger brush. At the point where the tone changes, apply clean water and brush the paint up to it: the colour will bleed into the area covered in water, gradually becoming lighter.

6 Once you have finished the tomatoes, repaint the stalks using a dark green mixed from a little pthalocyanine green and yellow ochre, subdued by adding a little cadmium red. Allow the tomatoes to dry completely before continuing.

7 Mix a deep terracotta colour using burnt umber, a little cadmium red and ultramarine blue. Brush clean water onto the side of each pot that is to remain light and apply the darker colour so that it touches the wet area: it will bleed into the water creating a graduated tone. Where the colour is very dark, allow the paint to puddle and leave to dry undisturbed.

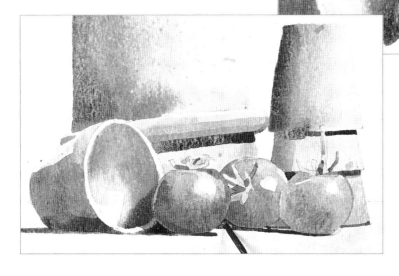

8 Once completely dry, use the same colour to add a few spatter marks to the pots, rendering the flaws in their surfaces. Blot off any unwanted spatters from the background using kitchen paper. Mix a deep brown using burnt umber and ultramarine blue, and use this for the shadows beneath the upturned pots and the tomatoes.

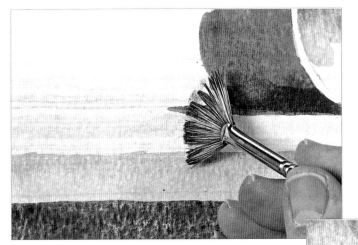

9 Lighten what remains of the dark-shadow mix by adding a little water and use to create the wood grain on the tabletop, applying a dry-brush technique: dip the fan blender into the paint and wipe the brush on kitchen paper so that most of the paint is removed before making any marks. Practise the technique on a separate sheet of paper before committing yourself.

10 Return to the rigger brush and complete the work by painting the edge of the tabletop with a mix made from yellow ochre and burnt umber. Add cadmium red to this mix to strengthen the shadows on the tomatoes.

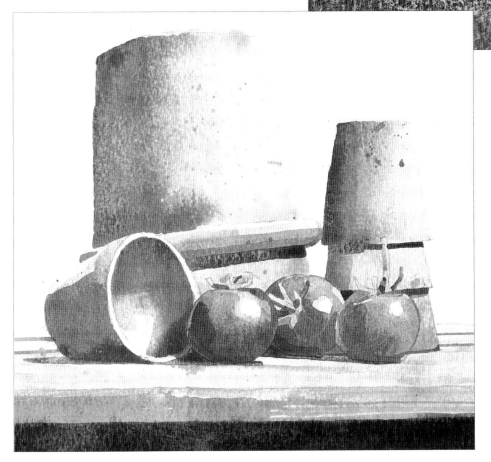

11 The completed painting demonstrates how much actual colour is needed to create a suitable transparent wash, how much water is needed in the mix, and how the wash is distributed onto the support. You will also have learnt how to build up tone and colour using layers, and how to integrate a number of watercolour techniques into the same image.

step 4 glazing techniques

focus: **garden tools**

Materials

25 x 30 cm (10 x 12 in) MDF board
 prepared with gesso

2B graphite pencil

Gloss acrylic painting medium

6 mm (¼ in) flat synthetic-fibre brush

Medium-sized rigger brush

The palette:

* *Titanium white*
* *Cadmium red medium*
* *Cadmium yellow medium*
* *Ultramarine blue*
* *Dioxazine purple*
* *Raw umber*
* *Yellow ochre*
* *Mars black*

Glazing is a traditional oil-painting technique, similar in principle to watercolour. In each case, you apply transparent layers of paint in order to qualify and modify the layer beneath. Acrylic paint is perfect for using with glazing techniques because the paint dries very quickly, allowing you to build the layers with relative speed. You can complete a work using this technique alone, or with various other techniques, including impasto (see Step 5, pages 286–291).

Most painting techniques involve mixing the paint physically on the palette before applying it to the paint surface. The paint has body and is invariably relatively opaque. The same is true when using glazing techniques, although the colours tend to be simpler and more pure. The difference here is that painting medium is added to the paint at the mixing stage to make it very thin and transparent – rather like a watercolour wash.

TONAL UNDERPAINTING

An intrinsic and important part of the traditional glazing technique is the tonal underpainting, or 'grisaille' (see page 191). This is usually carried out using tones of grey. It resembles a black-and-white photograph and should be

Glazing: You can alter the appearance of one paint layer simply by applying a second, transparent, layer of paint over the top of the first.

Adding glazing medium: Acrylic paint manufacturers produce a glazing medium specifically for glazing techniques, although gloss painting medium can also be used.

made so that the tones are slightly lighter than in reality and any deep black tones are dark grey. Any colour can be used for a tonal underpainting, as long as the result is monochromatic – that is, completed in tones of a single colour. Bear in mind, however, that any colour used for the underpainting will have a profound effect on the appearance of the colours that are applied as glazes over the top.

Working with a tonal underpainting in this way means that you make the most of the tonal considerations at an early stage and the subsequent colour mixes are relatively simple because the value of the tones reading through the thin glaze of paint do most of the work. The technique is therefore ideal for those who experience difficulty mixing the correct value colour as it divides the decision-making into two distinct parts: tone then colour.

USING COLOURED GLAZES

You can use a glaze to modify colours at any time during the execution of a painting, whatever the technique being used. For example, you could apply an all-over glaze of a suitable colour to finish off a painting. This is a relatively popular device that has

the effect of unifying and harmonizing all of the colours used to create an image. You can also apply a glaze to calm down and subdue an image in which the colours are considered to be too bright or strident.

The important thing to remember when using a glaze, is that it brings a completely different quality to a painting than is seen in works where the colours have been physically mixed together: glazed images seem brighter and more jewel-like. They seem possessed of an inner light with a greater depth of rich colour, which can be difficult to achieve using paint that has distinct volume or body.

Dark tones: Each glaze that you apply progressively darkens the image; transparent glazes will not read very well over very dark tones.

PAINTING THE GARDEN UTENSILS

This project demonstrates how to use glazing techniques to modify both the tone and the colour of an image – a valuable exercise that can be used with other painting techniques. With this arrangement of garden utensils, you need to think about colour and tone separately and so are forced to look hard and analyze what you see in depth.

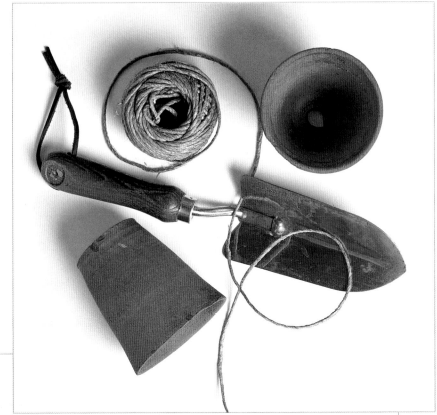

1 On the hard, white surface prepared using gesso, make a light pencil drawing using the 2B graphite pencil. Keep the drawing relatively light, as a dark graphite line might 'read' through the thin, transparent glazes of paint.

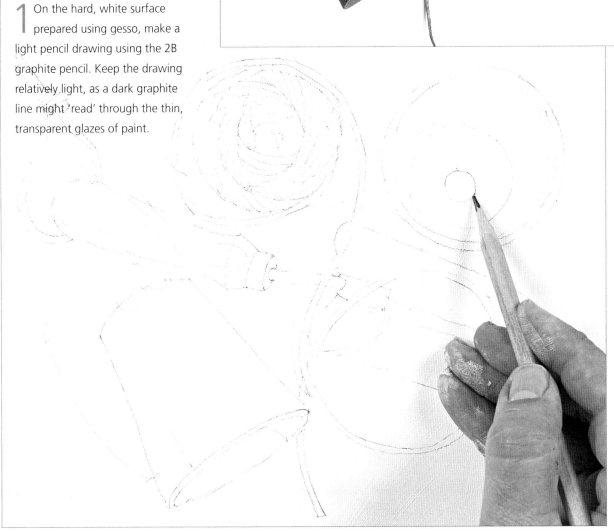

2 Create the grisaille, or tonal underpainting, using shades of grey made from mars black and titanium white. You can make opaque mixes for the underpainting, but here they are mixed together with plenty of water and gloss painting medium to keep the colours relatively transparent. Begin by establishing the lightest tones using the 6 mm (¼ in) synthetic-fibre brush.

3 Once the lightest tones are dry rework the image, painting in the range of slightly darker, medium tones. As before, keep the paint mixes reasonably transparent by adding gloss painting medium along with water.

4 Once the paint is dry, darken the grey mix further. Now seek out, and establish, the darker mid tones. Establish the darkest tones last of all. Remember not to make these too dark or the glazed colour will not read and may possibly look too dark.

5 Apply the first glaze to the terracotta flowerpots. Mix the colour using cadmium red, cadmium yellow and yellow ochre, adding plenty of gloss painting medium and water to keep the glaze transparent. Apply the paint smoothly, still using the 6 mm (¼ in) brush. Notice how the tonal underpainting immediately reads through the coloured glaze to create the form of the object.

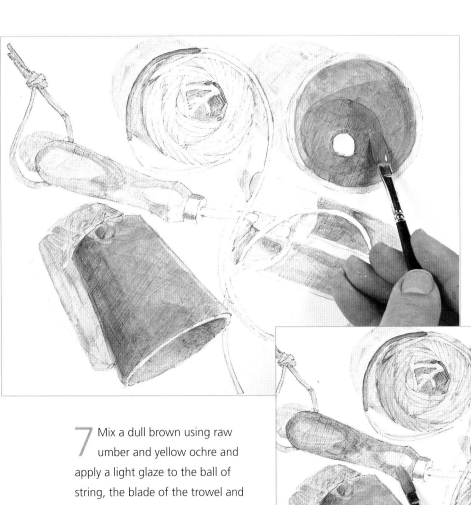

6 Darken the flowerpot mixture a little by adding more cadmium red and yellow ochre. Once the previous glaze is dry, repaint the flowerpots concentrating on those areas of mid and dark tone.

7 Mix a dull brown using raw umber and yellow ochre and apply a light glaze to the ball of string, the blade of the trowel and the handle of the trowel.

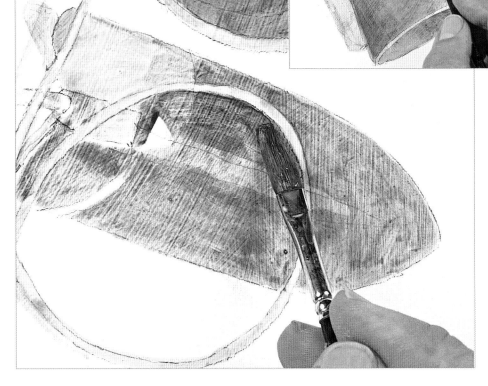

8 Now mix a blue-grey using a little mars black with ultramarine blue added to it. Use this colour to paint the dark, reflected colour seen on the blade of the trowel. Work carefully around the string that curls over the trowel blade and those areas on the blade that are light in tone or highlighted.

9 Add a little dioxazine purple to raw umber and use this to add colour to the shadows cast by the pots and the trowel, and to add a little definition to the trowel handle. You can also use this colour to paint in the darker tones seen on the ball of string. Add a little mars black to paint the dark hole at the centre of the string. Mix a little raw umber with titanium white and, using the rigger brush, begin to give definition to the separate coils that make up the ball of string. Notice that this colour is more opaque than previous mixes, owing to the addition of white.

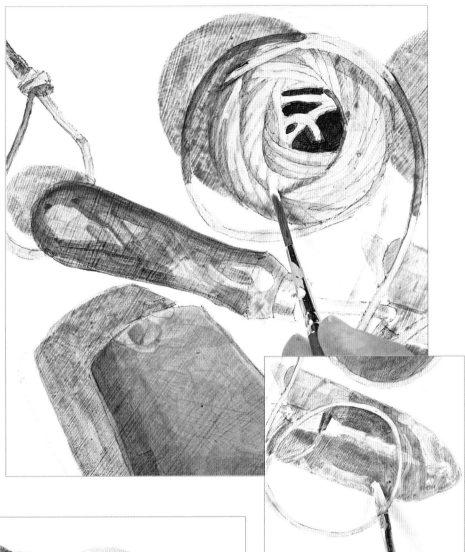

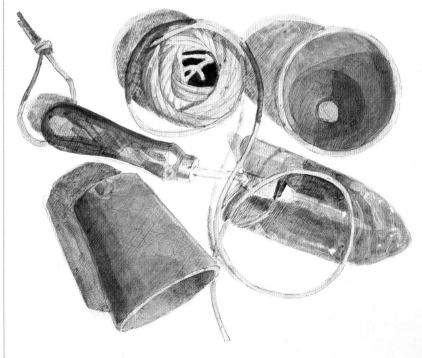

10 Finally, using a mix of just titanium white, water and painting medium, repaint the background, redefining the edges of each object as you work. Use a little of this mix to add a slightly lighter tone to the blade of the trowel.

11 In completing the painting, you will have discovered how to assess tone and colour separately, how to mix your colours so they are relatively transparent and how to build up the density of colours by working in layers.

step 5 impasto techniques

focus: **a bunch of radishes**

Materials

25 x 30 cm (10 x 12 in) prepared
 canvas board

Hard charcoal pencil

Fixative

Matte acrylic painting medium

Heavy gel painting medium

6 mm (¼ in) flat bristle brush

12 mm (½ in) flat bristle brush

Small trowel-shaped painting knife

The palette:

- *Titanium white*
- *Quinacridone red*
- *Cadmium red medium*
- *Lemon yellow*
- *Ultramarine blue*
- *Pthalocyanine green*
- *Raw umber*
- *Yellow ochre*
- *Mars black*

'Impasto' painting techniques are quite the opposite to glazing techniques (see Step 4, pages 280–285) and involve applying the paint thickly – sometimes very thickly indeed – so that the marks of the brush, or other means of application, are left visible. Again, this is a traditional oil-painting technique (see pages 220–227) that can be accomplished in far less time, owing to the quick-drying nature of acrylic paint.

The word *impasto* is Italian and means 'dough'. It describes the character or consistency of the paint, although in reality the paint should be more the consistency of soft butter. Impasto paintings have an almost tactile quality to them and the paint takes on a physical appearance: in really thick impasto work, the paint appears almost modelled into a third dimension. The surface of impasto work has a certain liveliness – the paint changing depending on the way light falls upon it – while the textural quality of impasto work makes it very expressive.

Mixing the paint: Use a palette or mixing knife to mix your paint. It is easier to clean than a brush and not so easily ruined.

Making mistakes: Correct any mistakes as you make them. This is simply done by scraping off the offending area using a palette or painting knife. You can then repaint the area in question, often reusing the paint you have just removed.

USING A PAINTING MEDIUM

Impasto work uses a large quantity of paint and, while the consistency of paint straight from the tube is ideal, it will not be long before you are on a trip to the art store to buy more. Mixing your paint with a heavy gel medium is more economical and the gel is exactly the right consistency for the technique. As with acrylic mediums of an ordinary consistency, heavy gel mediums are available that dry to leave a matte or a gloss finish. When using heavy gel mediums you will find it easier to mix the desired colour first, then add the required amount of medium: the paint colour should only alter slightly. A mix of thick paint and heavy gel medium will take longer to dry than normal. If you wish, you can extend the drying period further by adding a little retarding medium.

Exploiting the technique: Although brushes and painting knives are popular tools for impasto work, do not overlook the possibilities presented by combs, pieces of cutlery and bits of wood among others.

WORKING THE IMPASTO

It is easy to run into difficulties if you use very thick paint from the outset; it is far more practical to make an underpainting first using a thinner application of paint. Establishing the composition in this way serves as a guide for the thicker applications of paint to come, and helps mitigate any mistakes and wasted paint.

Use harder fibre brushes to apply the paint and keep your brushwork multi-directional. It is easy to build up an image in which all of the brushmarks run in the same direction, but this tends to limit the effect of impasto work, pulling the eye in the general direction of the massed brushmarks, rather than allowing the eye to wander around the composition in a more general way.

It is not always necessary to complete an entire painting using impasto techniques. Many artists use thinner paint techniques, resorting to applications of impasto for emphasis or to suggest physically, or represent, a texture. You can use many different tools to apply and manipulate the paint, including painting knives (see Step 6, pages 292–299).

PAINTING THE BUNCH OF RADISHES

Using thick applications of paint requires you to work precisely and with a certain surety – play with the paint surface too much and it becomes a mess. This project demonstrates how to mix the paint to the required consistency and to apply it using precise, directional brushstrokes or marks that have a certain economy.

1 Start by making a simple charcoal line drawing to help keep the painting on track. Once happy with your composition, give the drawing a coat of fixative in order to prevent the black charcoal dust from mixing with the colours in the subsequent underpainting.

2 Establish the underpainting, using the 6 mm (¼ in) bristle brush and a mixture of mars black diluted with water and a little matte painting medium. Block in the darkest shadow areas. Still working on the underpainting, mix a red for the radishes using quinacridone red and cadmium red, and block them in. Avoid a build-up of paint at this stage by keeping the consistency of your paint thin.

3 Now mix a bright green using pthalocyanine green and lemon yellow with a little added yellow ochre to subdue the colour. Use this mixture to block in the radish leaves. Allow the paint to dry completely before continuing.

4 You can now start the impasto work: all of your mixes from this point on will have heavy gel medium added to them in order to add body. Paint the radishes first, using the 6 mm (¼ in) flat bristle brush and directional brushstrokes that hint at the form of your subject. Mix several variations of red for this from quinacridone red, cadmium red, lemon yellow and titanium white.

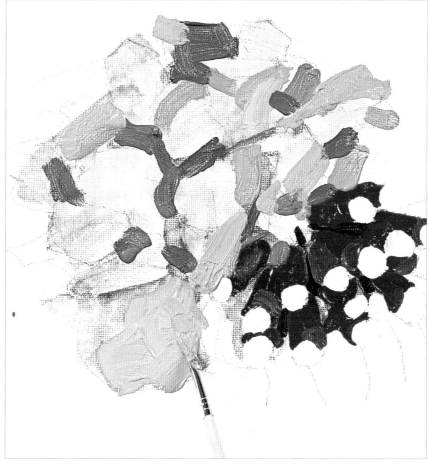

5 Apply a dab of pure titanium white to the end of each radish.

6 Mix various bright greens for the radish leaves using pthalocyanine green, lemon yellow, ultramarine blue and titanium white. Keep the paint thick and juicy and use directional strokes to help suggest the angle and fall of each separate leaf.

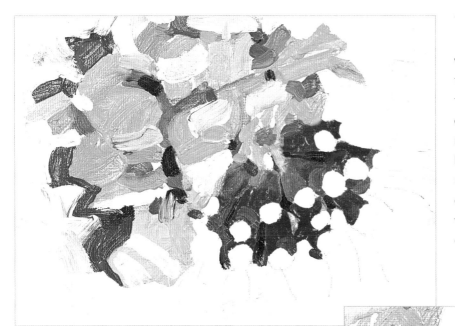

7 Mix a dark, neutral colour from raw umber and ultramarine blue into which you add titanium white and use this to paint the dark shadows around the radishes and the leaves. Use a light-ochre mix made from yellow ochre, raw umber and titanium white for the background. Apply this last colour using the 12 mm (½ in) bristle brush, changing to the 6 mm (¼ in) brush to work closely cutting in around the roots of the radishes.

8 Before the background colour dries, use the trowel-shaped painting knife to scrape away some of the paint around the ends of the radishes to reveal the white of the support and, in doing so, to suggest more roots.

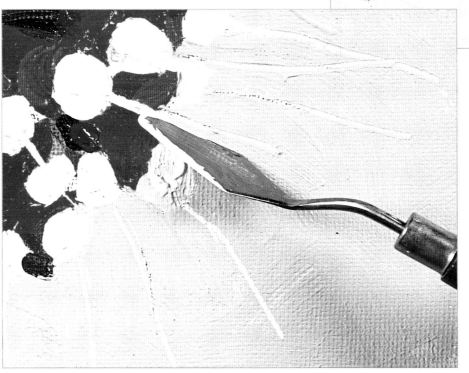

9 Use the side of the same painting knife to apply thin lines of titanium white paint to add to the suggestion of more roots. As the paint is pulled from the knife, the mark should become thinner, just as the root does in reality.

10 Complete the image by repainting the background using a light-beige mix made from raw umber, yellow ochre, mars black and titanium white. Apply the creamy paint using the 12 mm (½ in) bristle brush, changing to the 6 mm (¼ in) brush in the tight spaces between the roots.

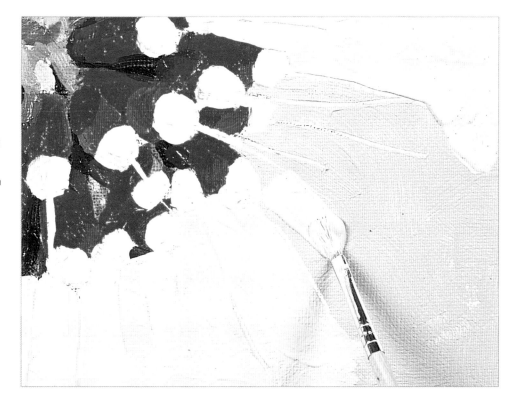

11 You can see from the finished painting, how the application of a thin underpainting avoids the need for too much detail in the subsequent layers of paint. By using simple marks and textures that often hint at more than they actually show, you keep the impasto work lively and interesting.

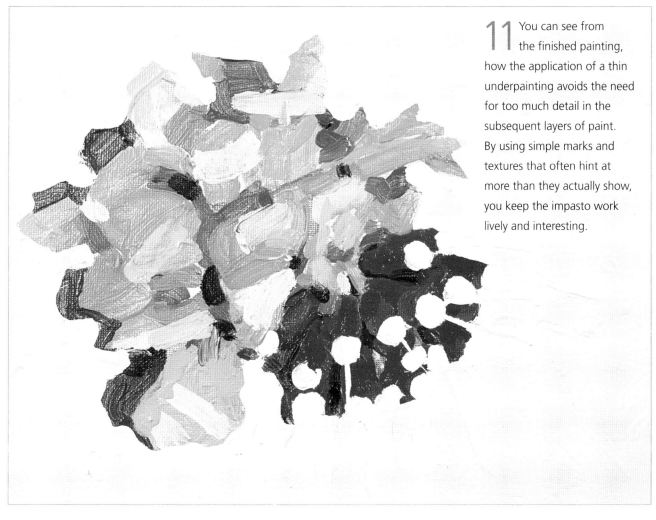

step 6 painting-knife techniques

focus: **onions and garlic**

Materials

25 x 30 cm (10 x 12 in) prepared
 canvas board

Hard charcoal pencil

Fixative

Heavy gel medium

6 mm (¼ in) flat bristle brush

Small trowel-shaped painting knife

Spatula-shaped painting knife with
 angled end

The palette:

- *Titanium white*
- *Quinacridone red*
- *Cadmium red medium*
- *Ultramarine blue*
- *Dioxazine purple*
- *Raw umber*
- *Burnt umber*
- *Yellow ochre*

Although brushes are seen as the most common – and certainly most controllable – way of applying paint to a surface, they are not the only option available. In previous sections you are encouraged to experiment with various 'found' tools in order to bring different qualities to the marks that you make (see Steps 3 and 5). The painting knife was invented for exactly this purpose and, although originally restricted to use with thick impasto paint, it is a missed opportunity not to exploit it further.

USING PAINTING KNIVES

Painting knives come in many different shapes and sizes and, in order to maximize their potential, you would do well to buy several. The tempered steel blade flexes under pressure and, in experienced hands, can be as sensitive and delicate to work with as a brush. Each differently shaped painting knife will deliver a surprising range of marks both in applying the paint and removing it.

The removal of paint, and the effects of sgraffito (see Step 8, page 307), are often overlooked yet they are just as important as the application of paint. Textures, patterns and linear effects are often more easily achieved by working back into wet areas of paint than by trying to create the same effect with more paint. If you do choose to work in this way, the paint will need to be workable, so use a retarding medium (see

Simple marks: The flat blade delivers a paint mark that is the same length as the blade itself.

Painting mediums and additives, page 258) to keep the paint 'open', giving you more time to work. Conversely, the fast drying time of acrylic paint can work to your advantage, making it possible to build up complex layers of paint that have been worked into with the knife, thereby revealing elements of the surface below.

ESTABLISHING AN UNDERPAINTING

As with impasto work, it can be a mistake to allow too heavy a build-up of paint too early on and, once dry, you will not be able to remove the paint. The answer is to work over a thin underpainting. You can make this using a brush or, if you prefer, the painting knife. In the case of the latter, you apply the paint to the surface in the desired areas, but scrape it off again before it dries. This leaves you with a pale ghost of the image. Once dry, you can continue to work on the underpainting using thicker paint.

USING PALETTE KNIVES AND PAINT SHAPERS

When using a palette knife with thin, fluid paint, the application technique is slightly different, because it is almost impossible to pick up large quantities of paint on the blade. A certain amount of paint will cling to the blade, but not enough to cover a large area. One solution is to apply the paint initially with a brush, then use the knife to manipulate and move it around the paint surface.

Silicone-rubber paint shapers come in various shapes and are a useful addition to your arsenal of mark-making tools, complementing the painting knife perfectly. Each handles more like a conventional brush and makes a range of marks that you will find very useful and slightly different in quality to those made using the knife.

Thin lines: You can achieve a thin painted line by pushing or pulling the knife while holding the blade on edge.

Painting dots: Use the very tip of the blade to make a series of dots.

Creating textures: By using the flat of the blade to stipple the paint, you can create a wide range of textures.

Thick lines: By turning the knife in your hand while making a mark, you can produce a stroke of varying thickness.

PAINTING THE ONIONS AND GARLIC

The rough, papery textures of the onions and garlic are ideal for experimenting with painting and palette knives. The marks possible when using a painting knife are completely different to those made when using a brush and can bring qualities to an image that are both rich and exciting.

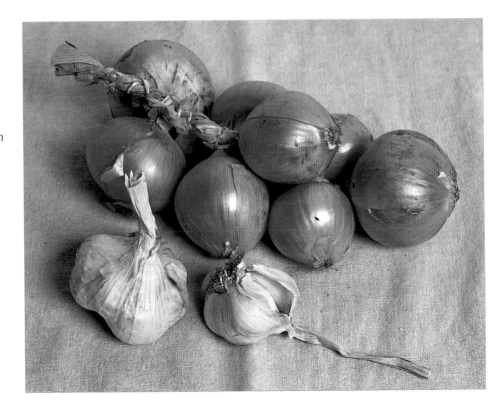

1 Begin by using the charcoal pencil to sketch in the composition. Once finished, give the drawing a coat of fixative if you wish, in order to prevent the charcoal dust mixing with subsequent applications of paint.

2 Make a thin underpainting to establish the colours and shapes of the main elements, providing a good base on which to build the knife work. Using the 6 mm (¼ in) bristle brush, mix a dull pink from yellow ochre, quinacridone red and titanium white. Use shades of this to block in the overall colour of the onions. There is no need to add any medium to any of these mixes, just use water.

3 Block in the colour of the garlic bulbs in the same way, using mid-tone mixes of titanium white and raw umber.

4 Now establish the background colour. Mix the colour for the shadows cast by the onions and garlic by using raw umber with ultramarine blue and titanium white. Make the main background colour by mixing together titanium white, raw umber and a little yellow ochre.

5 With the underpainting complete, and dry, you can continue the work using painting knives. In order to give the paint the necessary body add heavy gel medium to your mixes from now on. Begin by mixing a dull pink, similar to the colour of a sticking plaster, made from burnt umber and yellow ochre. Lighten this considerably by adding titanium white and give it a pink tinge by adding a small amount of quinacridone red. Use the small trowel-shaped painting knife to apply this to the onions. Use the blade of the knife to follow the shape of the onions, manipulating the end and side of the blade to apply the paint to the twisted stems.

6 Darken the onion mix using raw umber and a little cadmium red and paint the darker, mid-tone areas in the same way. Now mix a light ivory colour using titanium white, a little raw umber and a very small amount of ultramarine blue. Use this to establish the mid-tone areas of delicate colour on the bulbs of garlic.

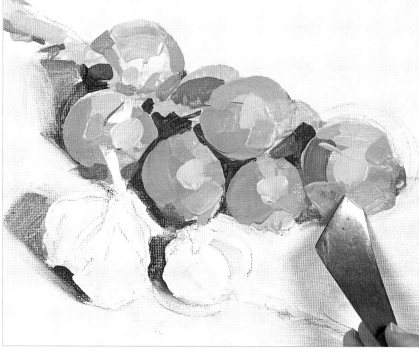

7 Wait for the paint on the onions to dry before applying further layers. Mix a rich, light brown using burnt umber, yellow ochre and titanium white with just a touch of quinacridone red. Darken this colour by adding more burnt umber and dioxazine purple, or lighten it by adding more titanium white. Apply the paint with the spatula-shaped knife, using the small-width blade to make short directional paint marks to develop and consolidate the spherical shape of each onion in turn.

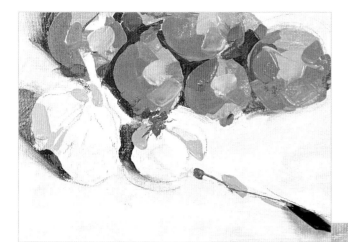

8 Make a darker mix for the garlic using raw umber with a little ultramarine blue and titanium white. Return to the trowel-shaped knife and use this mix to establish the small patches of darker colour seen on each bulb. Darken the mix further by adding more raw umber and ultramarine blue and apply this colour to the base of the garlic to represent the cluster of dry roots. Using the edge of the knife, pull a dark line of colour out from the bulb along the length of its brittle stem.

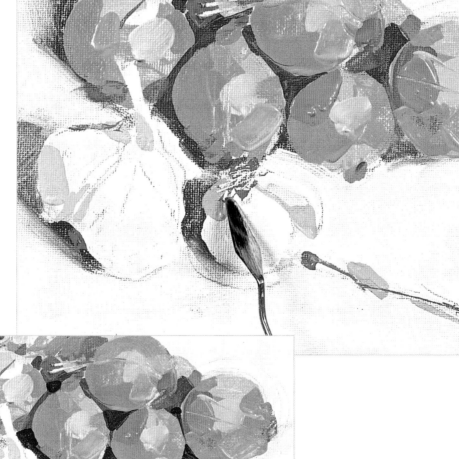

9 While the paint is still wet on both the onions and garlic, scratch into the paint to reveal the layer beneath. Use this technique to suggest both the linear marks on the skin of the onions and the light roots on the garlic.

10 Stay with the trowel-shaped knife to apply the shadows beneath the onions and garlic, using mixes similar to those used for the garlic in step 8.

11 Repaint the background using a light colour made by mixing together titanium white, raw umber, a little yellow ochre and a touch of ultramarine blue. Cut in carefully over and around the shadows, amending and redrawing the shapes of the vegetables as you apply the paint. Be liberal with the paint and use relatively short strokes.

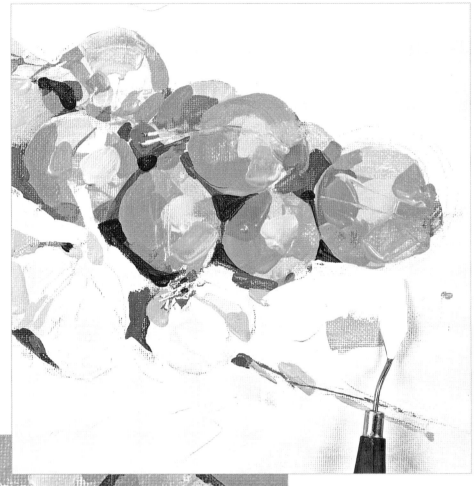

12 Apply pure titanium white to the lightest part of each garlic bulb using the small-width blade on the spatula-shaped knife.

13 To complete the image, draw in a few carefully placed linear marks using the charcoal pencil. Use them to describe the form of some of the bulbs, echoing the lines that can be seen on the dry skin: this helps to suggest their underlying form.

14 This project demonstrates how to mix paint on the palette with a painting knife, and how to transfer those mixes to the support. You will also have seen how a variety of marks are possible with a single painting knife by carefully holding and manipulating the knife in different ways.

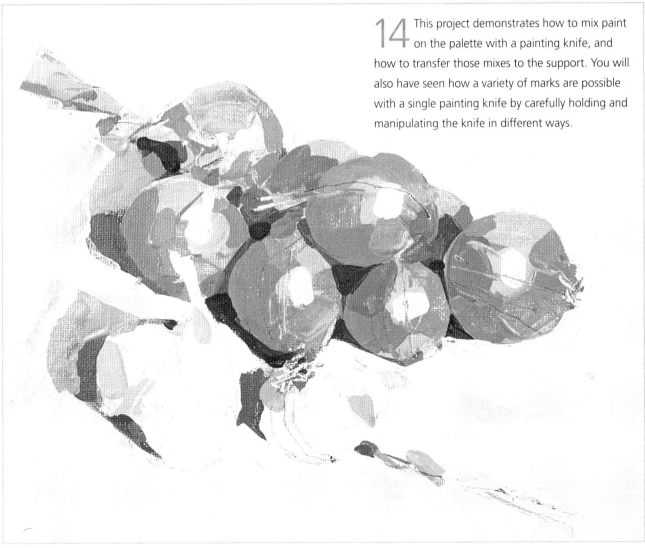

step 7 using texture pastes

focus: leeks and broccoli

Materials

25 x 40 cm (10 x 14 in) prepared
 canvas board

Hard charcoal pencil

Fixative

Matte acrylic painting medium

6 mm (¼ in) flat bristle brush

6 mm (¼ in) flat synthetic-fibre brush

Medium-sized rigger brush

Small trowel-shaped painting knife

Black lava texture paste

Natural sand texture paste

Scrap paper

The palette:

- *Titanium white*
- *Cadmium red medium*
- *Cadmium yellow medium*
- *Ultramarine blue*
- *Pthalocyanine green*
- *Raw umber*
- *Yellow ochre*

The representation of texture plays an important part in both abstract and pictorial work. Texture can be rendered as a two-dimensional illusion by using clever brushwork and paint effects, or it can be represented by giving the paint itself a physical texture, which can be both seen and felt. Impasto work goes some way to achieving a physical textural effect (see Step 5, pages 286–291), but the concept can be taken a step further by adding into your paint mixes one of the many texture pastes that are available.

USING TEXTURE PASTES

The pastes, available from most manufacturers of acrylic paint, have various descriptive names including 'resin sand', 'glass bead', 'black lava' or 'blended fibre'. You can apply them in one of two ways: the first is to mix them with your paint on the palette and apply using a brush or painting knife; the second is to apply them directly to the paint surface and paint over them once dry. Indeed it is quite possible to use a texture paste to prepare a surface prior to any paint being used. Take care when using texture pastes with certain styles of painting, however, as they very easily overpower or may simply look 'out of place'.

ALTERNATIVE TEXTURES

Acrylic manufacturers also make modelling paste, made from acrylic painting medium and marble dust. It sets very hard and can be carved or sanded; objects can also be pressed into it while still wet to leave an impression. A variation on this is to apply a layer of modelling paste to the paint surface and use various implements to 'stipple' and 'distress' the paste layer in order to create a textured surface. Once dry, this surface can then be painted over. The adhesive quality of acrylic paint and painting mediums makes it easy to create your own texture pastes

Black lava: flecks of black lava can either be allowed to show or be fully incorporated into the paint mix.

Resin sand: gives a subtle granular effect.

Glass beads: a slightly larger aggregate gives a more pronounced texture.

Blended fibre: this creates a softer, fluffier effect.

simply by adding suitable aggregates to your paint, together with a gel medium. Clean children's play sand, plaster, sawdust and even gravel or dried vegetation and leaves, can be added in this way.

PAINT SURFACES AND BRUSHES

Texture and modelling pastes tend to be quite heavy and, used in any quantity, can 'pull' at a canvas surface, causing it to sag, so it may make sense to opt for more rigid surfaces like canvas board for these techniques (see Paint surfaces, pages 259). Texture paste can also be very harsh on your brushes: it tends to work its way deep into the fibres of the brush you are using and, if not removed, will set hard, causing the fibres to splay. The answer is to clean your brushes scrupulously and use a brush to apply the paste while using a mixing or palette knife to mix the paint on the palette.

PAINTING THE LEEKS
AND BROCCOLI

The very nature of acrylic paint means that its handling and consistency can be altered to suit a wide range of picture-making situations. Texture pastes, which alter the actual physical texture of the paint, are an extreme example of this. Learning how to utilize texture pastes can broaden your mark-making and the effects possible.
The pastes can also help you solve certain representational problems, as demonstrated here with the head of broccoli.

1 Loosely sketch out the composition using the charcoal pencil and give the finished drawing a coat of fixative if you wish. This will prevent the charcoal dust from mixing with subsequent layers of paint.

2 Water and matte painting medium are used in the colour mixes throughout this project. Use the 6 mm (¼ in) bristle brush to mix a bright green from pthalocyanine green and cadmium yellow. This will be very bright and can be subdued by adding a little yellow ochre. Vary the concentrations of each colour and use the resulting range of bright greens to block in the leaves of the three leeks. Use your brushmarks to render the linear pattern on each leek. Take a little of the bright green and add titanium white to lighten it and a little ultramarine blue to transform it into a cool blue-green. Use this to establish the basic colour of the broccoli head. Add more titanium white to mix the colour for the paler stalk.

3 Create the background colour by mixing titanium white with a little raw umber and a little yellow ochre. Apply this to the area of the leek roots and, using the trowel-shaped painting knife (or the pointed wooden end of the paintbrush), mark the tangle of roots into the wet paint.

4 Return to the 6 mm (¼ in) bristle brush and loosely work the same mixture over the entire background.

5 Make a dark green with the same brush, using pthalocyanine green, raw umber and yellow ochre, and paint in the dark tone of green that runs around the top of the broccoli florets. Lighten the mix by adding titanium white and a little ultramarine blue. Now add black lava texture paste and use the mix to paint the rest of the broccoli head.

6 Allow this paint to dry before applying another layer in a slightly different shade of green, using the 6 mm (¼ in) bristle brush. Repeat the process, gradually building up the texture until the desired effect is achieved.

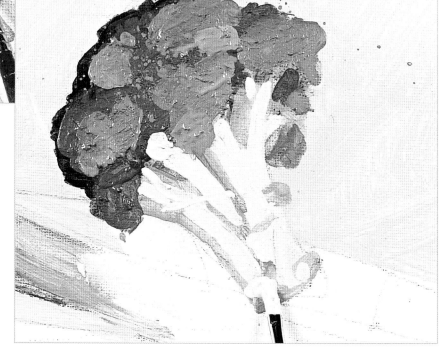

7 Mix a light green from pthalocyanine green, cadmium yellow, a little yellow ochre and ultramarine blue. Lighten the mix with white and use this to paint the stalk with the 6 mm (¼ in) synthetic-fibre brush, applying the paint relatively thickly so that it has a degree of physicality about it and the brushmarks are apparent.

8 Rework the leek leaves with the 6 mm (¼ in) bristle brush using the same light-green mixes made in step 2, with added cadmium red and white. Do not overwork this area, as you may obscure the brushmarks that show the linear patterns.

9 Using the rigger brush, mix yellow ochre with raw umber and apply to the area of fine roots at the base of each leek. Once this is dry, paint the roots, again using the rigger brush and a light mix made from titanium white with a little raw umber and yellow ochre.

10 Return to the 6 mm (¼ in) bristle brush and repaint the background using a mix made from raw umber, yellow ochre and titanium white, together with the natural sand texture paste. Add more raw umber and a little ultramarine blue into this mix for the shadows. Work the mixture carefully around the head of broccoli.

11 Loosely scribble charcoal over the roots to give them more definition. Mix an off-white using titanium white with a little raw umber and yellow ochre, and repaint the roots using an imprinting technique: tear off a small piece of scrap paper and dip the straight edge into the paint; now bend the paper between your fingers and press the paint-covered edge to the image. This will leave a wavy line that resembles a single root. Repeat the process until you are satisfied with the result.

12 In completing this painting, you will have learnt how to mix texture pastes with paint and how to apply them to the support. You will also have learnt that a little goes a long way and how to integrate the pastes into an image using traditional brushwork so that it does not stand out or look out of place.

step 8 paint effects

focus: **garden utensils**

Materials

40 x 50 cm (16 x 20 in) prepared
 canvas board

Hard charcoal pencil

Fixative

Matte acrylic painting medium

6 mm (¼ in) flat bristle brush

6 mm (¼ in) flat synthetic-fibre brush

Medium-sized rigger brush

Masking tape

The palette:

* *Titanium white*
* *Cadmium red medium*
* *Cadmium yellow medium*
* *Ultramarine blue*
* *Pthalocyanine green*
* *Dioxazine purple*
* *Raw umber*
* *Burnt umber*
* *Yellow ochre*
* *Mars black*

The traditional way of showing surface and texture in a painting is to use clever brushwork in rendering a representation or illusion of the texture in question. This can be done using brushwork alone but there are several other techniques. They either apply or remove the paint in different ways, often using a range of tools that includes brushes, knives, sponges or rags – whatever you find that works.

MASKING

Masking techniques are primarily intended to prevent paint from getting to areas of the work where it is not wanted. You can also use masking to give a painted area a unique edge quality, especially when using torn paper. When using thick paint make the mask from masking tape, paper or card, cut it to shape and hold it in place while you apply the paint.

An alternative to using paper or card when using thin paint is to use masking fluid, a rubber solution that you paint onto the support and allow to dry. You can then paint over the area and once this is dry you can remove the masking fluid by gently rubbing it with your fingers.

SGRAFFITO

Sgraffito is an Italian word meaning 'to scratch'. For this technique, you scratch or scrape through dry paint using a sharp implement or, for broader areas, sandpaper to reveal the paint surface beneath or, if done carefully, a previously applied wash of colour. You can achieve a softer effect by scraping back into wet paint using the wooden end of a paintbrush.

SCUMBLING

Scumbling refers to the technique of applying an uneven layer of paint over a previously applied layer which has been allowed to dry. You scrub or roll the paint onto the surface using stiff bristle brushes so that the layer beneath shows through. You can use the technique to build up complex areas of colour and texture over several layers. The technique is very successful on textured surfaces, like canvas, but can also be achieved on smooth surfaces.

BROKEN COLOUR

This technique usually refers to wet-into-wet applications of paint (see Watercolour techniques, page 274). Here, you apply marks of one colour loosely over another so that, although separate, they tend to blend together slightly to give an area of varied shimmering colour.

SPONGING

Sponges, both man-made and natural, are excellent tools. You can use them to smear paint onto a surface or in a dabbing or stippling action to build up areas of texture. These are good tools to use with scumbling techniques.

SPATTERING

A quick way to add interest and texture to a paint surface is to drop or spatter paint onto it. The technique is usually used with some form of masking. Different brushes and paint consistencies produce different effects as does spattering onto a wet surface rather than a dry one. As with scumbling, you can build up very complex textural effects by working in layers.

PAINTING THE GARDEN UTENSILS

In order to get the most from acrylic paint and to be able to solve representational problems, it is important that you learn as many techniques as possible. There are many different paint effects, each with subtle variations, a number of which are demonstrated and explored in this project. Matte acrylic painting medium should be used to mix the paints thoughout.

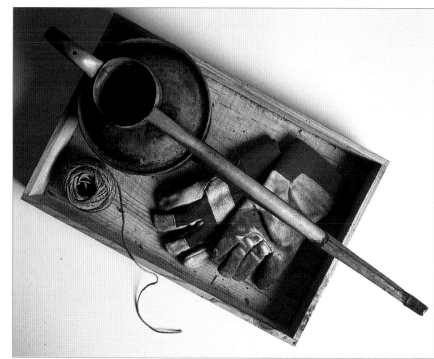

1 Sketch in the composition using the charcoal pencil: it has been arranged to read diagonally across the format, which enables the image to fill the space better. Your drawing can be as elaborate as you wish, but remember that much of it will be lost with the initial applications of paint. Once happy with the sketch, give it a light coat of fixative to prevent charcoal dust from mixing with subsequent layers of paint.

2 Establish the watering can first, using a thin mixture made from mars black, raw umber, a little pthalocyanine green and yellow ochre. Modify this dull green-grey mixture with titanium white, and loosely scrub the colour onto the watering can using the 6 mm (¼ in) flat bristle brush.

3 Take a little of the green-grey mix and add a little ultramarine blue and dioxazine purple and plenty of titanium white to produce the light grey for the gloves. For the ball of string, use a mix made from raw umber, yellow ochre and titanium white.

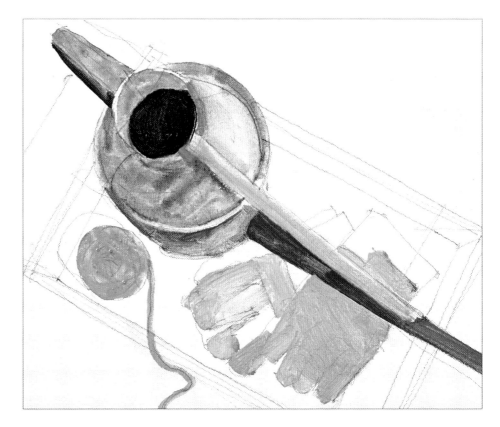

4 Mix together cadmium red and yellow ochre, and subdue the result using a little raw umber. Use this to paint the red of the gardening gloves. Now block in the box using a mix made from raw umber, yellow ochre, a little ultramarine blue and white. By adding a little dioxazine purple to this last mix, you can create the shadow colour at the top left-hand corner of the image. Darken this mix further by adding more raw umber and dioxazine purple and you have the very dark shadow colour that can be seen at the end of the box.

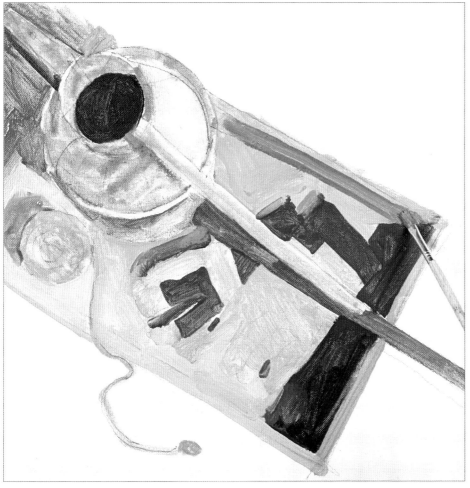

5 Once the paint on the watering can is dry, you can apply a scumbled layer of a dull grey-green made by mixing raw umber with a little pthalocyanine green and yellow ochre. Scrub a little of the same colour onto the gloves. Lighten the mix a little using titanium white and modify with a little mars black to create a range of light greys. Use these to refine the tones on the handle and rim of the can.

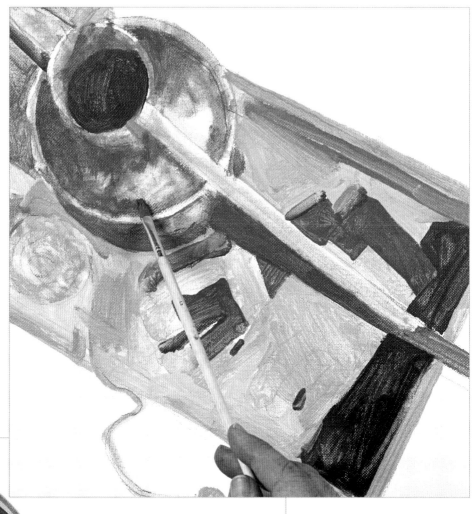

6 In order to get the crisp edge to the spout of the watering can, apply masking tape to the support once the paint is dry. You can then apply the light-grey mix from step 5 and remove the tape.

7 Rework the image, consolidating the colours and tones. Begin the process by repainting the ball of string using the 6 mm (¼ in) synthetic-fibre brush and a raw umber, yellow ochre and titanium white mix. Now move to the gloves, mixing a range of reds based on a cadmium red–yellow ochre mix for the red trim. Use variations of the grey mixed for the watering can to add detail to the fingers of the gloves.

8 Use raw umber and mars black to create a dark colour for the centre of the ball of string. Add a little yellow ochre to this mix and paint in the mid tones. Now lighten the mix considerably by adding titanium white and more yellow ochre, and carefully paint in the string that is catching the light. Use the rigger brush for this, as it will offer more control.

9 For the box, mix yellow ochre and a little cadmium yellow with titanium white. Using the 6 mm (¼ in) bristle brush, paint in the bottom of the box and, while the paint is still wet, inscribe a few lines into the paint using the end of the brush handle, to suggest the grain of the wood.

10 Mix a dark, rich brown using burnt umber, a little mars black, a little of the box mix and titanium white. Use this colour to consolidate the shadows cast by the can, the ball of string, the gloves and the end of the box.

11 Mix a light, straw colour from titanium white and yellow ochre. Use this to paint in the edge of the box with the synthetic-fibre brush. Switch to the bristle brush and mix a light cream to establish the background colour, using titanium white and raw umber.

12 Once this is dry, remix the background colour and, using the broken-colour technique, rework the background. Now lighten the colour with white and rework the area, wet into wet, using open, multi-directional brushstrokes.

13 During the course of this project you will have learnt how to use several different techniques in the same image and how to integrate them so that they do not appear obvious or contrived. No single technique dominates over others, but they work together to give a pleasing overall effect.

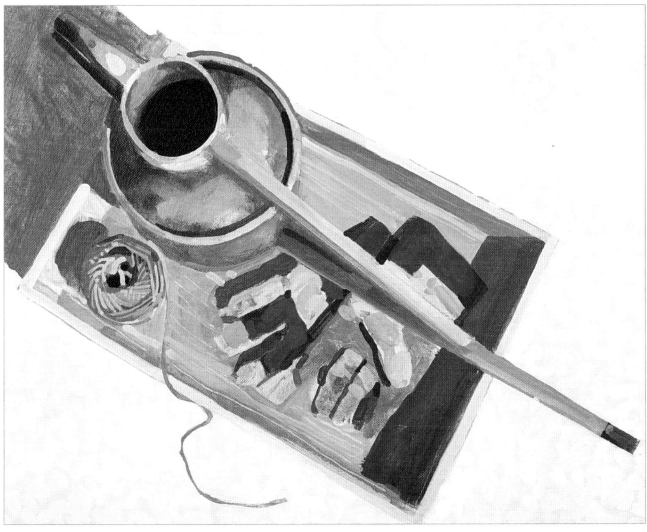

step 9 composition

focus: **arranging the elements**

Materials

Cartridge paper

2B pencil

Composition is all about placing or ordering the elements within an image and designing the pictorial space. A good composition seizes the viewer's attention and persuades the eye to follow a predetermined path into and around the work. Bad composition can lessen the impact of a good painting and, while a good composition will not make a bad painting great, it will certainly make it much better. Think of the composition as the foundation, or ground plan, upon which the painting is built.

Make a viewing frame by cutting a rectangular aperture into a piece of card and stretching four rubber bands across so that the aperture is divided equally into thirds horizontally and vertically.

USING A GRID

A design, or composition, can be very simple or very complex. Each of the various artistic disciplines has an effect on the composition – colour, line, tone, scale, texture, light and perspective – and you need to consider each carefully in terms of its impact on the overall design of a piece. Over hundreds of years artists and philosophers have devised various formulae that go some way to help in creating a good composition. Perhaps the best known is the 'golden section'. This is a mathematical formula that divides a line, or an area, in such a way that the size and proportion of the smaller area is to the larger area as the larger area is to the whole. This theory was put to good use in many paintings and was employed by architects when designing buildings, resulting in works of aesthetically pleasing proportions.

A similar device, and one that can provide a basis for the structure of a painting, is the so-called 'rule of thirds'. This simply uses two lines placed across the image horizontally and two placed vertically to divide the area into thirds. Placing important elements on or around the grid lines and the points at which they intersect invariably results in a pleasing composition.

VISUAL BALANCE

One of the most important elements of good composition is achieving what is termed as 'visual balance'. Balance in this instance does not mean

symmetry, but is achieved by relating one element within an image to another. These elements can take quite different forms: for example, you might balance a large object by two small objects; a large area of sombre colour by a small area of intense colour; or a small, highly textured part of the image with a larger, smoother passage. This 'point and counterpoint' is crucial in good composition and sets up something of a rhythm, which the eye is persuaded to follow.

LEADING THE EYE

Persuading the viewer to look at an image and move through or over it in a predetermined way, while holding the attention at specific points, is an important element in any good composition. There can be one focal point or several and you can achieve them in a number of ways, often using colour, or shape, or by introducing a visual pathway. Known as 'lead ins', these pathways might take the form of a path or stream in a landscape, or a swag of material in a still life.

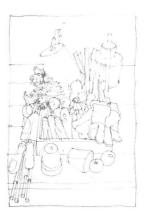

FORMAT

The first consideration when developing a composition is to decide on your format. There are three to choose from – the square, the vertical rectangle and the horizontal rectangle. Each has distinct characteristics to exploit when developing a good composition.

BREAKING THE RULES AND TESTING IDEAS

You can use each of the three formats with great results, and not necessarily conforming to whether they are better suited to landscapes, portraits or still lifes. In fact, artists often create more interesting and arresting images by working against type. Remember that no single compositional device should be used in isolation, but that each has a more or less equal part to play in forming the whole. To this end artists often try out several compositions, either by moving elements within the composition or by changing the position and angle of view.

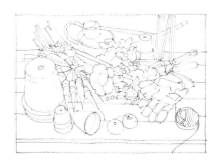

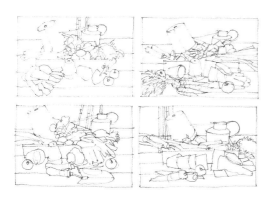

Experimenting with composition: Many artists make a series of small drawings, or 'thumbnails', which serve to explore the possibilities of various compositions, identifying and solving any visual problems in the process.

Square format (top): The square format provides a neutral area, which pulls the gaze equally around its perimeter, causing the attention to spiral ultimately to its centre. This can be a very good format for still lifes.

Portrait format (centre): With the vertical rectangle, the eyes tend to travel up and down the area, making it a favourite format with portrait painters.

Landscape format (bottom): The horizontal rectangle persuades the onlooker's gaze to move from side to side across the area, making it an ideal format for landscapes.

step 10 bringing it all together

focus: garden tools and vegetables

Materials

60 x 75 cm (24 x 30 in) prepared
 canvas board

Hard charcoal pencil

Fixative

Matte acrylic painting medium

6 mm (¼ in) flat bristle brush

3 mm (⅛ in) flat synthetic-fibre brush

6 mm (¼ in) flat synthetic-fibre brush

12 mm (½ in) flat synthetic-fibre brush

Medium-sized rigger brush

Masking tape

Small trowel-shaped painting knife

Spatula-shaped painting knife
 with angled end

2B graphite pencil

The palette:

* *Titanium white*
* *Quinacridone red*
* *Cadmium red
 medium*
* *Cadmium yellow
 medium*
* *Ultramarine blue*
* *Pthalocyanine green*
* *Dioxazine purple*
* *Raw umber*
* *Burnt umber*
* *Yellow ochre*
* *Mars black*

A number of the techniques used in the previous nine steps are brought together in this painting of vegetables and gardening paraphernalia. Colour mixing and paint handling are the two main areas of focus. However, you will also use a few techniques that create texture and will apply the paint with various tools other than a brush.

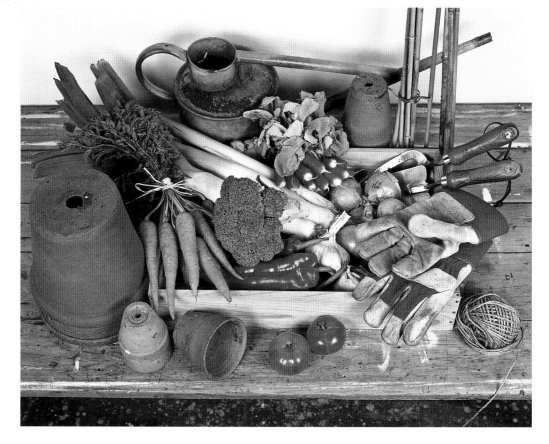

Stage 1: underpainting the composition

1 Begin by using the hard charcoal pencil to sketch in the main elements of the composition. Use light fluid strokes, holding the pencil a distance away from the point to prevent you from applying too much pressure.

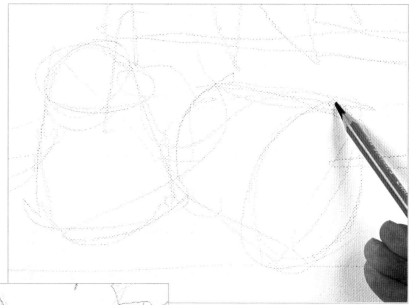

2 Having established the relative positions of the main compositional elements, rework the drawing, adjusting the various shapes and forms and adding moderate detail. Do not overdo the detail, however, as this can inhibit your brushwork and seduce you into simply filling in the shapes with paint rather than using the drawing as a guide.

3 The completed drawing should contain just enough information to act as a guide on which to build the painting. If you wish, give the finished drawing a coat of fixative to prevent the charcoal dust from mixing with subsequent layers of paint.

4 Using the 6 mm (¼ in) bristle brush begin the underpainting, mixing the paint to a relatively thin consistency using water and the matte painting medium. Try to avoid a heavy build-up of paint in the initial stages. Combine raw umber, yellow ochre and cadmium red to provide a range of terracotta hues for the flowerpots. Mix a dull orange by adding cadmium red and cadmium yellow to the terracotta mix. Use this to block in the carrots.

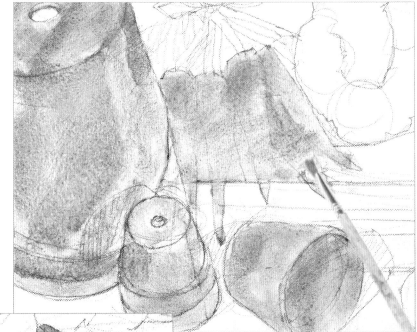

5 Mix cadmium red and quinacridone red to produce a deep red for the base colour of the peppers and the bunch of radishes. Add a little raw umber to this red to subdue it slightly and use this to paint in the red trim of the gloves.

6 Mix yellow ochre with a little raw umber and use this to paint in the bamboo canes. Add a little burnt umber to warm up the mix and use this to establish the colour of the onions and the handles of both the trowel and the hand fork.

7 Now focus on the greens. Mix a mid-green using a little pthalocyanine green and cadmium yellow. Subdue this with a little yellow ochre and paint in the foliage of the carrots. Add a little ultramarine blue and a little titanium white for the deeper green of the leek foliage, and add a little more yellow ochre and titanium white for the greens of the radish foliage. Add ultramarine blue and more titanium white to create a light blue-green for the head of the broccoli.

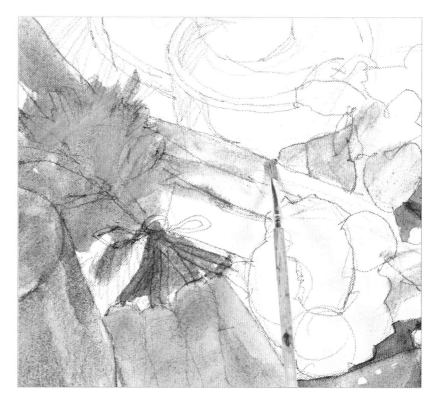

8 Use a simple mix of mars black and titanium white to paint the greys of the gloves and the watering can.

9 Paint the tabletop using a mix made from raw umber and yellow ochre. You can also scrub a little of this mix onto the gardening gloves. Darken the mix by adding more raw umber and a little mars black, and block in the dark area beneath the table. Paint the box containing the vegetables with a mix made from yellow ochre and white.

10 Brush a light grey, made from mars black and titanium white, into the area at the top of the picture to complete the underpainting. You have now established the overall colours of the painting, providing a good base for the subsequent, thicker layers of paint.

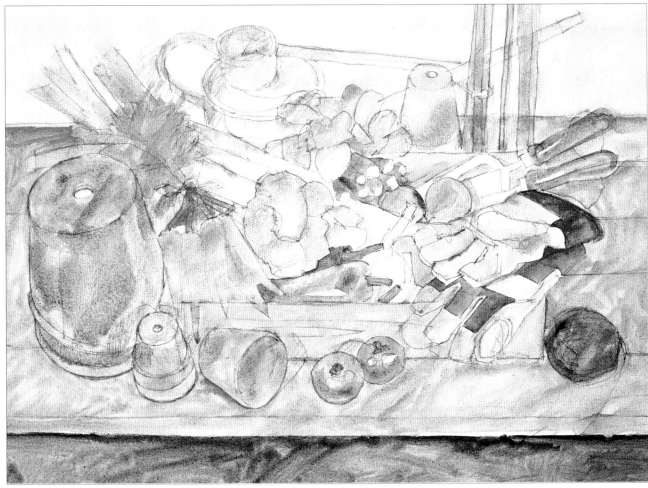

Stage 2: consolidating the colours

11 You can now begin to strengthen and consolidate the colours using paint that is thicker in consistency and more opaque. Using the 6 mm (¼ in) synthetic-fibre brush, begin with the flowerpots and a range of terracotta mixes. First mix a rich terracotta colour using yellow ochre, raw umber and a little cadmium red, then lighten the mix by adding titanium white and cadmium yellow and darken it using raw umber and dioxazine purple.

12 Use the darker terracotta mixes in the shadows between and around the carrots. You can then paint the main carrot shapes using a stronger orange mixed from cadmium red and cadmium yellow.

13 Mix together cadmium red and quinacridone red and rework the peppers. Paint around the highlighted areas, leaving the underpainting to show through. Paint the short stalks of the peppers using a bright green made from pthalocyanine green and cadmium yellow, subdued by adding a little yellow ochre.

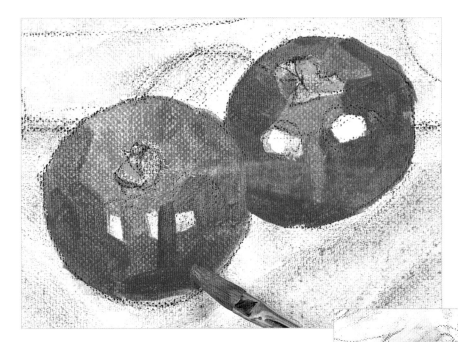

14 Use the same red mix to consolidate the colour of the tomatoes, adding cadmium yellow to lighten the mix and make it more orange as required.

15 You can use the same red mix as a base for the radishes – darken the colour with raw umber for those areas in shadow. For the slightly washed-out colour of the radish leaves create a good mid-green by mixing together pthalocyanine green and cadmium yellow. Cool the mix down by adding a little ultramarine blue and lighten it using titanium white and a little more cadmium yellow. Darken the mix for the shadow areas by adding a little cadmium red.

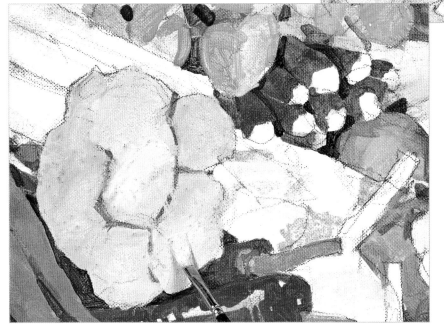

16 Add a little more ultramarine blue to the green mix used for the radish leaves together with titanium white and use the resulting blue-green for the head of broccoli. Add raw umber and mars black for the darker green mix.

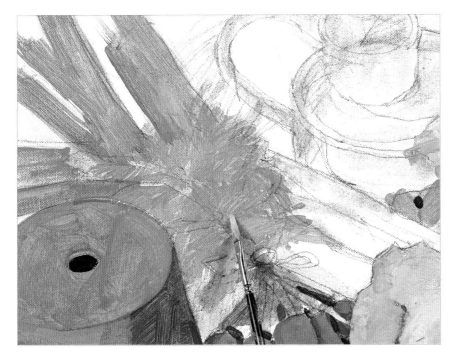

17 Make a deeper green for the leaves of the leeks by adding more ultramarine blue to the green mix used for the radish leaves. Apply using the 6 mm (¼ in) bristle brush, leaving linear marks to represent the texture of the leaves. Make this green brighter and more acidic by adding cadmium yellow and a little more pthalocyanine green. Using the 6 mm (¼ in) synthetic-fibre brush, repaint the carrot foliage making thin linear strokes with the side of the brush.

18 Return to the gloves, repainting the trim using a mix made from cadmium red with a little quinacridone red and raw umber. Now mix the darker greys, which you make using mars black and raw umber with the addition of titanium white. Once you have repainted the darks, lighten the colour with more titanium white and block in the lighter tones.

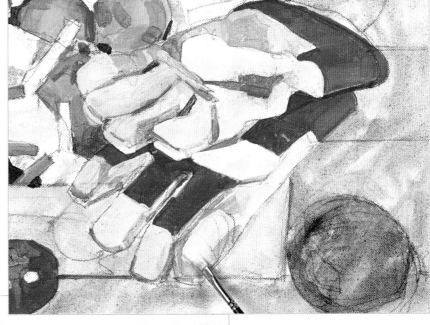

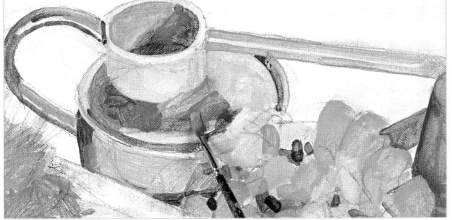

19 Add a little dioxazine purple to these grey mixes to achieve the colour of the watering can. Notice the slight green tinge where moss has coloured the galvanized steel surface of the can. Make this colour by adding a little ultramarine blue and yellow ochre to the grey mix.

Stage 3: developing tone

20 Stand back from your painting. You have strengthened the colours appreciably and the image now begins to exhibit a degree of depth. It is time to focus on the tonal contrast of the painting, adding the darker tones and picking out highlights.

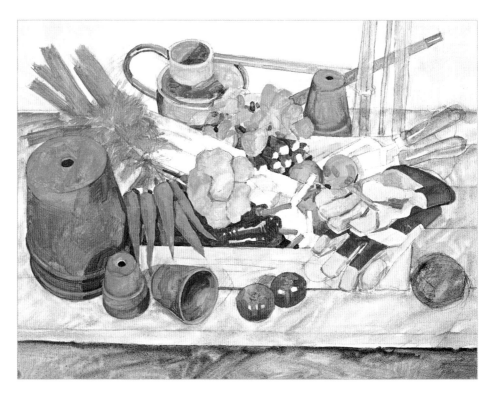

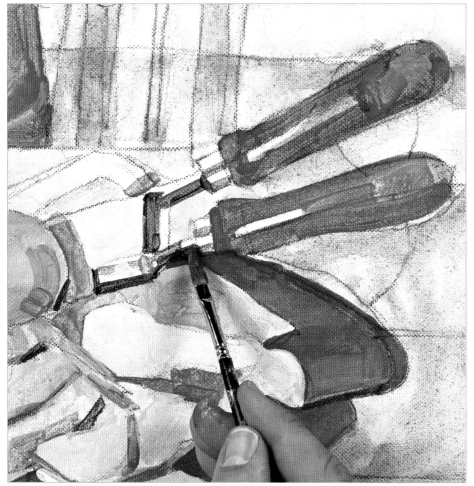

21 Make a raw umber-yellow ochre mix and, still using the 6 mm (¼ in) synthetic-fibre brush, use this mix to repaint the fork and trowel handles. Mix a deep grey from mars black, raw umber and a little titanium white and use this to redefine the dark reflections and shadows on the stainless steel.

22 Repaint the light wall at the top of the picture using titanium white, and the dark beneath the tabletop using a mars black-raw umber mix and the 12 mm (½ in) synthetic-fibre brush.

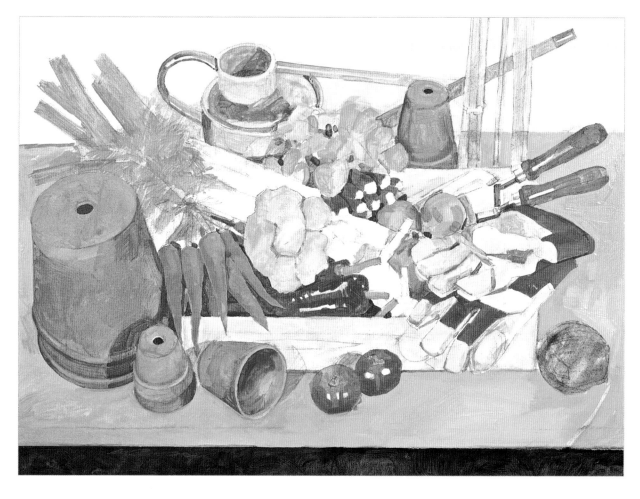

23 Now repaint the tabletop itself, using mixes based on raw umber, yellow ochre and titanium white with the 12 mm (½ in) flat synthetic-fibre brush. Maintain a crisp edge top and bottom by using masking tape to define the edges. Remove the tape once the paint has been applied.

24 Stand back from your work. See how the tabletop now looks more solid and the illusion of perspective front to back has been increased, which creates depth.

Stage 4: finishing the painting

25 Repaint the watering can using various combinations of mars black, raw umber, dioxazine purple, ultramarine blue and titanium white. Pay careful attention to the position of the darks on the handle and the spout, and paint these using a 3 mm (⅛ in) synthetic-fibre brush. Mix a green-grey for the body of the can (see step 19) and distribute the colour using your finger to recreate the appearance of its distressed surface.

26 Use variations of the same grey mixes to repaint the gloves, still using the smaller brush. Make precise directional strokes to suggest the folds of the fabric, and use the lighter greys to bring out the highlights. Repaint the red trim using the same technique and the colour mixed in step 18.

27 Using a medium-sized rigger brush use the same red on the peppers and the radishes, adding a little titanium white to lighten the colour slightly for the top of each radish. Apply pure titanium white for the very tip of each radish, pulling the thin root out using the point of the brush.

28 Mix a dark green for the leek leaves using pthalocyanine green and cadmium yellow, with a little ultramarine blue and raw umber. Use the 6 mm (¼ in) bristle brush to apply this, and scratch a series of loosely parallel lines through the wet paint using the small trowel-shaped painting knife.

29 Intensify the basic colour of the carrot leaves by loosely scrubbing on a deep green made from pthalocyanine green, cadmium yellow and yellow ochre, using the 6 mm (¼ in) synthetic-fibre brush. Allow this to dry.

30 Lighten the green from the previous step by adding titanium white and use this to paint in the lighter feathery profile of the carrot leaves. Create the strokes using the spatula-shaped painting knife: simply dip the short edge of the knife in the paint and press it to the paint surface in order to create a network of loosely connected linear marks.

31 Rework the carrots to give them more form. Mix a light orange and apply, using the rigger brush, to make a series of linear marks that suggest the form of each carrot.

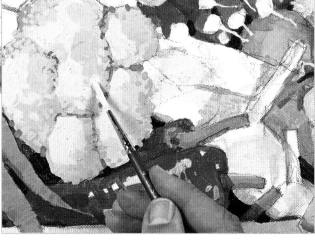

32 Use light-grey mixes with a little added raw umber to add colour to the cloves of garlic. Still using the rigger brush, rework the broccoli head using a range of blue-greens (see step 16) and short, stippled strokes that suggest the rough texture of the vegetable.

33 Paint the ball of string in three simple steps. Mix a mid-ochre-brown to match the colour of the string, using raw umber, yellow ochre and white and use the rigger brush to paint in the strands of string as they curve around and across the ball. Allow this to dry. Add more raw umber and a little mars black to the same brown and paint in the darks between the strands and at the centre. Finally, lighten the mix using white and paint in the lights.

34 Mix a light brown-ochre from burnt umber, raw umber, yellow ochre and titanium white. Use this colour to paint in a series of horizontal lines on the tabletop to represent the grain of the wood. Use the dark brown from step 33 to suggest the dark spaces between the lengths of wood.

35 Using the 6 mm (¼ in) synthetic-fibre brush, add titanium white to the ends of the leeks and also as highlights on the surface of the bulbs of garlic.

36 Finally add a few lines of sharp 2B pencil to suggest the wood grain on the side of the wooden box and to help capture the form of the two garlic bulbs.

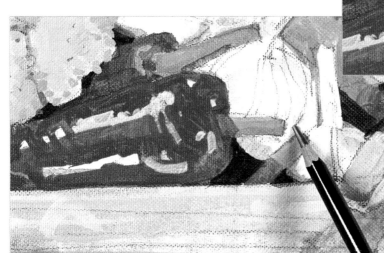

37 The finished image has a lively character that is helped by the straightforward, unfussed brushwork that is in character with the subject matter. The obvious brushmarks are used to very good effect in describing the different surface characteristics and textures of the various elements.

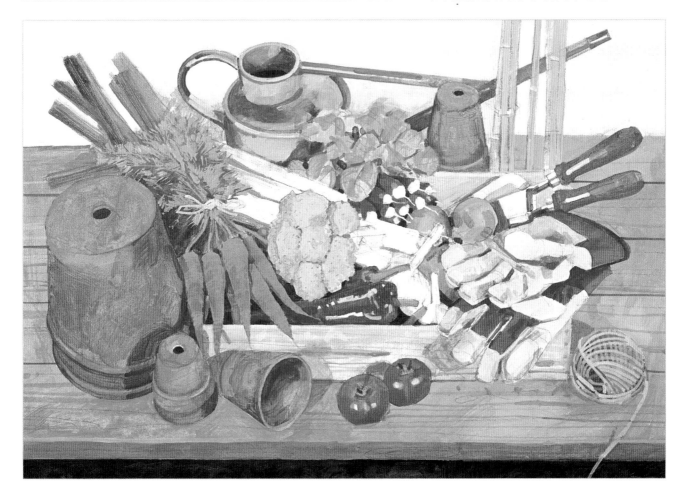

pastels
in 10 steps

before you begin

choosing the right materials

Compared with oil, acrylic or watercolour painting, pastel painting requires very little equipment; all you will need is a range of pastels and a surface on which to paint. No thinners or oils are called for and although you can manipulate the pigment on the surface with various tools, for the most part you can do it with just your fingers.

Shopping list

Miscellaneous:

Fixative

Paper towel

Torchon (paper stump – these are very cheap, so buy several of different sizes)

Sharp craft knife or scalpel

Painting surfaces:

30 x 36 cm (12 x 14 in) light ochre pastel paper

23 x 30 cm (9 x 12 in) light grey pastel paper

28 x 38 cm (11 x 15 in) light brown pastel paper

24 x 32 cm (9½ x 12½ in) light brown pastel board

21 x 29 cm (8½ x 11½ in) dark brown pastel paper

28 x 38 cm (11 x 15 in) mid green pastel paper

25 x 33 cm (10 x 13 in) blue pastel paper

53 x 74 cm (21 x 29 in) light brown pastel paper

53 x 74 cm (21 x 29 in) dark brown pastel paper

53 x 74 cm (21 x 29 in) deep blue pastel paper

Pastels:

Cadmium yellow deep (Hard/Soft)

Cadmium yellow (Hard/Soft)

Lemon yellow (Hard/Soft)

Deep orange (Hard/Soft)

Orange (Hard/Soft)

Light orange (Soft)

Cadmium red (Hard/Soft)

Crimson (Hard/Soft)

Dark red (Hard/Soft)

Burnt sienna dark (Soft)

Burnt sienna (Hard/Soft)

Burnt sienna light (Soft)

Light warm grey (Hard/Soft)

Warm grey (Hard/Soft)

Dark warm grey (Hard/Soft)

Dark cool grey (Hard)

Light cool grey (Hard/Soft)

Black (Hard/Soft)

Cerulean blue (Hard/Soft)

Cerulean blue deep (Hard)

Cobalt blue (Hard)

Ultramarine (Hard)

Payne's grey (Hard/Soft)

White (Hard/Soft)

Raw umber light (Hard/Soft)

Raw umber (Hard/Soft)

Vandyke brown (Hard/Soft)

Burnt umber (Hard/Soft)

Raw sienna (Hard/Soft)

Raw sienna deep (Hard)

Yellow ochre (Hard/Soft)

Ivory (Hard/Soft)

Light violet (Soft)

Violet (Hard/Soft)

Viridian (Hard/Soft)

Oxide of chromium (Hard/Soft)

Grey green (Hard/Soft)

Lime green (Hard/Soft)

Dark olive green (Hard)

Olive green (Hard)

Light green (Hard/Soft)

Mid green (Hard/Soft)

Dark green (Hard/Soft)

Pink (Hard)

The materials needed are available at most art stores. Buying a range of pastels to work with is slightly different to buying a set of oil, acrylic or watercolour paints, where it is possible to obtain a basic palette of colours that will enable you to mix most of the hues, tints and tones you will ever need. Because of the way in which pastels are made and applied, mixing is intended to be kept to a minimum. Purchase both hard and soft pastels for those colours where both types are given in the shopping list opposite.

PASTELS

Pastels are made by mixing a pigment or pigments together with an inert filler and a binder. The pigment is the substance that provides the colour, and traditionally its source is either organic (derived from animal or plant sources) or inorganic (derived from salts or metallic oxides). However, these days many pigments are manufactured synthetically. The filler (usually chalk) is added to bulk out the pigment and allow it to be made into a paste when it is mixed with the binder, which normally consists of a type of gum.

The wet paste is compressed into a stick, cut to length and allowed to dry.

Types of pastel

Pastels can either be hard or soft. However, as the characteristics of the individual pigments differ, some soft pastels are harder than others. The degree of softness can also vary according to the brand.

Soft pastels are traditionally round and wrapped in a paper sleeve which helps to hold the pastel together. Hard pastels, sometimes referred to as chalks, have no paper sleeve and are usually square in profile. The manufacturing process is very similar to that for soft pastels, but more binder is added to make the stick stronger. Hard pastels can be carefully sharpened to a point, making them ideal for rendering detail.

Pastel pencils (see page 14) resemble coloured pencils, but the pigment core is made from a mixture very similar to that of hard pastels. They are more of a drawing tool and are useful for adding detail to images created with traditional hard or soft pastel. All of the different types and brands of pastel can be intermixed.

CHOOSING A RANGE OF PASTELS

Pastels are applied directly to the surface in the same way that you would use a coloured pencil. Because of their softness, once they are on the surface you can mix and blend them in a variety of ways. However, in order to avoid the pastel painting from looking overworked it is best to keep this to a minimum. It is for this reason that pastel manufacturers create a wide range of tints and tones of each colour, and given that no two brands of pastels will provide exactly the same colours, there are an awful lot of colours, tints and tones available. It is impractical to buy every one of these colours, so where to begin?

All manufacturers supply sets of pastels that provide a range of colours to get you started. Many also offer sets that include a range of colours suitable for painting specific subjects, such as portraits or landscapes. These are tempting for the beginner, but it is far better to choose your own set of colours to suit your intended subjects and buy a separate box in which you can store and protect them.

For this book I have done exactly that and all of the projects have been executed using these pastels. Because manufacturers sometimes use different names for the same colours, I have chosen a set of pastels and given them my own generic names such as burnt sienna deep, burnt sienna or burnt sienna light. In some cases these will be the same as the actual manufacturers' names, while in others they will be names that I have picked because I think they match the characteristics of that particular colour. If this sounds a little complicated, simply take this book with you to the art store and match your selection of pastels as closely as you can to the colours in the colour palette chart on pages 340–341.

I have chosen these colours for several reasons. They give a range of warm and cool variants of each of the main colour groups (see pages 348–349) and also provide a range of tones, essential for indicating form. They are all easily available from several different manufacturers, and they will give you a very good basic set of pastels that you can build on as and when you feel it necessary.

LOOKING AFTER YOUR PASTELS

Pastels are relatively delicate and will break if they are dropped or used carelessly. Soft pastels are for the most part sold with a protective wrapper, on which is printed the manufacturer's name, the colour name and often the code of the pigments used. This wrapper is there to protect the pastel in transit and to add a degree of strength and stability. It can be torn away as the pastel is used but it is best not to remove it completely. To some extent the paper wrapper will also prevent pigment from getting onto your fingers.

Rather than keep pastels loose it is better to store them in a box. Any flat box that will prevent the pastels from clattering around and becoming broken will do, but you can find several types of box made specifically for the task at art stores. These boxes are constructed to the correct depth so that the pastels will not move around unduly during transport. Some have foam inserts that pad the pastels and prevent them from rolling around, while larger ones have drawers which are divided into sections so that the pastels can be arranged according to colour and type.

KEEPING PASTELS CLEAN

Pastels (particularly the soft type) can become dirty as pigment is transferred from pastel to pastel, either by close proximity to one another or by pastel-covered fingers. Fortunately, the solution is very simple: take a clean glass jar with a screw lid and three-quarters fill the jar with dry uncooked rice of any type. Push the dirty pastels into the rice, put the lid on and shake the jar gently. The abrasive action of the rice removes the dirty surface of the pastel to reveal the true colour beneath. Replace the rice once it is dirty.

Cleaning pastels: The larger the jar, the more pastels can be cleaned at any one time.

FIXATIVE

The surface of a pastel painting is delicate; if it is rubbed or shaken the pigment can easily be dislodged or smudged and the painting potentially ruined. In order to prevent this from happening, pastel paintings are usually 'fixed'. This means giving the painting a coat of fixative which holds the pigment dust in place.

Fixative consists of a colourless resin which is carried in a clear spirit solvent. Once it is applied to the painting the solvent evaporates quickly, leaving the resin behind to fix the pigment dust to the surface. The fixative is applied by atomizing it into tiny droplets which are sprayed onto the surface in one of three ways. The easiest of these is to use an aerosol can which delivers the fixative very evenly to the surface. The second way is by a pump-action spray, which is attached to the top of the fixative bottle and operated by your finger. The third way is via a mouth-operated atomizer. This consists of two hollow tubes joined at one end by a hinge, which opens out so that the tubes sit at 90 degrees to one another. Place one end of one tube in the bottle of fixative and the other in your mouth. Blowing down the tube causes the fixative to rise up the tube and atomize into a fine spray that is blown onto the surface.

Fixatives: There are various ways of applying fixative.

Applying fixative can dull the colours slightly, especially lighter tints, and for this reason many pastel artists choose not to use it. However, it does have the advantage that you can extend the range of tones by fixing then applying another layer of similar colours. Many artists fix during the painting process and finally apply the lighter accents and passages which are left unfixed to preserve their brightness.

PASTEL PAINTING SUPPORTS

Pastels can be applied to a variety of supports (the materials, or surfaces, upon which you paint), ranging from paper to board; in theory, they can be used on any surface that has sufficient tooth or texture to hold the pigment dust. This includes relatively smooth white drawing (cartridge) paper. In practice, however, it is better to use a surface that is made specifically for pastel work in order to build up sufficient depth of colour. The surfaces of pastel supports all have slightly different characteristics, with some much rougher or coarser in texture than others, and the choice of which to use is entirely a personal one. As a general rule, those surfaces that are very rough

are the most difficult to work with. Either side of textured papers intended for pastel can be used, with one side usually being slightly smoother than the other. Which side to use is a personal preference.

Supports are also available with a 'sanded' surface, coated with sand, silica, pumice, marble dust or a finely ground vegetable paste. Only the coated side of these papers is used. This type of surface is also applied to rigid card to make pastel boards, where again only the coated side of the support is used. At the oppposite end of the scale, you can also buy a softer surface support that resembles a smooth material like velour.

If you wish to create your own surface you can buy liquid grounds in a range of colours that you can paint on to either paper or board. These invariably consist of a liquid gesso mixed together with a pumice or marble dust which dries to leave a hard, finely textured surface. Alternatively, it is an easy task to prepare your own using an acrylic gesso into which you mix marble dust and, if you wish, acrylic paint of any colour.

Coloured supports

In pastel painting the support colour is very important as it affects the quality of the colours that are applied. Because pastels are used on a textured surface, this surface will inevitably show through in places and will have a profound influence on the finished work.

There are several considerations to take into account when you are choosing the colour and tone of the support for a particular painting. You may want to set an overall tonal value for the work, be it light, medium or dark. Alternatively, you may want the colour and tone to give an overall sense of warmth or coolness, or to provide the dominant or background colour of the subject. A contrasting colour will make the applied colours 'sing', or appear much brighter than they actually are. Subtle neutral colours – ochres, browns, greens, blues and greys –

are easier to work with, but as long as you take care, you will be able to achieve stunning results by using very strong bright colours that inevitably make the applied pastel colours really sing out.

You can use white papers and supports if you wish, but the pastel colours will lack the punch that they have when applied to a support that is even relatively light in colour or tone. If you cannot conveniently lay hands on a support in the colour you want, you can tint any white watercolour paper using either watercolour, gouache or acrylic paint.

MANIPULATING PASTEL ON THE SUPPORT

While you apply colour to the support with the pastel itself, once it is there you can manipulate it in a number of ways. The most convenient is to use your hand and fingers. Indeed, it will become second nature to blend or soften colours using your fingers, the only drawback being that it will necessitate numerous visits to the wash basin! Make sure that your hand and fingers are dry and grease-free and avoid eating food or putting your fingers in your mouth if they are covered in pigment.

The traditional tool for manipulating dry, crumbly drawing materials is the torchon, or tortillion, which is simply a stump of rolled or pulped paper with a point at one end, or sometimes both. These paper stumps are inexpensive and available in various sizes. The larger stumps can be used for broad work and the smaller ones for fine detail. They can become dirty with use but it is an easy task to clean and sharpen the point by rubbing it on a fine-grade glass paper.

You can also manipulate the pigment with sponges, cotton-wool buds, paper towels or brushes. While you can use any brush intended for watercolour, oil or acrylic paint, there are also a range of brushes made specifically for pastel work.

Erasers: Paper stumps are pointed in order to facilitate detailed eraser marks.

The ability to remove pigment from the support is important, not so much to make corrections but as a means of creating textural effects and adding highlights. You can do this with brushes, torchons and other mark-making tools and also erasers. The pigment can clog and make them dirty very quickly, but handled with care they can be very useful. Putty erasers get dirty far quicker than rubber or vinyl erasers, but a simple solution to this is to cut the eraser into small pieces then discard each piece as and when it becomes too dirty to use.

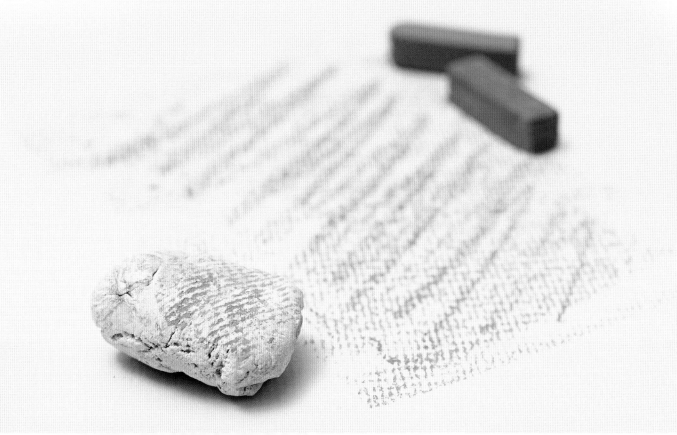

Soft pastels need to be sharpened with care as they break easily.

Hard and soft pastels can be given a point on glass paper.

A sharp craft knife will give a good point on hard pastels.

SHARPENING PASTELS

Soft pastels are difficult to sharpen as they break very easily. It is far better to use the pastel in such a way that the action of applying it on the support wears it down, creating a sharp edge or a point. However, you can maintain a sharp edge on a soft pastel by cutting it at right angles across its diameter. Alternatively, sharpen it by rubbing it on a piece of fine grit glass paper. Hard pastels, on the other hand, can be sharpened successfully by carefully using a sharp craft knife or a scalpel.

ADDITIONAL EQUIPMENT

You will need a drawing board on which to secure your support. These are made of wood and available in a range of sizes. Choose one that is large enough to accommodate the largest size of paper that you are likely to use. To hold the support on the drawing board, it is best to use clips rather than tape or drawing pins as they do not damage the corners of the support. When you are choosing clips, make sure that they will open wide enough to accommodate the thickness of the drawing board and support.

An easel is perhaps a luxury that you can initially do without, though you will find that a good sturdy easel makes positioning the support easy and practical. The easel you choose depends on practicalities such as cost, the angle at which you like the support, whether you prefer standing or sitting down to paint and if you are going to be working on location (see page 183). In all instances, choose the best that you can afford to ensure that it will last a long time and is stable and easily adjustable. Some easels on being set up can fight back in much the same way as deckchairs!

You may find a mahlstick useful – a traditional piece of equipment that consists of a wooden or metal stick with a soft ball at one end. The soft tip can be placed on the edge of the painting and the stick held in the non-drawing hand. The stick then acts as a support for your drawing hand and keeps it away from the work. Finally, use a roll of paper towel for wiping your hand, dusting off excess pigment and making corrections.

THE COLOUR PALETTE

The pastels used for the projects in the book were from various manufacturers and varied in degrees of hardness. For the exact type of pastel, refer to the materials list in the introduction to each project. The main projects used a combination of hard and soft pastels. My suggestion is that you equip yourself with both hard and soft variants of each colour used. As I have used generic titles for my pastel colours, to match up the palette take the book to your art store and choose a range of pastels that matches the colour swatches here. Do not be over-concerned if you cannot make an exact match – as long as the colours are similar you will be able to complete the projects.

Colour list

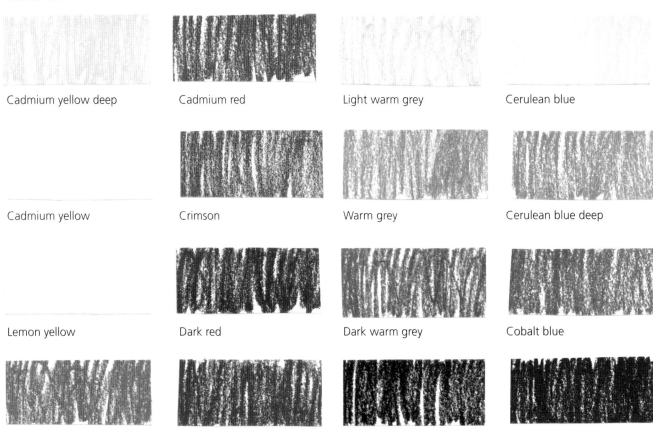

Cadmium yellow deep	Cadmium red	Light warm grey	Cerulean blue
Cadmium yellow	Crimson	Warm grey	Cerulean blue deep
Lemon yellow	Dark red	Dark warm grey	Cobalt blue
Deep orange	Burnt sienna dark	Dark cool grey	Ultramarine

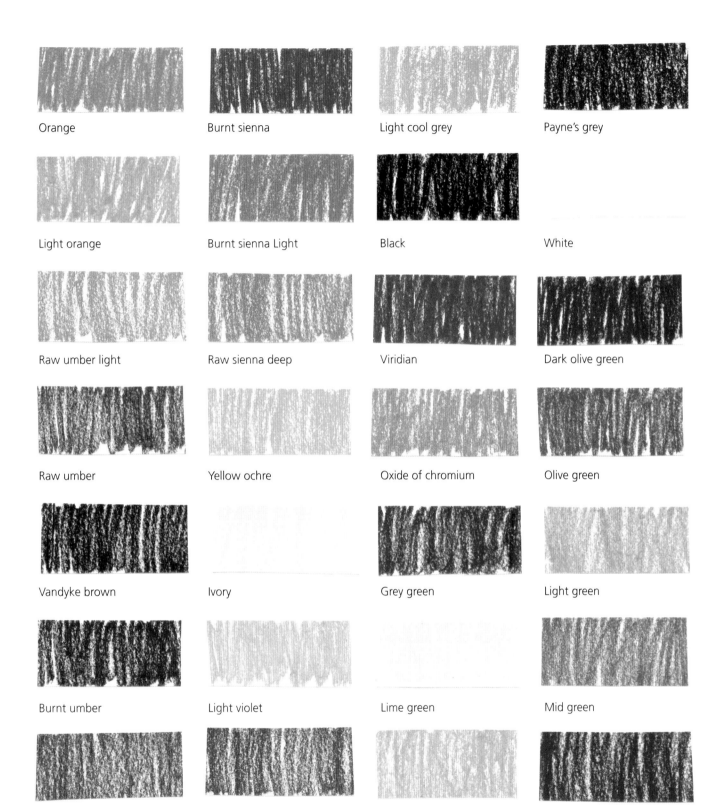

Orange

Burnt sienna

Light cool grey

Payne's grey

Light orange

Burnt sienna Light

Black

White

Raw umber light

Raw sienna deep

Viridian

Dark olive green

Raw umber

Yellow ochre

Oxide of chromium

Olive green

Vandyke brown

Ivory

Grey green

Light green

Burnt umber

Light violet

Lime green

Mid green

Raw sienna

Violet

Pink

Dark green

step 1 preparation and foundation

focus: **grapes and bananas**

Materials

30 x 36 cm (12 x 14 in) light ochre
 pastel paper
Fixative
Paper towel
Hard pastels:

- *Black*
- *Violet*
- *Light violet*
- *Burnt umber*
- *Raw sienna*
- *Mid green*
- *Cadmium yellow*
- *Cadmium yellow deep*
- *Payne's grey*
- *Ivory*
- *White*

There is an old adage that goes 'Plan to fail by failing to plan.' This is a truism that applies to all types of drawing and painting but is especially apt when working in pastel. The problems arise from choosing the wrong support type (see pages 336–337), something we will look at in more depth on pages 388–393, and from applying too thick an application of pastel in the early stages of the work.

Pastel dust needs a textured support on which to adhere. If the support is too smooth, you can make a mark but not enough pigment will be left behind, making it an almost impossible task to build up sufficient depth of colour. If the support is too coarse the exact opposite happens – too much pigment can attach itself to the support, making it very difficult to apply subsequent layers. The support texture also makes for a very open-textured image that is not always pleasing. Papers intended for pastel

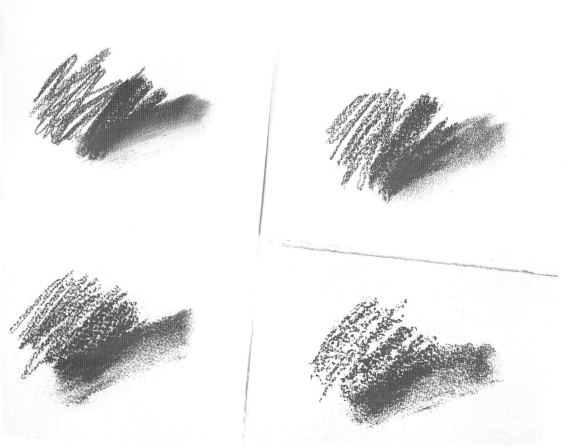

Support surfaces:
These four support surfaces have different textures but you can see how similar pastel marks look on each.

Hard pastels: Harder pastels and chalks are often better used in the initial stages of a painting as they deposit less pigment dust and do not clog up the texture, or tooth, of the support.

Removing dust: You can easily remove excess pastel dust by flicking over the area with a soft rag or a bristle brush. This must be done prior to applying fixative.

paintings have been made with this in mind and have a surface tooth or texture that marries perfectly with the delicate pigment dust.

A pastel painting is invariably constructed using a series of layers. As with painting in other mediums, the initial layer is either a drawing which will help keep further applications on track or a loose underpainting which puts in the elements of the picture and can concentrate on tone, colour or general shape and positioning. Often the drawing and the underpainting are made in such a way that they are indistinguishable from one another.

When you are painting in pastels it pays to use a loose approach at first, gradually tightening and defining specific areas as you work. It is not easy to make fine, precise or intricate detail with pastels but this method does make it possible.

UNDERDRAWING AND UNDERPAINTING

For the underdrawing, you can use charcoal instead of pastel. The dark charcoal dust may mix with the lighter pastel colours, but this can be alleviated by fixing the charcoal drawing before adding pastel. (Charcoal can also be used instead of black pastel at any point as it mixes with pastels very well.) Do not use graphite pencils for the underdrawing as sometimes the pressure you will need to apply leaves a slight indentation on the support surface which remains visible through the pastel work. Once you have finished the drawing, flick over the support with a soft rag or a large soft brush to remove any superfluous pastel and to prevent an early build up.

The same technique can be used on the underpainting, which is made with broad applications of pastel. The colours and tones are usually simplified to suggest local colour and the main areas of light, mid and dark tone. Many artists use the harder pastels for underpainting as, by their very nature, they deposit less pigment dust when used. This helps you to establish a good foundation for subsequent work unencumbered by a thick layer of pigment dust.

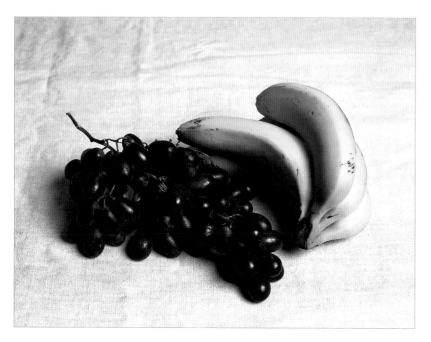

PAINTING THE GRAPES AND BANANAS

The grapes and bananas chosen for this exercise each consist of several small shapes that join together to make the whole. The exercise shows you how to loosely plan out the image so that you build a strong, informative foundation that will act as a guide for your subsequent applications of pastel. You will also discover just how to avoid a premature build-up of pigment dust.

1 Begin by using a hard black pastel to sketch out the shape and position of the bunch of grapes, together with its cast shadow. Work lightly and loosely. You may find it easier to position your lines more correctly if you sharpen the pastel to a point before you begin.

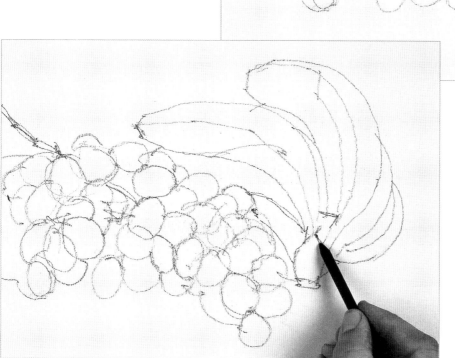

2 Now draw the bunch of bananas, positioning them carefully adjoining and slightly behind the grapes. If you make a mistake, don't panic – simply redraw. Remember, the subsequent pastel work will cover up any mistakes and the drawing is only meant to act as a guide.

3 Even though you have worked lightly you can 'knock back' the drawing further and remove excess black pastel dust by dusting over it with a soft rag, paper towel or bristle brush. There is no need to be concerned if the drawing appears to smudge, but you can give it a coat of fixative if you wish.

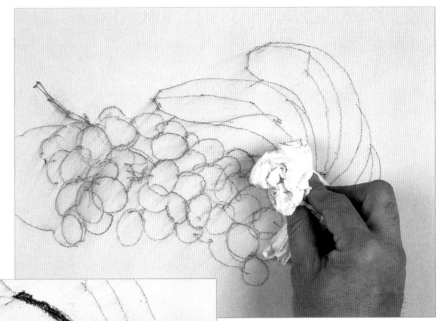

4 With black and burnt umber pastels, scribble simple strokes to block in the darker areas on the grape stalks and the bananas. Do not be concerned if a few patches of the support show through in places.

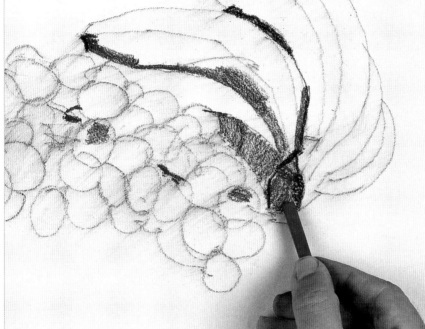

5 With slightly firmer strokes, use the black pastel to block in the darkest areas on and around each grape and the shadow cast by the bananas. Dust off the excess pigment.

6 Now, using combinations of burnt umber and violet, establish the basic colour of the grapes. As you work, vary the direction of your strokes, occasionally allowing them to follow and suggest the contours of individual grapes. At this stage, do not attempt to represent any highlighted areas.

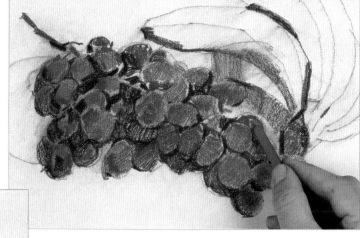

7 Next take the mid green and establish the areas of green on each banana. If this seems too strong do not worry – once the yellows are applied the green will be subdued to some extent. Pick out the stalk of the grapes with the same green. Apply simple strokes of Payne's grey along the edges of each banana in shadow, then use raw sienna to establish a base for the darker yellow areas on each banana where they face away from the light source.

8 Work cadmium yellow deep into the areas of banana where you have already applied raw sienna, which will darken the yellow slightly. Then apply a stronger, brighter cadmium yellow to the sides of the bananas that are in the light. This will mix with the green to give a good representation of the unripe skin.

9 Use Payne's grey to paint the shadow cast by the grapes onto the tablecloth then, with simple touches of a light violet pastel, pick out the highlighted areas on some of the grapes.

10 Block in the background with ivory, working carefully around the shape of the grapes and bananas and redefining their outline as you go if you consider it necessary. Build up the colour using a network of multi-directional strokes.

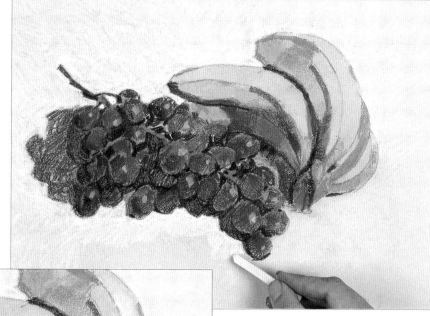

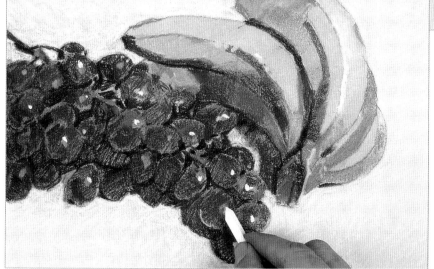

11 Finally, use white to add a highlighted area along the edge of the uppermost banana, then add simple dabs of white to pick out the brighter highlighted areas on the grapes.

12 The finished painting, although complete, is really just an underpainting and could be worked on further if you wish, because the build-up of pigment has been kept to a minimum. Leaving the support to show in places allows for further applications of thicker pastel to adhere easily.

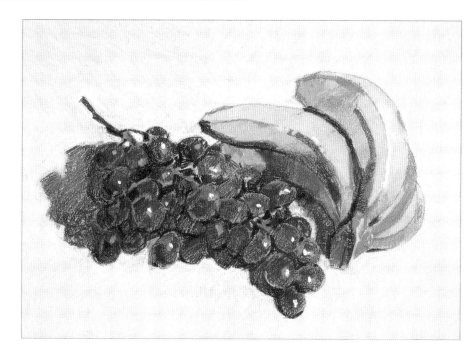

step 2 colour

focus: **orange, lime and lemon**

Materials

23 x 30 cm (9 x 12 in) light grey
 pastel paper

Soft pastels:

- *Cadmium red*
- *Dark red*
- *Deep orange*
- *Orange*
- *Light orange*
- *Lemon yellow*
- *Cadmium yellow*
- *Viridian green*
- *Mid green*
- *Light green*
- *Payne's grey*
- *Ivory black*
- *Raw umber*
- *Raw umber light*
- *Ivory*
- *White*

You may already be familiar with other painting materials, but when you are working in pastel the approach to colour and colour mixing is slightly different. Pastel is a 'dry' colour and is applied directly to the support with no prior mixing on a palette. While a degree of mixing through blending and layering does take place, it is more usual and often a better policy to keep the colours pure by using a pastel with a colour that approximates the one you want. A little knowledge of basic colour theory and terminology is a useful thing to have and will help you to understand what colour is and does.

Colour wheel

The colour wheel is a standard diagram that shows the progression and order of the colours as they merge from one to another. The wheel corresponds to the progression of the colours in the spectrum which make up white light. It is a useful device for making sense of colour relationships, colour theory and terminology.

Primary colours

The primary colours are red, yellow and blue – colours that cannot be made by mixing other colours together. There are several different versions of each primary colour.

The colour wheel: The wheel shows how the primary colours are mixed with one another to create a range of secondary and tertiary colours.

Tints and tones: Pastels are manufactured so that a range of tints and tones of each hue or colour is available. This cuts down on mixing. Here a light, medium and dark version of ultramarine are shown.

Creating neutrals: Mixing complementary colours together results in a range of neutral browns and greys – but take care you do not end up with dull, dirty colours that all look the same.

Secondary colours

Mixing any two primary colours together results in a secondary colour. For example, red and yellow make orange, yellow and blue make green and blue and red make violet. The exact hue or type of orange, green or violet will depend on which versions of each primary colour were used in the mix.

Tertiary colours

Tertiary colours are created when a primary colour is mixed in more or less equal parts with the secondary next to it on the colour wheel. These colours are red-orange, orange-yellow, yellow-green, green-blue, blue-violet and violet-red.

Complementary colours

Complementary colours fall opposite one another on the colour wheel. They have a very special relationship, in that when they are placed next to one another they make each other appear brighter than they really are. Conversely, when they are mixed together they subdue or neutralize one another. This results in a series of very important colours known as neutrals which include greys and browns.

Colour temperature

Colours are considered to be 'warm' or 'cool'. Red, orange and yellow are warm colours, while green, blue and violet are cool. However, this is complicated somewhat by each colour having both warm and cool

variants. For instance, cadmium red is a warm red because it leans towards being yellow; alizarin crimson, on the other hand, is a cool red because it leans towards blue.

Hue

The term 'hue' is simply another name for colour. Ultramarine, cobalt blue and cerulean are all blue hues. Crimson and cadmium red are red hues.

Value

This term is used in relation to tone and describes the relative lightness or darkness of a particular colour.

Saturation

The term saturation describes the relative intensity of a colour. Colours that are similar in hue will have different intensities of colour. Ultramarine is a more intense (more saturated) blue than cerulean, for example.

Harmony

Certain colour combinations are more harmonious than others. Colour harmony can be created in several different ways: monochromatic harmony is achieved by using tones of the same colour; analogous harmony by using groups of colours that are close or next to one another on the colour wheel; and complementary harmony is created by using colours that fall opposite one another on the colour wheel.

PAINTING THE ORANGE, LIME AND LEMON

These three objects are relatively simple in colour and when viewed individually show little colour variation over their surface. However, when they are placed together under a relatively strong light you can see how the colour of each affects the colour of its neighbour. It is the ability to depict this reflected colour that makes an image convincing.

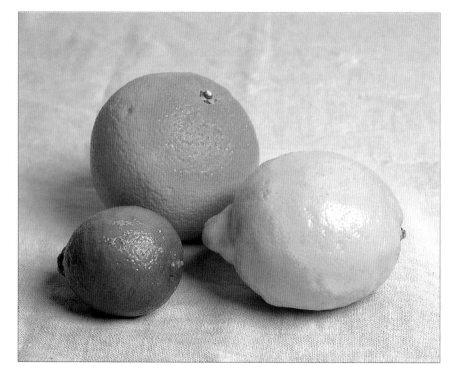

1 Begin by positioning the three objects relative to one another. Using simple shapes, draw the orange using an orange pastel, the lemon with a cadmium yellow pastel and the lime with a mid green pastel. Draw the position of each shadow with black.

2 Using closely aligned strokes and in some places adding a second layer of strokes crossing them (known respectively as hatching and cross-hatching), build up the basic colour of the orange. Use cadmium red for the dark tones in the area away from the light and deep orange for the mid tones.

3 Block in the lighter tones using orange. Work this slightly into the darker areas to soften the transition from dark to light. Put in a few dots of colour to indicate the pitted nature of the orange skin, then work light orange over the orange to suggest the highlight.

4 Use mid green for the mid tones on the lime, followed by an application of viridian green. Work this into the mid green area to soften the transition from one to the other.

5 Cross-hatch light green over these colours to show the highlighted area. A few hatched lines of orange along the top of the lime will suggest the reflected colour from the orange.

6 Moving on to the lemon, use raw umber for the areas in shadow and block in the rest of the lemon with a bright cadmium yellow, working it into the raw umber to produce lighter mid tones. Put in a touch of light orange along the top left of the lemon to indicate the reflected colour from the orange.

7 Work lemon yellow over the top of both the cadmium yellow and the raw umber to define the highlighted areas. Add touches of orange and cadmium yellow to show up the nuances in the lemon's colour.

8 A little green and a dab of yellow and ivory black are all that is needed to suggest the place where the orange was attached to its stalk. Next, draw in the shadows cast by the three objects to anchor them to the surface on which they rest, using Payne's grey for the bulk of the shadow and working black into the area of deep shadow closest to each object.

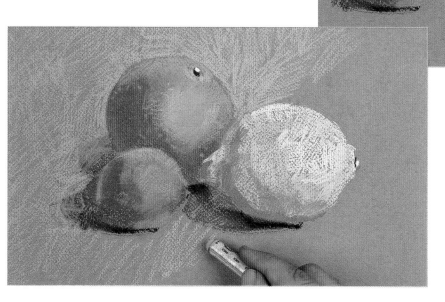

9 Block in the colour of the tablecloth, using a light raw umber pastel. Work over the area using scribbled cross-hatched strokes – try varying the direction of the strokes as this is far more aesthetically pleasing than allowing all of the strokes to run in the same direction.

10 Now rework the darker parts of each fruit, using the relevant colours as before but with the addition of a little dark red on both the orange and the lime and a little raw umber on the lemon. Add a little red also into the Payne's grey in the shadows. Finally, block in the highlights with a few deft strokes of white pastel.

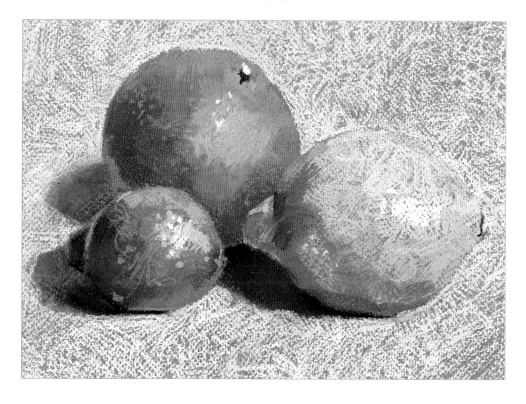

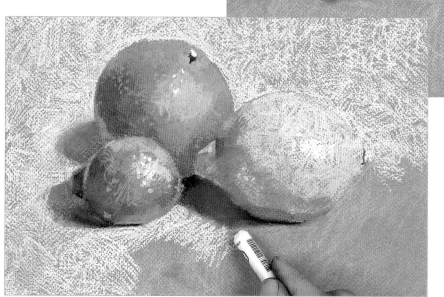

11 Using an ivory pastel, lift the tone of the whole painting dramatically by reworking the table cloth. As before, use multi-directional strokes of the pastel, working carefully up to and around the fruit and the shadows cast by the light source.

12 With the exercise complete, you can see how just two or three tones or tints of a colour are all that you need to create form and depth of colour and how limiting the mixing of colours to a minimum keeps the image bright and clean.

step 3 linear techniques

focus: **orange, pear and apple**

Materials

28 x 38 cm (11 x 15 in) light brown
 pastel paper

Hard pastels:

- *Cadmium red*
- *Orange*
- *Burnt umber*
- *Payne's grey*
- *Ivory*
- *White*
- *Light green*
- *Mid green*
- *Dark green*

Although they are essentially tools for making blocks or broad areas of colour, pastels can also be used to create work that consists of a series of lines. Techniques such as hatching and cross-hatching, done with the intention of building up what appears to be a solid area of colour or tone, are in fact techniques that use line, familiar to anyone who has drawn. It is the ability of pastels to switch from making bold blocks of colour to more intricate line work that makes the medium so versatile. Building areas of colour and tone in this linear way is very controllable. Although entire paintings are made using line work, it is more often than not used in combination with broadly applied areas of colour in order to modify form, add detail or create textural effects.

Soft pastels, hard pastels and pastel pencils can all be used to produce paintings using linear techniques. Needless to say, to make a line that is reasonably fine the drawing implement must have a point or a sharp edge. When you are using pastel pencils this is no problem as they are sharpened in the same way as a graphite or coloured pencil. Hard pastels are also easy to sharpen by carefully using a sharp knife. However, problems arise if you try to sharpen soft pastels to a point as they simply crumble. The trick is to use the 'sharp' edge that runs around the circumference of both ends of the pastel. It is relatively easy to keep this edge by cutting straight across the pastel end using a sharp craft knife (see page 339). In order to keep the edge 'sharp', turn the pastel between your fingers as you work.

LINEAR TECHNIQUES

When you are using hatched, cross-hatched or scribbled lines, the colour intensity and tonal depth are built up by a combination of the line

density (the spacing of the lines) and the pressure applied. An important point to remember is that the lines do not have to be straight. Indeed, drawing lines that curve to follow the form of the subject helps to suggest its shape and form in a very efficient and concise way.

With linear techniques colours tend to mix optically – that is, rather than physically blending, the colours remain separate and visible but are read as a mixed colour by the eye because of their proximity to one another. This again allows for a tremendous degree of control and makes it possible to create very subtle transitions from one colour or tone to another, ideal for suggesting form.

Density and form: In the rectangular shape, depth of tone and colour has been achieved by increasing the density of the cross-hatching. In the circular object, curved cross-hatched marks that follow the shape of the object help to indicate its form.

Optical mixing: Where one colour is cross-hatched over another, the colours can appear to 'mix', even though they are unmixed in the traditional sense of the word. Several colours can be used one over another to bond up complex colour mixes.

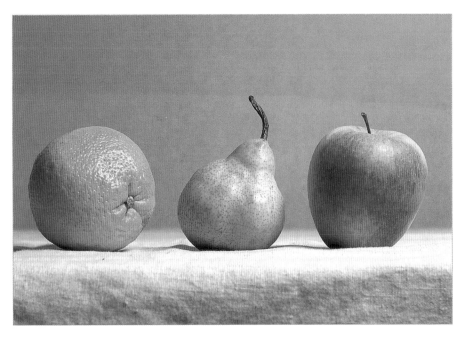

PAINTING THE ORANGE, PEAR AND APPLE

The purpose of this exercise is to show you how purely linear strokes can be combined and woven together to create both form and complex colour combinations that are mixed by the eye and not physically on the support.

1 Sketch out the composition in simple, basic shapes, with colours that approximate those of the objects being drawn – orange for the orange, light green for the pear and cadmium red for the apple. Use burnt umber for the stem of the fruit and ivory for the tablecloth. If you need to redraw do not worry, since subsequent applications of pastel will cover up any of your mistakes.

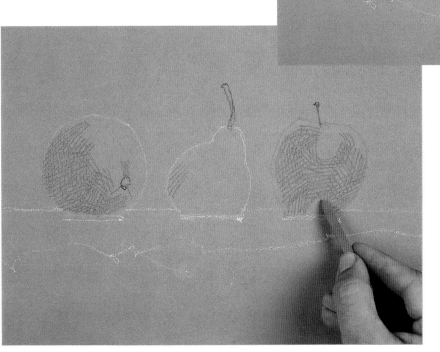

2 Begin building up the cross-hatching using the cadmium red. Cross-hatch the area in shadow on the orange, add a few hatched strokes on the shaded side of the pear to pick up the reflected colour from the orange, then cross-hatch the apple. As this is predominantly red, cover more or less all of the fruit with cross-hatching.

3 Now subdue areas of red on the apple with the orange pastel and add a few hatched orange strokes to indicate the reflected colour of the orange on the green pear. Establish the bulk of the orange by working orange hatching into the red to create the impression of a darker tone of orange.

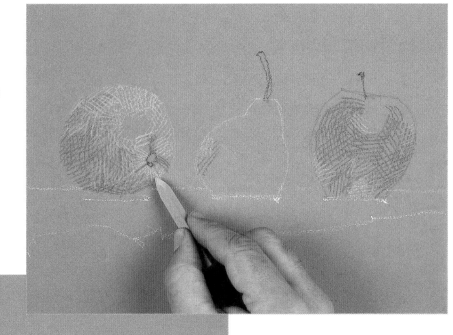

4 Next, add carefully hatched light green strokes across the top and sides of the apple together with a small area of green at the base. Use the same green to block in the pear, carefully considering the direction of these strokes so that they follow its form.

5 With mid green, a dab of light green and burnt umber, create the green stalk end of the orange. Using burnt umber, draw a simple line beneath the orange to indicate the cast shadow and rework the shaded side of the orange. Change to the white pastel and indicate the highlighted area with a combination of cross-hatched lines and small dots or dabs.

6 Move on to the pear and, using burnt umber, put in the colour of the stem and again make a simple mark at the base of the fruit to indicate its shadow. Make a few hatched lines of burnt umber on the side of the pear, followed by further work with the mid green and, for the darker tones, dark green. Paint the highlight in the same way as you did on the orange, then subdue the green of the pear by careful cross-hatching using the light orange pastel.

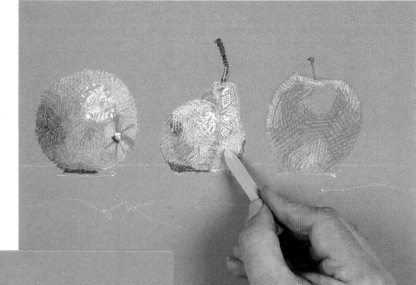

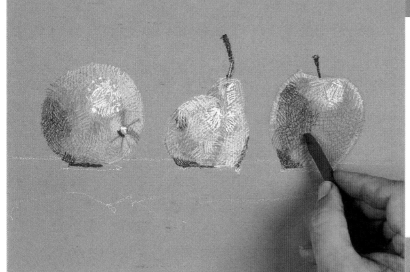

7 Treat the apple in the same way, using light orange and white to develop the highlight and areas of burnt umber to darken the side of the apple facing away from the light source.

8 Block in the tablecloth with the ivory pastel, indicating the parts of the cloth catching the light with denser cross-hatching. To create the cast shadows of the fruit, leave the colour of the support to show through.

9 Develop the colours and tones of the tablecloth by using Payne's grey in the shaded areas and white cross-hatched across the areas that are in the light. The background is simply the support colour.

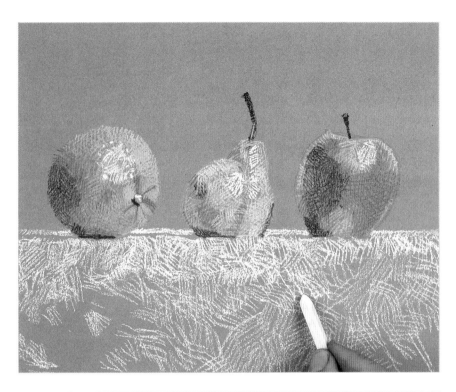

10 The finished image demonstrates how complex combinations of dense colour and tone can be created by the careful application of pastel in just a series of cross-hatched lines. The result is a crisp, clean image using a technique that is quick, simple and infinitely controllable.

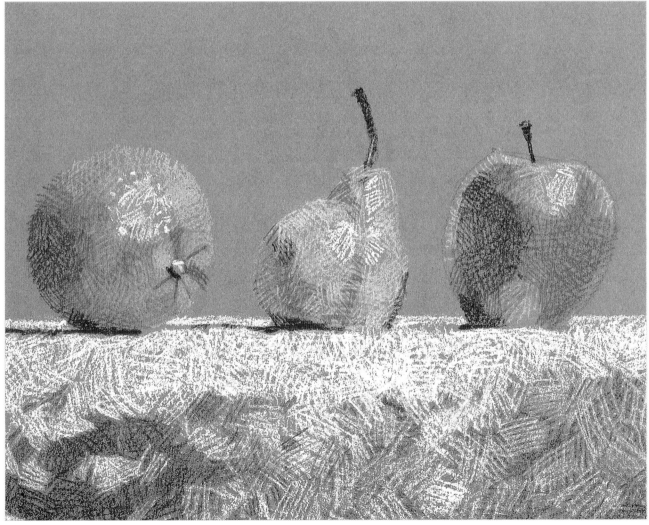

step 4 impasto

focus: **melon and pomegranate**

Materials

28 x 38 cm (11 x 15 in) light brown
 pastel paper

Fixative

Large torchon (paper stump)

Hard pastels:
- *Cadmium red*
- *Light green*
- *Ultramarine*
- *White*

Soft pastels:
- *Cadmium red*
- *Burnt sienna light*
- *Burnt sienna*
- *Burnt sienna deep*
- *Grey green*
- *Ivory*
- *Black*
- *Mid green*
- *Light green*
- *Lime green*
- *Cerulean blue*
- *Payne's grey*
- *Raw umber*
- *Light raw umber*

Impasto without an underpainting:
Thick pastel can be applied without a
prior underpainting, but this often
results in a lack of colour depth as the
support colour may show through more
than is desirable.

In Italian the word *impasto* means dough, which gives a clue
to the type of painting it is employed to describe – thick
applications of pigment which in the case of oils, for example,
may even be three-dimensional. The term impasto is also used
to describe dense and heavy applications of pastel although
these, needless to say, will lack the thickness and tactile
qualities of heavy applications of paint. Nevertheless, they
can add texture as well as vibrant colour.

WORKING WITH IMPASTO

In order to make heavy applications of pastel you will need a support
that has sufficient tooth, or texture, to hold the pigment. Papers and
boards designed for pastel are ideal, as are rough papers intended for
watercolour. You can begin the work by applying the pastel marks thickly
from the outset, gradually placing marks and colour next to one another
and piecing the image together as you would a jigsaw. Placing marks side

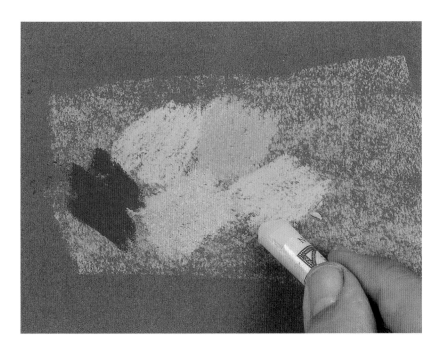

Impasto over an underpainting: Working over an underpainting which modifies the support colour can result in greater depth and intensity of colour.

by side in this way is advisable because it can be quite difficult to place a second thick pastel mark over an earlier one – the initial mark will have filled the texture of the support with pigment, making it difficult for the pigment of the second mark to take hold. It will skid over the first mark, failing to deposit much colour, and what colour is left behind is often indistinct as it will have mixed a little with the pigment from the first mark.

However, it is much better to establish the image using a thin underpainting (see pages 342–343) to put in the general shapes, colour, tones and composition. Once this has been fixed it will act as a very good guide for the impasto which, because of the underpainting, can often be applied at this stage with a degree of looseness and flair – both very attractive, if elusive, qualities in the best of pastel paintings. Where you need to make corrections you can flick over the area with a rag or a stiff bristle brush. Alternatively, scrape away the pigment with the blade of a craft knife – which is in fact a technique in itself, known as sgraffito, that can be used to describe a range of textural effects (see page 383).

Where you are working with a strongly coloured support, underpainting first also has the advantage that the colours of the impasto layer will tend to have a greater density and appear stronger as they will not be modified by the support showing through.

PLANNING YOUR PAINTING

To minimize mistakes when you are working with impasto, spend time considering how the image is to be put together and in what order, so that the impasto application is clean and precise and, wherever possible, made in a single layer of pigments. Keep blending of the impasto layer to a minimum and try to use neat colour from a single pastel in any one area. This will keep the colours bright and prevent the muddy mess that can result from overworking. Once you have finished you can give the image a coating of fixative, though this will have the effect of dulling the colour. Many pastel artists fix the work before they place on the lightest colours and highlights in order to retain their brightness.

Fixing impasto: Impasto pastel paintings smudge easily, so fixing is often a necessity. However, fixative dulls the colour slightly – especially in the case of lighter colours, as you can see in the left-hand yellow marking here.

PAINTING THE MELON AND POMEGRANATE

Both of these striking fruits are ideal to illustrate how building up firm applications of pastel produce impasto effects that show off their strong, vivid colours. In painting them, you will also have the chance to try your hand at textural effects that describe the pattern and surface of each fruit.

1 There is no need for an underdrawing as the shapes are very simple and basic. Begin by taking a short length of hard cadmium red pastel and, using this on its side, block in the shape of the pomegranate.

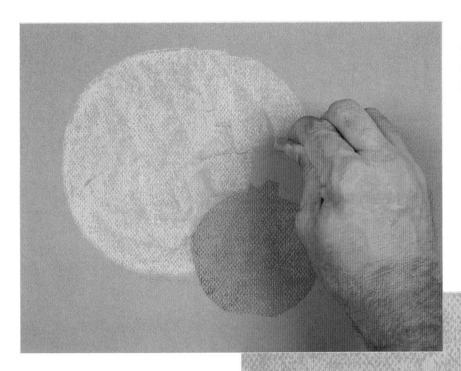

2 Next, take a hard light green pastel and in the same way block in the shape of the melon, positioning it relative to the pomegranate.

3 With a hard ultramarine pastel, block in the shadow of both the pomegranate and melon, then use a white pastel to establish the light-coloured tablecloth.

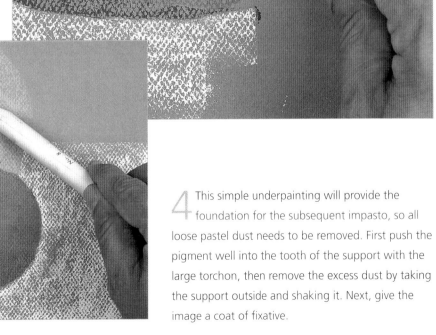

4 This simple underpainting will provide the foundation for the subsequent impasto, so all loose pastel dust needs to be removed. First push the pigment well into the tooth of the support with the large torchon, then remove the excess dust by taking the support outside and shaking it. Next, give the image a coat of fixative.

5 For the impasto, switch to soft pastels. Use precise, firm strokes to apply cadmium red, burnt sienna deep, burnt sienna and burnt sienna light to the relevant areas on the pomegranate. Overlay black in the shadow areas with touches of grey green and use ivory for the highlights.

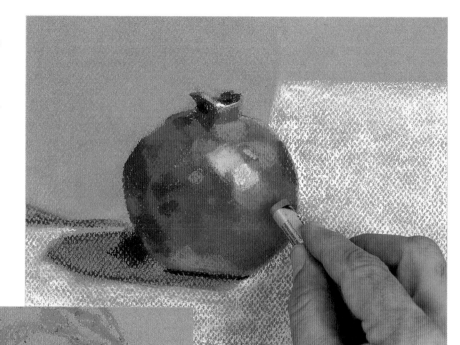

6 Establish the pattern on the side of the melon with mid green, then block in the darker areas of pattern with grey green.

7 Use light green on the lighter pattern together with touches of lime green on the end facing the light and around the reflected highlight. Apply cerulean blue to represent the colour of the reflected daylight.

8 Apply raw umber around the cast shadows and strengthen them with touches of Payne's grey and black. Paint light raw umber and ivory across the tablecloth, carefully working around the fruit and their shadows.

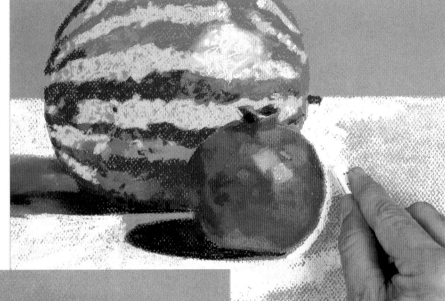

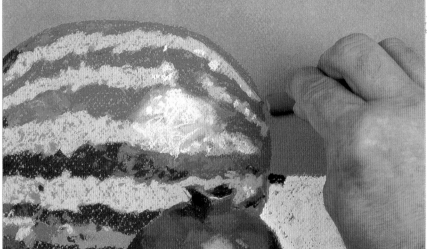

9 Finally, strengthen the background colour using a stick of raw umber on its side.

10 This relatively simple and straightforward image shows how impasto pastel can be applied cleanly and simply to produce a highly colourful image that does seem to possess a certain tactile quality without the colours becoming muddled and the surface overworked. The image can now be fixed, but do be aware of the slight colour shift that will inevitably occur.

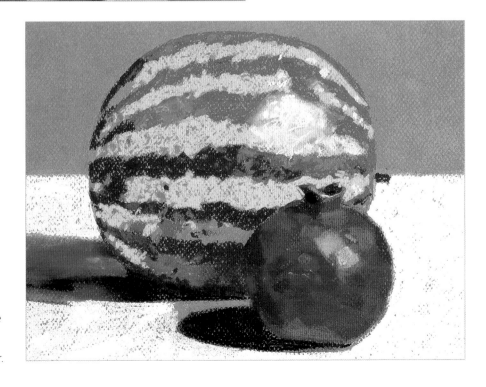

step 5 layering and blending

focus: **pears**

Materials

24 x 32 cm (9½ x 12½ in) light brown
 pastel board

Soft bristle brush

Fixative

Torchon (paper stump), optional

Hard pastels:

* *Light green*
* *Mid green*
* *Olive green*
* *Dark green*
* *Lime green*
* *Burnt umber*
* *Vandyke brown*
* *Payne's grey*
* *Ivory*
* *Yellow ochre*
* *Raw umber*

Pastels are like any other painting material in that images can
be built up in layers and colours blended together, except that
unlike watercolour, oil or acrylic paint, the applied colour is
dry. This has several advantages, not least the fact that there is
no hanging around either in the short term or, in the case of
oil paint, the long term waiting for the image to dry so that
work can continue. This makes pastel an ideal material for
working on location.

WORKING WITH LAYERS

As you have already discovered, a pastel painting invariably consists of
a series of layers. The initial layer establishes the foundation, providing a
guide for subsequent work; next the image is developed using heavier
applications of pastel that block in and strengthen colour and tone, then
detail is added. Working in this way prevents you from becoming bogged

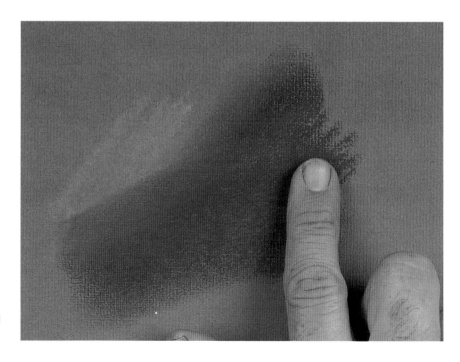

Blending with your finger: Your
finger is the easiest tool to use for
blending. Make sure that your fingers
are dry and grease-free and the resulting
blends will be smooth and effortless.

some pastels may have been made by combining as many as six different pigments, you can see that if you blend together two or more pastels the number of blended pigments could run into double figures.

However, when you are working with a limited range of colours, blending two of them together is often the only way in which you can achieve the colour you want. In this case, restrict any blended work to the initial layers that establish the composition and use applications of single pastel colours to the final layers and for detail.

Blending is nevertheless a useful technique for softening and blurring edges where one colour is adjacent to another. You can use paper towels, cotton-wool buds, brushes or torchons to blend colours together, but the quickest and easiest tool to use which is always to hand is a dry fingertip.

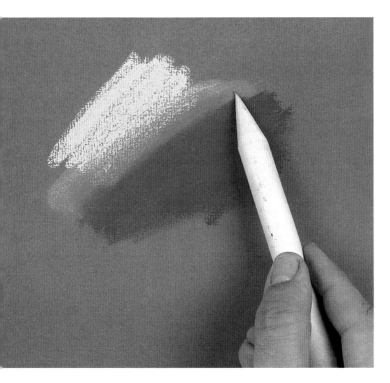

Using a torchon: A torchon is tailor-made for blending and its point makes it possible to blend small or difficult areas. You can also use it for applying pastel by simply rubbing the pastel on the torchon or by picking up pastel dust from elsewhere on the support.

Making a torchon: Torchons are very inexpensive to buy, but you can improvise a home-made one by rolling a strip of newspaper to create a cone.

down with detail in the earlier stages of the work. Your aim is to bring each area of the image along at the same speed, finally adding detail and highlights which bring the image to life. If you do not want the layered elements to mix with one another you will need to apply a layer of fixative as each stage of layering is completed.

THE PRINCIPLES OF BLENDING

Blending is best kept to a minimum, for blended pastels lose their brilliance as a result of the way in which pigment colours mix together. When the coloured light waves of the spectrum (the colours of a rainbow) are combined, the result is white light, known as additive colour mixing. However, if the same seven pigment colours are combined (subtractive colour mixing), the result is a muddy, almost black mess. Therefore, the fewer pigment colours that are mixed together the better – and as

PAINTING THE PEARS

This simple still life of two pears, 'framed' by the paper bag they were bought in, will show you how to build a pastel painting in layers. You will also find out by experience how blending with your finger or other suitable tool can produce an image that has both tonal and colour graduations that, if pushed to their limits, can almost resemble a photograph.

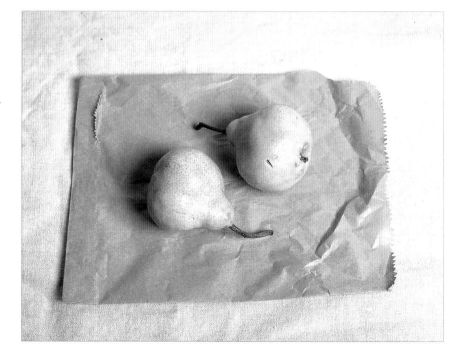

1 Begin by lightly drawing the position and shape of the two pears and the paper bag, using light green for the pears and burnt umber for the stalks and the bag. Draw in the shape and extent of the shadows, also with burnt umber.

2 Use light green to establish the colour of the pears, exerting light pressure to avoid too heavy a build-up of pigment dust. You will find that the type of textured support used here accepts the pastel colour very easily.

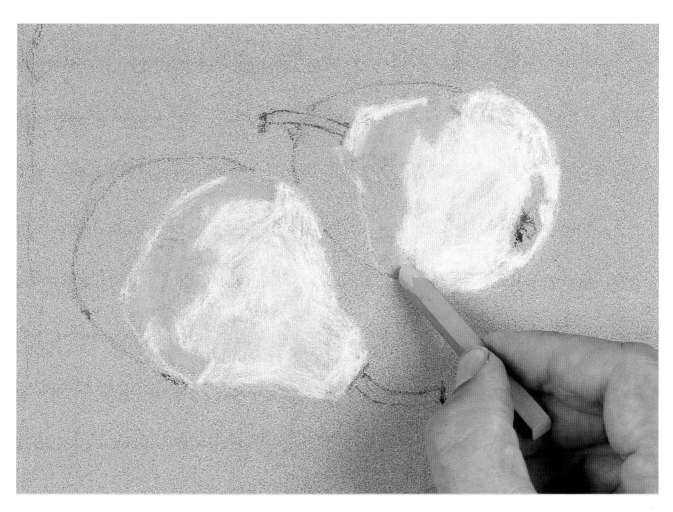

3 Apply mid green in exactly the same way to the side of each pear that is in shadow.

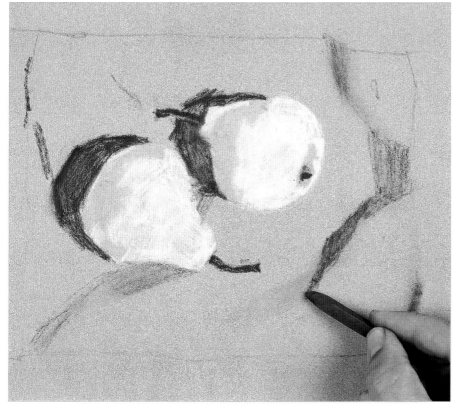

4 Using Payne's grey, paint in the shadow cast by the bag on to the tablecloth. Block in the colour of the stalks and the cast shadow of each pear with burnt umber then, with the same pastel, indicate the darkest shadows on the crumpled surface of the paper bag.

5 Draw around the shape of the bag with ivory to establish the colour of the tablecloth, making small dashes of colour along the serrated edge of the bag. The overall colour or look of the bag is represented by the colour of the support.

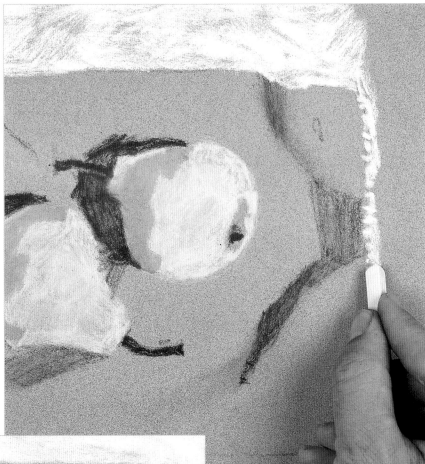

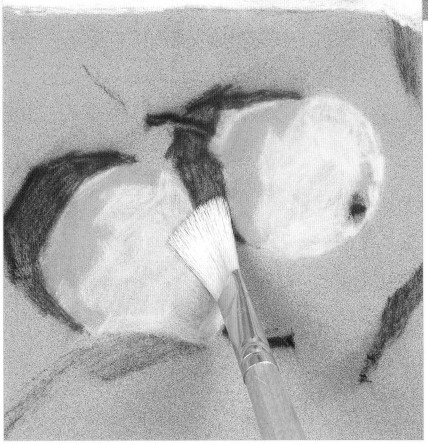

6 The overall basic colour scheme is now established and you need to remove the excess pastel by carefully brushing over the image with a fairly soft bristle brush. This process also serves to blend the colours together slightly, blurring the edges nicely between one colour and the next. You can now fix the painting.

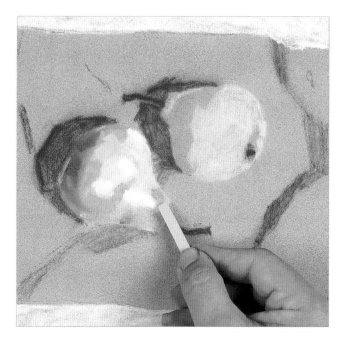

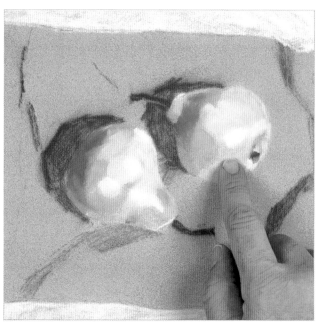

7 Develop the colours on each pear using light green, mid green, olive green and dark green, with lime green for the highlights and touches of yellow ochre.

8 The colours on the pears now need to be softened and blended carefully together. Whether you use a torchon or your fingers is a matter of personal choice, but you will find that you can achieve a softer blend with your fingers.

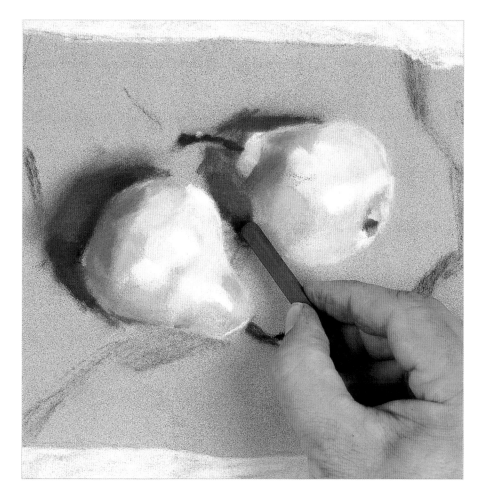

9 With Payne's grey and Vandyke brown, put in the darkest shadows. This has the effect of instantly adding depth to the image and the pears will seem to lift from the support surface.

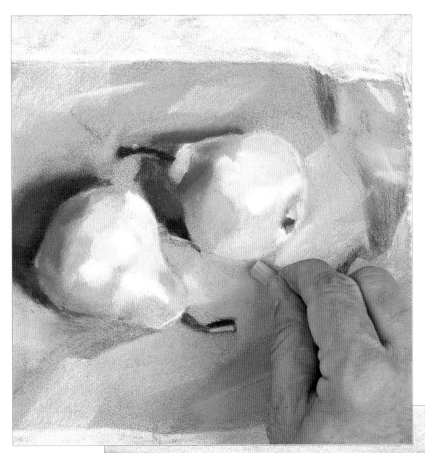

10 Now work on the crumpled paper bag, using ivory, raw umber and yellow ochre. Rather than applying the colour from the end of the pastel, use the edges of short lengths of hard pastel to make crisp angular marks that echo the shapes made by the creased paper.

11 With a few simple strokes, add highlights to each pear in light lime green.

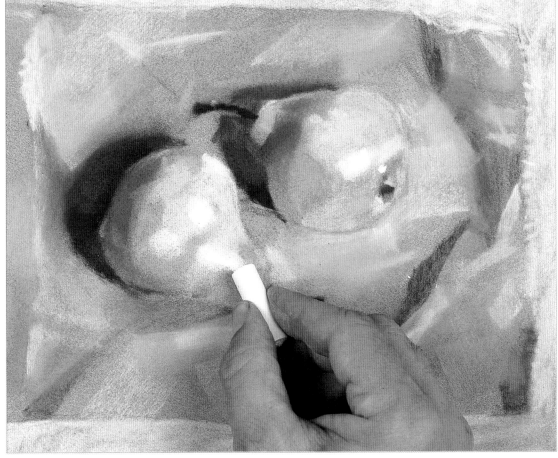

12 To add interest and increase the sense of realism, draw in the weave of the tablecloth with ivory pastel, though in reality it is not nearly so well-defined.

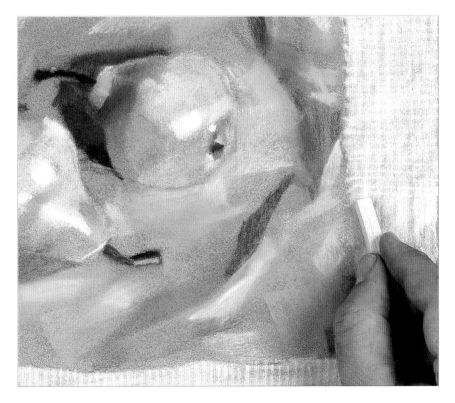

13 In the finished image you can see how simple blending can create gentle transitions between colours and tones, achieving a strong feeling of realism while avoiding muddy and confusing colour.

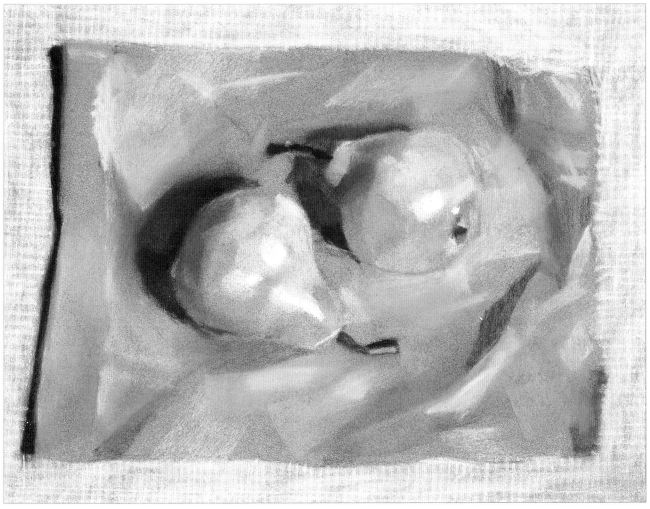

step 6 textural techniques

focus: **pomegranates**

Materials

21 x 29 cm (8½ x 11½ in) dark brown
 pastel paper
Fixative
Hard pastels:
- *Raw sienna*
- *White*

Soft pastels:
- *Cadmium red*
- *Dark red*
- *Burnt umber*
- *Yellow ochre*
- *Ivory*
- *Light cool grey*
- *Burnt sienna*
- *Light violet*
- *White*
- *Black*

The ability to represent the surface qualities of your subject is very important, as they make a large contribution in describing its true character. Smooth, pitted, rough, reflective, ribbed and granular are all words you might use to describe a surface, but how do you visually represent them? Pastel supports already have a surface texture which is there primarily so that the pigment has something to hold on to. This texture can be used to good effect, but if it is allowed to dominate it can detract from the subject itself.

The clever pastel artist is able to disguise this overall texture by using a range of techniques and a variety of different marks. There are two ways to approach this, either by painstakingly drawing and painting the visual qualities of a surface, capturing it in an almost photographic way, or by more quickly capturing just the essence of that surface. In reality, artists invariably combine both approaches in the same image.

Varying your marks: You can make different marks by varying the way you hold the pastel. These marks have been made using the end, the edge and the side of a hard pastel.

MAKING THE MOST OF MARKS

Learning to apply your pastels in a variety of ways is essential. A broad stroke using the side of a pastel will read very differently to a mark made using the end, as will a delicate, slowly made stroke compared to a fast, heavy stroke that is made with determination and impatience. A softly blended area will contrast with one that is loosely and coarsely painted, while linear strokes will describe a different texture to that suggested by dots or dashes.

Scumbling is a useful technique where one colour is painted loosely over another. Apply the colour being scumbled in loose, multi-directional and preferably wide, light strokes that allow elements of the base colour to show through – a technique known as glazing. You will find you can build up several layers

Frottage technique: Using frottage on a thin support has picked up the texture from a rough plank of wood.

Using different pastels: Here the same range of marks has been made, this time using a soft pastel.

of different-coloured pastels in this way. Broken colour is a similar technique, but the marks are heavier and more precise, and there are gaps left between them.

A good way to capture the quality of an edge is to tear or cut a piece of paper and place it on the image to act as a mask. Work the pastel up to and over the mask edge; when you remove the mask, the image of its edge will remain. Alternatively, when you want a straight edge, simply work up to the edge of a ruler.

Frottage is a texture-making technique that works only with thin supports. Place a textured object beneath the support, apply the pastel to the support surface and an image of the texture below will be transferred onto the support.

All these textural effects are made by applying pastel, but you can also create textures by removing it (see pages 382–383).

Scumbling: Here, blue pastel has been loosely scumbled over white pastel.

Masking: Working blue pastel over a torn paper mask has created an interesting edge quality to the painted area.

Broken colour: Orange, yellow and red pastel have been applied in turn to create a broken colour effect.

PAINTING THE POMEGRANATES

Describing the surface of objects is very important, both in adding interest to an image and suggesting their tactile qualities to the viewer. This exercise shows how combining a few different methods of pastel application will help to produce a more complex and arresting image.

1 With a hard raw sienna pastel, sketch in the shape of the pomegranates, the knife and the board.

2 Paint the bright red areas on the pomegranate skin with cadmium red, then turn to dark red to block in the area of seeds at the centre of the cut pomegranate and the darker skin of the uncut fruit.

3 Establish darker patches around the seeds and the handle of the knife with burnt umber pastel, then scribble a little of the same colour on the blade of the knife to represent the dark reflected colour from the pomegranate.

4 Block in the chopping board with yellow ochre, working carefully around the fruit and the knife. Use the straight edge of a sheet of white paper as a mask so that you can scribble the colour on quickly and loosely without straying out of the area of the board. Leave the support to show through and represent the cast shadows of the fruit and the knife.

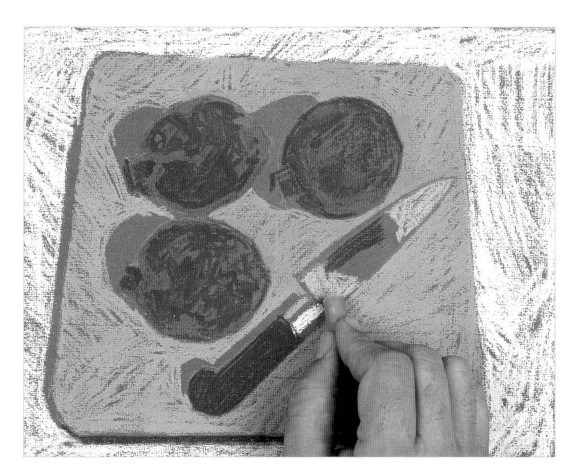

5 With the ivory pastel, block in the light cloth, allowing the support to show through as before for the shaded area at the edge of the chopping board. Use ivory for the reflection on the knife handle and a light cool grey for the blade of the knife. At this point you can brush over the image to remove excess pastel dust and give it a spray of fixative.

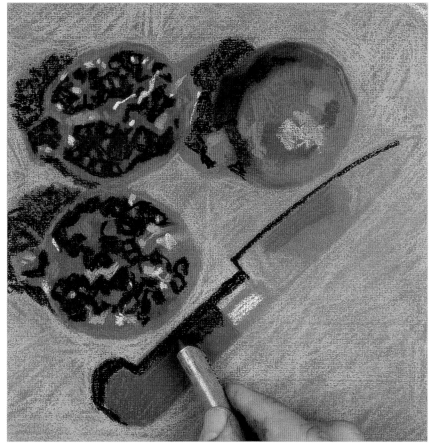

6 Repaint and strengthen the skin colour of the pomegranates with cadmium red and burnt sienna. Pick out the highlights on the seeds and the side of the fruit with touches of light violet and white, then block in the shadow areas around the fruit and the knife with black. Use black to paint in the dark seeds and the darker colour on the handle of the knife.

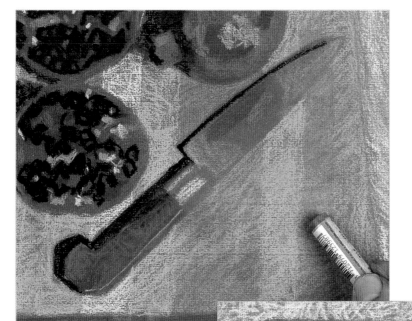

7 Add burnt umber to the shadows and to the handle of the knife. Indicate where the light hits the edge of the knife handle with a delicate line of yellow ochre and scribble a little burnt sienna onto the knife blade to increase the sense of reflected colour. Next, paint the wooden chopping board with combinations of yellow ochre, burnt umber and burnt sienna to block in the individual strips of wood that make up the board. Scumble these colours lightly over the base colour, allowing it to show through in places.

8 Repaint the cloth with light cool grey, applying it as an open scribble over the initial ivory underpainting.

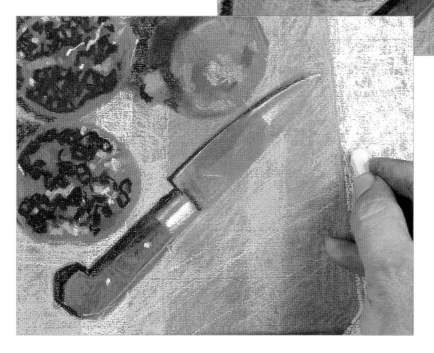

9 With the ivory pastel, dot in the brass rivets on the knife handle and draw several fine lines across the board to represent cut marks. Work the same colour over the cloth in open marks that allow the previous layer of pastel to show through.

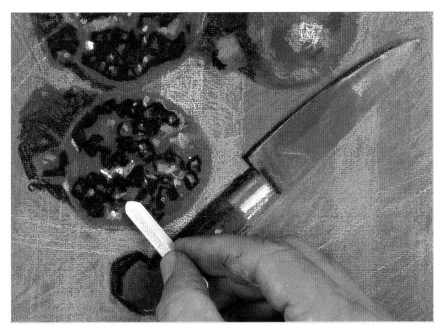

10 Finally, add highlights to the knife handle and the juicy seeds with hard white pastel.

11 The finished image shows how using a few alternative approaches and mark-making techniques in the same painting helps to distinguish between the different surface textures and characteristics.

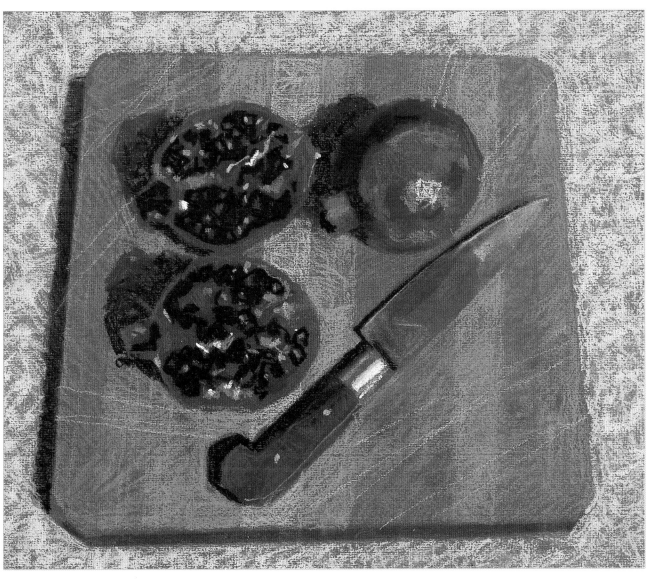

step 7 erasing and sgrafitto

focus: **pineapple**

Materials

28 x 38 cm (11 x 15 in) mid green pastel
 paper

Scalpel or sharp-pointed craft knife

Fixative

Hard pastels:

- *Light grey green*
- *Ivory*
- *Yellow ochre*
- *Raw sienna*
- *Burnt umber*
- *Light violet*
- *Light green*
- *Mid green*
- *Dark green*
- *Oxide of chromium*
- *Dark warm grey*
- *Grey green*
- *Black*
- *Light warm grey*

With pastel, you can easily solve most mistakes by applying fixative and then reworking the problem area using more pastel. However, if the area to be repainted has already been heavily worked, further applications of pastel may not take well. The answer is to remove the pastel dust from the surface of the support first, which you can do in a number of ways.

If you have not already fixed the area, you can simply brush away the pastel dust to reveal the texture of the support. Precise areas can sometimes be removed by carefully dabbing a piece of masking tape onto the support to lift the pigment away from the surface. Keep using fresh pieces of masking tape until you reach a point where the area will accept

Removing pastel with an eraser: The sharp edge of a hard eraser will create linear patterns when drawn through unfixed pastel work.

Using a craft knife: The flat edge of a sharp craft knife blade will scrape away even very thick accumulations of pastel.

MAKING TEXTURAL MARKS

Removing pastel from the support is also a very successful way of creating textural marks. You can employ all of the techniques described above, but perhaps the most successful are those where the pastel is scratched into with sharp instruments – a technique known as sgraffito. This is used to reveal areas of the support or a pastel colour that has been fixed.

You can vary the effects you can get with sgraffito by working dark over light colours, or by using several multi-coloured layers all of which have been successively scratched into, fixed then worked over with more pastel. However, perhaps the greatest benefit of sgraffito is that it allows you to draw very fine linear marks, which can be difficult to achieve with pastel. This is a useful technique for highlights and for creating textural effects in a landscape, such as grass or the linear patterns of tree barks. As with the scraping technique used for corrections, take care only to remove the pastel and avoid cutting into the support by scraping the blade sideways.

further applications of pastel. Dabbing a scrunched-up piece of tissue or paper towel works in a similar way but leaves behind a very pleasing 'marble' effect.

Erasers will lift lighter applications of pastel but they are of limited use on heavy applications; the eraser picks up pigment initially but quickly becomes dirty and clogged, then simply pushes and smears the pigment into and across the support, making the problem worse. Consequently, you should use an eraser with care.

On both fixed and non-fixed areas, heavy applications of pastel can be removed using the sharp edge of a craft knife. Pulled sideways across the support, it will scrape away most of the pastel back to the support surface. The process can sometimes flatten the texture of the paper, but if you spray the area with fixative before you rework it you will find that small particles of resin are deposited on which pastel takes quite well. Ensure that you do not cut into the support by mistake.

Linear marks with a scalpel: The sharp point of a scalpel will draw a very fine line through unfixed pastel.

PAINTING THE PINEAPPLE

A pineapple is a surprisingly difficult thing to draw well. This one, laid on a simple tablecloth, makes a subject on which to illustrate sgraffito techniques. These linear marks, made by scratching through the loose pastel dust, are ideal for describing the texture and pattern on the pineapple itself and the weave of the tablecloth. Such fine marks would be all but impossible to draw in pastel itself.

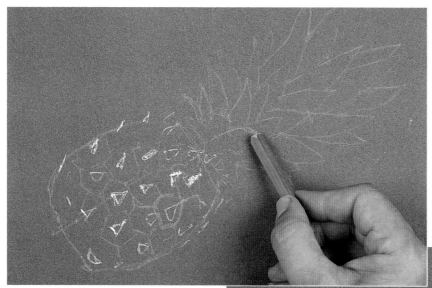

1 Sketch out the basic shape of the pineapple and its leaves, using an oxide of chromium pastel. Draw in the centre of each segment on the rough skin with ivory.

2 Develop the centre of each segment with further applications of ivory, yellow ochre and raw sienna.

3 Indicate the colours at the base of the pineapple with a combination of raw sienna, yellow ochre, burnt umber and light violet. Develop and block in the segments using a light and mid green.

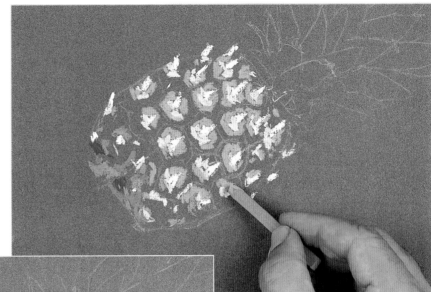

4 Next, add dark green touches around the edge of the segments.

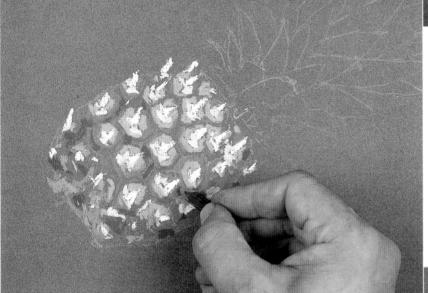

5 Paint in the brighter topmost leaves with light green and a little mid green, then block in the rest of the leaves with oxide of chromium.

6 Use dark warm grey to establish the shadow at the base of the fruit. Add small touches of grey green, dark green, dark warm grey and black to the parts of the foliage that are in deep shadow.

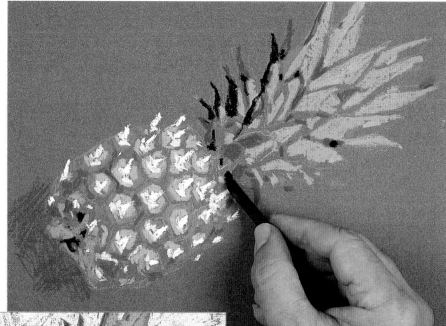

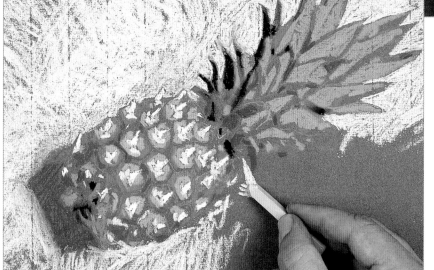

7 Block in the colour of the cloth in the background with light warm grey, working carefully around the shape of the pineapple and adjusting the shape of the fruit as you go should it seem necessary.

8 Lighten the background colour by carefully dusting off the excess pastel dust using paper towel, tissue or, if you wish, a bristle brush. Try not to disturb the unfixed pastel work on the pineapple itself.

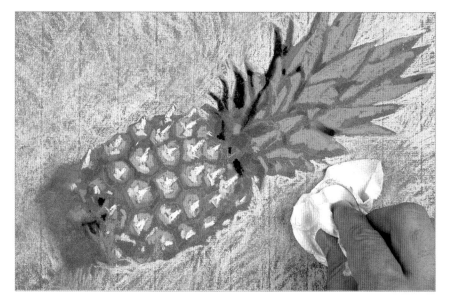

9 With a scalpel or sharp-pointed craft knife, scratch into the pastel on each of the segments to create a linear pattern that radiates out from each centre. Make the linear pattern on each of the leaves in the same way.

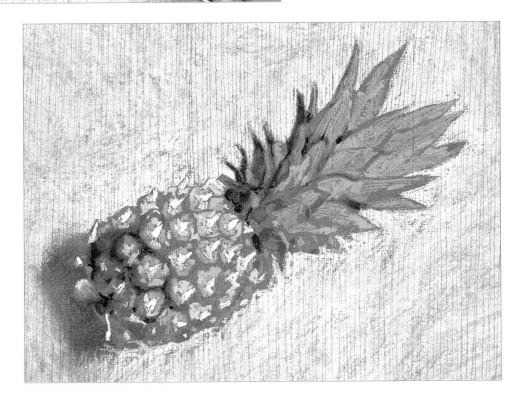

10 To complete the image, repaint the tablecloth with the ivory pastel then scratch a series of lines through the pastel to represent the weave of the cloth. Add touches of dark green to the foliage shadows and then fix the image.

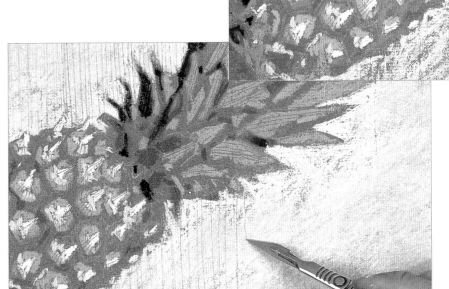

11 The finished image shows how a few simple sgraffito marks give added interest and a touch of realism. As with most things it is better not to overdo the technique, but it does provide a solution whenever fine linear marks are required.

step 8 support colour

focus: **lemons and strawberries**

Materials

25 x 33 cm (10 x 13 in) blue pastel paper

Hard pastels:

- *Raw sienna*
- *Yellow ochre*
- *Cadmium yellow*
- *Cadmium yellow deep*
- *Lemon yellow*
- *Light warm grey*
- *Warm grey*
- *Cool grey*
- *Dark cool grey*
- *Black*
- *White*
- *Ivory*
- *Light green*
- *Mid green*
- *Grey green*
- *Cadmium red*
- *Dark red*
- *Burnt umber*

The strongest influence on how your image will look comes from the colour and tone of your support, so you need to choose it very carefully. To see how the pastel colours that you plan to use will be affected, simply take a single pastel and make a block of that colour on several different papers; the variation in the applied colour will be remarkable. As a pastel artist, you can put this to very good use. Indeed, pastel paintings seldom look good when made on a white background; even bright colours look washed out and weak and the image tends to lack any real depth or substance.

CHOOSING A COLOUR

The first decision to make is whether the support colour should contrast or harmonize with the colours of your subject. Using a support that contrasts can make your pastel colours look much brighter than they might do otherwise – but take care with very bright support colours, which can easily dominate.

Choosing a support colour that harmonizes with the main colour scheme of the subject pulls all of the applied colours together. This type of support also cuts down on the work involved as you will find that you can allow its colour to show through and provide the overall mid colour or tone, using darker and lighter colours and tones to provide the shadows and highlights.

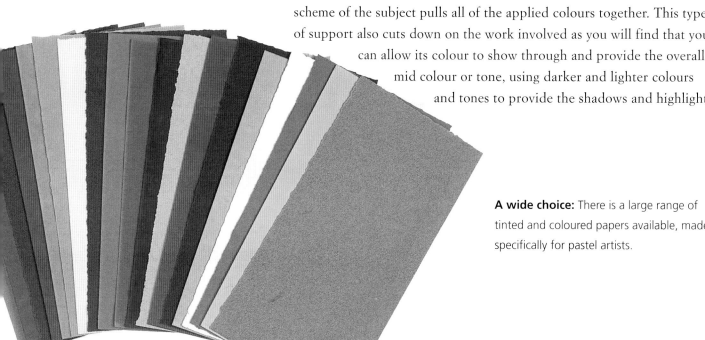

A wide choice: There is a large range of tinted and coloured papers available, made specifically for pastel artists.

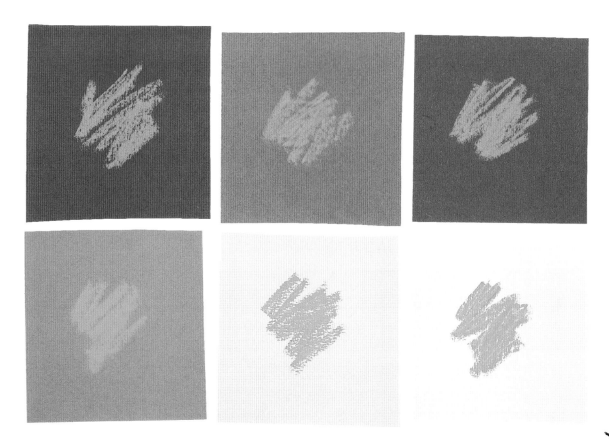

TONAL CONSIDERATIONS

Like bright-coloured papers, very dark- or light-toned papers can be difficult to work with. A mid-tone support is the easiest to use and will provide a good support on which to judge the lighter and darker tones of the subject. A large range of mid-toned, neutral-coloured pastel papers and boards is available, ranging from earthy browns, greens and blues through to dusty ochres and greys. However, while these will be the papers that you will tend to use most of the time, low-key (dark) subjects can benefit from being painted on dark-toned supports and conversely high-key (light) subjects may benefit from lighter-toned supports.

Remember that you can always tint your own support to suit your subject. Use 'not' surface watercolour paper (see page 94), and apply a wash of watercolour paint or thin acrylic paint. This does not have to be perfectly uniform, and in fact variations in the intensity of the colour will add interest. You can also colour the support using pastels, but it is important to avoid clogging the tooth of the support with pastel dust, so apply it sparingly.

Comparing different effects: The choice of support colour will have a marked effect on the way the colours you use are perceived. Here a light green appears to change colour when used on six different supports.

Tinting your own support: If you cannot find a suitably coloured support, try tinting a sheet of watercolour paper with either a watercolour or acrylic wash.

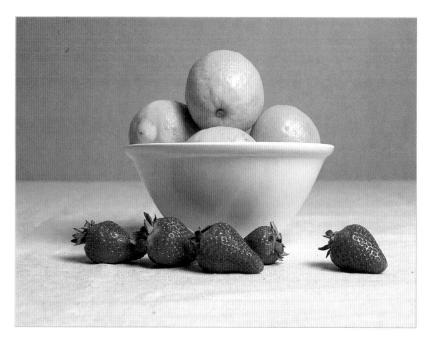

PAINTING THE LEMONS AND STRAWBERRIES

The lemons and strawberries are painted on a support that is deep blue in colour. This serves to intensify the yellow of the lemons and the red of the strawberries as the blue optically mixes with the colours of both, giving a slight green tinge to the lemons and a purple tinge to the strawberries. The white ceramic bowl also benefits from the slightly blue undertone present beneath the white and grey pastel.

1 Sketch out the composition using white for the bowl, red for the strawberries and yellow for the lemons.

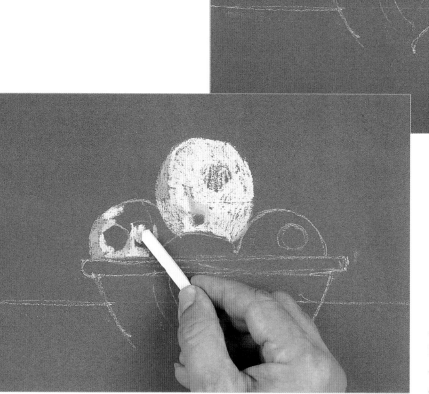

2 Paint the lemons first, using raw sienna for the side of the lemon in shadow and cadmium yellow and cadmium yellow deep for the main overall colours.

3 Turn your attention to the white ceramic bowl, blocking it in with a light warm grey, a warm and a cool mid grey and white. Create the dark shadow beneath the rim by allowing the blue of the support to show through.

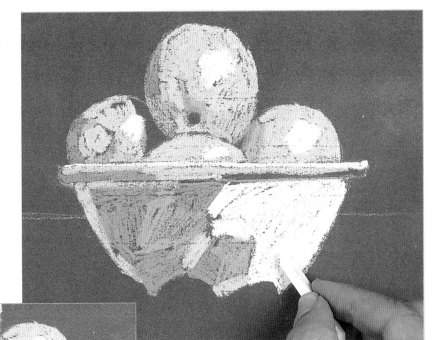

4 With touches of light and mid green, suggest the remains of the stalks on the strawberries. Paint the strawberries themselves using cadmium red and dark red.

5 Next, block in the background with yellow ochre, keeping the pastel work 'open' to allow the blue support to show through in places. Block in the tablecloth, using the same technique and a light warm grey pastel, 'cutting out' the shapes of the small leaves by leaving the colour of the support visible. At this point you can apply a coat of fixative to the image.

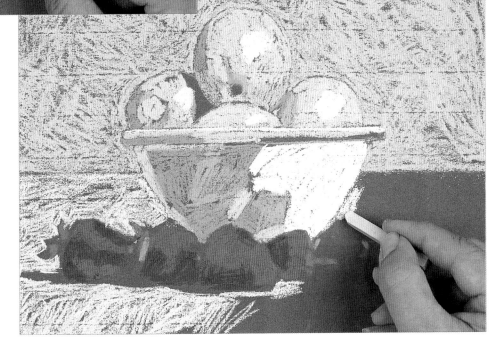

6 Return to the lemons, adding a touch of burnt umber into the shadows then repainting each lemon using cadmium yellow and cadmium yellow deep. Add touches of lemon yellow to the lit side of each lemon and to the lemon that is just peeking over the rim of the bowl, then put in each of the highlights with white.

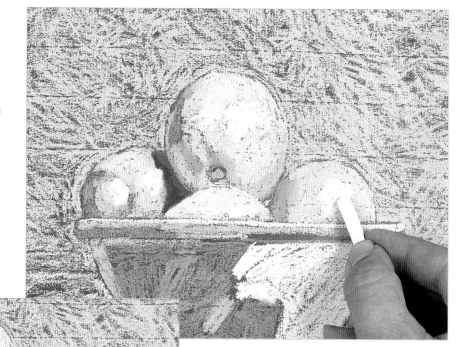

7 Using the same greys as before, repaint the bowl. Add a little dark red and raw sienna to the side of the bowl and, with your finger, carefully blend it into the surrounding grey. This represents the reflected colour of the strawberries.

8 Develop the small leaves with grey green and the mid and light green you used earlier. Repaint the strawberries with cadmium red as before, allowing the support and underpainting to show through in some places. This helps to represent the rough pitted surface of the fruit.

9 Scumble (see page 375) warm grey over the yellow ochre background and apply ivory over the tablecloth, using an open scribbling that allows the underpainting to show through in some places.

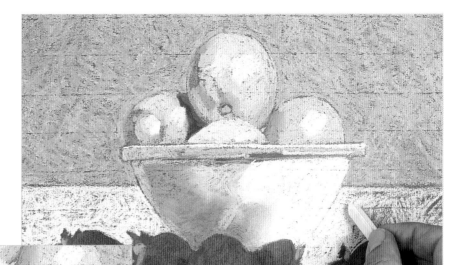

10 Finally, strengthen the shadows of the strawberries with touches of dark cool grey and black and add touches of white for the highlights.

11 The finished painting illustrates how the dark blue support helps to intensify the applied pastel colour and also shows through it, creating an overall colour harmony.

step 9 composition

focus: arranging the elements

Materials

2 L-shaped pieces of card

2 bulldog clips

White drawing (cartridge) paper

Black pastel pencil

Composition is the term used to describe the design of your picture – the way in which all of the different elements are organized within the overall frame. A good composition is pleasing to the eye, well-balanced, and persuades the viewer's eye to move around the image in the way the artist wishes. All of the elements within an image can have a profound effect on the composition, including colour, tone, texture, shape, size and perspective.

FORMAT

The first thing to consider is the format, or shape, of the intended painting. This is very important, as the format has a direct influence on the composition and the way in which the viewer's eye moves across or around the piece.

There are three main formats: horizontal, which is a rectangle with the longest side running horizontally; vertical, a rectangle with the longest side running vertically; and square, where all sides are of an equal length. While both rectangular formats can be altered and stretched, the square format always remains square regardless of its size.

While there are no set rules as to which format should be used for a particular subject, with a horizontal format the eye is persuaded to move from side to side across the image, which makes it a favourite choice with landscape artists. In contrast, the vertical format encourages the eye to move up and down and is therefore popular with portrait painters – hence the description of these two formats as 'landscape' and 'portrait' respectively. The square format persuades the eye to move equally in all directions, ultimately concentrating on the middle.

If you are unsure about which format to use, you will find a viewing frame a useful aid. It is a simple matter to make one by cutting two L-shaped pieces of card through which you can look at your subject in different formats and sizes. Once you have made your initial decision,

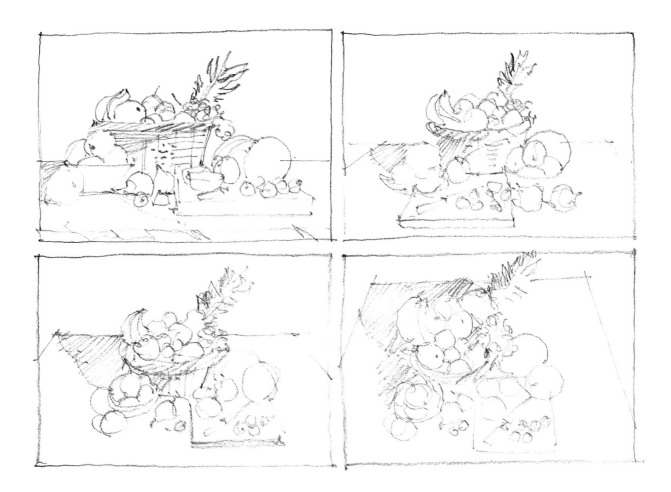

you can hold the pieces of card together at the corners with two clips to make the shape stable, while you check the composition carefully before you start work.

VISUAL BALANCE

A good composition is visually balanced, meaning that no one part overpowers another. This is achieved by using 'point and counterpoint'. For example, a large, dark mass might be offset, or balanced, by a much smaller mass that is brightly coloured, or a large flat area by an intricate, highly textured or detailed area. Alternatively, you could use colour to balance texture, light to balance dark, or complex to balance simple.

LEAD-INS

Artists often use a device known as a 'lead-in' which is intended to act as a visual pathway to draw the eye into the image. Lead-ins can be visually literal, such as a roadway, a river or a fallen tree along which the eye

Making thumbnail sketches: Spending a little time on thumbnail sketches first is well worth the effort, as you will have your composition worked out before you begin the painting proper.

instinctively travels into the image. However, you can also devise them in less literal ways, such as a shaft of light or the perspective of an object.

USING THUMBNAILS

The best way to work out your compositional ideas is through a series of thumbnail sketches. These are just large enough to enable you to try out ideas of position and layout with enough information on colour, tone, scale and so forth to be visible. They allow you to examine a number of alternative compositions and make decisions before you make a single mark on your support and can be used in conjunction with your viewing frame.

THE RULE OF THIRDS

Artists throughout the ages have devised various formulae that help create good composition, the most famous being the Golden Section, a mathematical formula on which many images and classical buildings have been based. A similar version is the 'rule of thirds'. This uses four lines that divide the picture area into nine areas of equal size and shape. The theory is that placing important elements on or around the lines or at the points where they intersect results in a pleasing composition. While it won't take care of all the aspects of composition, the theory does work and is certainly worth considering when you are planning out your image.

The rule of thirds: Placing objects on the horizontal and vertical lines, especially at their intersections, helps to construct a strong composition. Stretching four elastic bands around your viewfinder enables you to see these crucial points when you look through it.

Making a viewfinder: Cutting two L shapes out of card allows you to try looking at your subject through different permutations of size and format.

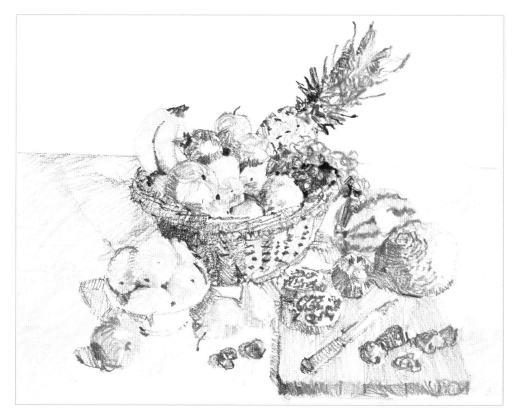

Horizontal format: When the viewer looks at a painting with a horizontal format their eye examines the composition from side to side.

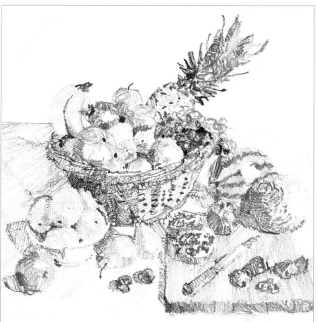

Square format: Here the eye explores the picture in all directions, finally focusing on the centre.

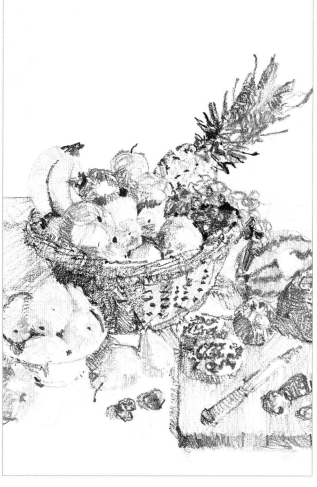

Vertical format: With the same subject given a vertical format, the eye reads up and down.

step 10 bringing it all together

focus: **still life with fruit**

Materials

53 x 74 cm (21 x 29 in)
 light brown pastel
 paper

Fixative

Brush or rag

Hard and soft pastels:

- *White*
- *Ivory*
- *Light cool grey*
- *Dark cool grey*
- *Dark warm grey*
- *Light warm grey*
- *Warm grey*
- *Payne's grey*
- *Grey green*
- *Oxide of chromium*
- *Light green*
- *Mid green*
- *Dark green*
- *Lime green*
- *Viridian*
- *Yellow ochre*
- *Cadmium yellow*

The fruit collected here, with its varied shapes, colours and surface textures, is all readily available from most fruit and vegetable stores. It provides the perfect subject for a pastel still life and in painting it you will employ many of the techniques that have been covered in the previous nine steps. Because this is quite a complex subject, you will need to make a drawing before you start the underpainting.

- *Cadmium yellow deep*
- *Lemon yellow*
- *Cadmium red*
- *Dark red*
- *Crimson*

- *Burnt umber*
- *Vandyke brown*
- *Raw sienna*
- *Raw umber*
- *Raw umber light*

- *Orange*
- *Deep orange*
- *Violet*
- *Light violet*
- *Cerulean blue*

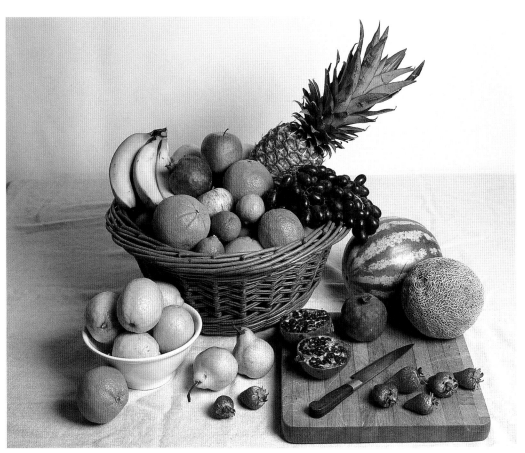

Stage 1: making an initial drawing

1 Begin by loosely mapping out the composition with a hard white pastel. Work lightly, using simple shapes. You can draw and redraw until the composition is correct and, if you wish to, carefully erase any lines you feel are incorrect. However, remember that all of the marks you make at this stage will be covered up with subsequent applications of pastel.

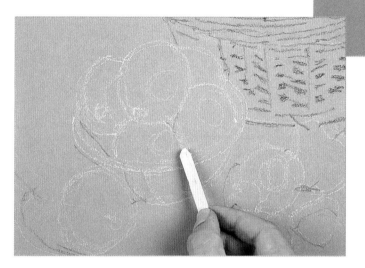

2 Once everything is satisfactorily positioned, redraw the fruit and its containers, using hard pastels in colours that approximately match those of each object being drawn. As before, work lightly so as to avoid a build up of pastel. When you are redrawing, always draw from observation rather than simply following previously applied lines. Use the inital drawing as a guide only.

3 Use a brush or a rag to remove surplus pigment dust. Once you are happy with the shape and position of everything you can apply a coat of fixative in order to prevent the drawing being erased or smudged by the side of your hand as you work.

4 All of the elements are now correctly positioned and the drawing will provide a good foundation and guide for the work to come.

Stage 2: underpainting the fruit in the basket

5 Using hard pastels throughout the underpainting, start to block in the image, beginning with the bananas. Use dark warm grey for the stalk end, dark green and yellow ochre for the shaded side and light green for the end of each banana, with cadmium yellow for the main colour. Give a quick blend with your finger to soften the colour slightly.

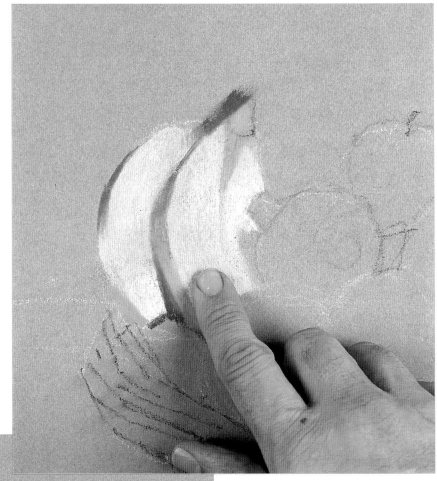

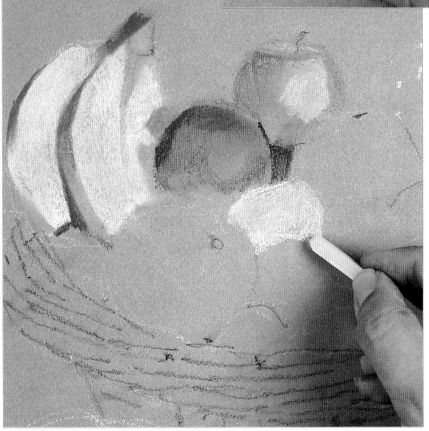

6 Now turn to the adjoining pomegranate, using cadmium red, burnt umber and orange. Block in the red apple with cadmium red, orange and cadmium yellow, then use light green and cadmium yellow for the lower apple. As before, soften the colours with your finger or a torchon.

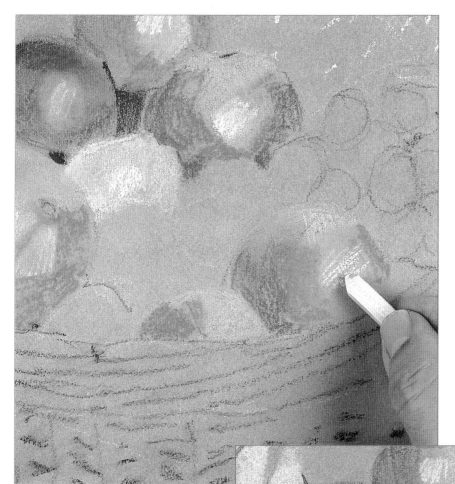

7 Block in the oranges using the same technique and applications of deep orange, orange, cadmium yellow and cadmium red. Add a little ivory to suggest the highlight.

8 For the shadows on the limes, apply light green, dark green and grey green and, as before, add ivory to the highlight. Use the dark green to apply a little of the reflected colour from the limes onto the side of the orange.

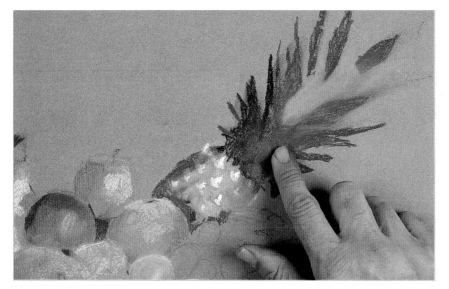

9 You will need several different colour combinations to block in the pineapple: ivory and yellow ochre with a little burnt umber for the segments, with extra details put in with light green and grey green; and dark warm grey, grey green and oxide of chromium for the leaves. Once they are applied, soften the colour with your finger.

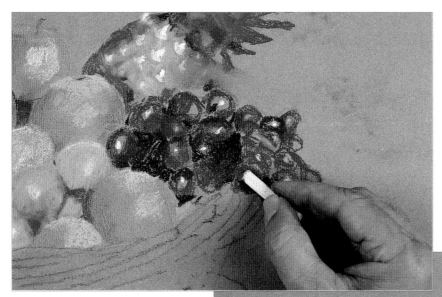

10 Complete the fruit in the basket with the addition of the grapes. Use dark red for the main colour with the addition of a little violet, touches of ivory to create the highlights and light green for the stem.

11 You will have now roughly blocked in all of the fruit in the basket and can, if you wish, give the image a spray with fixative. Notice how already the colour of the support is unifying the pastels and creating a colour harmony.

Stage 3: completing the underpainting

12 Block in the orange on the tablecloth using the same colours as in the oranges in the basket. Establish the shaded side of the lemons with burnt umber, raw sienna and yellow ochre, and use cadmium yellow deep, cadmium yellow and lemon yellow for their lit side. Block in the bowl with white, placing touches of dark warm grey to provide the shadow beneath the lemons and a little orange to suggest the reflected colour from the orange standing in front.

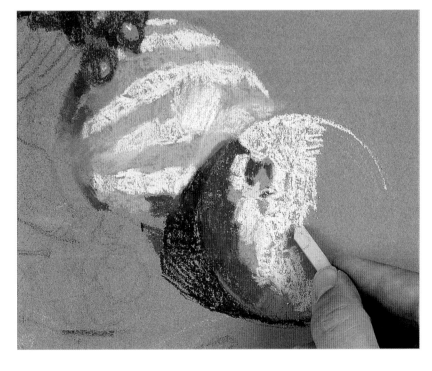

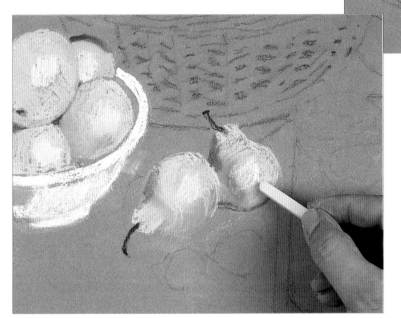

13 Move across to the pears and put in the stalks with burnt umber. Apply a little dark green for the shadows and a combination of light green overworked with cadmium yellow to provide the local colour. Add ivory for the highlights and soften them with your finger.

14 Next, block in the watermelon, using raw sienna at the basket end and dark green and grey green for the shadows. Put in the darker pattern with light green and mid green and the lighter pattern with lime green. Apply a little cerulean blue to represent the highlight and blend it into the surrounding greens with your finger. Use dark cool grey for the shadow of the other melon and dark warm grey, burnt umber and a little raw sienna on the fruit itself. Apply touches of warm grey and yellow ochre to the end of the fruit and then block it in using light warm grey.

15 For the pomegranates, use a combination of cadmium red, crimson and dark red, with burnt umber for the centre and a little light violet and raw sienna for the highlights. Establish the shadows with dark cool grey. Paint the strawberries with light and mid green for the stalks and crimson, cadmium red and burnt umber for the fruits themselves, adding subtle touches of light violet and ivory to provide the highlights.

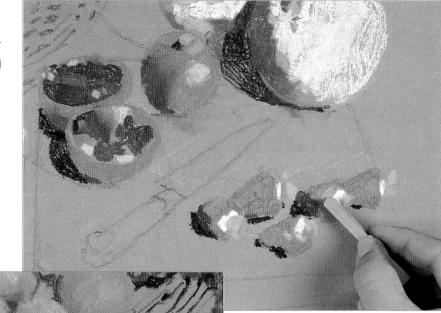

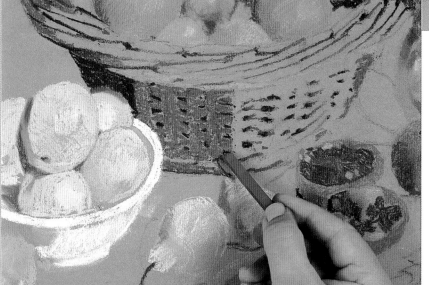

16 Suggest the deep shadows on the basket with Vandyke brown. Use raw sienna on the basket rim and burnt umber for the mid-toned wicker, working carefully to give the sense of the intricate weave.

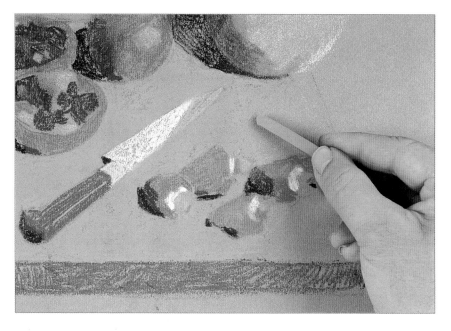

17 Block in the handle of the knife and the front edge of the cutting board, using the same burnt umber pastel. Apply yellow ochre for the brass centre on the knife and light warm grey and warm grey for the blade. Next, paint the top of the cutting block with raw sienna.

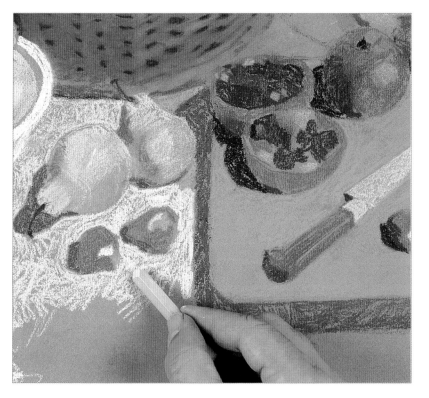

18 Use white for the wall at the back of the still life then block in the tablecloth with the same light warm grey you used on the knife blade. Once these two areas have been established the still life will appear anchored to the tablecloth rather than seeming to float in mid-air.

19 The image and the colours are now firmly established. Fixing the image at this stage will enable you to add further applications of pastel but will also slightly darken the pastel colours already applied. This is no bad thing as it simply serves to widen your palette of colours, with further applications looking especially bright.

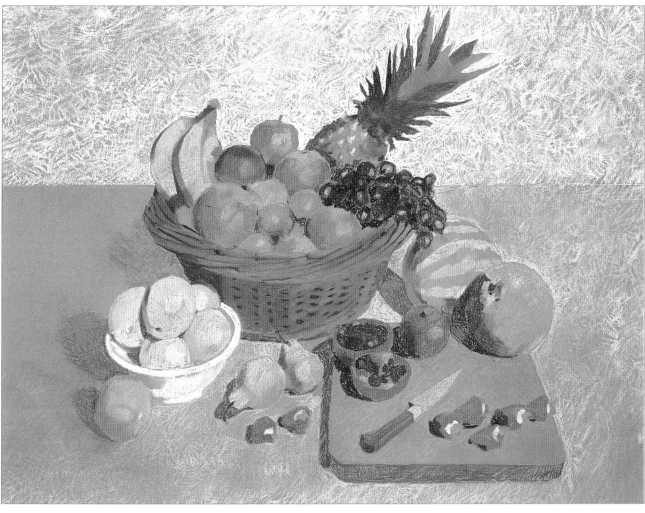

Stage 4: developing the fruit basket

20 Now turn to your soft pastels and repaint the light side of the bananas, using cadmium yellow. Apart from a little added dark grey in the shadows, leave the shaded sides of the bananas alone.

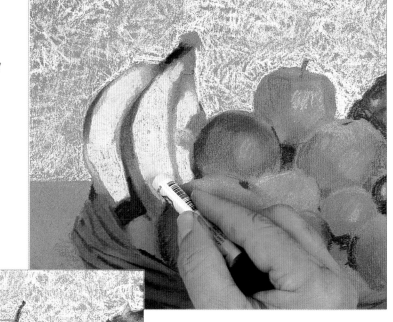

21 Strengthen the colours on the pomegranate, using cadmium red, dark red, deep orange and burnt umber, then touch in the highlight with ivory. Rework the apple with cadmium red and a little lime green blended in with your finger. Strengthen the lower apple with lime green and add an ivory highlight.

22 Repaint the oranges, with cadmium red and deep orange in the shadows and orange for the bulk of the colour. As before, provide the highlights with touches of ivory.

23 Treat the limes similarly, with grey green and viridian in the shadows and mid green and lime green adding form to the fruit. Again, use ivory for the highlights.

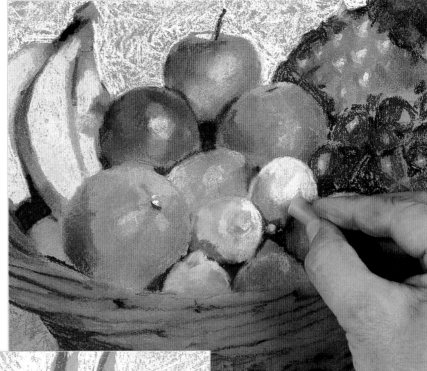

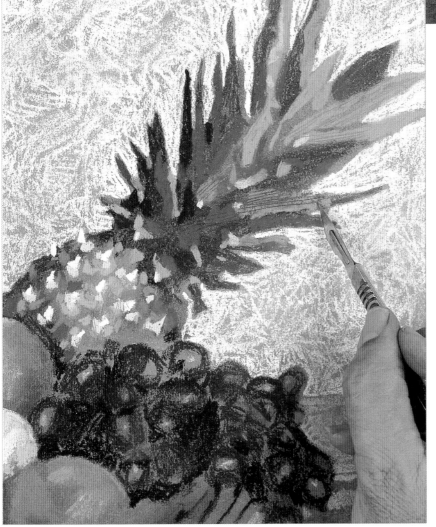

24 Repaint the body of the pineapple with dabs of ivory, yellow ochre, raw sienna, light green, mid green and dark green, describing the sections on its surface. Add further applications of dark green to the foliage and touches of cerulean blue together with oxide of chromium to describe the lighter areas. With a scalpel or sharp-pointed craft knife, add surface texture to both the fruit itself and the pointed foliage by scratching into the pastel.

25 Strengthen the grapes with applications of dark red and Payne's grey added into the shadows between and around each oval fruit. Describe the highlights with dabs of brilliant white.

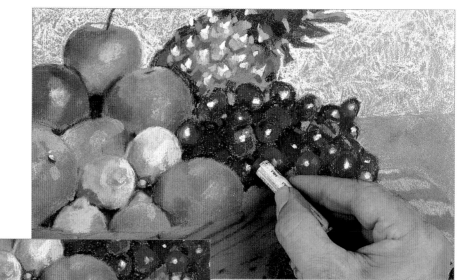

26 Now turn your attention to the basket and concentrate on using lighter browns to bring out the weave. Provide the mid tones with raw umber and raw umber light and catch the light on the cane work with ivory. Put touches of burnt umber into the shadows and dabs of raw sienna to add a little warmth.

27 The newly applied colours sit well over the subdued fixed underpainting and lend a solidity to the objects that would not be quite so apparent if they had been painted in a single layer. In order to maintain this depth and brilliance of colour it is better to leave the work unfixed.

Stage 5: developing the fruit on the table

28 Now rework the rest of the image in the same way, beginning with the lemons. Use the same colours as before, with lemon yellow providing the lighter areas. Accentuate the crispness of the white bowl with a heavy application of pure white on that side of the bowl in full light.

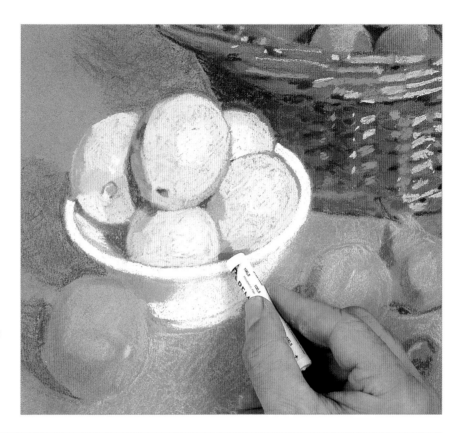

29 Repaint the orange in front of the bowl, using the same range of colours as for the oranges in the basket. Move on to the two pears, repainting them with cadmium yellow, mid green and lime green.

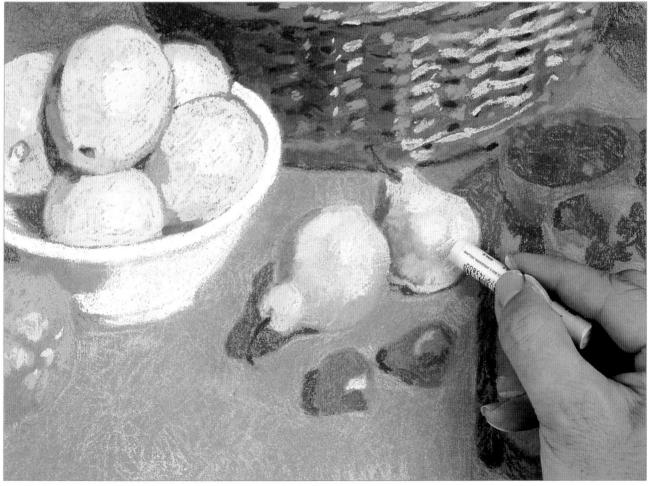

30 Using the same colours as before, repaint the colours on the watermelon but allow the underpainting to show through on the very top of it and in the shadows. The subdued colour helps these two areas to appear to recede. Describe the textured surface of the smaller melon by using an open scumble technique to paint raw sienna and layers of oxide of chromium in the shadows, followed by light warm grey and ivory on the side of the melon catching the light.

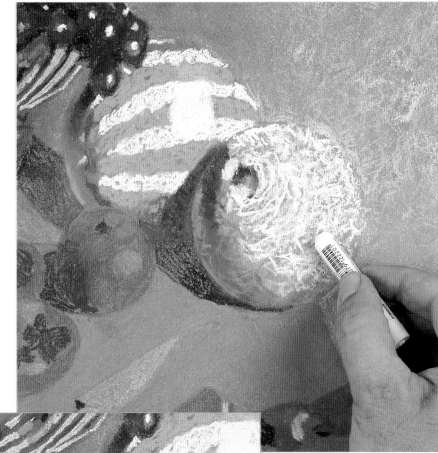

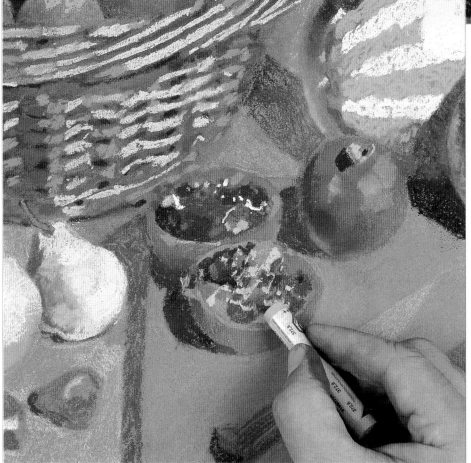

31 Next rework the pomegranates using cadmium red, dark red and deep orange. Bring out the highlights with orange, light violet and ivory.

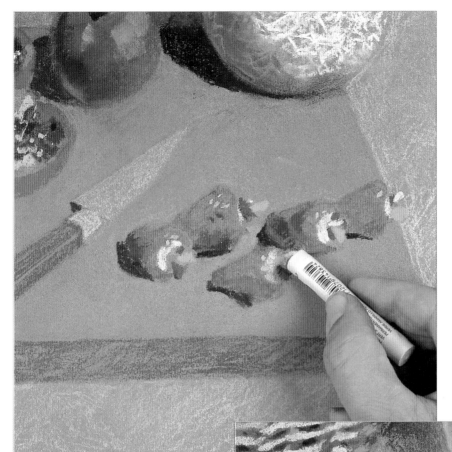

32 Give form to the strawberries with touches of cadmium red, deep orange, light violet and ivory. To bring the small tufts of foliage at the ends to life, paint in light green, grey green and lime green.

33 Next, paint in the strips of wood that make up the wooden block with yellow ochre and raw sienna. Strengthen the darker side using burnt umber. Finally, with ivory and yellow ochre hard pastels, draw fine lines running off at different angles to suggest the cut marks.

34 Add highlights to the knife blade using the light cool grey. Paint the colour of the brass ferrule and pins securing the blade to the handle with yellow ochre and make a few precise marks with white to provide the highlights on both the ferrule and the end of the handle.

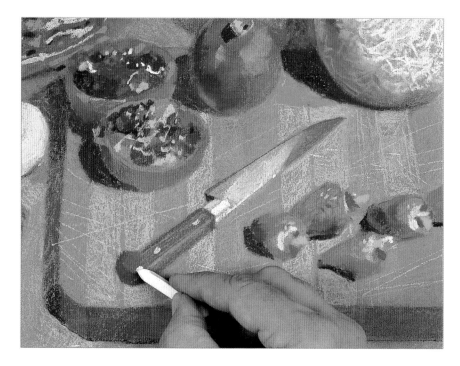

35 Repaint the wall behind the still life, using scribbled heavy applications of white. Cut in carefully around the fruit, especially the pineapple.

36 Give the tablecloth the same treatment. Finally, add dark warm grey into the shadows then paint the whole cloth with a layer of yellow ochre, followed in the lighter areas with ivory.

37 Once you have finished the painting you will be tempted to give it a spray of fixative, but this will dull many of the colours, especially the lighter ones. If you do apply fixative, return to and strengthen those colours that need it then leave this final application of colour unfixed.

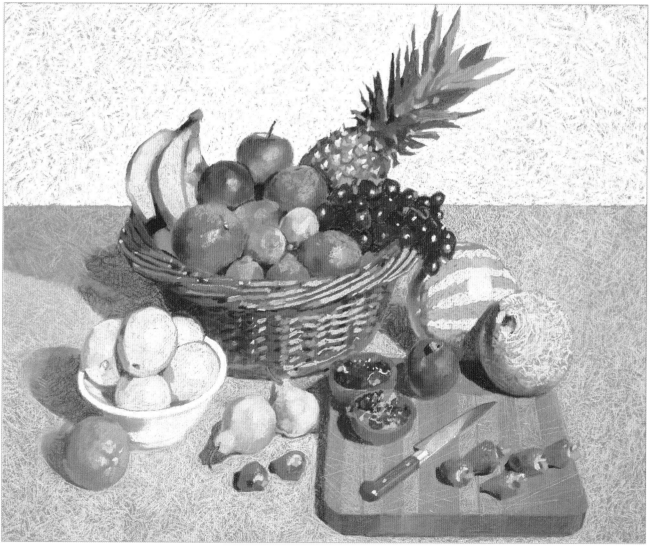

Index

Acknowledgements

Executive Editor Katy Denny
Editor Ruth Wiseall
Deputy Art Director Karen Sawyer
Designer Lisa Tai

Senior Production Controller Manjit Sihra
Artists Ian Sidaway and Adelene Fletcher
Photography © Octopus Publishing Group Ltd/Colin Bowling; Ian Sidaway; Paul Forrester.